Sound Design for Low and No Budget Films

Don't let your indie film be sabotaged by poor sound! One of the weakest technical aspects of a low or no budget short or feature film is usually the sound, and in *Sound Design for Low and No Budget Films*, author Patrick Winters explains what filmmakers need to do to fix that. Learn how to improve the sound quality of your low budget film with specific tools and practices for achieving a better soundtrack, including detailed, step-by-step explanations of how to edit your production track, create a sound design, record and edit ADR, Foley and sound effects, music, and much more. Focusing on the essential details indie filmmakers need to know, Winters teaches you how to turn a thin and distracting soundtrack into one that makes your film shine.

This practical guide offers:

- In-depth focus on hands-on, step-by-step instruction for achieving great sound in post-production, including recording and editing sound effects, ADR and Foley—even without expensive equipment and software.
- Techniques specifically designed for low and no budget projects, perfect for both students and aspiring indie filmmakers.
- A simple and direct style that any aspiring filmmaker or student can understand without already knowing the industry jargon.

Readers can follow the eResources URL (www.routledge.com/9781138839441) for video interviews from industry professionals, also viewable on YouTube.

Patrick Winters has been working in sound design for 30 years and teaching sound design for 12 years. He has personal experience working on major motion pictures as well as creating his own short films, stretching minimal budgets to get the best soundtracks possible.

San Diego Christian College
Library
Santee, CA

778.5
W788s

Sound Design for Low and No Budget Films

Patrick Winters

Routledge
Taylor & Francis Group

NEW YORK AND LONDON

First published 2017
by Routledge
711 Third Avenue, New York, NY 10017

and by Routledge
2 Park Square, Milton Park, Abingdon, Oxon OX14 4RN

Routledge is an imprint of the Taylor & Francis Group, an informa business

© 2017 Patrick Winters

The right of Patrick Winters to be identified as author of this work has been asserted by him in accordance with sections 77 and 78 of the Copyright, Designs and Patents Act 1988.

All rights reserved. No part of this book may be reprinted or reproduced or utilised in any form or by any electronic, mechanical, or other means, now known or hereafter invented, including photocopying and recording, or in any information storage or retrieval system, without permission in writing from the publishers. Printed in Canada.

Trademark notice: Product or corporate names may be trademarks or registered trademarks, and are used only for identification and explanation without intent to infringe.

Library of Congress Cataloging-in-Publication Data
Names: Winters, Patrick (Patrick O.) author.
Title: Sound design for low and no budget films / Patrick Winters.
Description: New York : Focal Press, 2017. | Includes bibliographical references.
Identifiers: LCCN 2016020795 | ISBN 9781138214033 (hardback) |
 ISBN 9781138839441 (pbk.) | ISBN 9781315733425 (ebk.)
Subjects: LCSH: Sound motion pictures. | Sound—Recording and reproducing. |
 Motion pictures—Sound effects.
Classification: LCC TR897 .W56 2017 | DDC 778.5/344—dc23
LC record available at https://lccn.loc.gov/2016020795

ISBN: 978-1-138-21403-3 (hbk)
ISBN: 978-1-138-83944-1 (pbk)
ISBN: 978-1-315-73342-5 (ebk)

Typeset in Giovanni
by Apex CoVantage, LLC

To my life partner, Patti Winters,
whose support and encouragement have made
it possible for me to write this book.

Contents

Preface

Welcome to the wonderful world of sound design. It's a creative art form that's only limited by your imagination. Sound design allows you to apply your imagination to films, television, radio, games, videos, websites, webisodes, commercials and more. Since every project has its own requirements, it forces us to try new things and stretch ourselves in untried ways. As we stretch, we grow and that allows us to apply deeper meaning to the sound designs we create.

This book was written for filmmakers and film students working to bring their vision to life. If you've picked up this book, you already know how important sound is to filmmaking. You already know that it takes a lot of work to create a sound design that serves your film. This book will guide you through the multiple steps that are needed to have the sound design you want for your film.

Reading this book will provide you with lots of worthwhile information, but it's up to you to apply it and learn as you go so that your next sound design is better than your first.

It is my hope that you find this book to be useful and that when you apply its information and lessons, you will be able to create a sound design that makes your film stand out from the crowd.

Patrick Winters

Acknowledgments

I would like to thank everyone who offered their support, encouragement and knowledge in the demanding endeavor of writing this book. Just like in the film and television industries, nothing is created solely by the director or author, but by a team of people working together. Every person that I contacted for information or the rights to use a quote or image responded positively. I have listed them and their role in creating the book in the Credits section.

CREDITS

Photographers

Catherine Clark (Foley), Image 9.1
Staff Sergeant Suzanne M. Day, DoD U.S. Air Force photographer, Inserted Images 8.1, 8.2 and 8.6
Nicole Maturo, Image 8.1
Patrick Winters, all other images that were created, captured or photographed

Photography and Video Talent

Jocelyn Barkenhagen, Ryan Barnas, Tyler Dance, Andrew Dessel, Matthew Dezii, Nick Gormack, Keith A. Johnson, Nicholas Jurczak, Riley Irving, Linsey Lack, Caleb Lazenby, Kevin Macchia, Eileen McTiernan, Matthew Mikkelsen, Rachel Morris, Patricia Quijada Salazar, Matt Salib, Jeffery Streeter, Garrett Winters, Riho Yamaguchi

Images

Danijel Daka Milosevic at danijelmilosevic.com, Room Calibration Chart, Image 12.3
Dorrough Electronics, Dorrough Meter, Image 12.1

Screen Capture Permissions

John Given, Corporate Counsel, Avid® Pro Tools® screen images used with permission of Avid Technology, Inc. Pro Tools screen images © 2015 Avid Technology, Inc. All rights reserved. AVID, the Avid logo, and Pro Tools are either registered trademarks or trademarks of Avid Technology, Inc. in the United States, Canada, European Union and/or other countries.
GarageBand Screen shots reprinted with permission from Apple Inc.

Video Footage

Scenes from Keith A. Johnson's short film, *Fixation*
Scenes from Patrick Winters' short film, *Skin Deep*
Scenes from Patrick Winters' short film, *Vanished*

Video Interviews

Steven Avila, Josh Berger, Terry Boyd Jr., Martin Czembor, Isaac Derfel, Marlena Grzaslewcz, Jeff Pullman, Ron Riddle, Matt Salib, Ian Shedd, Ben Whitver

Video Interviewers

Jon Hilton, Patrick Winters, Patti Winters

Quotes

Oakley Anderson-Moore (2013, August 25) Nofilmschool article, *Inside the World of Professional ADR with Julie Altus of Todd-SOUNDELUX.* http://nofilmschool.com/2013/08/inside-adr-julie-altus-of-todd-ao

Georgia Hilton, MPSE CAS MPE (2014, September 11). https://www.gearslutz.com/board/video-production-post-production/954125-delivery-specs-vod-itunes-netflix-other-requirements.html

Derek Jones, Chief Engineer and Production Manager at Megatrax (2010, February 22) blogs a great example of tempo mapping. http://duc.avid.com/showthread.php?t=267717

Debra Kaufman and Ron Lindeboom (2013) Creative Cow, John Roesch Article: *The Art of Foley: John Roesch Honored by MPSE.* https://library.creativecow.net/kaufman_debra/John-Roesch_Foley-MPSE/1

William Kallay (2004, September 24) fromscripttodvd.com article, *Avram Gold, M.P.S.E. Behind ADR,* http://www.fromscripttodvd.com/adr_fixed.htm

Tim Prebble, Sound Designer, Hiss and a Roar (2008, March 3) *Recording FX at 96k,* Music of Sound. http://www.musicofsound.co.nz/blog/recording-fx-at-96k

Rob Winter, British Film Institute, *The Best Music in Film,* Sight and Sound September 2004 issue. Quote from Lewis Gilbert, Director.

Consultants

Jake Ayres, Sound Engineer
Trip Brock, M.P.S.E., Supervising Sound Editor, Re-Recording Mixer and Founder of Monkeyland Audio
Philip Chatterton M.P.S.E., Foley Artist
Marlena Grzaslewcz, M.P.E.G., Dialogue Editor

Georgia Hilton, M.P.S.E., Post-Production Supervisor
Ron Riddle, Film and Television Composer

Special Thanks

Kelley Baker, Post-Production Sound Supervisor and Angry Filmmaker
Trip Brock and the crew at Monkeyland Audio, Glendale, CA
Philip Chatterton/Philip Rodrigues Singer M.P.S.E. of Marblehead at
http://www.marblehead.net/foley/
Jim Cox, Writer and Producer
Madeleine Gentle, Copy Editor
Ron Harris, Vice-President of Production and Sales, DuArt Media Services
John Makowski, Editorial Assistant
Emily McCloskey, Editor
Steven O'Brien, Composer at steven-obrien.net/ & soundcloud.com/StevenOBrien
Zachary Perry, Composer and Producer
Abigail M. Stanley, Production Editor

CHAPTER 1

Introduction

The sound and music are 50% of the entertainment in a movie.

George Lucas

PURPOSE

The idea behind this book is to give low and no budget filmmakers a guide to creating effective sound designs for their films. Sound design includes the dialogue, sound effects and music combined together to create an experience for the audience. Every film is different and has different needs, so although this book can't possibly address every situation, it does give filmmakers useful information that can be applied to nearly every film.

Many of the concepts and approaches in this book will vary according to the software, facility and the personnel. Sound design and mixing are creative endeavors that utilize technology, so there are many opinions on what is the best way to approach each. This book does not attempt to be comprehensive and cover every approach, but it is intended to act as a guide for you to do your sound design for your film.

The reason a filmmaker needs to concentrate on getting the best sound possible is because it will lift up the production value of your film. There's nothing that turns off an audience faster than bad sound. An image can be a bit soft in focus or a bit shaky and the audience is accepting, but when the sound is bad, they're often intolerant. So, in filmmaking, it is said that *the eye forgives and the ear does not.* This means that even if the image is perfect, if the sound is off just a bit, it will pull your audience out of the story.

Sound design can be done on a personal computer, so long as it has enough power, storage and the proper software. With the right equipment, a no or low budget filmmaker can do much of the work at home without having to pay for a studio.

Throughout the book I refer to DAWs and NLEs. I define a DAW (Digital Audio Workstation) as a NLE (Non-Linear Editing) in that you can edit in a non-linear manner. In order to differentiate between a NLE system that is primarily designed for audio and one that is primarily designed for picture, I refer to the audio editor as a DAW and the picture editor as a NLE.

This book is laid out in a way that allows you to work from the first page to the end and you'll have the consecutive steps for creating your soundtrack. During the course of the book, you'll be doing spotting, cueing, recording, editing, processing and mixing for some variation of the following steps:

- Dialogue
- ADR (Automated Dialogue Replacement)
- Group/Walla
- Special effects
- Backgrounds
- Foley
- Sound design
- Music
- Premix
- Stems
- Master
- M&E (Music and Effects)

The software that I use for the examples in the book is Pro Tools; however, the principles will apply to whatever NLE or DAW you choose to use for your sound design.

As you create your sound design, you'll use dialogue and possibly narration to provide information; you'll use sound effects to help make each scene seem real; you'll use music to emotionally affect the audience; and you'll mix all of the sounds together to create a stream of continuity that supports the story.

Sound design is more than creating monster sounds or spaceship sounds; it's about making all of the different aspects of a soundtrack work together to help tell your story. It's telling your story from the audio perspective.

SOUND DEFINITION

There are so many different definitions of the word *sound*. One common definition states that sound is something that can be heard. That's pretty straightforward. Another definition says that sound is vibrations that are heard. Both of these definitions bring up the old question: *If a tree falls in the forest and there is no one there to hear it, does it make a sound?* The answer is that a falling tree sound will exist with or without a listener. The definition that I like the most is: Sound is vibrations that travel thorough a medium such as air or water to a receiver.

There are many laws, rules, theorems, principles and properties of physics and psychoacoustic phenomena that affect the recording, editing and mixing of sounds. Such laws as the

Nyquist Sampling Theorem, the 3 to 1 Rule, Proximity Effect, Doppler Effect, Inverse Square Law, Equal Loudness Principle, masking, Haas Effect, harmonics and resonance, to name a few. This book is not about the scientific study of sound, but the creative use of it. However, many of these terms are used within the book and the meanings are included in the glossary.

SOUND'S ABILITIES

- Sound in the form of dialogue is great at conveying information and emotions.
- Sound can be used to establish a geographic location.
- Sound is often used to place the story in a historical period.
- Sound, along with picture editing, can be used to set the pace of a story.
- Sound is a great tool to create hyperrealism or simplify realism.
- Sound can be used to draw attention to some detail, person, situation or object.
- Sound is often used to help the audience make connections.
- Sound can be used to emphasize or smooth out a transition.
- Sound can be used to give meaning to the story or to define a character.
- Sound is commonly used to enhance and define a story or plot.

SOUND SUPERVISOR

There needs to be one person who is in charge of the soundtrack. They need to know who is doing what and make sure there is little overlap and that all sounds are created, acquired and edited into the tracks. The sound supervisor does this in addition to overseeing the mixing process as well as the budget and schedule. Some supervisors will create designed sound effects too. All of these responsibilities allow them to guide and maintain oversight of the film's entire sound design.

As a low or no budget filmmaker, you may not have the funds to hire a sound supervisor, but if you can, they'll help you keep organized while overseeing the process of post-sound production. If you can't afford a sound supervisor, then be as organized as you can be.

CONTRACTS, AGREEMENTS AND LICENSES

I am not a lawyer, but I've had experience with contracts, rights and permissions. Because contracts can be tricky, I suggest that you work with an entertainment lawyer should you have any questions or concerns.

I have discovered over many contracts that if you don't have it in writing, it's not valid and you have no recourse.

Some of the types of agreements you might be dealing with are:

- Work for Hire Agreements
- Composer Agreement
- Talent Release

- Deal Memo
- Picture Lock Agreement
- Distribution Agreement
- Deliverables
- Film Synchronization Rights
- Mechanical Rights
- Royalty Free (Full or Limited)
- Music Rights

One of the most common issues I've encountered with no and low budget productions, especially student films, is that of not getting all of the rights necessary to legally use an existing song in a film. The bottom line is that if you are having any kind of public screening of your film and you have music in it, you need to attain all of the appropriate rights first.

There's a lot of music available to filmmakers on CDs and as downloads. The owners of these songs or score cues usually require some form of payment or if offered for free, then acknowledgment in your film credits. Always check out the requirements.

Another common mistake is thinking that a song is in the public domain, but not doing the research to find out if that's true. Sometimes the sheet music is in the public domain, but not the recording. Just because a song was written before January 1, 1923 doesn't mean that the recording made after that date is in the public domain. Since 1923 there have been several changes to the copyrights laws and you'll need to make sure you don't violate any of them.

Now, get on with creating the best sound design you can for your film.

Location Sound

How Was That for Sound?

COMMON MISTAKES

Recording sound without headphones. I always say that you wouldn't shoot picture without looking through the viewfinder, so why would you record sound without listening through headphones? Headphones not only tell you if you are picking up a good dialogue signal, but they also tell you if there are any sounds in the background that are unwanted.

Positioning the microphone too far away from the speaker or sound source. The farther away from the sound source, the poorer the recording level and the greater the noise floor. The noise floor is the sound you hear in a room or outside on location that is outside of your control. It is the wind or distant traffic, air conditioning or machinery. Ideally, the level of the sound source or voice is at least 16dB above the noise floor. The closer to a 30dB difference the better. That's not always possible to achieve, but it's a good goal. If you can achieve at the very least the 16dB difference, then you'll have an easier time editing your dialogue.

Another issue with improper microphone placement is that of excessive reverberation. It's better to have to add a bit of reverberation in post-production than to have to do ADR (Automated Dialogue Replacement) because the dialogue sounds like it's been recorded in a bathroom.

Not recording any room tone or ambience. This makes it harder for the dialogue editor to smooth out the changes in ambience or room tone between each shot in a scene. It also makes it harder to have a long clean background or room tone to edit under any ADR lines.

Using the wrong microphone for the situation. A hyper-cardioid microphone will usually do a great job of recording dialogue on an exterior location, but if you then use it on an interior, especially in a reverberant room, then it will not be the best choice. You'll want to use a cardioid on your boom for the interior. The hyper-cardioid will have a difficult time with all of the reverberations.

Mixing all of the microphones onto one track. If all microphones are recorded onto one track it will bring up the level of the noise floor, because the noise floor from all microphones will be added together. It will also make it very difficult to edit the dialogue since you can't easily separate out what's been recorded together. It's best to keep all tracks discrete or separate from one another. It's common for each microphone to be recorded separately onto its own track and to be included in a mixed track also. The mix can be used in picture editing and the separate tracks can be used in dialogue editing.

Not having a sound report. A sound report has valuable information that the picture editor and the dialogue editor can use (see the sound report form at the end of the chapter).

Sound Conveys Emotion—Picture Conveys Information

Get your location sound recorded well and the rest of the process will be easier and better for it. There are ways to work with poorly recorded sound in post-production, but none of them will give you the quality you could have achieved with properly recorded dialogue. The goal of sound design for your film is to help pull the audience into the story and that becomes harder when the production track sounds bad.

Great Sound will Enhance and Support your Story

The most common problems with location sound recordings are noisy backgrounds, such as people talking or moving around, traffic, dogs barking, sirens going off and aircraft overhead. The more constant problems are traffic, wind, heating and air conditioning systems, elevators, refrigerators, clocks, computers and other office equipment. Some problems come from the talent, especially if they are wearing wireless microphones. The microphone could rub on their clothing, they could bump the microphone, causing a "hit," or they could be heavy breathers or they may make loud mouth noises when they talk. Other issues with wireless microphones are with interference from other radio signals. If the microphone is mounted on a boom pole,

there could be handling noise from the boom operator moving their hands along the pole or the microphone cable hitting the pole.

SINGLE SYSTEM

If you shot your film using a single system sound recording, then you'll not have to synchronize your picture and sound together for editing. Single system means that both the picture and sound were recorded onto the camera itself without a separate sound recorder. This system works well if you only need to have a couple of tracks of dialogue, as most cameras only record two tracks; however, there are some cameras that will record up to four tracks. Having four tracks may allow you to keep all of the microphones discrete, which is what you want for post-production. Single system sound is easier to work with than double system, but it gives you less flexibility in post-production, unless you can keep each microphone on its own track.

DOUBLE SYSTEM

If you shot your film using a double system sound recording, then you'll have to synchronize the sound and picture in your editing system. In order for this to go simply and smoothly, it is helpful if you record the sound on an audio recorder and also onto the camera. This gives the synchronization software a reference for achieving synchronization. The software will compare the sound that comes with the video to the sound that was recorded separately and line up the waveforms. If you have the timecode on both the video and the sound, you can use that to synchronize them. If you used several wireless microphones and a boom microphone all going to discrete or separate tracks, then those will show up in your timeline on their own track. You can then edit the higher quality sound with the picture. Some NLE (Non-Linear Editing) systems allow you to import and synchronize the sound, but only put the mixed track on the timeline. The system maintains a link to the other discrete or ISO (isolated) tracks, should you need them. This is all right if you are doing your sound post-production on a separate system that will allow for multiple tracks.

TIMECODE

The most important thing to know about timecode is that if you used it for both picture and sound, then they need to have an identical timecode in order to be in synchronization. That is, if the video camera is shooting 24 frames per second, then the sound needs to be recording at 24 frames per second too. If the sound is not recorded at the same speed as the picture, then the timecode will be off and the sound will have to be resolved to the proper speed before editing. You'll also want to make sure that your picture and sound are both set at either drop frame or non-drop frame or your timing will be off.

23.976 FPS
√ 24 FPS
25 FPS
29.97 FPS
29.97 FPS Drop
30 FPS
30 FPS Drop

Figure 2.1

SLATE

Figure 2.2

The classic slate does not have the timecode. It requires you to synchronize the sound and picture by sight in the timeline. You'll have synchronization when the first frame in which the two sticks come fully together and the waveform spike where the sound of the two sticks hitting together need to be lined up and linked together.

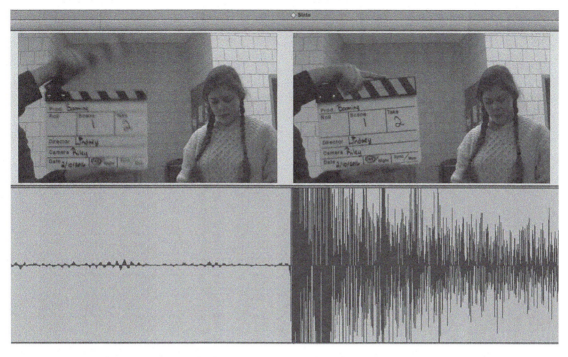

Figure 2.3

SMART SLATE

Smart Slates display the timecode on an LED screen. That timecode is jam-synchronized with the camera and audio recorder. That means that the audio recorder and the camera are running the same timecode in synchronization. This will allow for easy synchronization in post-production. Also, if there was a problem with the timecode, then you can switch to a manual synchronizing system where there'll be the actual sound and picture of the slate hitting together. This will allow for visually synchronizing the sound and picture in your editing software.

BOOM AND LAVALIERE

The most natural sound is recorded with a boom microphone. It'll pick up the dialogue and also some of the ambience of the location. This gives the dialogue a sense of place. Lavaliere microphones are usually hidden under clothing on an actor's body near the sternum. This means that the higher frequencies are being filtered or muffled by the clothing the actor is wearing. It also means that the low frequencies are being boosted because the lavaliere microphone is placed above the chest cavity. The chest cavity produces the strongest low frequencies in the actor's voice. So, the recording is missing some of the frequencies that would make the

voice sound more natural. When you're dialogue editing, you'll want to use the best sounding dialogue for each scene. Ideally, this would be the sound from the boom microphone, but if not, then the lavaliere can be used, but it will need to be equalized in order to sound more natural.

Lavalieres have an issue with clothing. Since they are buried beneath the actor's clothes, they can easily pick up the sound of the clothing movement and worse have clothes rubbed over them, which can ruin a take. When the placement of a microphone under clothing isn't the best option, then it can be placed in the hairline, under a hat rim, behind a button, or one of many other creative placements. The placement on the outside of the clothing will also remove some of the issues with the high and low frequencies needing to be equalized.

WIRED AND WIRELESS

The general rule of thumb is that a wired microphone is more reliable than a wireless one. One of the main reasons for this is that a wired microphone is much less susceptible to radio interferences than a wireless one. However, wireless microphones may allow for extended movement of the actor beyond what a wired microphone would allow.

WIDE SHOTS AND CLOSE-UPS

There should be a sense of perspective. If the shot is wide, then the dialogue should sound slightly distant. This works well with a boom microphone, but is hard to accomplish with a body mounted lavaliere microphone. For a close-up either microphone will work well.

TWO-PLUS CAMERA SET-UP

Some productions choose to shoot their film with two or more cameras. There are valid reasons for doing this, but there are also disadvantages to it too. One disadvantage is that if one camera is on a wide shot and the other is on a close-up, the boom microphone cannot get in close enough on the close-up shot to get good close sounding dialogue. It will have to sound unnatural because there was no room in the framing of the wide shot to allow the microphone to get in close.

This can be overcome by using a lavaliere microphone, which always sounds close because it's on the actor's body. The issue that this causes is that the dialogue editor is stuck with the lavaliere microphone on the close-up and the boom microphone on the wide shot or with using the lavaliere for the entire scene. The dialogue editor's choice will depend on the coverage and the editing. If there's no lavaliere sound for some of the lines in the scene, then those lines will either come from the boom microphone or will have to be looped in an ADR session. Either way, there will have to be some processing during the mix to get the dialogue to sound somewhat natural.

EXERCISE

A simple exercise to demonstrate the value of a well-placed microphone is to record a person speaking in a very reverberant room or hallway using an omni-directional lavaliere microphone and three microphones that are on boom poles. Each of the three microphones on booms will have a different pick-up pattern. One will be omni-directional, another will be cardioid and the third will be hyper-cardioid. You can either record all four microphones at the same time, if you have four inputs, or you can record them one at a time. Place the lavaliere microphone at the speaker's sternum. Have the speaker recite a short poem.

In a quiet room, you can play back each of the recordings and determine which microphone did the best job of rejecting the reverberations.

Another version of this set-up is to record the speaker on the boom microphones from 3 feet (1 meter) away and then record again from 2 feet (.6 meters) and then from 1 foot (.3 meters) away. You'll also need to record the speaker using a lavaliere microphone attached to the speaker's clothing at the sternum.

Play these recordings back in a quiet room and compare the quality of the sounds.

SAMPLE SOUND REPORT FORM

PRODUCTION SOUND REPORT

Sound Mixer: _____ Disk/Roll#: _____

Phone: _____ Prod Date: _____

Email: _____ Page: _____ of _____

Title: _____ Director: _____ Producer: _____

Recorder: _____ Sample Rate: _____ Bits: _____ Media: _____ File Type: _____

Timecode: _____ Tone: _____ Metafile Text: _____

Scene	Take	Segment or File#	Notes	Tracks							
				1	2	3	4	5	6	7	8

White (original) goes with the media. Yellow (2nd) to Editorial. Blue (3rd) to Production office. Pink (4th) for Sound Mixer.

Figure 2.4

CHAPTER 3

Sound Design

Figure 3.1

DEFINED

There are a couple of ways of defining the term *sound design*. It is commonly used to refer to the creation of a sound for a creature, alien, monster, spacecraft or other thing that humans may never have encountered before. This is what I refer to as a sound effects design. Sound design's larger meaning is the overall soundscape of a film. This includes the music, sound effects, designed sounds, backgrounds and even the dialogue.

For example, the language and thereby dialogue for the alien creatures in the movie *District 9*, 2008, was created by Sound Designer, David Whitehead. Not only did he create a new language for the aliens, but he also recorded himself speaking the language and then totally redesigned those dialogue sounds into the odd vocalizations of the aliens communicating.

Generally speaking, the term *sound editor* refers to someone who edits pre-recorded sounds and a *sound designer* is someone who creates new sounds by recording, editing and manipulating sounds. In a greater sense the overall sound design is the orchestration of sounds in order to create an intentional acoustic world that provides and supports the emotional elements of the story.

Sound design is used to subconsciously manipulate an audience into having an emotional response to the film's story. The audience is not supposed to notice that the sound design is leading them down a particular path. The use and quality of sound design is often where big budget movies and low and no budget movies diverge. A filmmaker who has limited money can make their film stand out by concentrating on the sound design.

INTRODUCTION

All of the information in this book is provided to help you create an effective sound design for your film. When you have a plan for recording, editing, processing and mixing all of the various types of sounds together, you are creating a sound design specifically for your film. The dialogue, ADR (Automated Dialogue Replacement), Foley, sound effects and music all need to work together to create that planned auditory world for the sake of the story.

Film sound does not happen by accident. It starts with a deep understanding of the story in general and each scene in particular. It then includes an understanding of each character and what their purpose is in the story. You then use your head, imagination and gut to determine what sounds will work to support the character and story. Use your head to determine what you need to do to create the sound you've imagined and then use your gut to determine if a sound is working. Basically, your job is to do whatever it takes sonically to breathe life and feeling into the film.

MOVIE EXAMPLES

The term *sound design* was conceived by Francis Ford Coppola as an appropriate film credit for the sound work created by Walter Murch for the film, *Apocalypse Now*, 1979. Murch not only did some of the picture editing on this movie, but he also created and integrated sound effects into the story line as a companion to the images. This collaboration of sound and picture added great depth and power to the film.

Today, sound design is commonly used for special sounds created for a specific machine, creature or event. A good example of this type of sound design is the shower scene in the remake of the movie *Psycho*, 1998.

When I was working on the remake of the movie *Psycho*, 1998, I was given the desirable job of creating the sound design for the famous "shower scene." I knew that just putting the required sound effects would not do justice to this important scene. I began by

listening to the shower scene from the original movie, which was made in 1960. I found the use of sound in it to be economical and effective, as there were only a handful of sound effects used.

The original version of the movie was mixed in monaural sound, not stereo, which gave me the idea of recording all the sounds for the remake shower scene in stereo, even the sound of the water itself.

I spotted the scene and determined what props I would need to create the desired sounds. I then purchased all the props, including a knife similar to the one used to stab the victim. My goal was to have the audience perceive the sounds as hyper-realistic, as though they were in the shower getting stabbed, not just watching it happen.

I searched for and found a hotel room that was nearly identical to the one shown in the film. Together with someone to record the sounds and a model to be the victim, we recorded a number of sounds. We recorded the shower from every camera angle used in the picture edit. We recorded the model washing her body, her feet moving in the bathtub, her back sliding down the tile and the water hitting her skin. Once we were done with the model, we recorded the water running down the drain and emptying, the shower curtain being moved and then pulled down and finally the shower handle being turned on.

I had purchased two shower curtains and four sets of curtain rings so that we could record several takes until we got the right sound.

Once all the body sounds for the victim and the shower itself were recorded, I moved on to the stabs. The original film had used only a beef roast and a heavy knife to make the stab sounds, but I wanted that hyper-realistic sound that would make the hair on the back of the head of each audience member stand up. I wanted to layer the stabs with various textures to make them seem terrifying. I used a roast, cantaloupe, watermelon, casaba and a cabbage to create the textures. I happily noticed that when I pulled the knife out of the cabbage, I could hear a special ring in the blade as though it hit bone.

I knew what music would be used in this scene, so I adjusted the pitch on the cabbage knife ring so that it would be off pitch from the music. I wanted that sound to be irritating to the audience, to make them feel uncomfortable. The other sounds of the beef and fruit stabs were useful for making the stabs sound real and disturbing, but it was the ring that really made the stabs horrific.

I consider this to be basic sound design, because I did more than place sound effects in synchronization with picture. I took into consideration the movie as a whole, the importance of the scene within the movie's story and how the music, sound effects and dialogue (scream) would all work together to create an intended emotional experience for the audience; one that was hyper-real.

RECORDING

There are different designs of microphones that can be used for recording sounds in general, including sounds for sound design. There are the two basic microphone designs: *dynamic microphones* and *condenser microphones*. Dynamics are effective at picking up sound that is close to the microphone, such as vocals in a live performance. Condenser microphones are effective at capturing sounds from a distance. Also, condensers usually do a better job of picking up a wider range of frequencies and have a greater dynamic range. That's why they are commonly used in film sound production.

There are specific-use microphones, such as hydrophones, for recording in a liquid environment, contact microphones for picking up direct sounds from a vibrating medium and parabolic microphones for picking up sounds from a long distance. There are even microphones that record frequencies far above human hearing, as high as 50kHz or more.

When you record your sound effects for your film, you'll mostly use either a shotgun microphone or a large diaphragm microphone. You may want to record some sounds in stereo and others in monaural. Ambiences are usually richer when recorded with stereo or surround microphones because they give the audience the sensation of being surrounded by the scenes' auditory environment.

When recording the sounds you'll use in your sound design, you can use a target volume level of –18dB to –20dB with –12dB being the loudest level, although you could go louder. You need to allow for some headroom, so that the signal being recorded doesn't distort. Since most recorders used in sound effects recording are digital, some headroom is necessary as digital does not have a gradual rise to distortion. It hits its 0dB limit and then immediately distorts into an unusable sound. You could put a limiter on the recorder to prevent the highest level from going above 0dB and if the sound is really loud, like a gunshot or door slam, you could use a pad to reduce the input level.

When you record your sound effects, it's valuable to verbally slate the recordings with the date, location and name of the sound you're recording. You may also want to include the take number. Some recorders will allow you to enter this information into the metadata, which is part of the recording. This practice will make it easier and faster to work with your files when you're editing. You may also choose to make a paper log of what you record.

CREATING

The greatest tool for creating a sound design is your imagination. You start by deciding how sound can best serve the story and what approach you need to take with sound to achieve that goal. You then need to be able to conceive what a particular sound for some creature, futuristic machine or unfamiliar experience might sound like. You can then determine what real-world sounds might be used to realize your imagined sounds. You may decide to take a common everyday sound and manipulate it and process it. You may decide to take several sounds and blend them together or layer them in a way that creates your conceived sound. You may create and use some synthesized sounds to augment the sound design or to be the sound design.

Most sound designers that I know prefer to start with organic sounds and then alter them. They may use some synthesized sounds, but would not commonly use them without some organic sounds layered into the design. It's important to experiment with the various sounds. Often trial and error leads to a sound that just happens to work. As you create the individual sound design elements, the important thing to remember is to make sure that all of the sounds work together to create an effective overall sound design.

EDITING AND PROCESSING

There's a lot of processing that can be done in audio editing software and even in video editing software. There are hundreds of software plugins that can be used to alter a sound. You may also choose to use a sampler or MIDI keyboard to alter sounds. The keyboard allows a sound designer to combine sounds and to alter and pitch shift those sounds by mapping them to the keyboard. This can be very useful when your sound design includes making a sound more musical in nature or when you want to easily control the pitch of a sound.

As you process various sounds to create your conceived sound design, you should layer them to hear what they'll sound like together. If something isn't working quite right, you can then alter that sound, replace it or perhaps delete it because it doesn't accomplish what you intended it to. Experimentation is part of the process.

If I were going to layer sound elements for an electronic pulse or laser gun, I might create some sounds like these:

- Click for turning on the gun
- Low-frequency hum as electronics are activated
- Rising pitch sound to represent it charging up
- Beeps to designate that it's charged
- Standby tone when it's in ready state
- Safety release tone alerting that it's ready to fire
- Electro-mechanical sound as the trigger is pulled
- Energy release sound as the pulse is fired
- Reverberant electronic recoil sound

MIXING

If you're mixing your own sound designs, you can set up the session in whatever way serves you. However, I suggest that you are very organized, so that you don't get lost in a sea of files. One of the main issues in being organized is to make sure you have appropriately named all of your files and tracks. I go by the idea that I might get hit by a bus and be put into a coma, so I want it to be easy for someone else to open my session and be able to see what I've done and continue to work. This is especially true if there is an eminent mix scheduled at a studio and the session has to be ready.

If you're having a studio do your mixing, then you'll want to be particularly organized so that time is not lost trying to figure out what tracks or sound files are where.

It's also helpful to the sound rerecordist to have both the sound design elements that you created and the original sounds used for that sound design on tracks near each other. That way they can make whatever adjustments might be needed to get the dialogue, music and sound effects to play together well.

> When I was creating the sound design for the shower scene in *Pyscho*, 1998, I knew that I wanted the sound of the water going down the drain to rotate around in a surround sound environment, as this would represent the victim's life being drained away. The psychological purpose was to encircle the audience with the sound, so it would give them the feeling of going down the drain too. I created that swirling effect, but I also had the unprocessed drain sound muted and placed on another track, just in case the director wanted to do something else with the sound.

To truly create designed sounds, you need to utilize your imagination, experiment with whatever objects and recordings you think might work and process and layer those sounds until you find the sound that works best. You'll know it's working when you're emotionally and subconsciously affected by the scene and don't notice the sound at all.

EXERCISES

Exercise 1

A Tyrannosaurus Rex was a large meat-eating dinosaur with sharp teeth that ate other creatures. No one knows what they would have sounded like. So, put your imagination to work and come up with the sound you believe it would have had. The Tyrannosaurus Rex sounds must be threatening enough to scare the audience. Choose a movie with a Tyrannosaurus Rex in it and design its vocal sounds by using other sounds. Hint: You could start with an elephant's call or a walrus's vocalizations or maybe a lion's roar as the foundation and then add other sounds to it. You could slow these sounds down, reverse them or pitch shift them up or down in order to make them sound bigger and meaner. You may also want to equalize the sounds to accentuate the low frequencies. Experiment until it feels right to you.

Exercise 2

Create a sound design without any picture to synchronize to. Using sound effects from a library and perhaps some you record on your own, try to create the futuristic gun sounds listed above and then edit them into the proper order.

- Click for turning on the gun
- Low-frequency hum as electronics are activated
- Rising pitch sound to represent it charging up
- Beeps to designate that it's charged
- Standby tone when it's in ready state
- Safety release tone alerting that it's ready to fire
- Electro-mechanical sound as the trigger is pulled
- Energy release sound as the pulse is fired
- Reverberant electronic recoil sound

Dialogue Editing
It's Work, Not Magic

INTRODUCTION

The best dialogue starts with the use of proper recording techniques during production. The more time and effort you put into getting good sound during production, the less time you need to put into improving it in post-production. Sometimes just switching locations, say from a busy street to a quiet one, can improve the production sound quality and this may avoid the need to do ADR (Automated Dialogue Replacement). Poor production sound is one of the most common technical problems with no and low budget films.

On set there is often a mindset that all that matters, in a technical sense, is the lighting and the camera work. It's not until post-production that many filmmakers realize that they should have spent more time recording good-quality sound during production. Better sound can be achieved with better planning and by giving the sound crew adequate time to prepare to record a scene.

There are many issues during production that can negatively affect the quality of sound recorded. Most of these are avoidable with proper planning and care during production.

The five top production sound problems are:

1. Dialogue levels are low in comparison to the background sounds, which are sometimes referred to as the noise floor. There should be a difference of at least 16dB between the noise floor and the dialogue level, if not much more.
2. Dialogue that is recorded with distortion or has mumbled words requires a lot of work to correct. They may be unsalvageable and thereby require the lines or words to be looped in an ADR session.
3. There is no room tone or ambience recorded, which helps with smoothing out the dialogue and providing a way to make the ADR blend in better with the dialogue.
4. One-take wonders. Even if the first take is the one that the director wants, it's good practice to do a second take for protection. Because if something should go wrong with that one and only take, the dialogue editor has nothing to fall back on, no second take where a clean line can be taken from to replace a line with a noise in it. It's that take or none.
5. Crew members or the director talking during a take can make it very difficult to clean up the dialogue, especially if their talking is during a line of dialogue.

The "production track" is the recording that you did on set, whether it was on location or in a studio. It's this sound that you edit with when you do the picture editing. It's often a mono or multi-mono track of some or all of the microphones used for a scene. At other times you may be editing the picture with all the audio tracks that were recorded on the set in a discrete layout, which means each microphone will have its own track in the timeline, but editing with all the tracks is not the norm. It's easier to edit the picture just using a mix of the production audio tracks. The discrete tracks can be imported into the picture editing software and then muted and edited along with the picture and mixed production track, but that might be difficult to handle unless you are doing the dialogue edit in the picture editing software, then you'll need those discrete tracks. However, you could use the timecode or waveform matching software to synchronize the discrete tracks after the picture edit is locked. You should determine your workflow before you start picture editing so you know what audio you need in the timeline.

Since the picture edit is primarily about telling the story and using the best performances by the actors, sound is often just going along for the ride. Once you finish a rough cut of the film, you'll play it back and probably notice that the sound is a bit rough too. Dialogue editing is essentially about smoothing out all those rough edits.

PICTURE LOCK

For greatest efficiency, the picture edit should be completed. You should have "picture lock" before the sound work begins. It is possible to begin sound work before picture lock, but additional expense and time may be incurred in re-conforming your audio edits to the newly re-edited picture.

For some projects, the sound may be prepared for mixing by the picture editor. These projects are usually those where extensive sound editing and additional sound effects are not required. These projects tend to be documentaries and dialogue or voice-over heavy projects. Since most projects consist at the very least of production sound, the preparation of this audio presents the minimum amount of work to be done to prepare for a mix.

COLLECTING MATERIALS

Information: You'll need to know the sample rate, bit depth and format of the audio, if you're transferring the audio to a DAW (Digital Audio Workstation) like Pro Tools or Nuendo. The DAW session will need to be set up using this information. Often the sample rate is 48k, but could be 96k or 192k. A bit depth of 24 is the most common. The format is ideally BWF (Broadcast Wave Format) as this is a cross-platform format and it includes useful metadata like scene and take numbers.

You'll also need to know the version of the picture edit. The picture editor should add this information to the new version of the picture edit they are giving you. If there have been changes in the picture edit since you started editing, you'll need to know that the new picture file given to you is not the same as the one you're currently working on. This can be designated as easily as adding to the name of the file v.2 or v.3 or whatever version is the most current. You may also want to include the date in the name or other information that helps you understand what version you're working on.

Picture: This is a QuickTime movie or other appropriate video format of an edited version of the film. QuickTime is one of the most commonly used formats and one that Pro Tools accepts.

Timecode Burn-In: This is a picture overlay of the timecode used in the picture edit. It usually appears in the upper or lower middle of the picture frame and ideally sits outside of the actual picture itself. It's not necessary, but can be very useful for checking synchronization between the picture and the sound. If you're doing your sound within the picture editing software, then you probably won't need to do a burn-in.

Figure 4.1

Guide Track: This is also called the reference track. It is the edited audio production track that was cut in synchronization with the picture. You get it from the picture editor.

Audio Output: The easiest way to make your production audio better is to transfer your project out of the video editing software into sound editing software. The way to do this transfer is with one of these two formats: OMF (Open Media Framework) or AAF (Advanced Authoring Format). Both of these are interchange formats used to transfer audio files between video and audio workstations. All the main NLE (Non-Linear Editing) programs will output at least one of these formats. However, the editing system you are using may require some third-party software to actually convert into OMF or AAF. The person doing the output should make sure that there are at least 10 seconds of "handles." The norm is to select the maximum, which could be as many as 999 frames. This is the beginning and end portion of the sound file that isn't used in the timeline. Handles are very useful in dialogue editing for finding room tone or alternate lines. There is also MXF (Media Exchange Format), which allows for the transfer of a complete project as a self-contained file. It may or may not work with your editing system.

Sound Reports: These are the reports filled out by the production sound mixer. They contain information such as the scene and take, along with the sample rate and bit depth of the audio files. It will also list what microphones were used and on which tracks. The report also lists which actor is on which track. There will be notes on what problems may have been encountered on any given take or that part of the take was good, but another part wasn't.

All Production Sound: These are all of the files of sound that were recorded during production. This will include the dialogue, wild lines, wild tracks, wild ADR and any sound effects that were able to be recorded.

Autoconforming: If your film has been edited using only one or two audio tracks, but there were several audio tracks recorded, then these additional tracks will need to be loaded into the audio editing system. There are various types of software or tools that will accomplish this task by automatically conforming the production tracks to the edited tracks.

Lined Script: This is sometimes called the marked-up script. This is the script supervisor's script that shows which actor was on camera for which lines of the script and any script changes during production. It also shows what scene and take numbers are associated with which lines of dialogue or actions. This can be an actual paper script, but is more likely to be a printout of software, such as ScriptE or Continuity, used by the script supervisor or scripty.

Audio EDL: This document will tell you what takes and what sections of takes or files were actually used in the picture edit.

Scene Shooting Date List: A list of shooting dates for each scene in the production audio files. Most production audio files are located in folders that have the shoot date on them. This, along with the lined script, will help you find alternate takes and wild lines.

FILE MANAGEMENT

Post-production works best if all sound files have been properly named. It creates a lot of extra work for the dialogue editor if they have to cross-reference the name of a file in the edited timeline with the original "data" name from the production sound. An editor or assistant editor can make sure that the names are the same, so that when the dialogue editor needs to access the original files they can do so using the timeline name. This saves time and thereby money and it allows the dialogue editor to do dialogue editing and not file searching. Thereby, if the dialogue editor has more time to edit dialogue, the film soundtrack will sound better.

If you're both the picture editor and the sound editor, then you can come up with whatever system works for you and can work cross-platform when you transfer the audio out of the picture editing software into the audio editing software. If you are editing picture and sound in the same software, then just make sure to name your files so that they give you the information you need to know.

The most common and basic approach to naming files is to include the scene and take numbers, if nothing else.

Remember to back up your sessions onto a separate hard drive at the end of the day, if not more often. This way you will never lose more than a day's work.

THE PROCESS

Spotting Session: This is where the director, picture editor, dialogue editor, post-supervisor and others sit down together and watch the film looking for sound issues, in particular dialogue issues. If you're the director, picture editor and the dialogue editor all in one, then you still need to sit down with yourself and go through the film looking for dialogue issues. Often the entire post-production sound crew is at the spotting session. Other times the director meets with the sound post-production supervisor only and then the supervisor meets with the sound crew. Whichever way this is done, the purpose is to determine where the areas of concern are for sound. These concerns may include ADR, Walla, sound effects, dialogue issues and general location sound problems. In particular you want to pay attention to off-microphone recordings, wireless microphone issues, dolly noise, crew noise and difficult to understand dialogue.

Save As: The first thing to do is import the OMF or AAF into your audio editing software. The industry standard is Pro Tools, but other software is used too. Immediately make a copy of the session, so that if all goes wrong, you have the original version of the audio to go back to.

Check Contents: Import the picture file into the software. In Pro Tools this would be a Quick-Time movie or a Media Composer MXF.

The qualified QuickTime codecs include:

- DNxHD
- ProRes 422
- DV25
- DV50
- H.264

The qualified Media Composer MXF codecs include:

- DNxXHD
- XDCAM
- AVC-Intra 100
- IMX
- JFIF
- Uncompressed SD

Put the guide track, or as some people call it, the reference track, into the session. Now go through the film looking and listening for any holes. This would be where the reference track shows sound, but the OMF tracks in the session do not. If that happens, then some file or files did not get transferred properly, either into the OMF or into Pro Tools.

Check Synchronization: You can go either through the entire film and check for picture and sound synchronization or you can do it scene by scene or even shot by shot. Whichever

approach you take, it's important for the picture and sound to be in synchronization before you do any editing, otherwise you'll have to correct the synchronization on all the sections you split out of the production track too. You'll start by checking synchronization of the OMF and production dialogue tracks against the guide track and if there is a discrepancy, then you'll have to find synchronization by visual cues in the waveforms and by phasing the signals. Phasing them is aligning them close together until the frequencies cancel each other out. Play the first scene with dialogue and the last scene with dialogue having both the guide track on and the production dialogue tracks turned on. Ideally, you will hear phasing and know that at least the length of the film is in synchronization, even if some lines or scenes are out within the body of the film.

Track Layout: Create eight dialogue tracks as a starting point. Name them DIA 1, DIA 2, and so on. Next create two tracks that you can move unwanted noises onto from the production track. You might call one of the tracks PFX X and the other track PFX Y. You can mute these two production effects tracks and just use them as a storage place, just in case you decide that those noises are useful for the mix. Move these noises, but remember to keep them in synchronization just in case they get used.

If there is ADR, then you may want to create the ADR tracks now or you can wait until you have the actual ADR files or session. If you're mixing the film at a studio, you should also have tracks for alternate takes. These are the takes that could work if there is a problem with the synchronized dialogue from the actual used take.

Reference Tone: These are usually 1kHz at either −18dBFS (EU/UK) or −20dBFS (US) and at 48kHz with 24-bit words. It's best to ask the rerecording studio what they prefer since they are the ones that will use the tone for calibrating their mixing and monitoring system. They may want either 30 or 60 seconds of reference tone.

Pops or Beeps: The synchronization pops are one frame long and occur exactly two seconds before the start of the session or FFOA (First Frame Of Action). There is also a tail pop that is exactly 2 seconds after the LFOA (Last Frame Of Action). The term "action" refers to the first or last frame of the picture. The head pop is referred to as the 2-pop since it occurs 2 seconds before FFOA. The pops at the head and tail of your short film or for each reel of a feature film, if it's divided into reels, will tell you if synchronization has been lost during the editing process.

Splitting Tracks: A common mistake is to put each actor on their own track and then edit the dialogue. A better way to edit a scene is to split the audio tracks by camera angle, so each shot has its own tracks. For example, if a scene starts with a two shot of the actors at a sidewalk hot dog stand and then goes to over the shoulder shots of each actor and then to close-ups, you have five camera angles, so use a different track for the dialogue from each of the five angles. When you move on to the next scene, you can checkerboard the sound for it by putting all its files on the tracks below the previous scene's tracks. When you finish the second scene and move on to the third scene, you can move back to working on the top tracks used for the first scene.

The main purpose for splitting dialogue tracks is that this allows for different processing of the sound for each of the different microphone placements when lines were recorded during

production. For example, the hot dog vendor is facing away from the busy street, so the microphone will be pointed toward the park behind the vendor, while the hot dog customer is facing the park, therefore the microphone will be pointed toward the busy street. The backgrounds will sound different and will need to be blended so that the cuts between the two characters are seamless. Even scenes shot in relatively quiet interiors can have different background sounds or levels. The sound of an air conditioner may be louder and more distinct in one shot than it is in a different shot. It all depends on which way the microphone was pointing in relationship to the noise source.

If you're mixing the film yourself, then you can come up with your own system, but the above system makes it easier and faster for the mixer to do automation on audio levels, panning, equalization, reverberation and other processing. It's always best to check with your mixer to see how they prefer to work and then build your tracks accordingly. This can save you time and money at the mix.

Production Sound Effects: As you go through the dialogue edit, you will be pulling out the production sounds like a car door opening and closing or a coffee cup being put down and putting them on a PFX or production sound effects track. If the production sound effect occurs during dialogue, then leave it in the dialogue track. You can then either use the production sound effect or put in a selected sound effect on one of the SFX or sound effects tracks. You will also want to search alternate takes to see if the dialogue with the noise in it can be replaced with clean dialogue from an alternate take. You may have to do a bit of ADR-type editing to get the line to synchronize properly.

Figure 4.2

Anytime you remove a sound or noise from the production track, you will need to fill in the remaining hole with the appropriate room tone or ambience otherwise the sound will drop out and you will hear silence. If you are mixing the film yourself you can just plug the hole with room tone from the same shot or another shot from the same camera angle. If you're mixing the film at a post-production facility, check with the rerecording engineer, who is doing your mixing, and see how they want to handle any room tone that's filling in a hole. Most of them will be fine with you filling the hole in the production track, while some may want you to put the room tone on a separate track. Putting the room tone fill on a separate track will allow the mixer to set levels and do whatever processing that may need to be done to the fill to make it match the production track where the hole occurs.

The lower the budget on a film, the more the need for production sound effects to be split out from the dialogue. This will save the producers money on sound effects and Foley, as the film will require less work in these areas of post-production because the dialogue editor already provides some of the sounds from the production track. This is especially true if you are making a foreign version of your film.

Foreign Version: If you are having someone else mix your film and you are not making a foreign version to have dubbed into another language, then you can leave the production sound effects on the production tracks. However, if you are going to have the film dubbed into another language, you'll need to put the production sound effects you want to use in the film onto the sound effects tracks. This way they will be used in the foreign mix, which is created without the production track or thereby the dialogue. The foreign mix is called an M&E (Music and Effects), but no dialogue. A standard mix contains a DME (Dialogue, Music and Effects).

The New York City post-production facility DuArt created a great guide on the basics of dialogue editing. Some of that information has been included in the following sections.

CLEANING

Audio professionals are frequently asked to "clean up" dialogue. It's commonly assumed by the inexperienced moviemaker that there are some cool magic devices out there that will take badly recorded material and correct it quickly and simply. The truth is that while there are many tools available to adjust for specific kinds of shortcomings in a recording, few of these remedies are without a price, in both a monetary and sonic sense. In most cases, nothing beats a great production recording as a place to start. In order that any given audio may be made to sound like a movie soundtrack, your various recorded tracks will be treated in varying ways depending on what has been recorded and where it needs to be exhibited.

SMOOTHING

Smoothing sound within a scene is done by overlapping audio from adjacent shots within a scene and adding small fades between the overlaps. This should be done with all shots in the project. We will address how to do this below. When the action moves from one scene to another, the room tone or ambience may be permitted to shift, sometimes drastically, so don't be too concerned with scene changes. It's changes within the scene that counts.

EDITING

If you do nothing else for the sound on your project, you should complete a dialogue edit. This is usually done after the picture has been completely edited. The dialogue edit in its simplest

form doesn't need to be especially complex or time-consuming, and will make any subsequent sound work proceed more quickly.

A serviceable dialogue edit can often be done on your non-linear video editing system. The biggest issue with trying to do a dialogue edit in one of the video editing software is that video editing is often based upon picture frame editing and not on the audio sample rate. Some of the non-linear video editing systems allow you to unlink the audio from the picture, do your sample level editing and then relink it to the picture to keep synchronization. Pro Tools and other audio editing software don't have this issue because they are designed to work with audio at the sample level.

The graphics included here are from Pro Tools, but the concepts described can be applied to any NLE or DAW system with multiple audio tracks.

The first step of your dialogue edit will be to split your tracks. This is often referred to as checkerboarding. The audio regions of each shot should occupy alternating tracks or their own track.

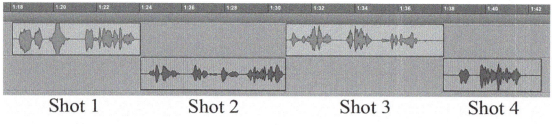

Figure 4.3

SPLITTING TRACKS

If your sound is stereo, which is unusual for dialogue, or recorded with more than one microphone (like a boom on channel 1 and a wireless on channels 2 and 3), keep all audio tracks grouped together side by side and split as before. The grouped pairs of tracks should not be mixed or combined sonically. Remember, you are not necessarily splitting by picture edit as some lines of dialogue may overlap shots. You are splitting the lines according to the position of the microphone or microphone angle.

Usually the boom microphone is the preferred track as a boom microphone picks up a more natural sound because a boom can be close on a close-up and must be farther from the actors on a wide shot. The wide shot doesn't allow the boom to be close, which is fine because the audience doesn't expect to hear the dialogue from a close-up perspective on a wide shot. It is also common to use wireless lavaliere microphones placed under the clothing of each actor, usually near the sternum, to capture dialogue that may be difficult for the boom to get. Lavalieres are not the best microphone to use as they have no perspective and they make the

dialogue sound muffled and have less high-end frequencies because the clothing acts as a filter. Equalization and reverberation are often needed to fix lavaliere microphones placed under clothing. The general rule is to try to make the boom microphone track work first and then go to the wireless lavaliere microphone track if you need to.

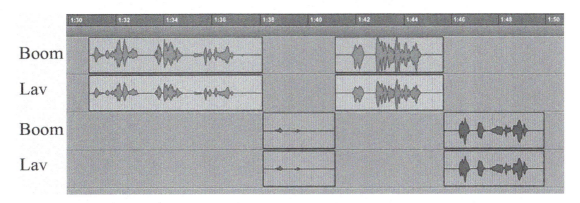

Figure 4.4

You could edit the dialogue by splitting off each character to its own track, but this can make it more difficult to smooth out the room tone.

The mix will move faster if audio is logically grouped by the way it sounds, the way it was recorded, or the way it should sound. For example, let's say you recorded a scene with two people having a conversation. A boom is used on each actor individually. This means the microphone will be pointing at each actor directly, but at opposing angles in the environment for the differing shots, like the hot dog vendor and customer mentioned above. Place the boom from shot 1 on one track and the boom from shot 2 on another track.

Also, make sure you cut out the section of each track in which the dialogue doesn't occur. In other words, checkerboard so that only the dialogue is heard, not the room tone between lines. For example, if you have a scene in which two wireless microphones were used, one placed on each of the two actors, then you'll have two recordings of the shot from two differently placed microphones. If you don't checkerboard the dialogue, then both tracks of dialogue will play at the same time. This means that the noise floor or room tome will be doubled in volume.

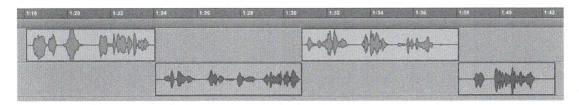

Figure 4.5

For a sound that needs special treatment applied in the mix, such as poorly recorded dialogue with heavy background noise or a voice that is to receive an effect like a telephone filter or off-camera dialogue, place the audio to be effected on its own track. The audio regions should be cut and placed to match what is happening on the picture.

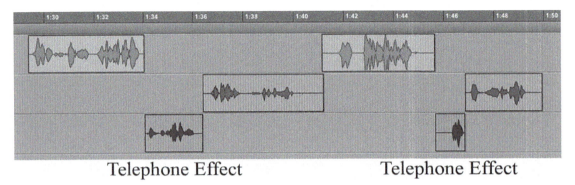

Telephone Effect Telephone Effect

Figure 4.6

Once tracks have been split, it's useful to create overlaps between them. This allows room tone to be faded from one shot to another in an effort to create smooth transitions between them. Overlaps should not extend to dialogue or other sounds that are not to be included in the film. This part of the edit requires the best sound reproduction that can be had. You may need to listen at a higher than usual volume and you may need to use headphones as well. At this point you are working on the room tone between the dialogue, not the dialogue itself.

Figure 4.7

Once overlaps have been added, most editing systems allow short fades to be rendered at the transition points.

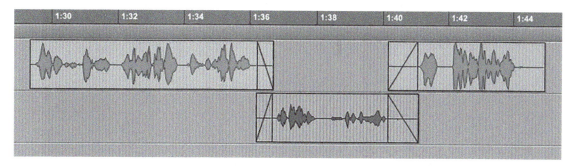

Figure 4.8

If you're crossfading two different sounds, then you will want to use a –3dB equal power crossfade to smooth out the levels, but if you're doing a crossfade between two identical sounds, then you'll need to use a –6dB equal gain crossfade to make them sound equal and smooth. Experiment with the crossfades until you hear what sounds right to you.

How do you know if the overlaps and fades smooth out the dialogue sufficiently? You listen to it. If you don't have an edit room that is properly set up for sound (an inferior sound set-up would include cheap speakers, lots of machine noise from computers and fans), try listening through a pair of headphones at a volume loud enough to hear the transitions between shots. Don't add equalization or other effects to make it sound good, though you can adjust volume levels between regions. If the transitions seem overly noticeable, you'll need to add some room tone on an additional track.

ROOM TONE

If usable room tone was recorded on location, that can be used. The tone needs to be the same or similar to the tone of the audio that is actually being used in the shots. Once again, this is determined by listening.

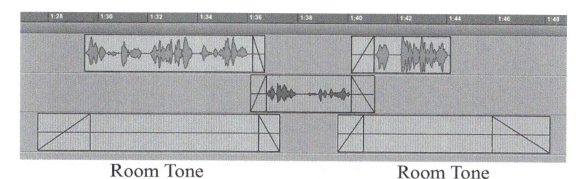

Figure 4.9

The shot that has the loudest room tone or noise floor is the one that the other shots will have to be adjusted to match. This will effectively make the background of the entire scene noisier, which is not the most desirable solution, but at least it will match from shot to shot.

If wild tone recorded on location doesn't match, the tone will have to be harvested from the existing production tracks, from the little spaces between the words or at the head and tail of shots. This may mean going into the original files that were recorded on set and finding a clean section of room tone. Clean sound can often be found right after the marker or the "action" call.

Room Tone

Figure 4.10

If the clean room tone section you find is too short, then you can extend it by duplicating the file.

Room Tone Looped

Figure 4.11

By reversing the direction of the duplicated room tone file (darker sections below) you can smooth out the transition from head to tail. You'll butt-up the end of the first file with the head of the duplicated file making the edit seamless. Now you can duplicate both files together; however, you may need to smooth the ends of the duplicated files to get them to match too. Continue duplicating and smoothing for a longer room tone. This is not an ideal solution, but it may work. There are plugins that can take a section of room tone and create as long of a file as you need.

Figure 4.12

Once you've finished editing a file, it's a good idea to lock that file if your system allows it. That way you can't accidentally move the file or, worse, delete it.

FIXING ISSUES

Alternate Words and Syllables

Sometimes there may be a noise during a scene and it might happen in the middle of a word or a syllable. If the noise is too loud or distracting, you may have to search through alternate takes to find the same word, syllable or phoneme that is clean and can be used to replace the noisy word or syllable. You'll need to find a replacement that matches the same performance, pitch and perspective as the original.

If you're editing in a replacement syllable or word, then it is best to find a hard consonant, like a *b*, *d*, *k*, *p* or a *t* to make the cut at. This will make the edit less noticeable and thereby more natural. Making the edit unnoticeable becomes more important when you are cutting in a phoneme, which is the smallest meaningful unit of speech that distinguishes one word from another. For example, if you remove the phoneme or letter "p" from the word "pant," it becomes ant. If you substitute the letter "r" for the letter "p," in pant, then you have changed the meaning of the word again. Since you are most likely replacing one "p" in pant with another "p" from another word that starts with the letter "p," then you'll be swapping the same phoneme.

Removing Dialogue Overlap

If a scene is cut with an unwanted dialogue overlap in it, you may need to fix it by using lines that don't overlap on alternate takes. Since the lines overlap, you'll have to do some intricate editing to have the lines clear of each other. You may have to remove sub-frames from vowels to shorten a word or remove spaces between words to speed up the delivery of the lines. All this has to be done without making the replacement lines appear out of synchronization with the lips. Ideally, the lips of at least one of the actors aren't seen in the shot.

Replacing Wide Shot Lines with Close-up Lines

When you're working on a scene in which there is a cut from a wide shot to a close-up, you may want to replace the dialogue in the wide shot with the same dialogue shot in close-up or as a wild line. You'll need to match synchronization with the wide shot dialogue. This will make the audio transition between the wide shot and the close-up seamless. If the actors' lips cannot be seen in the wide shot, then this task is easy.

Small Problems with Sound may be Hidden

When audio between adjacent shots cannot be smoothed out sufficiently, additional "room tone" or "ambience" should be added on a track to help hide the inconsistency. The room tone should be similar in sound to the production audio. For example, let's take a city park scene that consists of two characters talking at dusk. One character's close-up is shot first and the crickets are chirping softly, but the second character's close-up is shot later when there are more crickets and they are louder. The dialogue editor may have to put the louder crickets under the first character's shot to balance the background level of the crickets between the two shots.

Another way to disguise a background shift is to cut very close to the beginning of the first utterance of the dialogue line. The sound of the actor's voice might cover the change in background, especially if the volume level of the actor is adequate to mask the change. This is a trial and error procedure. If you do get it to work, make sure that you leave enough tail at the end of the line for the background to be slowly faded out of the mix.

That Which Cannot be made Intelligible, Smoothed Out or Hidden, Should be Replaced

If you or, preferably, someone who is unfamiliar with your project cannot understand the dialogue that has been recorded for a particular scene, the audio from that scene should be replaced either by an alternate take or by rerecording the lines.

If you have a great take between two characters, but there is the sound of a noisy car driving by at some point in the shot, you may have to find an adequately acted alternate take that doesn't have the car driving by and replace the section of dialogue that has been ruined by the car passing. It may take some fine dialogue editing to get the alternate take to synchronize up with the lips, but you'll have saved the scene.

If there is no alternate take, then you'll have to record dialogue over again in a post-production facility. When dialogue is replaced, all other sound (room tone, actor movements, other effects) must be replaced as well. As mentioned earlier in this chapter, dialogue replacement is called ADR (Automated Dialogue Replacement). It may also be called Automatic Dialogue Replacement or Additional Dialogue Replacement and is historically known as "looping." Find out more about ADR in Chapter 5.

It can be a challenge to make the dialogue tracks sound smooth. After all, the project was likely shot on different days or maybe even in different years. Assembling an apparently seamless stream of sound from a wide variety of recordings is the core of the craft of film sound.

Generally speaking, the dialogue tracks like to play the loudest of all of your tracks in the final mix. If additional sound effects or music are used at the same time as the dialogue, some problems can be concealed to some extent, but it is considered good practice to treat the dialogue track as if it will play alone.

The goal of dialogue editing is to make a smooth enough production track that the movie could play with just the production track and it would sound acceptable to an audience.

The process of cleaning up dialogue and smoothing out backgrounds is imperative for a quality soundtrack. This is one of the major sound issues that separate many low or no budget films from higher budget productions.

Wild Sound Recordings

Ideally, the location sound recordist will have made wild recordings that are helpful in post-production. If a scene has a very high noise level, such as a large fan or explosions, the recordist may record the actor's lines from the scene once the noise has stopped. These recordings will not be in synchrnization as the camera won't be rolling, but at least the lines were recorded at the location. It's better than having to resort to ADR. Wild lines are often recorded for scenes that are very wide shots or in which there is no place to put the microphone.

Actors are not the only thing recorded wild. Sometimes machines or locations need to be recorded because it would be difficult to record them in post-production. For example, in the movie *The World's Fastest Indian*, 2005, the character, Burt Munro, breaks a world land-speed record in 1967 by driving his customized Indian motorcycle at the Bonneville Salt Flats. Ideally, the production sound recordist would record the sounds of the replica motorcycle built for the movie. This would allow for greater authenticity than using some library motorcycle sound effects. Also, it would be better if the location sound recordist recorded the sounds of the actual Bonneville Salt Flats to be used as ambience or background by the sound effects editors.

Markers

If you are able to use markers in the software you are using to edit, it will be useful to create a marker for the first frame of every scene in the film. You may do this all at once for the entire film or as you finish working on each scene you may want to place a marker in your timeline at the beginning of the next scene. The most common naming system to use is one that states the scene number. These markers will allow you to move easily through the timeline to work on specific scenes as needed.

PROCESSING

It's common to use equalization, reverberation, compressors and noise reduction in order to make the dialogue sound better. These are many of the tools used by the rerecording mixer to

accomplish that goal. It's good practice not to use any of these tools while you're editing the dialogue, as you need to be listening to the actual sound in order to make proper decisions about that sound.

If you are doing your own dialogue edit and mix, then you may still want to follow this procedure as you will be in a different mindset when you're mixing than you were when you were editing and thereby will be better at making decisions about the sonic qualities of the production track as a whole.

In the Box

The steps for dialogue editing are essentially the same whether you are mixing yourself or you are going to a post-production facility to have them do the mix.

If you are doing your own mix, you may not want as many dialogue tracks as a studio mixer would want since you must control every element of the mix yourself.

Also, the more organized your tracks and sound files are, the easier and faster the mix will go. I suggest that you do not do your mix in the video editing software, as this type of software is not designed for user-friendly sound work. However, if it is your only option, you now have a guide for what work needs to be done in preparation for the mix.

EXERCISE

Acquire an edited scene with the production track only or better still, shoot a short scene with two actors, making sure you get a wide shot, medium shots and close-ups. Record with a boom on one track and with lavalieres on the other track. If your recorder has more than two tracks, then record each microphone on a separate track. Edit the scene together in picture editing software with all of the tracks of audio. Now use the above techniques to try to clean up and smooth out the dialogue between cuts.

CHAPTER 5

ADR

What Did They Say?

Figure 5.1

INTRODUCTION

The abbreviation ADR generally stands for Automated Dialogue Replacement, but it can also stand for Automatic or Additional Dialogue Recording depending on the background of the person talking. ADR is the dubbing in of replacement lines or additional lines for an actor. The process is automatic in that the actor can repeat a given line in synchronization with picture until they get the performance the way the director wants it to be.

AN OVERALL PHILOSOPHY ON SOUND IN THE PICTURES

Sound, to people, should be half of the film/TV experience. Visually the picture and actors are responsible for getting their role across and sound is no different. We want people to enjoy the movie as much as possible, so making sure that the sound works with the picture and helps carry the film instead of distracting from it is very important. In ADR, the goal is getting a good recording so people can NOT tell that something was re-done.

From the article, *Inside the World of Professional ADR with Julie Altus of Todd-SOUNDELUX,* which appears on the nofilmschool.com website, by writer Oakley Anderson-Moore.

The best ADR or "looping" is the recordings you don't have to do, because you took the time to record good dialogue during production. I have to admit that doing ADR is one of my least favorite jobs to do. It's a necessary job and not a particularly creative one. But, it can change a performance for the better. It can eliminate a distracting sound, repair a poor recording, or add a missed line. It can even be used to do additional lines that were not in the script and thus improve the story or add needed information.

Production dialogue is about getting the microphone into the best place. Sometimes actor blocking, a set piece, prop or light may make it nearly impossible to get a boom microphone placed best for recording the dialogue. You may have to resort to a wireless lavaliere microphone or a plant microphone. Even then it may not be possible to get a good recording no matter what you do. Sometimes generators, used for powering lights, are too loud and can be easily heard on the production track. Other times uncontrollable noise, such as a nearby freeway or ocean waves, can interfere with getting a good recording. If you're shooting an action scene, then there may be some special effects equipment that can cause too much noise. For example, you may have explosives, wind machines or rain machines, which can all affect the quality of your recordings. That's when you turn to fixing it in post, and that's when you utilize ADR.

Dubbing is a more general term for the replacement of audio in post-production. At the "large" end of the spectrum, entire movies can be dubbed from foreign languages into the local languages. Accents can be difficult to understand even if they are in the language of the audience, so dubbing may be needed to make the dialogue intelligible to a wider audience.

Dubbing can be used to replace an actor's voice by another actor's voice. A commonly known example of this would be the *Star Wars* character, Darth Vader, who was played by David Prowse, but James Earl Jones provided the character's voice.

Why Record ADR?

Besides those reasons already mentioned, there are many reasons for doing ADR. An actor's performance may not be exactly what the director wants. The quality of an actor's voice may not be right for the emotions of the character; the energy level of the delivery of the lines may not be right. The emotional state of the character may not be proper for the scene or they may be sick with a cold making them sound stuffy. If the actor is using an accent, they may make a mistake that needs to be corrected. Sometimes the director talks or gives cues to the actors during a scene, so the director's voice will overlap the actor's dialogue making it unusable. These are just issues with the actor.

There can be uncontrollable and undesirable sounds made while an actor speaks their lines. Some common issues are the noise from an airplane, off-screen cars and sirens. During action scenes there may be sounds such as explosions, car crashes, exploding bullet squibs and air ratchets. Action movies tend to have more ADR as they have noisier sets. The war movie, *Apocalypse Now* (Coppola 1979), is said to have required more than 80 percent of the dialogue to be dubbed. In a drama it's more common to have only about 10 percent ADR since the sets are usually quieter.

There may be technical issues such as a poor quality recording where the volume level is too low or overmodulated, the boom microphone may not be in the best place for picking up a line, or clothes rubbing against a wireless body microphone may cause noise. In all of these situations some or all of the spoken words might need to be replaced with clean audio.

It is common to add some off-camera dialogue to help the story. ADR lines can be added to an actor who has their back to the camera so lip synchronization isn't critical. This process is called "cheating a line." Sometimes this type of ADR is referred to as Additional Dialogue Recording.

In the case of "Unconditional Love," the sessions were held at Todd-SOUNDELUX West/Liberty Media, located in Santa Monica, California. In the studio, director P.J. Hogan, Gold and ADR Mixer Greg Steele and New Line Sound Supervisor, Sara Romilly, were on hand to record lines with actor Gregor Truter.

As the session goes on, Hogan makes suggestions on new lines for Gregor to say—dialogue which was not originally scripted. In the film, Kathy Bates is mowing the lawn in the foreground, while Rupert Everett is dragged into his house by his two friends, one of which is played by Gregor Truter. Since the audience's eyes focus on Bates, and Truter's image is so small in the frame, any words can be "cheated" into Truter's mouth.

"Leave her alone. You can't hit Americans. They sue!" Suggests Hogan.

From the article, *Avram Gold, M.P.S.E. Behind ADR,* which appears on the fromscripttodvd.com website, by writer William Kallay.

It is also necessary to replace any objectionable words or phrases in the script with ones that are acceptable on broadcast television or for commercial airline versions.

The major television networks have lists of objectionable words that need to be replaced by suitable ones for all audiences. These words usually refer to body parts or excrement, gender, sexual references or put-downs.

> In the movie *Far From Heaven* 2003, by Todd Haynes, I was the ADR editor and we had to replace the "F" word used by Dennis Quaid in the middle of an emotional exterior scene. The line in the script was: "Look! I just want to get the whole f*cking thing over with! Can you understand that?!" He did an excellent job of finding the emotional state he had during the scene and delivered the substitute word, "fricken," which fit in very well.

Selecting ADR Lines

The next question is, can the line be cleaned up or does it really require ADR? In *Far From Heaven* (2003) directed by Todd Haynes, Julianne Moore's character is walking down a staircase wearing high heels. The stairs are wooden and her heels are making a loud pounding sound as she descends. Toward the bottom of the stairs she says a line of dialogue. It is hard to understand what she is saying over the footsteps, so we elected to have the lines recorded in an ADR session.

It is the dialogue editor's job to listen to all the recorded lines from the production, note which ones are hard to understand or objectionable, and then suggest to the director the lines of dialogue that would be candidates for ADR.

The director then decides which lines they want to have redone in an ADR session. They may be all the lines that the dialogue editor suggested or they may only be some of them. Some of the suggested lines may not be done because the director likes the performance in the production dialogue and doesn't think that the lines are so bad they need to be recorded in an ADR session.

SPOTTING

Spotting is going through the film scene-by-scene and finding dialogue that needs to be replaced using ADR. Spotting is usually done in a session with the dialogue editor, post-sound supervisor, ADR editor and/or director. As the film is reviewed, they write down the ADR choices on a cue sheet. These sheets are then used for the ADR recording session.

Cue Sheets

You need to keep a record of what lines are required for ADR and where they are in the film. Use an ADR cue sheet, in chronological order, for each character with the reel number, timecode

and dialogue for the cue written in. The cue sheet can be on paper or input into an ADR software like VoiceQ, EdiCue or ADRStudio.

Not all ADR is for dialogue. It is often used for recording "efforts," which are not lines, but are gasps, grunts, sighs, snorts, breathing, panting, yelling, lip smacking and other such sounds humans make with their mouths. Sometimes the efforts are recorded in a walla session by other actors, but it's better if the on-screen actor does the efforts.

I suggest that you actually write these efforts onto the cue sheets, so that they are not forgotten during the session. Not recording them can have a negative impact on trying to make the ADR work. People commonly make mouth noises and respond to actions and dialogue without words. So, if they are not in the ADR, the words alone may sound a bit unnatural.

MICROPHONES

The choice of microphones can be determined by whether or not you are going to replace the dialogue for an entire scene or just a line or two in the scene. If you are replacing the entire scene, the choice of microphones is vast. If you are replacing just a line or two, you'll want to use the same microphone that was used in the production track. That way you will have a better chance of mixing in the ADR lines, so the audience doesn't notice them. If the dialogue was recorded with both a lavaliere and a boomed shotgun, you will want to use both of these microphones in the ADR session.

For example, if you used a Sennheiser ME 66 and a Tram TR-50 lavaliere for the location dialogue recording, then use the same microphones for your ADR recording. The ideal is to use the same microphone, preamplifier and windscreen, so the sound being recorded is being picked up by the same equipment used in production and will give it the same color. It's an ideal and won't be perfect, unless you are recording ADR on location. If you are not able to use the same make and model of microphone for your ADR, try to use microphones with the similar characteristics. If you used a shotgun to record the dialogue, then use a shotgun for the ADR. Do not use a large diaphragm microphone or a lavaliere microphone in place of the shotgun unless you have no choice and then plan on using it to do the ADR for the whole scene.

One of the most difficult challenges for a mixing engineer to do is blend a word or line into a scene and get them to match the sound of the production dialogue. The ADR and the production dialogue will have different ambience, sonic perspectives and reverberations. If you add to that the unique characteristics of the microphone used for the ADR and the room the ADR was recorded in, the job gets even more difficult.

Some of the more common microphones used on an ADR stage are the Neumann KMR81, Sennheiser 416, Sennheiser MKH 8050, 8060 and 8070, Schoeps CMIT 5U, Sanken CS-3e and various lavalieres such as Tram, Sanken, DPA, Sony, Sennheiser, Countryman and Lectrosonics. These are the most common microphones used in the industry for production sound recording, which is why they are found in ADR studios.

It is common to switch between various models of microphones depending on whether the scene's location is indoors or outdoors, or if you are recording breaths and efforts or some voice-over.

Microphone Placement

Normal ADR Microphone Placement

Figure 5.2

Microphone selection and placement are of paramount importance, as is understanding how the dialogue fits into the scene being recorded. Just like in production, position the microphone to match production shot angle.

You can use two microphones of the same make and model with one behind the other. You can start off by placing one about 3 feet or 1 meter behind the other and then adjust the distance to match perspective of the shot and scene. If you don't have two of the same microphones for your ADR, then you can use one microphone and then move the actor closer or farther from it to better match the location sound. Usually, you record using a close-microphone technique for close-up shots and on wider shots the actor moves away from the microphone to add a more natural sound. The best approach to properly positioning the microphone is to listen to the location sound and try to duplicate how it sounds by moving the microphone around until you match that sound.

It's fairly common for a scene to be recorded with both a boom microphone and a lavaliere microphone. This means that you should record the ADR with a lavaliere microphone along with the boom. That will allow the editor and mixer to have a choice as to which microphone works better for a given scene. If you do record with two microphones, and you may be blending them together, then you need to follow the 3 to 1 Rule in microphone and talent placement.

3 to 1 Rule: When placing the microphones near each other. For whatever distance the first microphone is away from the sound source, the second microphone needs to be three times that distance away from the first microphone. For example if the voice-over talent is 6 inches

or 15 centimeters from the first microphone, then the second microphone needs to be placed at least 18 inches or 45 centimeters away from the first microphone. Tripling the distance effectively reduces the volume going into the second microphone enough that no cancellation of frequencies is noticed. However, if you were to raise the input level from the distant microphone to match that of the closer microphone then you would hear some frequencies being cancelled once the two are mixed together. The ideal is to have the sound level in the distant microphone at least −9dB lower than the sound level of the first microphone. This will effectively make the phase cancellation unnoticeable to the human ear.

This rule of the microphone 3 to 1 or 3:1 placement is based on the Inverse Square Law, which states that sound levels drop over a distance. Specifically, the levels drop 6dB for every doubling of distance. For example, a teacher speaking at 60dB 3 feet out into the front of the classroom will be heard at 54dB 6 feet into the classroom; 48dB 12 feet into the room, and so on.

You can also try adding a delay to one of the two recorded tracks. Start with a 2 millisecond delay and then add another 2 millisecond delay until the phase cancellation issue isn't noticeable anymore. You may need as much as 20 or 30 milliseconds of delay depending on the set-up of the microphones and the volume level of the sound sources.

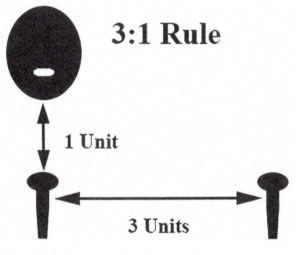

Figure 5.3

Before you get into doing the ADR recording, do a test recording to check for phasing issues.

When an entire scene is being replaced with ADR, some people may choose to use a large diaphragm microphone, but it will work best if the talent isn't too close to it, otherwise it sounds more like a narration and it's hard to equalize properly. Remember to keep the perspective of the shot.

ADR is a bit easier if you are doing an action film and the actors have to shout over the noise of cars or guns. The noisy environment will hide some of the studio sound of the ADR, making it easier to blend into the production track.

Where to Record

There are a couple of options for choosing a location to record the ADR. You can record in a studio or you can record in the original location or one that mimics it in terms of sounding similar. The latter is a preferable option if it is possible to record there. The sound will better match the original production track and the actors will have a stronger sense of place and this will help their performance considerably. Whichever option you choose will depend on where the original location was and how accessible it is, the reason for doing the ADR, and your ability to set up a mobile ADR rig, which will include a video monitor, a way of playing back the original production audio and a way of recording the ADR.

WORKING WITH ACTORS

Figure 5.4

HOW TO PREPARE FOR YOUR ADR SESSION

ADR is a great time to make changes and improvements, but also can be very time-consuming and difficult for many actors. You are basically trying to get them to recreate exactly the feelings and voice match and emotions of the scene that is being recorded.

But, it's a large empty stage and can be hard for actors to get back to the "place" they were at when shooting a scene. I would say, have a solid spotting session with your actors, with good

notes and proper explanations or reasons as to why they are re-doing the lines, so that they don't get frustrated—so they know what needs to be changed.

From the article, *Inside the World of Professional ADR with Julie Altus of Todd-SOUNDELUX*, which appears on the nofilmschool.com website, by writer Oakley Anderson-Moore.

ADR Recording Tips

- You can record ADR using a software program such as the NLE's (Non-Linear Editing) Media Composer, Final Cut Pro and Premiere, but it's easier and more effective to use a DAW (Digital Audio Workstation) such as Avid Pro Tools, Abelton, Logic Pro, Audition, Nuendo or Cubase.
- Don't add any processing, such as compression or de-essing to the recordings, as those can be done later in editing or mixing.
- There are different approaches to recording ADR or looping. One is with the visual and audio of the scene playing for each take, another is the visual and audio playing for a few times and then the audio is muted so the actor can fully hear their ADR lines and the other is without any visual, but just hearing the line from the production track and then repeating it.
- Allow the actor to choose between seeing written lines or just hearing the lines through the headphones—some may want both. Some actors prefer to hear the original track while doing ADR and others don't want anything after the three beeps or streamers.
- If an actor is having a hard time adjusting to doing ADR or getting all their lines delivered in a take, then work in small chunks of dialogue.
- Be sure the actor is re-acting their lines, not just mechanically reading them.
- Don't get caught-up in getting exact lip synchronization that can be achieved later in editing.
- Actors and directors should pay attention to the breathing that they did in the production track and try to follow it along with the lines as this can affect performance too.
- Always take breaks so the actor can maintain the energy required for delivering the lines. Repeating lines in an attempt to match emotion, pitch, timing, and the nuances of their original on-set delivery can take a lot out of a person.
- The actor's performance is what matters most. If the actor isn't able to recreate the scene's emotion in the ADR session and the production dialogue isn't too bad, then it might be better to accept the location sound.
- Ultimately, directors almost always prefer the production sound in the final mix, even if it is noisy and distorted.
- When the scene requiring ADR is outside on a busy street corner or perhaps indoors at a crowded restaurant, it is important that the actors speak loudly, just as they would naturally do at that location.
- Work with the talent to get the proper playback level in their headphones. Some people like a strong level while others prefer to just barely hear the lines.

PRODUCTION ADR RECORDING

Location ADR is often done immediately after a scene when the lines and performance are fresh in the actor's mind. Even just recording the scene without the camera and with the noisy special effects machines turned off can give the dialogue editor enough to work with and might avoid an expensive ADR session.

Sometimes location ADR is done with a portable ADR system complete with a booth. Other times some improvising is called for; for example, a crewmember's motel room with the drapes closed and blankets set up to reduce room noise.

POST-PRODUCTION ADR RECORDING

Figure 5.5

Distant Studio ADR Recording

On many big budget films in which the director and actor are separated by thousands of miles, ADR over ISDN (Integrated Services for Digital Network) lines is the preferred method. In order to accomplish this, the audio and visual elements on both stages must be electronically interlocked using SMPTE (Society of Motion Picture and Television Engineers) timecode. For example, an actor in Sydney and the director in Los Angeles must view the same footage at

exactly the same time. They will also be able to talk with each other. This allows the recording session to be done in real time, with the director directing the actor in the other time zone. In some situations there may be a slight delay of up to a half of a second, but it will be consistent for the session.

Low Budget ADR Technique

DIY ADR

Low budget ADR is a hard sell. Without a stage and proper rigs to keep timecode, it's not the easiest thing to sync all those things in line. But, a good microphone can be very helpful. If it's super low-budget, record the best you can, and try playing with some "plug-ins" if those are available.

From the article, *Inside the World of Professional ADR with Julie Altus of Todd-SOUNDELUX*, which appears on the nofilmschool.com website, by writer Oakley Anderson-Moore.

If you can afford to rent a recording studio, then you want one that has recording software that is capable of doing loop recording. The most common software used for recording ADR is Pro Tools. The cost of an ADR studio can easily be a $100 or more per hour.

The best way to save money is to be prepared for your ADR session. One helpful way of being prepared is to find out what specifications (specs) are required by the studio for your session. They will need to have certain formats or codecs that work on their system. You will need to output the video and audio to match their needs. In other words, you will need to supply the studio with the type of media that they can accept for their system. For example, they may require the video be a QuickTime movie using the H264 codec and with audio at 48k and 24 bits. The studio will provide an engineer to record the ADR, which leaves you free to direct the actors. Another way of being prepared is to work with the actors prior to the ADR session so that they are ready to go, but don't overwork the actors as this may flatten their performance.

No Budget ADR Technique

If you cannot afford to rent a recording studio, but you have a computer, camera and a microphone, then you can still do ADR in your living room or bedroom. Ideally, your bedroom is quiet and doesn't have any reverberation in it. Reverberation is caused by sound bouncing off of hard surfaces and into the microphone after the voice has reached the surface. However, reverberation can be reduced by closing the curtains, leaning the mattress against a wall and the box spring against another wall. It can also be helpful if you have carpeting on your bedroom floor.

However, if you have a hard surface on your bedroom floor such as linoleum or wood, you can place a blanket or throw a rug on the floor to knock down reverberations from there.

It is better to reduce reverberation in the recording and then add it in post-production, if necessary, so that you can control the amount of reverberation. Reverberation is added in order to make the ADR sound like it belongs in the location in which the scene was shot. For example, a scene shot in a cathedral would have a considerable amount of reverberation, while a scene shot in the middle of a wheat field is not likely to have any.

Once the reverberations are minimalized and you have turned off any noise-making appliances like clocks, air conditioners, heaters, fans, and so on, you can play back the video on the computer with the actor wearing headphones; even your typical poor quality earbuds will work here. The actor will listen to the line and repeat it in synchronization with their lips in the picture. If you can't see the actor's lips in the scene, then it's better for not having to be performed in perfect synchronization.

While the actor is speaking into the microphone, which is ideally set on a microphone stand and not being handheld, you will be recording the ADR lines directly into the video camera's audio input. The camera will be recording the video playing on the computer along with the actor's ADR line on the camera's audio track. This will give you synchronization and allow you to import it into your NLE and line up the new audio and video with the original. Delete the new video and the bad production line audio and then replace it with the ADR line. If you don't have a camera, then you could record the ADR on an audio recorder and line up the new line by ear and eye.

Remember to wear headphones. That is how you'll know if you are getting a quality recording of the ADR lines.

If you have a computer, Pro Tools, GarageBand or similar audio recording and editing software that allows you to play your film, an I/O (Input/Output) device, the proper microphone and headphones, then you can record ADR in synchronization to picture.

If you are editing your film with a NLE system, then you may be able to record directly in to it. Many NLEs, such as Avid Media Composer, Final Cut Pro, Sony Vegas and Adobe Premiere can record audio or even loop record audio within the program. Some of the NLEs have companion software that will record ADR too. You can use GarageBand, Audition, Sound Forge, Logic, Nuendo, Pro Tools, and so on as a stand-alone recording and editing software.

If you do not have any equipment, but you have access to it at a school or through a connection at a studio or company with facilities, by all means try to use them.

EDITING

If you are really fortunate, the talent will hit perfect synchronization with the production line; however, this is not as common as we might like. You may also have to do some cleanup work to eliminate slurring or mouth sounds.

Hollywood commonly uses Revoice Pro software to time align takes with the original production track dialogue. In my experience it works about 80–90 percent of the time and

greatly speeds up editing. The issue with it not working usually has to do with the poor quality of the production recording.

If you don't have software or a plugin that helps with ADR editing, you'll need to do it by sight and sound. You'll have to line up the new ADR lines with the picture or production track waveform to achieve synchronization. You should also use the spoken production lines as a reference for synchronization. If you play the ADR and production lines together, you can hear if they are in or out of synchronization and make adjustments until they match up.

You can compare the waveform of the original production recording with the waveform of the ADR line. If they line up visually and sound in synchronization when played, you have succeeded in your editing.

You will probably have to do some slicing up and moving around of the words and phrases in the ADR lines. If an ADR word is later in the timeline than the production track word it's replacing, then make a cut just before the late word and then slide it into exact position. If the word is early, then slide it later in the timeline. You may even have to do some slicing and moving on the syllable or individual letter level to get the synchronization right and to provide the best inflection.

Sometimes the director may like the beginning of one sentence and the end of another. You can then combine the two into one line of ADR replacement, so long as the intonation and acting works too. They may also want one word, syllable, phoneme or letter sound inserted in a different take. Piecing together or compositing a performance from separate takes is called "comping." Comping allows for the best performance to be created out of the various takes of an ADR line. You may then need to do some fine-tuning to make sure the flow of the words sound right and are in synchronization with the original production lines.

Pay attention to the pitch the actor is speaking at when they record the ADR lines and compare it to the original dialogue track. It is common for humans to speak slightly above their normal pitch when they are in stressful environments like a film set. You may need to pitch shift the ADR lines up by as much as a semitone or more.

At other times you may need to pitch shift down the ADR to match the production dialogue. An octave consists of 12 semitones and a semitone consists of 100 cents.

Start off with slight adjustments of 25–35 cents and then double that until it matches the production sound it's replacing.

Sometimes the ADR line you want to use doesn't match the timing of the production line. You can use time expansion and compression to get the lines in synchronization. I've had to compress or expand a vowel in a word to get it to be in synchronization.

If the production track has any breaths or mouth sounds in it and they add to the performance, then you'll want to include those in your ADR edit. That's why recording efforts are very helpful.

There have been entire films that have been looped, especially short films. If you're working on one of these films, it's helpful to have the dialogue characters split out. Put each character on a different track. It's important for doing the mix to maintain the track layout consistently across all of the reels. For example if the character Tyler is on track 1 in reel 1, make sure Tyler is on track 1 in reel 2, 3, and so on.

If, in your ADR session, you used both a wireless lavaliere microphone and a boom microphone to replicate your production recording, you can now use either the lavaliere or the boom or a combination of both to try to get the same sound as the production track microphones. If you use both microphones, listen for any phasing issues. Your ears are the discerning tool for matching the ADR sound to the production dialogue sound.

In order to get the ADR lines to sound like they belong in the location that the original dialogue was recorded in, processing may need to be done during the mix session. This procedure will be covered in Chapters 13 and 14.

Preparing for a Foreign Language Dubbing Session

Films that are being released in a foreign language will utilize ADR to replace the actor's lines used in the domestic release of the film. The foreign mix of the film will only contain the sound effects and the music. This allows each foreign country to dub in their language. The filmmaker will need to send M&E (Music and Effects) sound tracks to the foreign language distributors so they can have it dubbed.

EXERCISE

You can take any dialogue scene from a movie and use it as the source for doing ADR. Find people to play the part of each character that has a speaking role in the scene. Recording one character at a time, play the video of each of the character's lines for them and have them repeat it into a microphone. If you are able to loop record the ADR, all the better. Looping is the ability to play and record over and over again; in this case, while in synchronization with the picture. If you can play the original recording through headphones for the actors, it will help them with acting and synchronizing.

Make sure that you start recording a few seconds before the line and stop a couple of seconds after the line. This allows your actor to adjust to the timing of the scene and thereby know when the line is going to start. It's common to place three beeps before each line to help the actors with timing. The 1k tones or beeps are usually one frame in length and spaced equally. The standard in film is 16 frames between beeps, because 16 frames of a 35 millimeter film equals 1 foot, but 1 second between beeps is common and will work too. The trick is to space the beeps exactly the same distance or time apart so they are consistent for the talent. There is no fourth spaced beep as that is the start of the line being recorded.

You'll want to direct your actors by letting them know what their emotional state is and what the scene is about. This will help them get into character and to properly practice each line before recording. It's also useful to give them feedback on their performance as they practice and record their lines.

ADR CUE SHEET FORM

ADR Cue Sheet

Page out of Pages____/_____

Reel #	Character		Actor	Production Title
	ADR Mixer		ADR Supervisor	

Cue #	TC	Line	Takes & Notes
	IN : : : OUT : : :	 Scene:	1 2 3 4 5 6 7 8 9 10
	IN : : : OUT : : :	 Scene:	1 2 3 4 5 6 7 8 9 10
	IN : : : OUT : : :	 Scene:	1 2 3 4 5 6 7 8 9 10
	IN : : : OUT : : :	 Scene:	1 2 3 4 5 6 7 8 9 10
	IN : : : OUT : : :	 Scene:	1 2 3 4 5 6 7 8 9 10
	IN : : : OUT : : :	 Scene:	1 2 3 4 5 6 7 8 9 10
	IN : : : OUT : : :	 Scene:	1 2 3 4 5 6 7 8 9 10
	IN : : : OUT : : :	 Scene:	1 2 3 4 5 6 7 8 9 10
	IN : : : OUT : : :	 Scene:	1 2 3 4 5 6 7 8 9 10

Created by Patrick Winters 2/14

Figure 5.6

Walla/Group/Loop Group/ Group ADR/Rhubarb

Why Can't I Hear Them?

INTRODUCTION

Walla is the vocal sounds that people make in the background as the actors with speaking parts deliver their lines. If there are no actors speaking dialogue, then walla would be the murmur of the crowd. Walla is recorded because the background actors don't typically say anything during the shooting of a scene. The focus of sound on any given scene is the recording of the dialogue, not the background sounds. The walla recording may be for general backgrounds, or specific reactions to the action of secondary actors and extras taking place in a scene. These background voices are usually recorded in post-production much like ADR (Automated Dialogue Replacement) is recorded. Anywhere from a few to 20 or more actors may be

needed to voice the background voices of a movie. These group voices are then blended with the production track in the final sound mix of the film. Walla, which can be recorded on set as wild sound, is often referred to as "omnies".

It is thought that walla originated in old radio broadcasts in order to give the audience a sense of a group or crowd of people. Since radio back in the 1930s and the 1940s was not very high fidelity, the people creating the walla could actually say walla-walla-walla and it would sound like a group of people talking. If you were listening to a radio show from England the people there might be saying rhubarb instead of walla. Today, audiences are used to a higher fidelity of sound, so they would hear the repeated word distinctly. This means that actual words or at least syllables that sound like they could be words need to be used by the voice actors recording the walla.

A different approach to walla is when the loop group actors are making sure that no recognizable words are used. The idea is to keep the walla subliminal. If a recognizable word is distinguishable it might be distracting, so basic gibberish is another way to go. With this technique, the actors will use syllables and sounds to make up a conversation that has no real words in it, but when played under the actual dialogue, it sounds real.

When I was the ADR Editor on *Far From Heaven*, 2002, I needed to have the loop group actors talk about subjects that were commonly discussed in 1956, when the movie takes place. In order to avoid mistakes, I did an extensive search into what songs and singers were popular that year, what baseball teams were in the World Series, what new cars had just been produced, what people were in the news and other similar subjects. I did not allow discussion about movies or television shows as that might catch the ear of an audience member and distract them enough to make them think about the fact that they are actually watching a movie and thus disconnect them from the story.

There were several large group scenes in the movie that required me to have 15 people in the loop group. One of the scenes was a cheerful New Year's Eve party, complete with a countdown to midnight. We did several takes so that I could layer the shouts and cheers to approximate the 50 or 60 background actors in the scene.

We will assume that you have shot a scene in your film in which the principal actors have a conversation. Let's make the location of the conversation a Greek restaurant that is full of diners. When you shot the scene, all the background actors or extras in the background were mouthing words, but not actually saying anything. That way you were able to record the principal actors having their conversation cleanly. In the background there may be a waiter at a table taking an order, mouthing the words. The waiter may also have felt pads on the bottom of their shoes to keep them from creating noise when the waiter walks away. The footsteps will be recorded in a Foley session. You may have had a host taking a couple to a table somewhere

behind the principal actor's table. As the host passed by they may have mouthed the words, "Right this way, please." Along with the general chatter of the diners, these are the sorts of sounds recorded in a looping session.

GROUP LEADERS

Group leaders or supervisors are the people who oversee the acting side of the recording session. The ADR editor or dialogue editor on the film would have come up with the list of cues, which need to be recorded. The group leader will have the list of cues to record and will decide which of the actors are needed for any given cue. Usually, the sound supervisor, but sometimes the ADR editor, will oversee the looping session.

The group leader may also direct the loop group during a recording. They usually use hand signals to communicate to the actors to get the volume up or down or to increase or decrease the intensity.

The group leader will determine what the age range of the actors needs to be, what type of voice is called for, the mood of the scene, what ethnic voices are required and among other things, the energy level. All of these aspects come together to heighten the intentions of a given scene. They will bring it to life and add depth and color.

RESEARCH AND SCRIPTING

If the film takes place in an uncommon time period, culture, location or other world, the group leader will have to do research to determine what limitations there are on the lines they write for the group actors. You can't have lines that mention cars when the film takes place in the 1890s or Brooklyn accents when the film takes place on the streets of Paris, unless it's a comedy and the story calls for it.

The group leader will watch background actors that did not have their lines recorded during production and come up with words that match their lip flaps or mouth movements. This is more critical when the actor is delivering their line somewhere near the principal actors and their lip movements can be seen clearly.

WALLA

The loop group adds all the background talking. One of the recordings they do is the ambient sound of people talking. This "walla" makes the scene sound more natural, just like a real restaurant. However, a little walla can go a long way. Don't overdo it unless the scene calls for it.

The number of ADR or walla actors at the session will depend on the scenes and the number of background actors in them. It's normal to have between 6 and 10 actors in a loop group, unless there are scenes that require more actors. These are usually battle scenes, parties or large crowds, like at a sporting event. You might be tempted to actually go to a sporting event and

record the crowd, but this doesn't usually turn out well. The noise in such a large group is often too loud to use and there are often other unwanted sounds mixed in. Ideally, you'll record the loop group several times, then layer those takes and build the crowd to a level that works for the scene and works with the dialogue of the principal actors.

Figure 6.1

For some scenes you may use all of the loop group actors, while for others only a few. When you need all of the actors, it's common to position them around the microphone in a horseshoe shape or group them together in a cluster.

Depending on the scene, it can be useful to place some actors off the microphone axis and to change their positions in the room between each take. This will keep it from sounding staged.

You can create a depth of walla sound by having the actors walk by the microphone. This pass-by or cross-by technique usually involves the actors pairing up and having a conversation that starts before they get to the microphone and then ends shortly after they pass the microphone. This technique gives a scene the sense of people moving past the camera. It works well in scenes taking place on a busy sidewalk, shopping mall, airports and other locations that have people passing by.

A variation on the pass-by technique is the donut. This is where the looping actors walk around a microphone in a circle while constantly conversing.

Choose the technique that works best with the scene. You might use the horseshoe technique for a busy bar or the donut technique for a New York City hot dog stand.

When doing any of these walla techniques, each actor must always match the volume of the other actors around them, so they don't stand out in the overall walla. Also, they need to put themselves in the location of the scene. For example, if the scene is at a horse racetrack and a race is on, they need to shout as though they are actually at the racetrack. At the other end of the spectrum of locations is, if the scene is in an art museum, they need to talk at a quiet level.

SPECIFICS

A specific is when someone, like the Greek restaurant's host, says, "Right this way, please," which is a specific line of dialogue. Since it wasn't recorded on set, it will be done by one of the loop group actors. The actor doing the line would be chosen by the loop leader to match the on-screen character. The specific lines are recorded just like standard ADR, which is in lip synchronization with the character on screen, who was silently lip flapping. If it is not known what the character is mouthing, then some line that matches the lip flapping will have to be made up either by the ADR editor, group leader or the actor performing the line.

The closer the character saying the specific is to the principal characters, the more likely it is that they will be heard in the final mix. Specific cues are usually done as separate recordings that will be added to the general walla recording for that scene.

Figure 6.2

CALLOUTS

Another type of walla is "callouts," which are specific lines spoken by a background actor that are supposed to stand out from the general walla. These are not specifics as there is no attempt to be in lip-sync or synchronization with a character.

Callouts are meant to stand out and be heard by the audience. The loop group actor doing a callout will need to project their voice as though they are actually in the scene. If the scene is at train station, we might hear, "All aboard" just before the train departs. If the scene is at a boxing match, the loop group actor might callout, "Knock the bum out." In the Greek restaurant scene, we might hear, "Check please" or "Are you ready to order?" There will not be a specific character in the scene saying the line, but it will be added in to the overall walla.

Callouts are usually done by a selected loop group actor, but at other times the callouts may be done by several actors or by the entire loop group. For example, in the boxing scene just mentioned, several actors will stand around the microphone shouting callouts one person at a time. These can then be spaced out around the dialogue, so as not to interfere with it, when the walla is edited.

EFFORTS

Efforts are the non-dialogue sounds that actors make. These are often not recorded during production and need to be added later in the group ADR session. For example, if a principal actor is involved in a fistfight in a scene, they only appear to be getting hit. They will move their head rapidly to one side to look like they were just hit, but they were not actually hit. These types of scenes are hard to record audio for on set because there is so much movement, so most of the sound is done in post-production. A loop group actor will make the necessary grunts and groans for the principal actors in the fight.

Other types of efforts might include breathing heavily, kissing, sex scenes, gasps and other such human voice sounds that are not actually speech.

In the movie *Finding Forrester*, 2000, the post-sound team was told to add the sound of a couple having sex in the apartment next door to the bedroom of the main character, Jamal Wallace. It was the actors in the loop group who supplied these sounds and their acting was very convincing.

SCREAMS

In order to save the voices of the actors, it's common to have someone else provide screams. If you record screams for your film, make sure the microphone is sufficiently far enough away to avoid distortion. If your recorder has a pad, you may want to turn it on to lower

the recording level. A pad attenuates or reduces the signal by a specified amount of decibels. A common amount for a pad is –10dB, but there are other options depending on the equipment you use. There are recorders that have –12dB, –15dB, –18dB, –20dB and more. When using a pad, it's better to insert the pad after the microphone. Most recorders and mixers have pads that can be turned on when you're recording. The problem with most pads that are on microphones is that the pad occurs between the capsule and the microphone preamplifier. This means that the loud part of the signal has been reduced, but the signal noise floor remains the same.

In the shower scene of the remake of *Psycho*, 1998, the victim screams as she is being stabbed. I cannot verify it, but one of the other people who worked on the remake of *Psycho* with me claims that the screams that are heard are not from the actor playing the victim, but from another person who was recorded separately.

It is rumored that the scream in the original *Psycho*, 1960, was also a different actor, but Janet Leigh, who played the part of the victim, claims it was her doing the screaming.

A classic scream that has been heard in many movies is the Wilhelm scream.

Wilhelm Scream

It's highly likely that you have heard the "Wilhelm scream" in one or more of the movies you've seen in your life. It's a classic scream that has been an inside joke for sound editors for decades. Actor, Sheb Wooley, is assumed to have voiced the scream in 1951 for use in the movie, *Distant Drums*. It was used again in the 1953 movie *The Charge at Feather River*, when the character, Private Wilhelm, is hit with an arrow and screams. Sound designer Ben Burtt named the scream after the character. You can find the scream in most *Star Wars* and *Indiana Jones* movies. The scream can also be found on YouTube.

PERFORMING

Most loop group performers are actors. They may have a stage or screen background or they may be voice-over artists. They often have training in improvisation, which allows them to react rapidly to a scene. Improvisation training also means the actors are able to change characters rapidly and come up with lines on the spot.

Another talent that is used by loop group actors is the ability to change voices. The actors will have a number of characters that they can perform. These are not usually cartoon characters, but real people, like police officers, cashiers and EMTs (Emergency Medical Technicians). Another talent they may have is the ability to use dialects or accents. For example, in the Greek restaurant some or all the employees may speak with Greek accents. The key is to keep it real. Hiring a native speaker to help with this might be necessary.

In a walla session there is usually only a few scripted lines, if any. If the lines haven't been written, it is often up to the loop group actors to make up the lines. Although they are recording lines made up on the spot, top-level actors would have done research on the location and era of the film so they can say appropriate lines. Loop group actors never use swear words and they never mention brand names like Sony, Ford or Apple unless they are requested to do so.

The overall job of the loop group is to enhance and augment the story. This may involve the actors changing the feel, texture or mood of a scene. They can add excitement to a crowd scene or make it a bit calmer. Loop group utterances can subtly comment on a character or even affect the audience's ideas about the plot. The overall purpose is to make the story or even a scene play better while keeping the loop groups vocals and utterances relatively unnoticed.

If you cannot afford to hire a loop group, then you need to enlist your friends who have done some acting. If they have performed improvisation, the better the acting will be. People who can improvise are used to acting spontaneously. If your actor friends are used to performing on stage, they'll have to adjust to performing in front of a microphone instead of out to an audience.

In order for your friends to prepare for a walla session, they can practice by watching a movie or television drama and speaking lines for the background characters, even if the character's lips aren't moving. This type of practice will help prepare them for the real session.

RECORDING

You can use nearly any recording studio to record walla for the film you're working on. If you cannot afford to go to a studio to record the walla, then find a large room that is very quiet. Ideally, the room has carpeting, drapes, wall hangings or anything else that will cut down on sound reflections. The fewer hard surfaces in the room, the better the sound. A hard surface might be a window, door, mirror, ceiling, floor, whiteboard or anything else that doesn't absorb sound.

You will then need a recording device and at least one microphone. The recording device could be a handheld audio recorder, a computer or even a video camera. The important function is that whatever the device, it needs to be silent and have a way to input audio.

The microphone is usually a boom-type microphone like the ones commonly used during production. It could be the same one that was used for the production of the film. It usually has a cardioid or super-cardioid pick-up pattern. The microphones commonly used are the Sennheiser MKH416, MKH50, MKH60, MKH8060, Neumann KMR81, Schoeps MK41 or a similar short shotgun model.

You might use the Sennheiser MKH416 for recording specifics from a single actor who is doing specific lines or callouts. Use it in a standard ADR set-up, in which the microphone is about 3 or 4 feet or about 1 meter away and above the actor pointed toward their mouth. You might need to point the microphone slightly above or below the mouth to avoid mouth noises. If the cue is for a character that's farther back in the scene, you can position the ADR actor back farther than 4 feet so their line fits the character's position in reference to the camera. The actor may need to be 9 or 10 feet or 3 meters away from the microphone.

The design of the MKH416 and many other shotgun microphones cause them to pick up sound from the rear lobe of the microphone and that may cause the lines to sound a bit like they were recorded in a box or hallway. It can help mitigate rear lobe pick-up by putting some sound deadening material directly behind the microphone.

The Sennheiser MKH50 or MKH60 are better suited when the entire loop group is performing because they can be placed farther away and higher up in the air than the single actor microphone can be. The distance will depend on how many actors and background actors there

are, how they are placed in the scene and the deadness of the room. With a group of 6–8 actors, you can start by placing the microphone about 5–6 feet or a couple of meters from the group and then adjust according to your needs.

If you use the two mono microphone system, one for specifics and one for the group, you may want to put them on separate tracks unless the ADR editor prefers to have them all on one track. If they are all recorded onto one track, you'll have to turn off the microphone that isn't being used for a given cue, otherwise you'll get the sound from both microphones and it probably won't be very useful.

You may want to record the walla of the loop group in stereo or in surround. These are artistic choices that you make to better serve the story. However, when you record with mono microphones, you have greater flexibility in placing the walla wherever you want it in a stereo or surround environment when you do the mix.

If you choose to record walla in stereo, you can either use a stereo microphone or you can use two cardioid microphones in stereo configuration such as the X-Y design. There are other configurations that are stereo techniques, such as the A-B, M/S and ORTF, each of which has a slightly different sound, but the X-Y configuration is very serviceable for walla.

Figure 6.3

Surround sound walla can be recorded with one 5.1 microphone or by placing five microphones in an array that's a 5.0 or 5.1 configuration. Not all scenes will call for a surround sound walla experience. Use surround sound with caution as it may cause the audience to look around at who's talking behind them.

Figure 6.4

For walla that is supposed to take place in an exterior location, you may want to use a microphone that picks up less of the recording studio sound. This will help reduce some of the reflections that tell an audience what size the room is. It's key to experiment with the type of microphone and the placement of it to find the sweet spot where the sound is just right.

When you use more than one microphone to record a group, be careful of the 3 to 1 Rule, which helps reduce the risk of phase cancellation. The rule works like this. If the sound source (talent) is 3 feet or 1 meter from the microphone, then the second microphone should be three times that from the sound source, or about 9 feet or 3 meters. So, if the two microphones are too close, some of the frequencies could be lost in the recording. These are typically some of the lower frequencies that are lost.

EDITING

When you edit walla, it's a bit like editing a sound effect or a background, even though it's actually part of ADR. You choose takes or part of a take that works with the scene. If it doesn't work well with the scene you will know it because it won't feel right. You might layer the walla to get the

right effect just like you do with sound effects. You choose the places for callouts where they don't interfere with the dialogue or draw too much attention to the callout, unless that's desired. Remember, you are using these vocal sounds to add depth to a given scene and to support the story.

First, listen to all the takes and decide which performance works best for the given shot or scene. Next, place the line or vocalization near the place in the timeline that you want it to be in synchronization. Now, if lip-sync is required, go into the detail work of lining up the ADR line with the lip flapping on screen. You may have to do some editing of syllables, consonants or vowels to get the lines to fit perfectly. If there are two lines that would work, you can edit them both on different tracks and play them with the scene in the final mix and decide then which one to use.

If you are having your sound mixed at a mixing studio, you will need to ask the rerecording mixer where to put the specific lines. They may want them on the ADR tracks or somewhere else.

RESOURCES

Do research on what the terms and codes are used by the actual police, hospitals and airports that exist at the script's location for each scene.

Examples for Police, Hospital and Airport Scenes:

Police calls can be heard streaming online and you can copy them down for a looping actor to use.

Police Scanner Lines

Officer: 22, Code 33. Code 33 on channel 1. 223, I'm in pursuit north on University from Main, a red van, unknown plate, wanted for speeding. 10–4, a red van, north on University from Main, wanted for speeding.
Dispatcher: 35, a 242 at 1918 Blake.
Officer: 35, a 415e. Go ahead.
Dispatcher: At 1532 Beaker, a neighbor reports a loud radio.
Officer: That's on beat 15. I'm on beat 16.
Dispatcher: 10–22 for now and I'll get that officer to take it when they come 10–8. 35 check

More commonly, instead of saying there's a 417, police officers just say there's a man with a gun inside the SpotOut Dry Cleaners at 23rd and Main Street.

Hospital Code

Attention Please: Medical Emergency: Trauma Activation, Category 2, arriving in 3 minutes—Emergency Department exam room 3
Attention Please: Missing Person, male child, wearing blue denim pants and yellow T-shirt; short black hair; with glasses, last seen on 4th floor

> Attention Please: Hazardous Spill, Laboratory on 2nd floor
> Attention Please: Security Alert: Lockdown

Hospital codes vary from region to region and sometimes from hospital to hospital. The codes for some west coast hospitals are:

- RED—Fire
- BLUE—Adult Medical Emergency
- WHITE—Pediatric Medical Emergency
- PINK—Infant Abduction
- PURPLE—Child Abduction
- YELLOW—Bomb Threat
- GRAY—Combative Person
- SILVER—Person with a Weapon and/or Active Shooter and/or Hostage Situation
- ORANGE—Hazardous Material Spill/Release
- TRIAGE INTERNAL—Internal Disaster
- TRIAGE EXTERNAL—External Disaster

The codes for some east coast hospitals are:

- RED—Fire
- BLUE—Cardiac/Respiratory Arrest
- WHITE—Hostage
- PINK—Infant/Child Abduction
- YELLOW—Lockdown
- GREY—Violence/Security Alert
- ORANGE—Hazmat/Bioterrorism
- BLACK—Bomb Threat
- GREEN—Mass Casualty/Disaster
- BROWN—Severe Weather

Airport Lines

The white zone is for loading and unloading of passengers only. There is no parking in the white zone.

Please stand to the right so others can pass on the left.

Caution, the moving walkway is ending.

Thomas Smith, immediate boarding please through gate XX, you are delaying your flight!

Flight XX has been delayed. Please contact your carrier (airline) for further information.

Flight XX is now boarding at gate XX.

Flight XX is now boarding. Would all passengers proceed to gate XX.

Will Jane Jones please report to the nearest airport telephone?

We are now inviting passengers with small children and any passengers requiring special assistance to come forward and begin boarding first.

Good afternoon passengers. This is the pre-boarding announcement for flight XX to X-city. We are now inviting those passengers with small children, and any passengers requiring special assistance, to begin boarding at this time. Please have your boarding pass and identification ready.

We are now boarding seats (or zone) X. Will passengers with those seats (or zone) only please come forward.

This is the final boarding call for passengers Thomas Smith and Jane Jones booked on flight XX to X-city. Please proceed to gate X immediately.

This is a security announcement; baggage must not be left unattended at any time. Baggage left unattended will be removed and may be destroyed.

This is a security announcement. Please maintain control of your bags at all times. Unattended baggage is subject to search and seizure.

The city of X has limited (or no) smoking in the airport. Please refrain from smoking in the airport, except in designated areas.

In the interest of air safety and your personal safety, we advise you to keep a close watch of your carry-on items. Do not accept any carry-on items from persons unknown to you. Report any suspicious persons to your nearest law enforcement officer. Thank you and have a good flight.

Welcome to X-city. X-city is in the Y Time Zone, please set your watches accordingly.

EXERCISE

Use a scene from a film that has people appearing to talk in the background or shoot a scene in which the background actors are pretending to talk. You can get a group of friends together and record them doing the talking. You would then add your group walla to the scene and see how well it works. Now edit their lines into the scene in synchronization with the background actor's lips. It can help to play the scene on a monitor while shooting the monitor and the actors, making sure to make an audio recording of the actors' group lines, so that you have a reference that can be used to synchronize to during editing.

Narration

It Isn't Dialogue

INTRODUCTION

Narration is different from dialogue in that the speaker or actor is not usually seen delivering the lines. First-person narration is when the voice-over is that of one of the characters in the film, usually one of the main characters. Third-person narration is when the voice-over is from an observer's viewpoint.

Narration is often used to introduce a story, provide backstory, express the thoughts or the emotions of a character, explain a flashback, flash-forward or even the plot and sometimes to finish a story.

PURPOSES

Narration is an acceptable part of filmmaking. It's a common convention in film noir movies. Some people do dislike it though, because it is sometimes used to fill in backstory, plot or other information that wasn't covered well in the script or during production. However, it can be used very effectively to help tell a story. There are a number of good examples of the effective use of a narrator. The movie, *Citizen Kane*, 1941, uses a third-person narrator, speaking in a style used by newsreel announcers for the opening news report. The movie, *Taxi Driver*, 1976, has the main character as a narrator, but he isn't speaking to the audience; his narration is more of a diary he's telling himself. The movie, *The Shawshank Redemption*, 1994, is commonly referred

to as a prime example of well-integrated narration, although some people feel it would have been better without it. Morgan Freeman's character, Red, provides insight into the characters and the story that would be hard to convey using dialogue or action; in addition, the narration helps the audience follow the story as it develops over a 20-year period. In the movie, *Annie Hall*, 1977, the narrator, Woody Allen, is one of the main characters and he addresses the audience directly, looking into the camera to offer information.

Narration should be used to enlighten, to add information, but not to replace action or exposition. It should be an optional tool, not a crutch for a poorly developed plot or inadequate dialogue. However, there are times when circumstances outside of a filmmaker's control make narration necessary. It's better to have a completed film that makes sense than a confusing one that is never exhibited.

PRE-PRODUCTION

Narration can either be diegetic or non-diegetic. Diegetic is when the voice of the narrator comes from one of the characters in the story. Non-diegetic is when the narrator is not part of the story, but is an objective observer of the story, often referred to as the "voice of god."

If you decide that you need to use narration or that it was already part of your original script, then the best place to start is deciding if you want the narrator to read the lines in time to the picture or just to read them without the picture. Reading to the picture is best if the words need to match the timing. If the picture is going to be edited to the narration, then timing isn't much of an issue unless you have a limited length of shots.

> When I was editing a documentary called *The History of Computers*, there was a lot of historical footage that was often short in length. This required editing the picture and then determining how much time a narrator would have to say a line to match the shot length. Sometimes the script would have to be edited to shorten the lines to match picture length.

If you've discovered a hole in the plot line of your film and need to add some information for the audience, then using narration may be a more cost-effective way of finishing your film. Shooting additional scenes can be expensive and time-consuming, while writing and recording narration might be the lower cost answer.

Adding narration out of necessity may mean re-editing the film to leave room for the narration to play over picture. You won't want dialogue competing with the narration. Whatever you do, it will probably be a trade-off.

In order to prepare for the recording session, you might want to create a cue sheet for each of the narration sections that list the starting timecode or minutes and seconds, scene number and lines to be read. If you are using a recording system that allows you to enter a file name for every take, then that will be helpful later when you are editing. I suggest that you use a file name such as: *NarrSc16Tk03*.

RECORDING

You'll need to decide what settings you want for your recording session, whether you are using an audio recorder, video camera or audio recording software. Most dialogue is recorded at 24 bit, 48kHz and as a BWF (.bwf) file. Some sound mixers record at 96kHz and that would be fine too. If your editing software doesn't recognize 96kHz, then you should choose 48kHz or you may have to down convert it to 48kHz for your software.

Voice-over is usually recorded in a booth or studio that is fairly dead acoustically. The booth is not as big as a studio, but more of a one or two-person room, while a studio is often big enough for several people. A bedroom would work for recording the voice-over, if a studio is out of your budget. The important thing to do is keep the noise floor low. You can put blankets on the floor of the room, you can hang blankets over the windows and doors, whatever will make the room sound as close to dead as possible. Try placing the talent so that a blanket or curtain is directly behind them. This should help cut down on the reflections of the voice, which will bounce directly off the wall behind the talent and into the microphone. I would also place a blanket directly behind the microphone to help stop some of the sound from reflecting from that direction.

Another method of cutting down on reverberations or reflections of the voice-over is to create a blanket booth. You can use adjustable garment racks to create a voice over booth. I suggest using three racks, which can be purchased anywhere from $12 to $20 each at a local store. If you put them in a U shape, looking from above, so that you have created a three-sided booth, you can hold them together more easily. You can now adjust the height to allow for the talent to sit in a chair and be well below the top of the booth. The racks are not very sturdy, so they need to support each other. You could use heavy weights to hold them in place. You might want to build the booth in the corner of a room to add more stability. You may also want to put a dowel or board on the fourth side to help support the booth even more. Once the framing is done, hang some lightweight blankets over the three garment racks. You may need some sort of spring clamp or duct tape to hold them on. Make sure the booth is steady before you put the microphone and stand inside it. Now do a test recording and see how it sounds. You may have to put a blanket over the top of the three garment racks to really knock down the reflections. Be careful with the booth once the talent is inside as this is a temporary structure that could easily collapse.

Voice-overs are sometimes recorded on location. This can be done either during production or in post-production. The reason may be practical or creative. The practical approach is often one in which an actor is leaving for a faraway place and you need their narration lines before they leave. Yes, they could record their lines at a studio in the far-off place, but that will cost money and be at a later time, when they are not in character.

If you are recording an actor's lines on location, you have the choice of recording those lines in the actual location, so that the ambience of the location gets recorded too, or recording them in a hotel room, where you can put up sound blankets to deaden the room noise, or better yet, at a local studio. Recording the actor's lines at the actual location places the voice of the actor in the scene that's been shot there. This is a creative choice that the director needs to make. Do you want the talent to sound like they are in the location or be more of a voice of god?

Voice-overs are sometimes recorded to picture, so the voice-over talent needs some way to watch the video while delivering the lines. If you are recording the voice-over in a bedroom or hotel room, you could sit at a desk with the talent and play the video while recording their narration. If you are recording in a studio, they probably have a video monitor set up already in place.

Ideally, a studio cardioid microphone would be used for recording the voice-over. One of the most common voice microphones is the large diaphragm Neumann U87. It has a more intimate sound to it. When talent is standing or sitting and speaking fairly close to the microphone there is a proximity effect, which accentuates the bass frequencies and warms up the voice of the actor. If you are recording with two microphones for two voice-over talents, there can be issues with frequencies being canceled out.

When I recorded the voice-over narration for the New Zealand made movie, *Two Little Boys*, 2012, I used two Neumann U87 microphones, one for each of the two main characters. At various points in the movie one or the other character would be narrating.

The director, Rob Sarkies, wanted to have both actors, Bret McKenzie and Hamish Blake, in the booth at the same time so they could react to each other. This arrangement required specific microphone placement in that I did not want to break the 3 to 1 Rule.

3 to 1 Rule: When placing the microphones near each other, for whatever distance the first microphone is away from the sound source, the second microphone needs to be three times that distance away from the first microphone. For example, if the voice-over talent is 6 inches or 15 centimeters from the first microphone, then the second microphone needs to be placed at least 18 inches or 45 centimeters away from the first microphone. Tripling the distance effectively reduces the volume going into the second microphone enough that no cancellation of frequencies is noticed. However, if you were to raise the input level from the second microphone to match that of the first microphone then you would hear some frequencies being canceled once the two are mixed together. The ideal is to have the sound level in the second microphone to be at least –9dB lower than the sound level of the first microphone. This will effectively make the phase cancellation unnoticeable to the human ear.

The 3 to 1 Rule for microphone placement works with the Inverse-Square Law, which states that sound levels drop 6dB for every doubling of distance from the sound source. For example, if the sound of a drum is 60dB when you are standing 4 feet or 1.22 meters away, then when you are standing 8 feet or 2.44 meters away, the sound will be 54dB, which is 6dB less. If we apply the law to the use of two microphones in order to get the desired –9dB to avoid noticeable phase cancellation, you would need to place the second microphone 12 feet or 3.66 meters away. Twelve feet or 3.66 meters is three times the original distance of 4 feet or 1.22 meters, therefore the 3 to 1 Rule utilizes the Inverse-Square Law to reduce the level of sound entering the second microphone by 9dB.

You can also try adding a delay to one of the two recorded tracks. Start with a 2.5 millisecond delay and then add another 2.5 millisecond delay until the phase cancellation issue isn't noticeable anymore. You may need as much as 20 or 30 milliseconds of delay depending on the set-up of the microphones and the volume level of the sound sources. If you use too much delay you'll notice it as it will start to sound reverberant.

Before you get into doing the recording, do a test recording. Have the talent read a line or two and then play the recording back. This will let you know how they sound. It will also tell you if the volume level is good and if there are any unwanted sounds. It only takes a couple of minutes, but it may save you having to redo an entire session. It can be helpful to record about 10 seconds of room tone or ambience. Some noise reduction software can sample a section of sound and then remove that sound from a recording. This may be helpful in removing unwanted sounds like an air conditioner from a voice-over done in a hotel room or office.

Recorders

If you are not recording in a studio, then you will need to have a recording device. This could be an audio recorder, a video camera with a microphone input or a computer with either a microphone input or a USB input. The USB input will take specially designed microphones that have a USB plug for inputting into a computer.

There are also USB to XLR converters with built-in preamplifiers, which will allow you to use a standard XLR microphone and run its signal directly into your computer. If you go this route, I suggest that you use a converter that has a built-in volume control so that you get a usable level.

If you're recording directly into a computer, you will need to have some audio software to do the recording. Most computers come with some way of recording audio. If your computer didn't come with any audio software, then you can download software for free. For example, Audacity is one of many free audio software applications for both Windows and Mac operating systems.

Microphones

The type of microphone that is commonly used is a large diaphragm condenser with a cardioid pick-up pattern. However, if the narrator is one of the characters in the story and you want the narration to sound like it comes from within the world of the story, then you might want to use the same microphone that was used on location to record the dialogue for a scene or sequence in which the voice-over will be added.

Headphones

If you are recording the voice-over in your bedroom, hotel room or some other non-studio environment, which includes recording on location, make sure you wear headphones.

There is no way to know if you have a great recording unless you are able to listen to it. If you are recording in a studio, you'll be able to hear the talent through the control room monitors.

Talent

The goal of the director in recording voice-over narration is to help get the actor or talent into the right frame of mind. If the talent is doing a first-person narration, then the director will have to get them back into the character they played in the film. If it's a third-person voice of god narration, then the director will have to work with the talent to find the right voice style, pacing and emotion.

There should be room temperature water for the talent to drink. You can add a bit of real lemon juice to the water to help even more. This keeps down the lip smack sounds. Do not provide milk products, caffeinated drinks or carbonated beverages. The milk creates mucous in the throat, caffeine gives people the jitters and carbonation causes belching.

I always have talent stand up to deliver their lines as this helps them keep up their energy level in the delivery. However, if the script is long and the session is going to go on for hours, I'll get them to sit on the front edge of a chair. This helps keep up their energy level and keeps them from slumping back in the chair. I also get them to hold the script up at eye level so they aren't looking down and talking into their chest. This position will give the best quality and a more natural sound to the voice-over.

Plosives

In a voice-over session, most talent will stand fairly close to the microphone or what is called a "close-miced" position, which means that whenever they speak any consonant that has an expulsion of air in it may cause a "pop" sound or plosive, which is short for the word "explosive." The eight common plosive consonants are:

- P as in Pitch
- B as in Bass
- T as in Tempo
- C as in Chord
- K as in Key
- Q as in Quote
- D as in Duet
- G as in Guitar

It's good practice to see if the talent is prone to speaking with plosives by having them repeat "peanut butter cup" several times into the microphone. If there are plosives, then there are several options for dealing with them.

Talent Position: Move the talent back from the microphone until there are no plosives in their speech. If they are too far away from the microphone for a good recording, then try a different technique from the following options.

Pop Filter: This is standard equipment for any voice session. The pop filter breaks up the air before it gets to the microphone diaphragm. The diaphragm is the part of the microphone that picks up the vibrations from the voice. Pop filters are usually made from either a sheer mesh material or from a thin metal sheet with holes in it.

The pop filter should be far enough from the microphone diaphragm in order to keep the air from hitting it. You can test it by saying "peanut butter cup" into the microphone while holding your hand directly in front of the microphone. If you feel a burst of air from the plosives, then the filter needs to be moved farther from the microphone until you don't feel the air much at all. You might also try adding a second pop filter in front of the first.

Windscreen: The part of the microphone that has holes in it to let the sound pass through to the diaphragm is called the windscreen or windshield. These are often wire mesh covers. They will stop some wind or air, but it's not always effective. You'll probably need to use a foam windscreen to help reduce plosives by putting it over the microphone's windscreen.

Pop Pencil: If you don't have a pop filter to stop the air, then try taping a pencil or pen in the middle of the microphone's diaphragm area. This will split any burst of plosive air and thereby redirect it before it hits the microphone.

Off-axis Position: Instead of having the talent face directly into the microphone, try an "off-mic" placement by turning the microphone to one side, so the air passes by without going into the diaphragm. The angle should be enough to avoid plosives, but not so much as to sound "off-mic."

EQ (Equalization) or High-pass Filter: Some microphones have a built-in equalizer, which will reduce low-frequency sounds like plosives. The amount of roll-off and the frequency at which the roll-off starts will vary from microphone to microphone.

If you want greater control over the frequencies, then you could use an equalizer that's either a piece of hardware or a plugin or filter in your recording software. The issue with using a filter is that you may have to remove some of the frequencies of the talent's voice along with the plosive sound.

Omni-directional Microphone: It's difficult, but not impossible, to have plosives when you use an omni-directional microphone. However, this may not be the best type of pick-up pattern for the room or location you are recording in.

Software Plugin: There are plugins that can be used to remove or repair plosive sounds. iZotope RX will remove plosives quite effectively.

If you don't catch a plosive during the recording session, you might be able to edit in a substitute letter. I've taken a "p" from one word that wasn't plosive and edited it into another word that did have a plosive "p." I was able to fix the problem by replacing the plosive letter with one that didn't have a plosive.

Sibilants

All voice-over talent have some level of sibilance in their speech. Most are not very noticeable, but some have heavy sibilance sounds. They are easy to hear in words like snake, yes and scissors. Words like sssnake have a hiss or whistle sound associated with the letter "s." The letter "z" can also be the cause of sibilance.

This effect starts at frequencies around 4,000–5,000Hz, and can go as high as 10,000Hz. It can be removed or at least reduced using an equalizer or a special form of an equalizer called a de-esser. These software plugins or their analog counterparts can be adjusted to find the appropriate frequencies to reduce or remove the unwanted sound.

The letters "S" and "Z" are the main causes of sibilance, but there are several possible sounds that can cause sibilances.

- S as in Sip
- Z as in Zip
- Ch as in Chip
- Sh as in Shin
- G as in Gin
- J as in Jeans

Unfortunately, there is nothing like a pop filter for sibilance as the sound is created in the mouth of the talent. However, if you are faced with sibilance sounds, then there are a few options for dealing with them.

Talent Position: You can try to position the talent a bit farther from the microphone than usual, perhaps 12–18 inches. This can have the effect of reducing the sibilances, but also reducing the level of the voice, while picking up too much of the room tone or noise floor.

Microphone Position: Another possible way to deal with sibilances is to position the microphone at about 10–15 degrees below the mouth so that it's pointing more toward the throat of the talent.

Change Microphones: Some microphones are more sensitive to the higher frequencies that are in the sibilance range than others, so trying a different microphone could be helpful.

Equalizer or De-esser: This is either a piece of hardware or a plugin in your audio or video software. It can be used to reduce the frequencies between 2,000Hz and 10,000Hz. A good starting place to reduce frequencies is around 4,000Hz.

Proximity Effect

The proximity effect causes an increase of lower frequencies from a sound source, such as a voice-over talent, talking closer to a microphone. This can be useful when the intention is to give the talent a sound that is warmer, which is done by increasing the frequencies between 100Hz and 700Hz. The closer the talent is to the microphone the more these lower frequencies are picked up.

Most human voices fall somewhere in a range between 200Hz and 2,500Hz. Some people have speaking voices that are higher and some have voices that are lower.

In the following graph, the "A" signifies what frequencies might be boosted when the talent is within a few inches or centimeters of the microphone. The "B" signifies that the lower frequencies decrease when the talent is about 12–16 inches or 30–40 centimeters from the microphone.

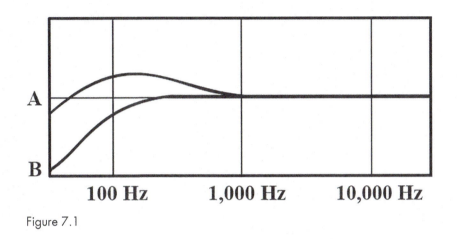

Figure 7.1

EDITING

Once you have finished recording your voice-over narration, then it's time to edit together the best takes. You may want to import the voice-over into your dialogue session or keep it in its own session for editing. I prefer to keep different aspects of sound design in separate sessions and then combine them once they're all edited.

This final mix allows me to hear all the elements at once and make adjustments according to how everything plays together.

If you have recorded the voice-over into an audio recorder or into audio software that doesn't play video, then you'll need to import the voice-over into editing software that allows you to place the voice-over against the picture.

Once you have the audio files imported into the editing system, make sure each file is named. It's really hard to know what a file is when it's named Audio 01 or Audio 32. If you have script scene numbers that reference the narration, then you could use those as names. For example, *NarrSc16Tk03* might be a useful name. If you do this when you are recording the narration, it will save having to name the files now.

You'll want a project or session that has the edited picture along with its production track audio in it. This could be your actual picture editing session. The edited picture and production sound will act as a guide track to let you know where to place the narration.

I usually create two narration tracks. The first one I call "narration" and the second one I call "options." The narration track is the one I edit to. The options track is the one that I use for listening to different takes and for lining up the lines to picture.

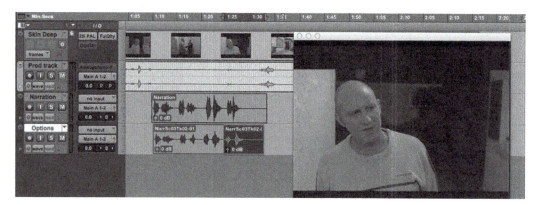

Figure 7.2

Sometimes an entire sentence or paragraph will be perfect and will not need any editing work on it. Those are great takes. Usually you'll have to piece together the narration using parts of different takes to get the most effective read. This piecing together or compositing is called *comping*. You may have to comp together several sections of a paragraph or even a sentence to get the right sounding performance. The blackened section in the timeline of these two images has been comped or moved up to the narration track to create a better performance.

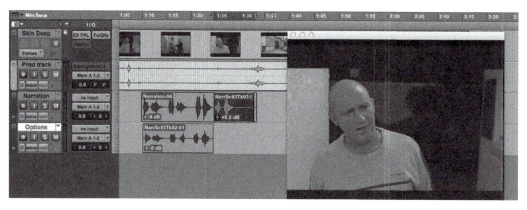

Figure 7.3

Now, continue through the film comping together the voice-over until you are satisfied. Sometimes you may hear a click at the edit point between two files, adding a short crossfade at the edit point can usually eliminate this.

PROCESSING

EQ

If you're doing your own mix, you may want to add some EQ or compression to the voice-over narration. It is better to get the EQ right before you add any compression, as the compression will affect the EQ. If you are having the film mixed at a studio, you'll leave the voice-over "dry," which means without any filtering added to it. Whichever approach you take, you'll not want to add any filters until you can hear the voice-over playing with the other sounds.

Every voice, microphone, room and film are a bit different, so you'll have to experiment with the EQ in order to find the best sound for your film. A good starting place is to boost the 3,000–10,000Hz range to bring out more detail in the voice. Be careful not to add so much that it makes the voice thin and too bright. You can then work in the 100–700Hz range to add warmth to the voice. This is the same range as is boosted with the proximity effect. Be careful not to add so much that the voice sounds muffled or unnatural.

In terms of adjusting the frequency volume levels, a good starting point with EQ is to boost or cut by only 2dB or 3dB and then up to 6dB, but only if necessary. *Boost* is to increase the volume level of selected frequencies when adding EQ. *Cut* is to decrease the volume level of selected frequencies when adding EQ. The Q is how broad the frequency range is around a specific selected frequency that you are boosting or cutting.

Compression reduces the dynamic range of a signal, which in this case is a voice. The dynamic range is the loudest volume level minus the quietest volume level. It's measured in decibels (dB). Compression actually compresses the loudest into a reduced range. For example, if the loudest volume level of your recording is –10dB and the quietest is –40dB, compression can reduce that –30dB range by a variable amount. By adding compression to bring down the peak levels, you are making the voice sound more consistent. As a result of compression, breaths and inflections are more noticeable and natural. Compression should just level out the read, but don't apply too much. There should still be high and low-volume levels as that's part of the narrator's tools for acting.

A potential issue with the use of compression to bring down the peaks is that once you add make-up gain, to get back to the input level, it will bring up the noise floor too. The noise floor is the level of ambient noise that's in the studio or other recording environment and it's also the electronic noise that is inherent in a given sound system.

Here are some good starting point settings for compression:

Ratio: 3:1
For every 3dB of signal above the threshold entering the compressor, the compressor only allows 1dB to pass through.
Threshold: –20dB to –30dB
When a signal is loud enough to go above the threshold, the compressor kicks in.
Attack: 1ms to 5ms

This is how long the compressor waits until it kicks in.

Release: 10ms to 15ms

This is how long it takes the compressor to stop working once the threshold is no longer being crossed.

Output gain: +3dB to +10dB

This is the make-up gain that you add to the output in order to get the signal back to where it was before the compressor dropped the volume level.

EXERCISE

Download a script from the internet for a movie such as *The Shawshank Redemption*, 1994, and find one of the narrations written into the script that you want to record. Find talent that will do the voice-over and set up a recording session.

Make sure that all the technical aspects of the session are set up properly and do a test. Once the equipment is set up, start working with the talent. Try to get a good solid performance from the talent. The more you work with the talent the better you'll get at it. The key is to get the right read and feel for the scene.

CHAPTER 8

Sound Effects

Creating Reality

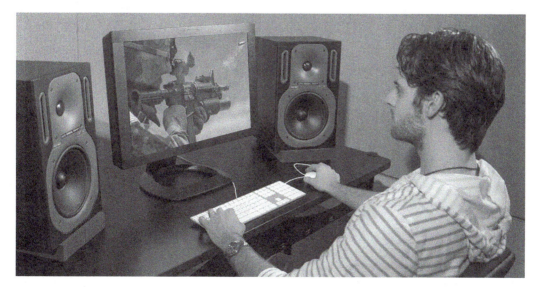

Figure 8.1

SOUND EFFECT FUNCTIONS

There are many functions of sound effects for film. For example, they can provide necessary sounds to the film, such as car-bys, sirens and gunshots. They can provide information about the film, such as location, time period and ethnicity, and they can provide information about the story or a character. Sound effects and sound design can suggest a mood or feeling, such as sadness, happiness and fear. They can tell an audience to expect trouble or that everything is going to end well. They can affect the pace and tension of a scene. For example, a ticking clock might tell the audience that time is moving slowly or that time is running out, which can be used to create tension in a scene. With regard to a story location, the right sounds can tell an audience where a scene is taking place. Breaking waves signify that the scene is taking place near a beach. The sound of Big Ben tolling is only going to occur in London. Sound can tell the audience what time period the scene takes place in. A film with a Zeppelin airship means a time period between the 1895 and 1940. Sounds provide the audience with information and with intended emotions. The filmmaker's job is to use them effectively.

Other uses for sound might include a signature sound that could be used to help define a character, event or location. A low, barely perceptible rumble might be used to signify that the antagonist is nearby and about to strike.

Sound can be used to heighten realism, such as the sounds I used in the shower scene for the *Psycho*, 1998, remake. Generally speaking, sound can connect otherwise unconnected ideas, characters, places, images or moments and provide information to the audience about the story, scene, character, object or action. Sound can also be used to bridge two scenes making the transition a smooth one instead of abrupt.

TYPES OF SOUND EFFECTS

There are several types of sound effects and they each have their own role in helping to tell the story.

Hard or Spot Sound Effects: Sounds that are directly linked to a visual that requires synchronization between the two. An example would be a car door closing in a shot. The audience can see exactly when the door closes and thereby expect to hear the door close in synchronization with the action.

Background Sound Effects (BG or atmosphere or ambience): Sounds that do not synchronize with anything in the picture, but are used to indicate the location or setting to the audience, such as forest sounds, wind and carnivals.

Foley Sound Effects: Sounds that synchronize with a character's actions, and require the expertise of a Foley artist to properly perform. Footsteps, the movement of hand props and the rustling of cloth are the three common Foley units. For example, a character walking into a room, taking off their coat, sitting down and then drinking a cup of tea would

require all three types of Foley. Most Foley artists do not perform sound effects like car doors and tire squeals that are usually taken from sound effects libraries or recorded by the sound effects editors.

Loop Group or Walla: The sound of people talking in the background is also considered a "BG," but only if the people talking are unintelligible and whatever language they are speaking is not recognizable. However, there are times when the walla needs to be intelligible. There are also times when a loop group actor needs to speak an intelligible line.

Design Sound Effects: Sounds that have never existed and would normally not exist in nature, or that are impossible to record in nature. For example, these sounds may be designed to represent futuristic technology, alien beings, mythological creatures or real creatures that no longer exist, like dinosaurs.

Off-screen Sound Effects (which are more of a location than a type): Sound effects that occur, but are not necessarily in synchronization with anything seen on screen, such as an off-screen siren or toilet flush. For example, if one of the characters leaves the living room and comes back into the living room with a glass of water, we would need to hear them out in the kitchen getting the glass, turning on the water, filling the glass and then turning off the water, even though we don't see it on the screen.

THE GREY AREA (FOLEY AND SOUND EFFECTS)

It is the sound supervisor's job to determine if a sound effect is to be provided by the sound effects editor or by a Foley artist. However, it's not uncommon for both Foley artists and sound effects editors to have sounds for the same purpose. For example, a Foley artist may create the sound of a handgun being handled and a sound effects editor may go to their library of sounds for pre-recorded sound effects of a handgun and edit in gun handling sounds. Either of these or perhaps both or parts of both may be used in the final mix. It's always better to have a sound covered twice than have it missing.

A potential issue with the handgun example is that the Foley artist may not have a particular weapon, such as a Smith & Wesson M&P 9, and so they will have to use other guns, metallic objects or pieces of metal to replicate the mechanical handling sounds. This would mean that the sounds are not the realistic ones that would be heard by someone who is familiar with this gun. Since it's a common civilian and police issue handgun, many members of the audience might detect an inaccuracy if the Foley sounds are used in the mix.

The sound effects editor will probably have these sounds in their library or can buy the necessary sound effects needed for the Smith & Wesson M&P 9. They can then build the sound effects into a believable representation of the mechanical handling of the gun.

There are sound effects specialists who are sound editors who have an area of specialty, such as guns, cars or airplanes. If a film has a lot of weapons used in it, a specialty sound editor, who knows what a particular weapon actually sounds like and probably has recordings of that weapon, might be hired to edit all of those sounds.

PRODUCTION SOUND EFFECTS

Production sound effects are the sound effects that were recorded during the production of the film. They are usually separated out of the dialogue track, which is also called the production track, and placed on a separate track from the actual dialogue. This separate track is called a production effects track or PFX track. They can then either be used in the mix, sweetened with additional sounds or be replaced by other sound effects.

LOCATION SOUND EFFECTS

Sound effects recorded wild on location can be hard effects or they can be ambiences. Wild sounds are recorded without a picture. These wild sounds are usually recorded by the production sound team, but could be recorded later by the post-sound team. The important aspect is that they are recorded in the same location as the production. Usually these recordings are of objects, creatures or ambiences that relate to the production and are sounds to be used in post-production.

CUSTOM-RECORDED SOUND EFFECTS

These are custom sound effects that are created for a specific film. These custom effects are recorded when the desired sound couldn't be found in a library or couldn't easily be created from several effects edited together. These sound effects are recorded by either the sound editor, a sound effects recordist or during a Foley session.

FOLEY SOUND EFFECTS

Foley sound effects are those that are created by Foley artists in synchronization with the picture. Since they are performed to a picture, they are tailored to the actions on screen and thereby do not usually require a lot of editing or at least as much editing as library sound effects would.

The sound effects created in a Foley session are those that are more readily recorded within the limits of a Foley stage. Airplanes, explosions and trains are not sound effects that a Foley artist would normally create. They mainly focus on three areas: footsteps, clothing rustle and the handling of small props. The small props may be such sounds as the opening of a champagne bottle, the clanging together of swords or the washing of dishes.

LIBRARY SOUND EFFECTS

These are the pre-recorded sound effects that are usually purchased, but can sometimes be found for free. They can come as a set of CDs, a file collection on a hard drive or as an internet download. They may also be sound effects that you've recorded for your own library.

One of the creative elements that can make a big budget film stand out from a low budget one is that there is often the budget to custom record nearly all the sounds for the major motion picture. However, if you are making a low or no budget film you may have little money to spend, but you probably have more time to spend on the sound. Use that time to custom record as many of the sound effects as you realistically can.

I've used library sounds in big budget movies, but usually only when there is no time or money to go out and record the ones that I would like to use. Also, there are times when it's not practical to custom record a sound effect.

A minor character in the movie, *Finding Forrester*, 2000, was a Connecticut Warbler bird. It's viewed and referred to in one scene, so there needed to be the sound of the bird's call. I knew that the production wouldn't pay for me to fly from the west coast to the east coast to record the call of one little bird, so I searched through all the sound effects and bird-call libraries I had, but could not find a usable call. Since there were fewer resources on the internet back in 2000, I was not able to find a recording of the bird that was clean enough to use in the film. Most of the recordings had a lot of wind or tree noise competing with the bird's call. This led to me calling organizations, such as the Audubon Society and the Cornell Lab of Ornithology, to try to find the sound of the bird. I did eventually get a good recording of the bird's call, but it took a lot of searching.

Some library sound effects are ones that would be difficult to record, like an avalanche, an arctic fox mating call or a submarine travelling at top speed. Other library sounds that are more commonly used are ones like cars, airplanes and weapons.

There is nothing wrong with using library sound effects, but if you want to control all of the sonic elements in a film, you need to try to record all the sounds you'll be using.

SPOTTING

Spotting is the process of going through the film or each reel of the film and noting at what timecode or minute and second a sound effect is needed. If the sound effect is a long one, then note both the beginning and ending timecodes or total minutes and seconds, so you know what length you'll need.

You should note everything. There is nothing worse than getting to a mix and discovering a sound effect or other sound is missing. You need to spot for everything that could make a sound. If it moves, it needs a sound. It doesn't mean you'll use that sound in the final mix, but you need to have the option. You may also want to have alternatives for some of the sounds as you may have to change a sound effect that doesn't work well with the rest of the sounds or the music.

By making a sound rich environment for your film, you are increasing the production value. If you're doing your own sound design, you can reduce the number of tracks and sounds by making proper choices as you spot the film and as you're doing the editing. Whatever you

can do for your film before you get to the mixing stage, the better off you'll be during the mix, especially if you are having the mix done professionally.

CREATING

When you create sound effects for film, you are not necessarily concerned with recording the sound that an object or creature makes in the real world, but with the sound that an audience would expect to hear. Very few people know what the sound of a bullet or knife penetrating a human body sounds like, but there's a visceral or gut sense of what that might sound like. The job of the sound editor is to give the audience the sound they anticipate will accompany the action. The key is to make the sound believable. If it's not believable, then it might distract the audience and momentarily take them out of the story.

The most realistic sound for an underwater volcano erupting is a recording of such a volcano erupting. However, that might be difficult to achieve. This type of big sound has been recorded by a NOAA research team in 2015 and you might be able to acquire that sound, but the sound you get might not give you the dynamic, dense and detailed sound that will support the sound design for the story. You could use the actual low-frequency recording as a foundation for the erupting sounds, but you'll probably have to layer in other sounds to make it come alive for an audience.

Here are a few examples of how to create some usable sound effects.

- *Bats or Birds Flying*: Leather or rubber gloves flapping or an umbrella being opened and closed rapidly. You may have to filter out some of the low frequency to reduce the sound of the gloves or umbrella.
- *Bats Shrieks*: Chicken or kitten sounds can be used if they are pitch shifted up.
- *Elevator Door*: Metal filing cabinet being opened and closed.
- *Lava Bubbling*: Bubbling sound from a large pot of boiling water or pouring water onto a concrete block. You may pitch shift and time stretch the sound to match the action.
- *Mining Car*: Rollercoaster car. If this is at an amusement park, you may need to get permission to go in before the general public to get clean sounds.
- *Robotic Movements and Footsteps*: Printers, DVD players and photocopier sounds are good for robotics.
- *Spaceship Door Opening*: A train door opening, a car hatch opening, even two pieces of paper sliding together can work.

RECORDING

Ideally, sound effects are considered from the beginning. Some of the top directors focus on sound effects from the script stage forward. They know how important sound is to the film and they work to achieve a high level of creativity in the entire soundtrack. It's not uncommon for a big budget production to hire a sound person to start recording sound effects and backgrounds during production. This means that the budget must include funds for someone

to start early in the project. There is no reason why a low or no budget film cannot have someone record sound effects prior to or during production. The sounds that are recorded may help tell the story and shape the film as it's being made.

Sound effects are usually recorded without a picture reference, although you could easily take along the video on a laptop, notebook or even a smartphone, if you want to make sure you have the timing correct. You could even call them location-recorded Foley sound effects, if you're performing them to picture.

A common format for recording sound effects is WAV or BWF, at 48K sampling rate and 24-bit word depth. If you're going to be doing a significant amount of processing, especially pitch shifting, of the sounds you record, then you would be better off recording at 96k or even 192k to maintain the accuracy and quality of the sounds. Most professional sound design effects recording is being done at 24 bit and 96k.

It's the intense processing that requires a higher sample rate. If you increase the sample rate, then you can add equalization, reverb, pitch shifting, time shifting and other processing without introducing any noticeable errors or artifacts into the sounds. Sound designer, Tim Prebble, discusses recording at 96k in an article called *Recording FX at 96k*.

In a nutshell, there are two aspects I find beneficial about recording at high sample rates. Firstly, I am capturing a lot more data than usual. I do all my editing etc. at 24 bit 48k, as that is what the Euphonix mixing desk is natively working at in Park Road Post. But when I am working on creating sounds I am often interested in manipulating them in many ways and having more data to start off with means the artefacts created through manipulation are far less readily apparent. Take a simple pitch shift. I love to hear sounds at half speed and at quarter speed, as it both slows the evolution and envelope of a sound but also adds gravity to it, through lower frequencies becoming more dominant. But at quarter speed you are talking about a two octave pitch shift. Most software I have used starts to sound bad after a one octave shift, simply because at half speed every second sample has to be artificially created, and at quarter speed the artefacts are doubly as bad. BUT with the much denser data stream of 96k I can play at half speed and it sounds as good as my old 24 bit 48k stream did! This is a serious advantage!!! The same benefit applies when you timestretch a sound . . . working at 96k I suddenly discovered plugins working successfully way past the point I would normally avoid. . . .

The other aspect of 96k recording is that even if we can't hear above 20k, that doesn't mean there isn't sound up there. I remember reading a beautiful quote from someone watching a Tui (a bird native to New Zealand) sing, and they noticed that half the time the Tui was singing they couldn't hear what it was singing as it was off the top of the person's hearing range. So presuming I have a microphone that has a higher frequency response than my ears I could record that Tui at 96k, pitch it down an octave and listen . . . see what I mean? The same theory applies to any sound generating object that creates high frequency harmonics, especially metal which is very resonant . . .

> So recording sound effects it makes a lot of sense to record at 96k. Sure it creates twice the amount of data but I now tend to import my recordings into a 96k ProTools session and create pitched versions of the sounds before I output to a 48k session for syncing, cutting etc . . .

Recording and playing back audio at the 24-bit depth level is what you need for a high quality recording. Because 24 bit allows you to record at a lower level, it will give the recording more headroom, which means a greater dynamic range. That said, most films sound very good at 24 bits and 48k.

There are microphones that record outside the normal human hearing range of 20–20kHz. This will allow for the recording of higher frequencies and the subsequent pitching them down to within normal human hearing. You may wind up with some interesting sounds that could be useful additions to your current film or your library. Sound frequencies below 20Hz are referred to as infrasound and those frequencies above the 20,000Hz level are called ultrasound. That said, for most sound recording purposes the microphones that record in the normal hearing range are quite adequate.

In order to easily record sound effects, you'll need a portable recorder and a microphone. The recorder could be a video camera; however, the preamplifiers used to boost the audio signal coming from the microphone are often not of high quality on most cameras. I suggest that you use a decent portable audio recorder. It should be able to record at the minimum of 24 bits and 48k in order to achieve and maintain quality. It should also be able to record .wav or .bwf files. Recording sounds as .mp3 files is not ideal for working with sound effects, especially if you are going to do any processing. MP3 files are designed to have the minimal amount of audio information needed for a listener to believe they are hearing the music or sounds as it was recorded, even though they are not, which is due to the type of compression used.

BWF (.bwf) files contain metadata that can be useful to the picture editor and the sound editors, especially the dialogue editor. The metadata can include timecode stamping, scene, shot and take numbers, recordist's name, channel names, date and time as well as notes and other useful information.

If you are recording a loud sound like a gunshot or door slam, you'll probably have to use a pad on the input. A pad attenuates or reduces the signal level by a specified amount of decibels. A common amount for a pad is –10dB, but there are other options depending on the equipment you use. I've seen –12dB, –15dB, –18dB, –20dB, –30dB and others. It's better to insert a pad after the microphone. Most recorders have pads that can be turned on when you're recording.

If you're recording the sound effects in a studio, similar to a Foley recording session, then you would record to the studio recorder or directly into a DAW (Digital Audio Workstation), such as Pro Tools. There have been times when I have recorded directly into a portable audio recorder I took into a studio. Since I didn't need an engineer, I wore headphones so I could monitor the sound effects I was creating.

The most common type of microphone used to record sound effects is a mono shotgun. Sometimes you may want to record a sound in stereo and if it's a background you may want to record it in surround sound.

At times you may have to go to a location to get the exact sound you need. Let's say you need to record the vocalizations of an orca or killer whale. They produce three types of sounds. They use clicks, whistles and pulsed calls to communicate. One place to record orcas is at a marine park like SeaWorld. Call ahead because you'll need to get permission to record at their facility. They may ask that you have liability insurance to cover any injury that may occur to their staff or the general public, which is caused by your actions. If you want to record a sound that would require you to be on someone's private property, then always get permission before you go. Tell the owner or decision maker what you need to record, how it will be used, how many people will be with you and what equipment and vehicles you may need to take with you.

When you're recording on location, try to isolate each sound so that you can control them later during post-production. Isolated sounds allow you to layer and manipulate them independently. If you need to record the sound of a Ford Mustang starting up, revving the engine, sliding into gear, popping the clutch, tires squealing away and the motor fading in the distance, it's better to record each sound separately and then edit and layer them on the timeline to create the sounds you want. Recording all of those sounds in one continuous recording will not allow much if any room to manipulate them.

Record your location sound effects with as a little extraneous noise as possible. It's great to have a recording of a jet ski as it passes by, but if you can hear birds chirping, people talking on the beach, the wind blowing through the trees and a distant siren, the recording is not very useful. You'll need to find a quieter place and wait for the wind to dissipate. You may think that a location sounds quiet, but there might be a noticeable distant sound or there may be a subtle nearby sound that detracts from the purity of your recording. You have to wear your headphones and you have to pay close attention to everything that you hear to get a good clean recording. I wanted the recording of two trees rubbing together in the wind, but had to wait for the birds to stop and the distant motorcycle to fade away before I could get a good clean recording. However, there was wind in the recording as that's what made the trees rub together.

It's always good practice to record something up close and then record it from a couple of other distances away. This will allow you to place the sound in the environment in which the audience sees it. You may also choose to record something with different microphones or pick-up patterns to get a slightly different sound.

Make sure you record the sound effects at a usable level. If the level is as low as −40dB, then it is not going to be of much use. Try to record near −20dB with highs near −12dB so you have a safe amount of headroom below the −0dB disaster point. This will give you a good recording, with a lower noise floor and will allow you to manipulate the sound with various signal processors.

Library sound effects are great, if you don't have any time or budget to record your own sound effects, but they were not recorded for your film—they're generic. You can use them

and try to make them fit, but it's better to record your own. Recording your own sound effects allows you to build your own library that can serve you from film to film.

LINCOLN'S WATCH

The location sound recordist will have kept a daily sound report of all the sounds and takes that were recorded for the film. These reports will have notes as to when and where any non-synchronized sound was recorded. The report might say that on day five of the shoot, the sound of one of President Lincoln's watches was recorded. If this wasn't done during production, then a sound effects recordist will travel to where the watch is located and record the ticking of the watch, the opening and closing of the cover, the winding of the watch and any other sound that might be made by the watch.

In the movie, *Lincoln*, 2012, one of the pocket watches that had belonged to President Lincoln was recorded at the Kentucky History Society by sound effects recordist, Greg Smith. He put the ticking watch in a lined box that had a small omni-directional Tram lavaliere microphone in it and recorded the ticks that were used in the movie.

EDITING

Editing sound effects is different than editing all the other sounds that are in a film. Dialogue, ADR (Automated Dialogue Replacement), Group, Foley and Music are all recorded in synchronization with the picture, but sound effects including backgrounds are usually recorded wild.

Ideally, you can wait until there is picture lock before you start editing. It's time-consuming to have to adjust all the sound tracks because of a picture change, especially if the changes are made just before a mix. A really smart director will realize this and not make changes in the last few days leading up to the mixing session. I've received a change list the day before a mix, so instead of focusing on making the soundtrack better, I was forced to spend time adjusting the synchronization of the sounds to the new cut of the picture. This requires that you either adjust it by hand-and-eye to match the new picture cut or use specialty software such as Conformalizer, which automatically makes the cuts for you. Whichever one you do, you'll still have to check all of the sound effects to make sure they are in synchronization and you'll have to smooth the sound effects to make sure there are no jumps in the sounds at the new edit points.

Layering

Layering is one very useful aspect of the editing of sound effects. It is a sound creation technique that is used for backgrounds, sound design and sound effects. Layering is the compounding

of sounds to create a new distinct sound. Since you want to be able to control the level and processing for each sound independently, you'll build your layered effects one sound element at a time. If you are creating the sound effect of a motorized drawbridge rising, you might start with a sound of a large electric motor starting up and then add the sound of the motor running continuously until the drawbridge stops. Other layers might include the sound of chains or gears moving. You might then add some metallic scrapes and bangs. Each of these sounds will be on a separate layer or track.

A visual example of what a layered sound effect might look like for the firing of a specialized weapon is shown below.

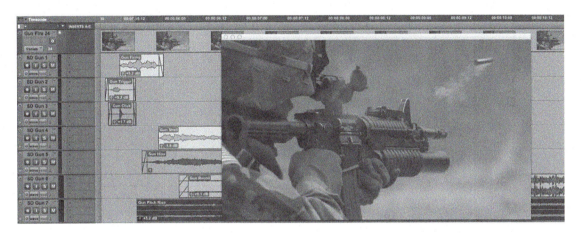

Figure 8.2

As you cut the sound effects, make certain that you have a natural beginning and a natural ending. The sound you need may have an abrupt beginning or ending or it may fade. If it has a fade, ideally, you can let the sound fade out on its own and you'll not have to add a fade to it. If you have to use a fade, make sure it fades in a way that does not draw attention to itself. Sometimes, for timing purposes, you may need to cut out a section of sound somewhere in the middle. It may sound fine with a cut, but it might not, so in order to get it to sound right, you could try a crossfade.

If you are cutting a sound effect in the middle, make sure you cut it at the zero crossing point, which is neither negative nor positive, but at zero. In some software, such as Pro Tools, there is a centerline on a track, which is known as the zero crossing. If you cut at that point, there should be no pop or click, but if you cut above or below the line, you may well have a click. This zero point cutting works better with higher frequencies than with lower ones, as there are fewer crossings of the zero point with lower frequencies. If cutting at the zero point is not an option, you could try a very short crossfade.

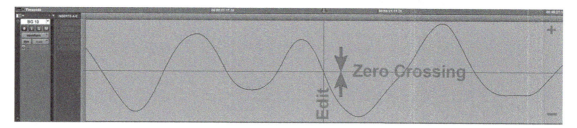

Figure 8.3

When you are editing, try different options. Experimenting with the sounds can make you aware of an option you hadn't thought of, but it may work well. I'm a big fan of serendipity. You never know what happy accident might work.

Pro Tools Automation

If you are using Pro Tools or some other DAW for your mixing, you can tie all of your automation to the audio clips. In Pro Tools, when you select the *Automation Follows Audio* button, whatever automation has been applied to a given clip will stay with that clip no matter where it's relocated in the timeline.

Figure 8.4

The button turns orange when it's turned off. So turn it off when there are times where you don't want the automation to follow the clip. For example, if you're replacing a line of ADR with a different take, you would turn off the automation so that it would remain on the timeline and would then be applied to the new clip. It's a lot easier than losing the automation and having to recreate it, especially if you've applied volume, panning, reverberation and equalization to the clip. This may also apply to a change in a music cue or even the bigger task of having to conform the timeline to a new picture cut.

POV (Point of View)

Usually the POV is that of the main character, the idea being that the sounds the audience hears are those that the main character would hear. The POV can also be the overall viewpoint, which is from a more omniscient position.

If you had a sound design that was focused on the POV of a dog, the sound palette would be very different from that of a human. Any Foley footsteps of people would be a bit louder as the dog is closer to their feet. Any other sound that comes from down low, near foot level, would be louder for a dog. Also, the dog wouldn't understand the dialogue, except a few command words and it would be able to hear sounds far above what humans hear. Dogs hear between 64Hz and 44kHz, so there would be some missing low-frequency sound and twice the high ones.

Cutting for Perspective

The first shot of a scene is often the establishing shot, which is usually a wide shot showing the environment where the scene takes place. After the establishing shot, the editing could change to another type of shot, such as a close-up.

When you are editing sound and the shot changes from one distinct perspective to another one, you'll need to allow for the volume level to change too. If you are mixing the film as you edit, then you could do that volume change in the timeline as you go.

If you are taking the session to a rerecording studio, they may want the sounds cut for perspective. They would want the distant sounds on one track and the closer sounds on another. This will allow the mixer to set the levels for the distant shot and the closer shot and keep moving forward to the rest of the scene. It's one way of keeping the mix moving and thereby saving money. If you're doing a premix, you could set the levels for both shoots and keep them on the same track. It would be just a matter of dropping and raising the volume automation as the scene progresses.

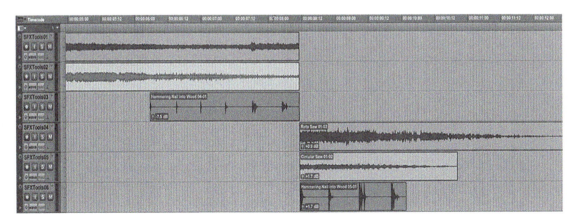

Figure 8.5

PROCESSING

Processing means the use of filters to alter the sound in some way. Reverse, pitch shift, time shift, equalization, reverberation, flanger and vocoders are some examples of filters. This is where you can put your imagination to the test. Processing allows you to manipulate sounds in order to create the sound that's in your head.

Figure 8.6

Some processing can be done simply by sampling a sound and then playing it on a keyboard. This allows for a sound to actually be played like music.

For one of the knife stab sounds that I used in the movie *Psycho*, 1998, I processed it by shifting the pitch. I didn't want to match the pitch of the music. This would have caused the knife stabs to blend in with the music. Thereby, the music would have masked some of the intensity of the knife stabs. I wanted them both to stand out separately.

Techniques

Some of the more common tools used in creating and processing sound effects for film are:

- *Echo*: One or more delayed sounds are repeated from the original sound. To be perceived as echo, the delay has to be enough to hear the initial sound being repeated distinctly. Echo is defined by the distinct repetitions of a sound occurring after 30 milliseconds.
- *Reverberation (Reverb)*: When large numbers of delayed sounds are mixed over several seconds, the combined sound is like being in a large room. The initial sound bounces off

the various surfaces in a room and then reflects them into your ear. These reflected sounds are short in duration. Reverberation is characterized as random and blended repetitions of a sound occurring within 30 milliseconds after the original sound is made.

- *Flanger*: This is when a copy of a sound is added to the original sound with a constantly varying short delay. The sound is split in two with part of it being filtered with an all-pass filter to produce a phase shift, and the other part being left unfiltered. The two parts are then mixed together. The voice of C-3PO from *Star Wars* is a good example of this filtering technique.
- *Chorus*: This is when a delayed signal is added to the original signal. The variable times of a delay affect the pitch by lowering and raising it. The longer the delay, the lower the pitch. This pitch shifting can be used to create harmonics with the original sound.
- *Equalization (EQ)*: Different frequencies are cut (attenuated) or boosted (amplified) to produce the desired group of frequencies. You can create the sound of a telephone by cutting some of the low frequencies and boosting some of the higher ones.
- *Pitch Shifting*: This is when you shift the pitch of a sound either up or down. This can be used to make a dog growl sound like a dinosaur.
- *Time Stretching*: This is the process of changing the speed of a sound by making it slower or faster. This is usually done without affecting its pitch, but the two can be done together.
- *Sampling and Synthesizing*: Synthesizing is creating sounds electronically, while sampling is manipulating recorded sounds. Some people believe that synthesizers produce less realistic sound effects, but they can be used to augment organic sounds. Samplers are great for taking an organic sound and changing its pitch by playing the sound on a keyboard.

EXERCISE

The key to creating really good sound effects is your imagination. A roller coaster needs to sound like an audience's *idea* of a roller coaster, but you don't have to record a roller coaster to convince them, especially if you live hundreds of miles away from the nearest roller coaster. If you have something that will work equally well or better, use it.

This exercise is about creating the sound of a roller coaster passing by the listener. Use your imagination to discover sounds that might work together to create the roller coaster sound. For example, you might start with a train, thunder, wind, winter tires on pavement and appropriate screams. Blend the sounds together, pitch shift or time stretch some of them until you are convinced you are hearing a roller coaster. Now add stereo panning and some Doppler effect to give the sounds the sense of passing by. If it's not quite realistic, then add other sounds and tweak them. The approach is similar to doing sound design, except that you are creating the sound for something that actually exists.

Foley

Who or What is Foley?

Jack Donovan Foley

Figure 9.1

FOLEY HISTORY

The history of Foley began with a man named Jack Foley who worked at Universal Studios in Hollywood. Talkies were making a big hit in cinemas in the late 1920s, so Universal decided to turn their silent movie, the musical, *Show Boat*, 1929, into a talkie. Yes, I'm not kidding, it was shot as a silent musical. The producers asked Jack Foley if he could add some sound effects to the movie, so he took on the job. Many of the techniques he created are still in use today. Primarily, he added sound effects, footsteps and clothes rustle to this and other movies. So, because of Jack, we call it Foley and it's spelled with a capital "F." But Jack didn't call it Foley; he called it sound effects. It didn't take on his name until other studios decided to "add those sounds Jack Foley is doing over at Universal." Desilu Studios was the first to call their newly built sound effects stage a Foley stage.

Jack performed his Foley to picture on 10-minute reels. If there was a noticeable mistake, then he would have to start all over again until there was a good 10-minute take. There was no

stopping and starting again in those days; it was all 10 minutes or nothing. Jack performed his sound effects in a closed in space on one side of Universal's stage 10, while the other side of the stage was used by a 40-piece orchestra to perform the music to the film.

The main reason for creating Foley sound effects is to augment the production soundtrack and thereby to create a more realistic soundscape. During production the sound crew are concerned with getting the dialogue, not someone's footsteps, clothing movements or prop handing. So, all the other sounds have to be added in post-production. This is especially true when it comes to lines that require ADR (Automated Dialogue Replacement) or for foreign versions of the film. Since the production track dialogue will not be in the mix, any footsteps, cloth movements and specific sound effects must be added under the new dialogue lines.

A low or no budget film can be made to sound more professional by adding Foley sound effects. However, if the production dialogue wasn't recorded well then even Foley can't save it.

Foley is not so much a mechanical operation as it is a sound art form, which is performed by artists. It requires thought, planning and creative performance in order to customize the sound effects to the scene, characters and the film in general.

OVERVIEW

Foley can make your film sound like a much bigger budget production. The more time and effort you put into the Foley sounds the greater the production value for your film. Most of the low and no budget films I've seen lack a full and deep soundtrack. A big part of improving the soundtrack is adding Foley.

Ideally no one will ever know you added Foley to the soundtrack, it'll just naturally be there. Foley artist, Philip Chatterton tells of one experience he had in doing Foley for a film.

Foley is the art of not being heard. If you can tell it's Foley then it's not very good! I performed Foley for a film called *First Degree*, 1995 starring Rob Lowe. There was a critical scene in which the police detective, played by Lowe, discovers the widow who he has fallen in love with is the killer. The scene had no dialogue and began with an overhead shot of his small apartment slowly descending to eye level. The detective discovers a photo album and realizes an important clue, which changes the film's direction. I remember we worked very hard on that scene because there was so little that was happening, every subtle action was noticeable. When it came time for the final sound, the film mixer called me in to show me the scene. I watched it gobsmacked! When he stopped the playback I asked why he hadn't used a single bit of our Foley? I explained how hard we had worked on the scene and how it took several hours for just 3 minutes of the reel. He laughed and said, "Buddy that was all you!" It seems the scene was shot MOS and had no production track. Wow, I literally fooled myself. I think that this is the art of Foley.

Philip Chatterton M.P.S.E., Foley Artist

The three areas of Foley are footsteps, moves and specifics.

Footsteps are the sounds of feet falling upon various surfaces. Usually the feet are inside a shoe, but they may be barefoot or wearing skis. Whatever is needed to make the sound that matches the feet on screen is used. Walking footsteps is where the term Foley Walker came from; however, most people who do Foley prefer to be called Foley Artists.

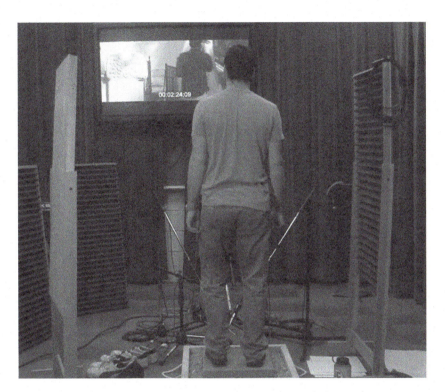

Figure 9.2

Moves, also called cloth or clothes rustle, refers to the sound garments make when an actor is moving in them. This could be a three-piece suit, battle armor, a diving suit or a wedding dress, to name a few.

If you are wearing long pants and you walk a few steps, you'll notice that your pants rub together and make a distinctive clothing rustle sound. Different types of material make different sounds when rubbed. You cannot use wool to make a silk clothing sound and nylon doesn't sound like cotton.

Types of moves include actions like putting on a pair of gloves, tying shoes or taking off a hat. These simple and natural clothing sounds bring life to a film soundtrack.

Figure 9.3

Specifics, which include hand pats, are sounds that actors make by touching or interacting with something. They commonly touch something with their hands, but other parts of the body come in contact with objects too. The actor could be dismantling a pistol, wrapping a present, stirring a teacup, kicking a ball or cleaning a window. All of these sounds would be considered specifics.

Figure 9.4

The Foley artists watch a screen or monitor that displays the scene to which they will perform the Foley moves. Watching the screen allows them to perform in synchronization with the action. They perform actions, which include walking, running, fighting, dressing, handling props, sitting in a chair, shuffling cards, peeling an apple, stirring a tea cup, breaking objects and more.

What Foley artists do on a film varies from film to film. Foley crews may do a lot on a film that delves into the sound effects area, while other times they do what is considered to be traditional Foley.

Traditionally Foley includes:

- Footsteps for the main characters
- Footsteps for background characters
- Cloth pass for any clothing that moves
- Prop handling of books, guns, glasses, plates, doorknobs, and so on
- Hands touching or rubbing things such as skin, surfaces, and so on
- Grabs and pats of cloth, skin, suitcase, doors, telephones, knives and other objects
- Human contacts such as kissing, hugging, scratching, hitting, and so on.

The above is what is traditionally recorded or "shot" in the most basic of Foley passes, especially in dramatic films where those Foley sounds are much of what are required for sound effects.

The Foley artist and the SFX editor often work together to create a complete sound effect. The Foley artist performs the "naturally occurring" sound elements while the SFX editor adds the sound effects that are beyond what can be created in a Foley session.

Beyond the traditional Foley sounds are those that are in the grey area between Foley and sound effects or are outright sound effects. The grey area would be where the sound editor may cut in an effect and the Foley artist may perform the same type of sound effect. Usually only one of these is used in the mix, but they could be layered together.

> In the title sequence of the film, *Finding Forrester*, 2000, there is shot of a hot dog cart being pushed down the street. I edited the various sound effects of the cart as it bumped and clanged down the street, but Foley also recorded sounds for this shot. My sounds came from various sources and Foley performed theirs to the action using various objects from their collection. I don't know which sounds were actually used in the mix, but we both covered the sounds. So, the sounds for the cart were in one of those grey areas between Foley and sound effects.

In some films, the Foley artists may help the sound designers or sound editors by performing sounds that may have taken a long time to edit into a sound effects track using library effects. For example, it could be a lot of work finding the right sounds and then editing them into the tracks to create the sounds of a microwave oven tumbling down a hillside, but Foley could do it much faster and in picture synchronization on the stage.

SPOTTING AND CUEING

As with other areas of post-production sound, you start by going over the film and spotting where sounds are needed. Using timecode or minutes and seconds, you need to note at what times to place footsteps, cloth moves, hand props, special props and even custom effects. I suggest that you start with spotting footsteps and then move on to specifics. Cloth moves do not require frame accurate synchronization. It's hard to tell if a wedding dress swooshing down some stairs is a frame or two off.

If you are working with someone who is editing sound effects or if there is a supervising sound editor, then you need to meet with them and determine whether the Foley artists or sound effects editors are going to cover a needed sound. Even though Foley and sound effects sometimes work in that grey area that could be the responsibility of both, it's a waste of time and money to have both provide the same sounds unless those sounds are being combined together. Sound effects may record their own custom sounds or they may use sounds from a sound effects library. These may be used with Foley sounds to create a more detailed or specific type of sound or they may be recorded in place of performing them in a Foley session.

If you are working on a low budget film, where there isn't enough money to have full Foley coverage, then you need to decide on what actions to cover, and what actions not to cover. If you are up against a deadline, there may not be enough time to physically perform everything on your spotting list, so select what's going to be noticed by an audience, if it's not already in the soundtrack.

If you are spotting a scene that doesn't have dialogue, you may not need to spot it for Foley at all, or at least for footsteps. Listen to the production track and if the footsteps are recorded well, then there is no need to record Foley footsteps, even if the film is going to have a foreign release. One issue to look out for is if the scene has been edited in a way that the footsteps are not in synchronization from cut to cut. You'll need to do some tricky editing or do Foley footsteps in order to replace the out-of-synchronization footsteps with ones that sound like they are in synchronization with the picture.

You'll have to listen to the dialogue-free scene to judge cloth and props handling sound levels to determine if they need to be replaced too. You may just need to do some sweetening to some of the sounds. Sweetening is when the original production sounds are used in the mix and sound effects are added to them. These layered sounds are designed to enhance the original recording.

Once you have spotted which sounds need to go where, you can prepare for a recording session by cueing the film. Cueing is actually determining what sounds go on to which tracks.

You may choose to do your spotting and cueing on paper or you could use a tool that may be in your sound editing software. That tool is making dummy sound files that have been given the name of the Foley sound needing to be recorded. Pro Tools allows you to select an area where a sound would occur and then to "consolidate" that area. This turns the selected area

into a dummy file. The dummy file, "King Kong's footsteps," could be named *KKFeetSand*. King Kong's love interest is Anne Darrow. Her dummy Foley footsteps might be labeled *AnneBoots-Sand*. This would tell the Foley artist what shoes to wear and on what surface to walk, which in this case is boots and sand.

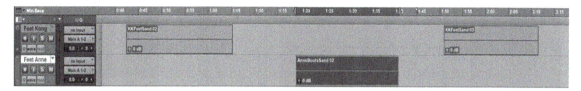

Figure 9.5

If it's a feature film that has several reels to it, then make sure you make the tracks identical for each reel. For instance, if you have a main character named Brown and his footsteps are on the first track and another main character named Green and her footsteps are on the second track, keep the order the same for every reel. Even if you are mixing the film yourself, keep them the same so you can concentrate on the mixing, not trying to find out where a character's footsteps' tracks are located. An exception would be if a character moves from one surface to another. You may elect to put the footsteps from the second surface on the track immediately below or next to the track for the first surface.

When you are creating the dummy files, having the surfaces on two different tracks will help the Foley artist by not making them try to jump across a pit or two to get to the right surface. If you desire to, you can move the two takes to the same track in editing.

I was one of the Foley artists on a big budget short film called *Ritzville*, 1981, which was supported by Paramount Pictures. We recorded the Foley on the old Desilu Studio's Foley stage. The pits on this stage were quite large and I chose to do the footsteps for a scene in which one of the characters walked rapidly from concrete to grass up a flight of concrete stairs and back to grass. I was just able to do it in one continuous take, but it would have been easier to do the concrete in one take and then go back and do the grass in another take. The editor could then put the character's concrete footsteps on one track and the character's grass footsteps on the track below it or perhaps combine them seamlessly onto one track.

Once you have cued the main characters, it's time to move on to the background characters. Background characters are not identified by name like main characters, but are identified

by some visual characteristic that tells the Foley artist who they should be performing. You might have background characters such as "short man, red hat," "woman blue shorts" or "balloon boy." If there are a lot of characters on screen, just cue the ones that are in the foreground.

SYNCHRONIZED RECORDING

Professional Foley Stage

Once you've completed spotting where sounds are needed, it's time to gather the clothes, shoes, surfaces and props you'll need to record or "shoot" the Foley. If you can afford to use a Foley stage, it's a better option, as they are whisper quiet and will have many built-in surfaces to walk on. These surfaces are called "pits." They are usually either square or rectangular and contain substances such as concrete, carpet, linoleum, hardwood, sand, gravel, asphalt, dirt, grass (try synthetic Easter grass), marble, cobblestone, steel and brick. There is usually a water pit too. The water tends to be a bit messy to work with and may take some experimenting to get the right sound.

The pits are built into the floor of the Foley stage. Sometimes these pits are several feet or about one 1 meter deep. This reduces vibrations and adds an authenticity to the sound of the surfaces. A concrete paver that is only a couple of inches thick or about 5 centimeters will have a different sound than a concrete pit that is 3 feet or 1 meter deep. The paver will sound a bit hollow in comparison.

Snow can be created using shaved or finely crushed ice, chunky salt, like rock salt, or cornstarch. I prefer corn starch, but only when it's in a leather pouch otherwise the Foley stage gets cloudy with cornstarch dust. I use an old leather purse filled with cornstarch and then taped shut with duct tape. I perform the "footsteps" by holding the purse in both of my hands and squeezing it. This produces a very realistic sounding snow crunch. If the snow in the scene has a frozen look, you can try crushed ice or rock salt to get the right crunch sound.

It's also easier to adjust the sound of the room in a studio. Most studios have panels of sound-absorbing and sound-reflecting surfaces that can be positioned in order to approximate the size, ambience and type of room that the Foley scene was shot in. Some studios have two Foley stages, one for interior Foley and one for exterior Foley. The exterior stage would be great for recording Foley for a war film and the interior stage would be more for a standard drama, which some Foley artists refer to as a "walk and talk" film.

Studios have a wide variety of microphones that can be used for recording. This will allow the Foley mixer or Foley artist to select the type of microphone that will work best for their performance, the perspective of the scene and for the acoustics of the room they are performing in.

It's common for most Foley stages to be equipped with two microphone stands with microphones on each. You can then experiment with where to place each one to get a good balance of sound that will match the location the scene takes place in and the distance

the actor is from the camera. Having a second microphone and placing it behind and slightly higher allows the Foley mixer to choose the better-sounding angle or to mix both microphones together.

A typical setup is for there to be a directional microphone for close micing and a large diaphragm microphone to the room tone. These two can be mixed together during the Foley recording to make the recording more or less present sounding. The general rule is that when the scene is an interior, you place the microphone loosely so it picks up some of the room tone and when the scene is an exterior, you place the microphone tightly so there is a more present sound and the room tone is reduced.

Some Foley artists and mixers use three or more microphones for recording Foley. They may set up two directional microphones to record the actual Foley and a third one that records the room in general. The two directional microphones are usually spaced one behind the other by about 2–3 feet or .6–1 meter. They may also be spaced near each other, but one of them is placed slightly off-axis to pick up more of the room tone. Remember the 3 to 1 Rule when placing the microphones near each other. For whatever distance the first microphone is away from the sound source, the second microphone needs to be three times that distance away from the first microphone. This rule also applies to reflective surfaces, which can act as a second microphone and cause phase cancellation to some of the frequencies just like the second microphone can.

Using all of these microphones allows for the Foley sounds to be placed in the scene's environment or location by choosing the most appropriate close recording and then adding a bit of the general room microphone in order to get the sound to sit properly in the scene's room. This can be done either while recording the Foley or during the mix. If you are not familiar with doing it during the recording of the Foley, then it's better to mix the microphones during the film mix. If you only use one of the microphones in the mix, then the 3 to 1 Rule doesn't apply, as it refers to using more than one microphone.

The reason for having all these microphones is to match the perspective of the shot. The perspective is how close or far away a character is to the camera. If they are farther away, you may want to move a microphone farther away, say a foot or two, around .3–.6 meters, to make it sound appropriate. You'll have to experiment with the distance to get it right.

The *inverse square law* ($1/r^2$) is also an important aspect of recording Foley. It states that for each doubling of the distance from a sound source, the sound pressure level will be lowered by 6dB. For example: Let's say a Foley artist hits a car door with a sledgehammer and it causes a 70dB signal into the first microphone, which is 3 feet or 1 meter away from the car door. If the second microphone is 6 feet or 2 meters away from the car door, then it will pick up a 62dB signal, 6dB less, and the third microphone, which is doubled in distance to 12 feet or 4 meters away, will pick up a 56dB signal. Thus, for every doubling of distance the level drops by 6dB. The inverse square law would more appropriately be called the inverse distance law. What this law means for the Foley artist is that you can control the sound level by adjusting your distance from the microphones or by having two or more microphones at various distances from the sound source.

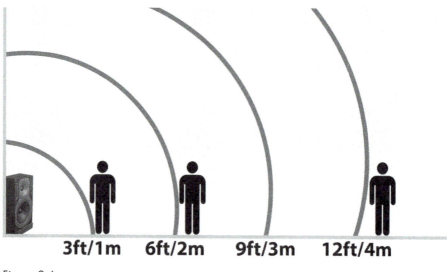

3ft/1m 6ft/2m 9ft/3m 12ft/4m

Figure 9.6

If you are recording Foley "flat," without EQ (Equalization), reverberation and no perspective microphone placement, then it needs to be recorded well and with a strong signal. Since this method usually requires only one microphone, it's harder to place the sounds into a scene. That means that properly placing it into a scene will be done by either the Foley editor or the rerecording mixer during the final mix where EQ and reverberation can be used to tailor the sound. If you are doing your own mixing, then you can record with one microphone, by placing it about 2–3 feet or .6–1 meter away from the sound source and then adjust the distance until the sound matches what you see on screen in terms of hearing the Foley at the right perspective.

Instead of moving the microphone away from the sound source, you could try keeping the single microphone at about 2–3 feet or .6–1 meter away and position the microphone so it's not pointing directly at the sound source. This off-axis positioning should not be more than 15 degrees from the sound source. This will cut down on some of the really present frequencies that make the Foley sound like it's too close and too detailed, while also picking up more of the room sound. You'll still need to overperform it so you get a good recording. You can overperform by trying to make each sound much louder than it really is in life. In the mix, it will be brought down in volume to match the scene.

When you're recording really delicate sounds, you may position the microphone only inches or centimeters away from the sounds source.

Footsteps are not generally quiet Foley sounds, so start by positioning the microphone 3–5 feet or 1–2 meters away, depending on the surface, the shoes and the sound level of the character's footsteps as suggested by their proximity to the camera. Is the shot a close-up, medium shot or wide shot or some other framing?

Generally, when a character is walking barefoot on carpet, there isn't a need to do footsteps; however, if there's a close-up of their feet or everything else is very quiet, you might want to add Foley footsteps to these scenes.

Moves recordings are quieter sounds, so start with the microphone about 2–3 feet or .6–1 meter, away from the cloth you are using and then adjust according to what gives a good recording level.

Specifics can run the range from quiet to loud, so you'll have to decide the proper distance by what type of sound it is that you are Foleying. You could start at the 2–3 feet or .6 to 1 meter distance and then adjust from there.

Temporary Foley Stage

If you can't afford to pay for a Foley stage, you can still record very worthwhile Foley. Most of the common surface sounds can be reasonably replicated without a pit. Most home improvement stores will have most of the surfaces you'll need. For example, concrete pavers are usually a couple of inches or 5 centimeters thick and about 16 × 16 inches or 40 × 40 centimeters. It's not much space to walk on, but you could use two, three or four to give you more walking room. Place the concrete on top of a carpet remnant and you've got a pit. A bag of pea gravel, a bag of soil and a bag of sand are all available at your local hardware store. Don't use potting soil, as it usually contains organic matter in it that can smell and besides it's too soft to sound much like dirt. The hardware store may also have self-adhesive linoleum tiles, ceramic tiles, marble, brick, pavers and small sheets of steel. These can be poured into or attached to the pits described below.

If you want to build low cost pits, then you can buy a ½ inch thick 8 feet × 4 feet or 1.2 centimeters thick 1.2 × 2.4 meter sheet of plywood and cut it into 8 equal 2 × 2 feet or .6 × .6 meter squares. Attach 2 × 4 inch × 2 feet or 5 centimeters × 10 centimeters × .6 meter boards to all four edges of each 2 × 2 feet piece of plywood and you have a box. You may want to seal the seams on the inside of the box with a latex or silicon caulk. This will help keep the loose materials like sand and dirt from leaking out.

Figure 9.7

These homemade pits are not perfect, but they are adequate. The key to using them is to find ways of reducing the wood sound of the pit itself. Putting the pit on thick carpet or a folded blanket can reduce the wood sound somewhat. Alternately, you could build the pits onto a basement or garage floor or anywhere where the floor is solid cement or tile-type material. You would still build the 2 × 2 feet boxes, but without the plywood bottom. If you can attach it to the wall it will help keep it from moving. Once in place, use caulk to line the inside edges of each box to the floor. This will keep materials from leaking out. Now fill the pits with the various materials and surfaces. The deeper the better with materials like sand and dirt as this makes for a more realistic sound. Remember, you may have to dismantle all of this, so don't make it too deep. In order to have deeper pits, you may choose to use 2 × 6 inch boards to make the frames.

If you need to record water Foley, then a small hard plastic kids' swimming pool may work for your needs. Don't fill the pool too full; it doesn't take a lot of water to make most water Foley. The main issue with using a pool is the splash sound you get from water hitting the sides. You'll have to be careful to avoid any unwanted splashes. You could try draping towels around the edge of the pool to dampen the splashes. Once you've completed your water Foley, you can bail the water out bucket by bucket or use a water pump and a hose to move it outside or to a drain.

Once you have built your pits, you may want to put them in a functional working order. Usually the exterior pits go next to each other and the interior pits go next to other interior pits.

The key to recording Foley outside of a studio is to find a room that is very quiet and has only a few hard surfaces. A bedroom could work well for the studio, if there's carpet on the floor and curtains on the windows. You could then add some blankets or sheets of foam, like those used on bed mattresses, to the walls. These could be leaned against or gaffer taped to the wall. Be careful not to pull off the paint when you remove the tape. The important thing to do is to reduce the amount of reflections you hear from sound bouncing around the room. The more dead the room is the better it is for recording, unless you need the sound of Foley in a very reflective or "live" room. A truly dead room would have no reflective sounds and a very low noise floor. The noise floor is what you hear in a sound system or recording when there are no other sounds being made in the room.

One common problem with recording outside of a studio is the noise floor, which can be created by objects like a furnace, refrigerator, air conditioner, outside traffic, wind or a fan. Ideally, you can turn the noisemakers inside the building off, so they are quiet. The traffic and wind may require a heavy blanket over the window to reduce the noise. If you turn off the refrigerator, put your car keys in it, so you remember to turn it on when you next need to drive somewhere, which hopefully isn't too long after your recording session. The other type of noise floor is caused by the actual electronic noise that's inherent in a sound system. This noise could be caused by the microphone preamplifiers, A/D (Analogue to Digital) converters, microphone circuitry, faders or some other part of the signal flow.

When recording Foley remember that you need to make the sounds bigger than life. This allows for a better recording and keeps the acoustic noise floor down. If you're layering Foley sound effects, then each layer will have the noise floor in it, so if you use three different Foley recordings to make a gun sound, each of those layers will add another level of noise floor, so the noise floor could become three times as loud.

If you're not recording Foley on a Foley stage, you will have to find the best position for the microphone or microphones. If the noise floor is high, you may have to put the microphone closer to the walking surfaces, cloth or prop than would be normal. This will make the sounds a bit harsh and probably not as realistic as the scene might call for, but it will keep the noise floor lower. It's a trade-off for not being able to record in an acoustically treated and thereby quiet room or stage.

If the room you are recording Foley in is small and fairly reflective, you may want to use a large diaphragm condenser microphone with a cardioid pick-up pattern instead of a shotgun. Most shotgun microphones have a hard time handling reflections in a small room with hard surfaces. They also tend to pick up sounds from behind them because some also have a rear lobe that picks up sound from the rear of the microphone.

In order to reduce low-end rumble, vibration from the surface being walked upon, or the street vibration next to your recording location, you can place the microphone stand on top of a sofa cushion, yoga mat or other such cushioning objects. You would also be wise to use a high-pass filter for low-end roll-off, if the microphone has one. This built in equalization will reduce low-frequency sounds like those from a truck passing by. The amount of roll-off and the frequency at which the roll-off starts will vary from microphone to microphone. The microphone you use may have built into it a −10dB at 100Hz, −18dB at 120Hz, −20dB at 50Hz or something similar.

The roll-off filter will have a flat line for no roll-off and a bent line for roll-off that looks something like this image.

Figure 9.8

Most audio recorders have a roll off switch built into them. They are usually located near the microphone inputs or by the faders.

Before you push the big red button and start recording, you'll want to set up your recording session. If you are planning on doing some processing to some of your Foley recordings, you may want to set your sample rate to 192kHz or at least 96kHz, if 192kHz is not an option. For example, you may want to drop the pitch of a sound without getting noisy artifacts such

as aliasing added into it. The higher resolutions of the 96k and 192k sample rates will allow you to manipulate the sound without noticeable quality loss. If you're not planning on doing any major sound manipulations, then the standard 48k sample rate will work fine. The bit rate should be 24 bits or more. The most common format is BWF (Broadcast Wave Format) or .bwf.

Basic Equipment

You'll need a way to record the Foley, using an audio recorder, video camera or video recorder or a computer with media recording software. You'll need at least one microphone. You may need a way to amplify the microphone signal and possibly an I/O (Input and Output) box for your computer input. You'll want a way for the Foley artist to be able to watch the scene on a monitor. You'll also want a way in which to talk with the Foley artist if you're in a separate control room. Most consoles have a talkback system that allows you to communicate to the talent. If you are in the same room, that won't be an issue.

To keep equipment costs down you might consider buying a USB interface that allows you to plug a standard microphone directly into your computer. There are some interfaces that have built-in preamplifiers to power the microphone signal. Some have microphone volume controls as well as headphone volume controls. Whatever you do, make sure the interface has zero latency or you'll be hearing the sounds a bit later than they are actually performed. This could be really problematic when you are trying to record Foley to picture in synchronization. Even though you could use a USB microphone, you need to realize that they are not really designed well for Foley recording.

Recording Foley Outside

Some people have tried recording exterior scene Foley outside. They may record at the exact location at which the scene was shot or one that sounds like the exact location. The main issue with doing this is the noise floor or ambience. If you're going to layer several sounds recorded at the location together, then you'll have several layers of ambience too. A light breeze in the trees becomes doubled with two layers and tripled with three layers of Foley.

If you are just recording the footsteps or maybe a few of the specifics at the location and then you layer other sounds that were recorded on the Foley stage with those, then there wouldn't be as much of an issue with multiple ambiences.

Recording with EQ

Whether you are recording on a Foley stage or in your home, you may want to use some EQ on the recording. This can help reduce the low-end rumbles and the very bright high-ends. As mentioned earlier, some microphones have roll-off switches to reduce low frequencies and some even have high-frequency roll-off switches. Below is an example of what an EQ setting might look like.

Figure 9.9

Many Foley mixers will not record with any equalization. They leave that to the Foley editor or rerecording mixer.

Recording with Software

If you are using a computer and video or audio editing software to record your Foley, you may be able to put the system into loop record. This will allow the Foley artist to watch and perform to a scene as it is automatically being repeated on screen. This is useful if the actions are difficult to follow as it allows the Foley artist to get in the rhythm of the action until they get it right.

It could be helpful to the person performing the Foley to have equally spaced three countdown beeps ahead of the starting point for the recording. This could help them find the rhythm. The classic three beeps are 1k tones that are 1 frame in duration and separated by 16 frames each. The record in point will be 16 frames after the last beep. Some engineers are using 24-frame separated beeps and others are using 1 second separations between beeps. The choice is yours. Just be consistent. Instead of beeps, streamers generated by specialized software can be used. A Streamer is a diagonal line running left to right across the picture. The actor starts speaking once the line reaches the right side of the screen.

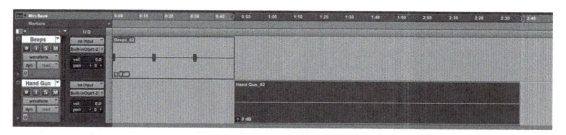

Figure 9.10

When recording into Pro Tools or any other video or audio software, it's important that the edited production track or "work track" be imported along with the video into the timeline. It's then available for the Foley artist, should they want to hear some part of the track, to help determine what a surface might be, what type of shoes to wear or discover other information that will be useful. This track is usually muted until the Foley artist wants to hear it.

If you're recording into a camera, you can shoot the video monitor, the Foley artist is watching, along with the Foley artist to give you a visual cue for synchronizing the Foley sounds you're recording with the picture. If you are recording to a portable audio recorder, which is more of a sound editor's approach to sound effects than a Foley mixer's, you'll need to keep good notes as to what each sound is and at what point or timecode in the film the sound occurs. It's common practice to slate each take with the information you'll need for editing the sounds. I usually describe the scene or give the scene number and then tell what the sound is going to be used for. For example, I'll say, "scene four, Butch hammering nail." Then I would record a variety of a hammer and nail hits. Since you don't have any picture to watch when you do this, you need to vocally identify the sounds. If you want the sounds to be close to synchronization, then you could play the video on a laptop, smartphone, tablet or other device that can play video. That way you only have to find the starting synchronization and the other sounds for that take should line up closely.

MICROPHONES

The type of microphone you use depends on the acoustics of the room you are recording in, the perspective of the sound in the scene, as well as the location of the scene for which you are doing the Foley. The ideal Foley stage has the ability to be very dead or to be more lively just by adding and arranging sound-absorbing material or sound reflective material. These materials can be used to come close to replicating the sound of the room or exterior location the scene occurs in. The key is to record the Foley sound in a way that it can be easily fitted into the mix with as little EQ or reverberating added as is possible.

If you were recording Foley in your apartment, you would probably use both a large diaphragm condenser cardioid and a hyper-cardioid microphone depending on what types of sound you were recording. The hyper-cardioid will normally do a better job of rejecting off-axis sounds, like your neighbor's television. A super-cardioid could work too, but the issue is that

nearly all of them are designed with an interference tube, which can have a hard time cancelling out reflective sounds. If you are recording in a room that has some significant reflections in it, you may be better off using a cardioid microphone for everything.

A large diaphragm microphone cardioid like a Neumann U87 or a Rode NT1A may work well for some sounds, like a heavy body fall, a slap in the face, a punch in the stomach or a similar intense sound, whereas a smaller diaphragm microphone like a Neumann KMR-81i or a Sennheiser MKH 50 might be a better choice for footsteps. It's good to have one of each type of microphone to find out which one works well in the room you have chosen to record your Foley in.

As for the microphone pick-up patterns, hyper-cardioid, super-cardioid and cardioid microphones, all are unidirectional and have their places in Foley recording. I suggest putting some sort of baffling or sound deadening material behind a hyper-cardioid, or shotgun when the room you are recording in is not acoustically treated. The rear lobe on these microphones will pick up reflections from behind. Some have rear lobes that are more significant than others. It depends on the make and model.

If you are recording in a dead room, then you might get away with a shotgun microphone, which is different from the others because it has an interference tube in it. Interference tubes are designed to cancel out various frequencies based upon the length of the tubes. The longer the tube, the lower the frequencies that can be cancelled out. When you use a shotgun, which is a hyper-cardioid or super-cardioid with the interference tube, for exterior recording the interference tube does a great job of rejecting off-axis sound, but on interiors, it has a hard time with low frequencies, which bounce around the room. If you are using the shotgun in a fairly reflective room, its rear lobe will pick up reflection that will give the overall sound a hollow or bathroom type sound. This is when you should try a cardioid microphone, which doesn't have a rear lobe or an interference tube.

There are many worthy microphones that can be used for Foley and here is a list of some of the microphones that are commonly used to record Foley. The order of the list is roughly from the most expensive at the top, to least expansive at the bottom.

- Neumann U87 large diaphragm condenser—cardioid, omni and Figure-8
- Schoeps CMIT 5U super-cardioid—interference tube
- Schoeps MK41 super-cardioid
- Neumann KMR-81i super-cardioid—interference tube
- Sennheiser MKH 60 super-cardioid—interference tube
- Sanken CS-3E super-cardioid—semi-interference tube
- Sennheiser MKH 8060 super-cardioid—interference tube
- Sennheiser MKH 40 wide angle cardioid
- Sennheiser MKH 50 super-cardioid
- Sennheiser MKH 8040 cardioid
- Sennheiser MKH 8050 super-cardioid
- AKG C414 large diaphragm condenser—multiple pick-up patterns
- Neumann TLM 103 large diaphragm condenser—cardioid
- Sennheiser MKH 416 super-cardioid—interference tube

- Neumann KM 185 hyper-cardioid
- Audio-Technica AT4053b hyper-cardioid
- Audio-Technica AT4051b cardioid
- Sennheiser ME 64 cardioid
- Sennheiser ME 66 super-cardioid—interference tube
- Rode NT1A large diaphragm condenser—cardioid
- AKG C 3000 large diaphragm condenser—cardioid

Moves

Cloth moves are often a delicate sound. The quieter the Foley stage the better. You might try using a large diaphragm microphone and hear how that sounds. If the room isn't quiet enough, then you can try a super-cardioid or hyper-cardioid microphone. The hyper-cardioid has a narrower pick-up pattern than the super-cardioid, so take that into consideration when selecting the microphone. The reflectiveness of the room and the distance between the microphone and the cloth will be a major determining factor for the best microphone to use.

Footsteps

Cardioid microphones require that the sound source should be fairly close to the microphone. These footsteps will sound more dynamic and unbalanced from heel to toe. The unidirectional microphones provide a more tightly focused sound than cardioid microphones. They also allow you to place the microphone farther away from the sound source, which gives the footsteps a more natural and rounded sound. However, they can have a hard time with room reflections, especially in a small room with lots of hard surfaces.

Specifics

What microphone you use to record specifics is dependent on what type of sound you need to record. Just like with cloth and footsteps, you need to select the best microphone for the sound. If you are recording a delicate sound like a bird breaking out of an egg, you may choose the large diaphragm cardioid microphone, but if the sound is of someone clipping their toenails, you may want a unidirectional microphone. However, if the character clipping their toenails is an unsavory character, I might choose the microphone that picked up the greatest nuances, which might be the large diaphragm cardioid. I could then use that hyper-real sound to manipulate the audience into disliking the character.

Outdoor

If you choose to record your Foley or at least the Foley footsteps outside, then you want a good low noise hyper-cardioid microphone like the Neumann KM 185 or a super-cardioid microphone like the Sennheiser MKH 416.

PERFORMANCE

Before you start shooting the Foley, make sure your cellphone is turned off, your pockets are empty and you have removed your watch and jewelry, including any rings. You don't want any accidental sounds ruining a good take. Many Foley artists wear shorts and T-shirts to reduce the risk of unwanted clothing rustle sounds.

Some Foley artists like to wear headphones to make sure the sounds they make are working with the picture, but most do not wear headphones and rely on their ears to judge the sound's appropriateness as they make it. If the Foley is done on a Foley stage with a Foley mixer, then it's the mixer that hears the recorded sounds and can give feedback to the Foley artist as to whether or not the sounds work well.

Check to make sure you have all the props, shoes, cloth and pits you need to do your work for the entire film. There is no one way to record and perform Foley, but there are some conventions and procedures that will make the process more effective. These will allow you to perform the Foley in a manner that helps support the story and add life to the characters in the film. Jack Foley always put himself into the place of the character he was performing and that standard has remained for all Foley artists to this day.

In a CreativeCow article entitled *The Art of Foley: John Roesch Honored by MPSE*, renowned Foley artist, John Roesch, explains his approach to performing Foley:

"There is a soul or feeling to Foley that you can't emulate in a strictly digital domain or cutting it from a digital library. How would one even do that if one is assembling a special weapon that's only used in space and has interlocking chambers? I'm sure there are some sound effects that could be used, but we can detail it out . . . someone is performing them, and that performance is detailed to the picture at that moment."

MOVES OR CLOTH

Moves are the common starting point for recording Foley because they allow the Foley artist to get familiar with the film before having to do footstep or specific sounds in hard synchronization with the picture, however, many seasoned artists will start with footsteps.

Moves are usually recorded in mono with a directional microphone placed about 3 feet or 1 meter in front of the Foley artist. Some people prefer to sit in a quiet chair to perform Foley moves and others prefer to stand. Make sure you can easily see the screen the film will be played on.

When you're ready to record, use a piece of material or a garment that matches the type of material being worn by the actor in the film and hold it loosely in your hands. As the actor moves, rub the material against your body. Mimic the movement of their arms, legs and body. If the actor reaches up to turn on an overhead light, the cloth should be rubbed in time with

the arm motion. Ideally, you'll be able to recreate all the actions in a continuous motion. When you rub the cloth on your body, do it in a smooth but strong stroke, so it actually sounds like something is moving and not just an indistinguishable blur of rubbing. In other words, overact the movements so they are much louder than they would be in real life. That will give you a good recording that can play well at a lower volume in the film mix.

Most professional Foley artists will perform cloth movements for an entire scene, reel or short film from beginning to end in one take and on one track. This takes a lot of experience, so if you are not a professional, it's better to take a short film or a reel, scene by scene. If you are using audio recording software and you make a mistake, then stop and go back to the nearest cut or scene change to punch record into the film and continue on to the end. Even the professionals have to punch into a track from time to time.

This method of doing all of the cloth all the way through a reel or short film in one take and on just one track comes from the tight deadlines that are part of television production. This approach is becoming more common in films too. The main reason for this is that budgets are getting tighter and thereby time is tighter as well. This technique can work well for some films, but not for others. It depends on what materials are being used and if the film is more action-oriented or is a straight drama. You'll have an option to be able to control the various moves sounds in the mix, if they are recorded on multiple tracks. Having just one take and one track really limits what can be done in a mix. If the moves track for your film is too involved for a single take, you may want to record each of the character's movements on separate tracks from beginning to end. This will give you some control in mixing your film's Foley moves.

Some Foley artists prefer to record what are called touches or pats on the moves tracks; for example, kisses, handshakes and pats. However, many Foley artists prefer to put pats or touches on the "specifics" tracks or on their own separate tracks. If you're doing a film with several reels, then be consistent with what tracks you put the touches on, either the moves tracks, specifics tracks or pats tracks, but choose just one.

When the character you're doing the moves for walks toward the camera and then walks away, you may choose to adjust the levels of the movement to match. Adjusting the levels can be done by either the Foley artist or the Foley mixer who is recording the session or by both working together. Start with the fader in a low position and then increase the volume as the actor approaches the camera and then drop the fader as the actor moves away. If you are recording your own Foley footsteps, then you may want to adjust the volume level of the moves during the film mix instead. Most Foley artists are able to control the volume of their footsteps as they walk the Foley, so they can match the sound of someone walking away or toward camera.

SPECIFICS OR PROPS

Specifics or props are the sounds created by the actor that are not footsteps, pats or clothing movements. The Foley artists use props to create the sound that an audience expects to hear when they're watching a film.

In order to record the specifics, you'll have to spot to the film, which is making a list of all the objects or props that an actor touches. You then find those props and bring those to the Foley recording session.

Specifics are the fun part of Foley. They are the created sound effects, which are based upon what a character touches, falls on or in some manner their body comes into contact with.

When you create a specific sound effect, you don't necessarily need to have the exact item that was used as a prop on the set. What you need is something that can make a sound that the audience will accept as being that prop. For example, you might use a staple gun and a door latch to make the combined sounds of a gun being loaded and cocked. The gun sounds are an example of layering sound effects. The stapler might be recorded on one or two tracks and then the door latch on another track. Combined together they sound like a gun.

It's best to plan out your specifics recordings. If you are doing a war film, you might want to keep all gun sounds on one track or if layered, then on several tracks next to each other. If you are doing a film about boys and girls at a skateboard park, you'll want to keep all the skate wheel sounds on adjacent tracks. The mix will be easier and faster when the sounds and tracks are well organized.

When you shoot the specific sounds, the microphone should be about 3 feet or 1 meter away from the action. Some sounds may require the microphone to be closer to the sound source because they are quieter. Other sounds may require more distance to work with the action on screen. Keep the microphone pointed away from the Foley artist's face to avoid picking up breathing sounds.

You normally might write down all the cues for the props from the beginning to the end of the reel or short film. When you perform the cues, you might go from beginning to end, but it might be faster and easier to perform a similar sound all at once. For example, you might do all the paper cues at once and then move on to do all the gun cues and then the dishes and silverware on the next pass. This way you don't have to change microphones or move and adjust microphones for each scene, but only at the end of each pass for the entire reel or the entire short film.

PATS AND GRABS

Pats tracks are recordings of the film's character's hands touching things such as their own skin or someone else's skin. Their hands may also touch the surface of an object or rub the object. Pats or "body touches" include grabbing onto something; for example, it might be their own or someone else's body, a piece of cloth or clothing, an object such as a door, steering wheel or knife.

Pats can include interactions between people or between people and objects. These actions include such things as kissing, hugging, pushing and pulling. They are often performed while sitting, but may be done standing in the case of hugging, pushing and pulling.

If you're recording light sounds like rubbing your arm, you will need a sensitive microphone. You'll need to position your arm close to it for recording an adequate volume level.

It's always better to overperform and thereby create a louder sound. It's better to lower the sound level in the mix than to have to increase it too much as the noise floor will increase too.

FOOTSTEPS

Performing Foley footsteps is a difficult technique and is usually harder than doing any other Foley. To be good at footsteps takes practice, practice, practice. When performing footsteps, the microphone should be placed about 3 feet or 1 meter away from the Foley artist and positioned in front of them. This microphone distance might work well for an exterior scene, as this will reduce the roomy sound of the studio. If the scene is an interior, then the microphone should be about 6 feet or 2 meters away from the artist. These distances for the microphone will give the recordings the proper sound of being in a room. You will have to adjust the microphone distance to match the films rooms, so experiment until it sounds right.

There is no one way to walk Foley footsteps, but a common approach is to walk heel to toe in one place. You have to stay in one place because the pits aren't big enough to walk very far and because the microphone is only in one place, so you have to do your Foley footsteps in front of it. Some Foley artists use a technique in which they roll their foot from the outside of their heel to the inside of their big toe to better simulate walking. However you choose to walk a character, make sure it fits that character. One character may walk lightly and on the balls of their feet, while another may walk flat-footed. Always take your cue from the actors.

When a character comes to a stop, they often make a last step sound. If the last step is on concrete, you might hear a gritty scuff. Coffee grounds on the concrete can help make that scuffing sound. If you want a more harsh sound, you could put a bit of sand on the concrete instead. If the character stops on linoleum or tiles you would probably hear a short slap or tap. The sound you are listening for is one that conveys the information that the character is coming to a stop. You may also choose to perform a short gritty scuff for a character that is simply shifting their weight from one foot to the other.

It isn't important what the shoes look like. Many Foley artists have shoes that are held together with gaffer's tape. The gaffer's tape may also be on the shoe to keep it from squeaking. What's important is to have shoes that sound like they are made with the same type of material that the actor on screen is wearing. It would be odd to hear ballet slippers trying to make the sound of cowboy boots, unless it's a comedy. The key is to create the sound of the shoe that the audience would be expecting, if they thought about it. The sound of a man's dress shoe with its leather sole and heel makes a noticeable clicking sound, so in order to avoid that harsh sound, use softer soled desert boots. They might sound just right.

In order to find synchronization with a character on screen, you need to watch their shoulders move and time yours to match theirs. This will give you the same sway and stride that the character has as they walk. If you try to watch the character's feet, you will probably get confused quickly, especially if they are moving erratically. If you cannot see the character's shoulders, then you can get the walking movement from their arms, hands or hips.

There is usually a rhythm to a character's walk, so you can find that rhythm and move with it. If the steps are complicated you can find the rhythm and then play it in your head as you walk. Running is the same motion, but faster and with shorter steps. Climbing stairs is also a faster and shorter step. The focus for climbing stairs is more on the balls of your feet and each step is like a stop.

When performing and recording Foley footsteps it's important to remember that even if the character's feet aren't on screen, if the character is walking or running, you need to perform their footsteps. Also, a character may take a step into a room and walk across the room to join in a conversation with two other characters in front of a window, but the audience only sees the character take a step toward the other characters and then the next shot is of the two actors at the window, then the first character enters the shot and joins in the conversation. During the time the character wasn't on screen, but was walking across the room to the window, we need to hear their footsteps. So, the Foley artist will usually recreate all of the footsteps of each actor, regardless of whether or not the steps are seen.

If you don't know what type of shoes a character is wearing, because they are never shown on screen, check through the film to see what shoes the character normally wears or if that doesn't tell you anything, then make a choice that would fit that character. Background characters are easier than the main characters, if they are in a group. The best approach is to pick background actors who are in the foreground and appear dominant in the scene and do their footsteps, but the other background characters can just be a wash of footsteps.

The best Foley walking is when the Foley artist takes on the role of the character on screen. If the on-screen character is angry, the Foley artist needs to feel the anger and walk the footsteps in that mood. If the character is happy, then the Foley artist needs to feel the happiness and walk the footsteps accordingly.

Recording the Foley footstep tracks can take a considerable amount of time. While you are recording them, listen to the footsteps and decide if they sound natural, distinctive and that they fit the character.

LIBRARIES

Not everyone can afford to hire Foley artists or rent a Foley stage. They may not even have the budget to build their own Foley pits in their basement. That's when you may want to consider buying Foley sound effects, either on a hard drive, CD or as a download from one of the many sound effects websites.

You can find Foley sound effects in many of the sound libraries. These can be useful for some Foley effects, but in general they require work to make them fit well. It's important to realize that they are not performed to picture, as the Foley artist will do, so they do not have the same emotional and psychological impact as the custom-made ones do.

If you choose to use a Foley library for your effects, then try to adjust the footsteps so they don't all sound the same. Build in some variation to the footfalls. Give them some character. It may take a bit of editing, but it can be done. Pitch shift, time shift, equalizing and a bit of editing can give you a variety of footsteps sounds from just one footstep.

There are software, such as LeSound's AudioSteps, which will allow you to add footsteps in synchronization using provided library samples.

EDITING

Once you have recorded the Foley, it's time to make sure it's in synchronization with the action. Ideally, you are editing in the same software in which you recorded the Foley. Otherwise you'll have to import the Foley into your editing software. The key here is to make certain that the imported Foley comes into the editing software in synchronization. If it doesn't come into the timeline in synchronization, you'll have to move it into place.

When you record the moves pass, the synchronization doesn't have to be perfect. The Foley editor will fix anything that's out of synchronization. An audience would have a hard time telling if a dress swoosh was a frame or two out of synchronization, but they would notice if a footstep or door knock were out of "sync" or synchronization.

As you move along the timeline editing the Foley, be listening for unwanted sounds and any talking that may have occurred between the Foley artist and the Foley mixer. These will need to be edited out.

Foley always needs to be edited somewhat. Foley artists are human and they can perform the Foley effects in near synchronization with the picture, but there is always a bit of reaction time built into us humans. If the synchronization doesn't seem to be right on, then you may want to advance the sound before picture by fractions of a frame or even whole frames to compensate for the reaction time during the recording process. This is a trial and error technique, so keep trying until it seems right.

The guide track, which is the edited production track that comes with the edited picture, is a great reference for you to use in Foley editing. I usually put it at the top of all the audio tracks, so I can access it quickly.

Figure 9.11

If you are editing footsteps or specifics, you may want to play them against the guide track to see how they line up. This will tell you if you nailed it or not. If the Foley is there to "sweeten" the production track, then you want to make sure your Foley is in synchronization with the production track sounds.

The moves or cloth pass will not have many places where the synchronization needs to be spot on. A worthwhile approach to moves is to play them at a lower volume, closer to what

they might sound like in the mix and then judge how well they work. If you play them at a normal or louder level, they will sound unrealistic and you'll try to make them work by processing or editing them, but you'll probably get frustrated in the end because they won't sound right. Remember, moves are not normally meant to stand out in the mix. They are there to add depth and character to the film, but not draw attention to themselves.

As you edit the Foley, you may find sounds that you do not think fit well. Feel free to delete these and search for others that might work better. I've been known to do a bit of copying and pasting to help make a scene work.

In the movie *Far From Heaven*, 2002, the main character often wore dresses that had petticoats under it. When she walked the dress made a noticeable swooshing sound. As the Foley editor, I saw this as part of her character. She seemed like someone who was caught up in following social norms and reacting to life more than acting on her own. There were several scenes in which she seemed confused or uncertain, so I used a heavier sounding dress swoosh to help demonstrate her emotional state.

One of the most difficult techniques in Foley editing is cutting the footsteps into precise synchronization when the feet are not on screen. There is no direct visual reference, so you have to estimate by watching the shoulders of the actor. If you watch the shoulders frame by frame, there will be one frame that is in focus more than the others. It is at that better focused frame that the actor's foot has first touched the ground. Synchronize the beginning sound of the Foley footsteps to that frame and then play it to hear if it sounds right. If it doesn't sound quite right, try synchronizing-up the next footfall in the timeline and then testing it by playing it at normal speed. You may find that the footsteps sound more natural if the Foley footfall happens one frame prior to the better focused frame.

A common mistake is to use the waveform of a sound to determine synchronization to an action. You can use the waveform of a door slam to synchronize up with the picture, but you need to play it to determine if it sounds right. Even if the waveform appears to be right on, you may need to slide it a frame or two to make it feel right to the audience.

SOUND EFFECT RESOURCES

Tricks for creating some of the sounds you may need:

- Corn starch in a leather pouch makes the sound of snow-crunching footsteps
- Fire crackling by slowly crushing potato chips or cellophane in your hands
- A thin stick to make a whoosh sound
- An old chair can make a controllable creaking sound
- Twisting and snapping celery makes a good bone break sound
- A watermelon hit with a hammer makes a good head hitting sound

- Liquid hand soap or gel makes a squishing sound
- Frozen lettuce wrapped in a chamois cloth makes a head crush noise when hit
- Coconut shells cut in half and stuffed with cloth makes great horse hooves
- Wrap a heavy Sunday newspaper with Gaffer's tape for a good "body punching" surface
- A large staple gun along with other metal pieces can make a good gun sound
- A wrecking yard car door or fender can work for car and heavy metal sounds
- You can change a sound by putting the sound-making object on different surfaces

Use your imagination to come up with what objects could be manipulated to make the sound you want. After all, Foley is a wonderfully creative art form.

EXERCISE

Select a scene from a film that has no dialogue in it and using either a sound editing software that can play video or using video editing software, play the video and record your Foley audio in synchronization to the picture. Don't try to do too much in one take. It may be useful to listen to the guide track on a pair of headphones as you perform, but it's not essential as you can see the action on the screen. Record the footsteps, cloth and props for a scene and then edit them and mix them. See how it brings the scene to life.

Backgrounds

What's an Ambience, Atmosphere or Background?

Figure 10.1

INTRODUCTION

Backgrounds are an important part of sound effects. They are the general ambience sounds that are added to the sound mix to give the location realism. Backgrounds are also referred to as BGs, ambiences or atmospheres. They are not room tone. Room tone is the sound of the location or set from the production recordings. Backgrounds are usually continuous sounds like wind, birds, rain, traffic and crowds. These sounds are either taken from a sound effects library or are custom recordings, often for a specific film.

Backgrounds are the foundation on which all the other sound effects are placed. It is best to start your sound effects editing with backgrounds so you can build the sounds of the scene in a way that helps tell the story and define the characters. These sounds help create a mood, establish a location, time period and evoke emotions. They are essential for a good sound design for your film.

If you have a scene with two people arguing in their one-room Bronx apartment, which was shot at a very quiet location or perhaps in a studio, you have to add the sounds of the city to "sell" the location to the audience. If you want the apartment to be located near

a train track, you can add a train passing sound to the background. Even though the audience may not be able to see outside, they know where the apartment is as well as the socio-economic level of the fighting couple. If you add a specific sound of train wheel screeches just before the argument breaks out, you're foreshadowing the fight. Alternately, you may wait and add the train wheel screeches later in the fight scene just to build the tension in the scene. I think of this as subliminally manipulating the audience for emotional and psychological purposes.

Using the right backgrounds can make a scene or character seem sad, tense, safe, happy, fearful and all the other emotions that we need to portray with our sounds. Sometimes the backgrounds will be bigger sounds to convey a heavier emotion and other times a basic background can evoke the right emotion in a scene. The most important part of picking a background is for it to serve the story. If you do this well, the audience will immediately respond because you have drawn them into the scene.

SPOTTING

The first thing you need to do is go through the film and spot what backgrounds you'll need and where in the film you'll need to use them.

The most important part of spotting the film for backgrounds is to determine what scenes need background recordings and what those recordings will be. I like to make a list of what backgrounds I'll need. I write down the location of the scene, what type of ambience I'll need, whether it's day or night and also what specifics I might need to record. An entry on my list might look like this:

EXT: PARK in early morning, busy traffic in distance, light wind, small water fountain nearby, lots of birds.

On occasion, you may get lucky and get just the right combination of sounds and at the right levels in one recoding, but that would be rare. You would also then be stuck with just that recording unless you also did separate recordings of each element. Since the goal is to be able to control all the different sounds you use in the mix, you'll want to record each element individually. This will allow you to adjust the volume of each sound as well as add EQ (Equalization) or other processing independently. This also gives you the creative freedom to manipulate each element to create the environment that you think works best for the scene and story.

If the film is a period piece, you'll need to find recording locations that match the time period of the film. It's not a good thing to hear a cellphone ring in a 1950's diner, so when you record some diner ambience, pay close attention to the sounds you're hearing as they may be out of place for your film.

PRODUCTION SOUND

Once you've spotted the film, you can check to see if any of the backgrounds were recorded by the sound mixer during production. If so, you may be able to use them and save some time by not having to record that particular background.

During the shooting of a film the location sound recordist may have opportunities to record ambiences, room tone and specific sounds along with wild lines. Wild lines are the actor lines that are not recorded in synchronization with the picture. The ambience and room tone recordings are done when the camera isn't rolling and the crew and talent are either gone or are ideally frozen in place and being very quiet. A smart production will make the time for 15 seconds of room tone or ambience to be recorded, but tight budgets and schedules often don't allow for it. Usually the ambiences are recorded by the post-sound editorial crew after production has ended, but sometimes you can find what you need among the production recordings.

ROOM TONE

Some people think room tone means silence, but it actually means the subtle, unique and sometimes quiet sounds that you find in every room. The location sound recordist will do whatever they can to minimize these room sounds, but there's only so much they can do.

I have often turned off refrigerators, computers and heating or air conditioning systems to get a quieter noise floor for the room tone. I turn off whatever noise producing equipment I can. When I turn off a refrigerator, I always put my car keys in it. I'm not leaving the location until I open the refrigerator door and when I see the light out, I realize I need to turn it back on.

Ideally, room tone will be recorded for every camera angle, not just the overall location. This will allow the dialogue editor to clean up the production track more easily and to allow ADR (Automated Dialogue Replacement) to fit more seamlessly into the production track. In reality, there is very little time for recording room tone at all during production. However, it's helpful if the location sound recordist can get at least 15 seconds of good clean room tone for each location.

RECORDING

You will need the following equipment:

1. Microphone or microphones, surround, stereo or mono, each with a windscreen.
2. Recording device of some type, ideally digital, such as an audio recorder or video camera.
3. Headphones to monitor the recordings, not earbuds, which tend to have a very limited lower frequency range and unusual dips and bumps above 2k.

Microphones

Once you know which backgrounds you need to record, you'll have to determine when and where you'll record them. You also need to decide what microphone you'll use and how you'll

record them. Will you record the background as a mono, stereo or surround sound file? You'll need a microphone or microphones designed to do the chosen type of recording.

Surround sound microphones are fairly expensive and complicated, so it might be better to record stereo and pan those two tracks into the surrounds. However, if you desire to have surround backgrounds, then there are several forms of surround recording such as 5.0, 5.1 or 7.1 that may work for you. If you choose to do a surround recording, you'll need to have at least a 6-track recorder for all of the 5.1 inputs and at least an 8-track recorder for all of the 7.1 inputs. The Holophone H series of microphones are great for 5.1 and 7.1 surround recording.

If you have access to a surround microphone then you'll be able to get some very realistic atmospheres. You could construct your own 5.0 surround microphone system. It would require five microphones and a mechanism to hold them all in the proper configuration. A common mechanism for a stereo or LCR (Left-Center-Right) recording is the classic Decca Tree. It holds three omni-directional microphones in a triangular array that has the center microphone closer to the sound source. There are many variations on this concept and it can be expanded to a surround configuration that utilizes five omni-directional microphones or five cardioid microphones or a combination of both to get the coverage. You should be able to create your own surround microphone system with some research and experimentation.

If you don't need surround backgrounds, then there are many approaches to recording stereo backgrounds, such as the ORTF, MS, A-B and X-Y. Some of these approaches are complex, while others are more straightforward. If the style you choose involves using two microphones, then there are certain parameters that are required in terms of placement of microphones in regard to distance from each other and relative angle. I suggest one of the two techniques that follow.

First, you might consider an XY set-up.

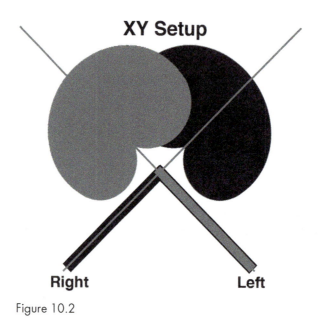

Figure 10.2

These set-ups involve the use of two identical cardioid microphone's position in order to pick up the optimum stereo field. The microphones are placed directly over one another and they are at a 90-degree angle from each other. This set-up will give you a stereo sound, but it's not a very wide one and it doesn't pick up much in the center of the arrangement.

Second, you might consider AB stereophonic recording.

AB Setup

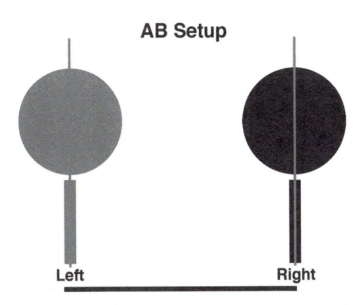

Left **Right**

Figure 10.3

The AB approach usually uses two omni-directional microphones spaced between 6 inches and 24 inches or 17 centimeters and 60 centimeters. The spacing depends on how far away the sound source is and how much separation you desire.

If you can't afford a stereo microphone or you don't own two matching microphones for the ORTF, X-Y, A-B or MS style of recording, then you could use your camera. Cameras usually have a built-in stereo microphone. It's not the best quality microphone, but it will work. If you use the microphone on the camera, you should be aware of any camera or handling noise as these may interfere with the quality of your ambience recording. I suggest that you set up the camera, check your microphone input levels, hit the record button and step away, hold still and listen.

If stereo isn't important to your film then you can use a mono microphone. A good non-directional condenser microphone will work very well for backgrounds. This would be a microphone that is omni-directional and is powered by battery or phantom power from a recorder or mixer. If you only have one microphone and it's a shotgun, cardioid, super-cardioid or a hyper-cardioid, then you can use it, but realize that its pick-up pattern is directional, so you aren't getting a broad background.

If you are recording specific sounds, you may want to use a shotgun, cardioid, super-cardioid or a hyper-cardioid microphone to help isolate the sounds from the surroundings.

Recorders

The industry standard recorders are expensive pieces of gear that often record multiple channels of audio. These are commonly used to record dialogue during production; however, they can be used to record surround, stereo or mono ambiences as well. If you own one, then use it. There are lower-cost eight-track recorders, under $1,000, available. If you can afford one of these, then some of them will work well for both production sound and post-production sound, such as surround sound backgrounds. If you don't own a multi-track recorder and need to record ambiences, there are other lower cost approaches.

Your backgrounds don't have to be surround sound. If you own or have access to a portable digital stereo recorder that has built-in microphones, you may be able to record some decent ambiences with it. These are the low-cost handheld recorders that usually employ some form of either the XY or AB technique for recording stereo. If you have your own microphones to use, then you can use them as inputs into these lower-cost recorders, so long as they have XLR inputs.

If you cannot afford any other recorder, then you could use a video camera, even an inexpensive one. The reason why this is rarely done is that cameras generally have poor microphone signal amplifiers, have relatively inexpensive microphones attached and can generate noise in your recordings. Another issue is the format of the recording. Most cameras will record audio at 24k and 16 bit and some will record at 48k and 24 bit. Many sound effects are recorded at 48k and 24 bit for general sounds that will not have much effects processing added to them. However, the trend is for sound effects to be recorded at 96k and 24 bit so that they can be processed and manipulated by using such effects as time shifting, pitch shifting and other intensive processing effects.

It's important to record the ambience or background at a usable level. If the level is approaching –40dB, it's too low and will not normally yield an acceptable sound. Increase the recorder input level, until the meter level is closer to –30dB or even –20dB, and you'll have a usable recording. If the input level is at maximum, try moving closer to the subject. You can increase the level by 6dB by moving half the distance to the subject. If it's a general wash of ambience that you want, then get the best recording you can.

Headphones

I like to say that you would not shoot a scene without looking into the viewfinder, so why would you try to record sound without listening on headphones? If you're not monitoring the sound, you will not know if you recorded the sound you need.

An important feature of headphones is that they force you to focus on the sound the microphone is picking up and you can't hear that without wearing a pair of headphones.

Recording the Backgrounds

Once you have found the right background to record, you'll need to set up your recording equipment, put on your headphones and adjust the microphone direction until you hear the background you want, then start recording. Always record more than you think you need, because this gives you some flexibility in editing the background to work with the scene in which it will be used. When you play back your recording you will notice that even a simple ambience will change over time. I played back some autumn suburban night ambiences I had recorded and I noticed that the beginning of the recording sounded very different than the ending. During the 10 minutes I was recording the wind picked up, the leaves on the trees began to rustle and several dogs starting barking. The first minute and last minute were distinctly two different ambiences when compared with each other.

Once you've recorded the background sound that you want, then you can focus on recording some of the individual elements. For example, if the scene you are recording sound for takes place at a zoo, you may want to add some specific animals to the mix by going to the different animal enclosures and recording the bears, lions and monkeys. These can be blended into the overall ambience you first recorded to give a stronger sense of being at the zoo. What you use and how you use it will of course depend on the film and the scenes it's used in.

Matching Ambience Sound

Matching ambience sound means that you record the sound in a way that could match a scene in your film if it were needed. These matching ambiences can be used for an entire segment, scene or location in order to make the background sound have consistency. The matching background may have a bit more character to it, so it helps define the location better. The matching ambience may also be used to cover or patch up any mistakes when you don't have any actual room tone or ambience from the production tracks. However, it may take some editing or some long crossfades to make it work well.

Note that the sound does not necessarily have to be synchronized with the pictures, just matched. This means it doesn't need to include specific sounds on cue (e.g. a hammer striking a nail), it is only required to match the generally expected sounds of the scene (e.g. background construction noise).

LIBRARY

Sound effect libraries are a great source of general background sounds. These libraries may be on the internet, CDs or hard drives. Although most big budget movies tend to record and create their own background sound effects, it is not uncommon for a sound editor to grab a pre-recorded sound such as a nice whistling wind from a library to use as a background effect when the need arises. I have recorded various types of wind and I have never been entirely satisfied with the whistling winds that I've recorded. It's hard to get nature to do what you want it to do.

EDITING

Once you have all the backgrounds or ambiences you need for the film, it's time to edit them.

If your film is going to have a foreign language release, you'll need to create backgrounds for every scene that has dialogue in it. If there is a dialogue editor, then they will create these underlying room tones or ambiences from production tracks. However, these are often just foundations. If you want a more detailed, effective and sound designed background, you'll have to create it from various sound elements.

As you work on a scene you may find that using one simple background is all that you need to establish the location. However, most of the time you will use several background sounds to create the overall ambience. These sounds will be put on separate tracks, creating a layered effect. If a scene takes place at a beach, you may have an ocean wave's layer, a gull's calling layer, a wind layer and whatever else is appropriate to support the scene in particular and the story in general. If the film is a big budget movie, a sound editor may include two, three or more different winds that could play together, depending on the scene. However, having several winds available for use in the mix is more about providing options. The director usually has not heard the sound effect before the mix session, so they can make a decision on which wind or winds at that time. Wind can be an important part of the overall sound design.

When I was recording ambiences for the movie, *Finding Forrester*, 2000, I needed a fairly quiet foundation bed for the South Bronx, where William Forrester, Sean Connery's character, lived. Post-production was being done in Portland, Oregon, since that's where Gus Van Sant, the director, lived. So, I decided to find a secondary suburban street on which to get my foundation recording. I parked my car and got out my recorder and stereo microphone. Standing next to the car with my headphones on, I started listening to the evening time neighborhood. I thought it would work well, so I started recording it. When I was only 10 seconds into the recording, I heard a sharp and distinctive chattering. I looked around for the source of this intrusive noise and spotted a squirrel on the telephone lines above me. It had mistaken the gray fuzzy wind cover on my microphone as an intruding squirrel and was giving it a warning to get out of its territory. I packed up my gear and drove two blocks away and got my "Bronx" ambience recording.

Once you have a foundation ambience, you can start building in other elements such as birds, traffic, people yelling, police sirens and other urban sounds that would be common to the South Bronx or whatever location you need to establish with background sounds. By keeping all of these elements as separate sounds, you are able to control the placement and mix volume level for all of them.

In the movie, *Far From Heaven*, 2002, I didn't just edit in a recording of general urban birds for the various exterior scenes, but I actually built bird ambiences. I researched what birds would be found in Hartford, Connecticut, the main location of the story, during the three seasons that the movie timeline occurs in, autumn, winter and spring. I then built bird ambiences using the appropriate species of birds for each season. For each of the seasons I would create a light, medium and heavy bird track. I could then add individual birds in places that called for them. That's how detailed a sound design can become.

I like to use a lot of different elements when I build backgrounds because life is rarely just one sound. As I built the bird ambience for *Far From Heaven*, I was very careful not to put a bird where it would interfere with the dialogue or worse yet draw attention to itself. I chose what kind of bird I thought worked best with the scene and then placed it where I thought it should go. A classic example or perhaps cliché of bird usage is when a crow starts cawing just before a fight breaks out between two characters in a scene. Maybe you pan the crow's caw to the left where a densely leaved tree is seen. If you don't have a crow, a dog barking could work too.

Everything in a soundtrack is thought about, created and placed. Very little happens by accident.

The main background for any scene comes from the dialogue track, which is placed in the center channel of the mix. These would have been recorded in mono as they are in the dialogue recording. It is a good idea to listen to these dialogue backgrounds to learn what sounds were recorded during production. You can now make a decision as to how to approach the backgrounds. If you're doing a surround mix, then you may want to augment the mono backgrounds with other mono backgrounds with the intent of placing them in the center channel. You could then add stereo backgrounds to the left and right channels as well as the surrounds. You could also add slightly different backgrounds to the left and right surrounds. If the scene is in a large factory, then you might have the sound of some pounding machine on one side of the surrounds and a whirling sound on the other side. This creates a sense of being inside the space of the factory.

If you're doing a stereo mix, then there will not be a center channel, just the left and right. In that case, you can place either mono or stereo backgrounds in the mix. The mono backgrounds will go to both channels as mono and the stereo backgrounds will stay split into left and right.

If the film is going to have a foreign release, then you'll need to have in place a background that's similar to the original dialogue recording. This will allow the dialogue in the foreign language to be mixed in with the non-production backgrounds.

It is important to use the same backgrounds for the same locations. If a number of scenes take place at a beach on Lake Tahoe, then each time the film's story returns to that beach location the background sounds should be the same. You would not want to use gusting wind in one scene and then whistling wind in another unless there is a visually noticeable change in the winds for the two scenes. There is a specific set of birds that would be at Lake Tahoe and to have a cardinal call there would be wrong. You could have a Bald Eagle cry or a Red-Tail hawk cry as they are found at the lake. However, if there's a Bald Eagle in a shot, don't make the all too common mistake of using a Red-Tailed Hawk cry for the eagle's cry.

Normally, ambiences stop at the end of a scene where the picture cut occurs; however, there may be a reason to continue the ambience into the next scene. This overlap may be a good way to transition into the next scene. It may be there to tie together two elements of the story.

This screen capture shows an example of a one-frame overlap with a crossfade.

Figure 10.4

In order to ease into the next scene, it's always a good idea to overlap the backgrounds from one scene going into the next scene by at least one frame, if not more. You'll have to do a test with different lengths to sense what's working. Once the length of the overlap is determined, you'll need to crossfade between the two scenes by that length. These short crossfades smooth out the transition and thereby make them less jarring. However, you might want the scene change to be jarring, if it helps put the audience in a desired psychological state. You need to decide if crossfades or straight cuts work better for your film.

LAYERING

Usually backgrounds are layered with various sounds to make an environment that works with a particular scene or location.

When I was working on the film, *To Die For*, 1995, one of my jobs was to layer the sounds for the last scene in the movie. It took place on a frozen pond. I selected two different winds to play with the scene. One gusty wind would play through the entire scene, while the other whistling wind would come in and out as the scene progressed. There was also a sparse bird background, with only hardy winter birds calling. As the camera moves across the ice, it slowly reveals the main character dead beneath the ice. I chose such a basic ambience because I wanted to emphasize the lack of morals and humanity that the main character possessed. I wanted the soundtrack to be cold, empty and dead, just like the main character.

Other times I have used a number of background sounds to create the ambience for a scene. If the scene is an exterior, then there is usually wind and probably birds. If the scene is supposed to take place near a road, there will be some level of traffic. If it takes place near or on a beach, there may be the sound of waves. If it's a nice day at the beach, there may be a crowd of people. Each scene will determine what background sounds you need to use to make the scene work.

On top of the general backgrounds you will probably add in more specific sounds to fill out the overall design of the sound for a given scene.

PROCESSING

Doing some form of processing to a sound, such as reverberation, time shifting and pitch shifting, can have a dramatic effect. The important thing to remember is not to overdo it.

In the movie, *Psycho*, 1998, I did more processing of sounds than I usually do. One constant background sound was the hum of the fluorescent lights outside the Bates Motel. In this scene, Norman Bates is chatting with Marion Crane about their lives. During the scene the audience starts to like Norman, but they also find him a bit strange. This was intentional manipulation by the director. My job was to help play into the manipulation, so I pitch shifted the fluorescent lights to create a slightly irritating sound, beyond the normal irritating sound that fluorescent lights can make. I was careful to not change the pitch to a frequency that would have called attention to the lights. If I had done that, I would have failed, because I would have caused the audience to realize they were watching a movie and were no longer engaged in it.

EXERCISE

Focus on recording two different backgrounds really well. One background should be an exterior and the other one should be an interior. The goal is to get as clean a recording as possible. Neither of the backgrounds should have talking in them. When we want talking, we record walla. You should choose a background that has some character to it. For example, you might want to record an interior such as a bowling alley or factory. They have character and a strong sense of location. The hard part about these two locations is that there is usually talking going on, so you'll have to find a way to eliminate the talking.

When you record the exterior, you may have lots of unwanted sounds to avoid, such as traffic, airplanes, wind, birds or people. Depending on the background you want to record, some of these may be desirable.

Remember, you want as clean a background as you can get. Other sounds will be added to it to fill it out to the specific location you are trying to create.

Once you have both backgrounds, layer in some other sounds with them to create a specific environment.

Musical Score

In the Mood?

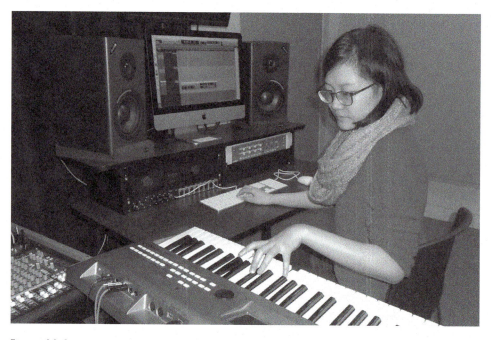

Figure 11.1

Film music is another weapon in the armoury of the director. The score should inevitably have a strong theme, which reflects the mood of the film either in a leading character or the action of the film. Thus any form of music from symphonies through pop to synthesiser can be used. Music is more powerful when it is used sparingly and should never be used when it is thought to enhance a poorly written or badly played scene. This is something to be avoided. Sometimes natural sounds are more effective than music.

Director, Lewis Gilbert, quoted in BFI: Sight and Sound, September 2004, *The Best Music in Film.*

INTRODUCTION

It is rare for music not to be a part of the sound design for a film. There have been some films without it, but it really serves the main function of supporting the emotional aspects of the story. There are other vital functions, but emotions are considered the primary reason to use music.

There are several ways to provide music for a film. The classic way is to record an orchestral score for the film. This requires a considerable budget to pay for the musicians, engineers, studio and other staff to orchestrate, arrange and conduct the music. This is often the best way to create a score, because the music is written for the film and is timed out to match the emotional

content of each scene that uses music. A customized score using real instruments has a richer sound than most digital scores; also the musicians can put feeling into their playing that would be hard to replicate with samples or synthesizers.

If you can't afford a full orchestral score, then there are alternatives. For example, if you can afford to hire a few musicians, then you can use their real instrument tracks to augment the sound of a digital score. There are some great instrument samples for digital scores, but it can be difficult to get them to sound right. Having a few real musicians included in the music can help "sell" the sound.

If you can't afford to hire any musicians, then you can use samples to create the score. There are some well-performed samples that come with Pro Tools and other music creation software or you can buy some orchestral music packages. EastWest Studios, Vienna Symphonic Library and ProjectSAM Symphobia instrument samples are some of the best available.

If you don't have software like Pro Tools, Logic, Cubase or Nuendo, you can use software such as GarageBand to create a score using MIDI (Musical Instrument Digital Interface), synthesizers and sample loops that are available for it. If you have a PC, there's software like FL Studio, Stagelight and Mixcraft; you will have to buy Mixcraft. Apple's GarageBand works with Mac computers and is a low-cost option. There is also a Windows version of GarageBand called GarageBand, but it's not an Apple product like the Mac version.

There are also royalty-free libraries from which you can purchase CDs, music-loaded hard drives or downloadable music that could function as a score for your film. Because they are pre-existing music cues, it may be difficult to get them to fit well, so you may need to edit them and alter them so they work for your film. Some of the companies that sell music tracks will also do some customization of their music for you. For example, Megatrax will customize their existent tracks or create an entirely new score for your film. There is a significant cost for the customization or score creation.

You may have a friend who is a musician or you know a band that could create music for your film. This could work, but it can be a big challenge for the band. Composing music for a film is very different than writing songs for performance. Film music is usually there to support the scene and not to be noticed by the audience. Performance music is there to be noticed and is not designed to work with the changes in emotions and actions that may occur in any given scene. Score is designed to transform along with any emotional or action oriented change, while popular music has a fairly defined structure. This is not to say your friend or the band won't be able to do a good job; it's to say that they need to know how to create underscore, not songs.

Score is different from a standard musical composition in that music written for a film rarely stands on its own. Score is part of the story and relates to specific characters and events, so listening to just the music is usually less than satisfactory. There are some films in which the score works as listening music, but they are not common. Some scores can be repurposed as soundtracks by stitching together some of the music, but to have a soundtrack album with all 40 or 50 music cues from the movie would probably not be very popular.

Another common issue is whether or not to have wall-to-wall music in your film. Wall-to-wall music makes your film more of a music video than a dramatic story. An average dramatic film of 90 minutes in length will have about 40–60 minutes of music in it. There are films

that are 90 minutes long that have nearly 90 minutes of music, but that's not the norm. If you have too much music in your film, it can become wallpaper and loses its impact because the audience starts to tune it out.

Beyond the many ways to create a score are questions such as:

- What genre of music fits the story?
- What tempo or rhythm works for a given scene?
- What instruments will work and which might compete with the frequencies of the dialogue or sound effects?
- How many themes will the film have?
- How many cues will it have and which key will each use?

MAKING NOTES

Whether you're the director, composer or both, you should write down notes on what your thoughts, ideas and views are about music's role in the story. Include the underlying mood and the emotions of each character in any given scene in the film. These will help you determine what your goals are for the music in the film.

It might be useful to find a couple of films that are similar to the one you are working on and listen to the music for them. You may get ideas as to what music to use in your film or perhaps not to use.

All of these notes will help in the creation of a musical score that is in synchronization with the various events in the film.

SPOTTING SESSION

- *Spotting*: The process of determining where, when and why to use music.
- *Spotting Notes*: A list of every cue in the film and where it starts and ends. The notes usually include comments about music genre and purpose for the cue.

If you, as the director, have never worked with a composer, it can be a bit intimidating either because you don't know how to work with a composer or you might feel like you need to know musical composition in order to communicate, but the reality is that most composers can work from your description of what you want the music to accomplish in a given scene and for the film as a whole. The key here is that you, as the director, need to know what genre of music you want for your film and then find a composer who has experience with that genre. The director should also pay attention to the general style of the composer. Most composers have examples of their work online where you can check out some of their scores.

In a larger production, the director will sit with the composer, picture editor, music editor and other interested parties and go through the film scene by scene. They will discuss which scenes need music, why they need music, what style of music will work, what mood the audience

should feel and what else the music should accomplish. This may be done either before or after the picture is locked. It's common for there to be changes made to the picture after the meeting. Often these changes affect the timing of the cues and require some editing to make them fit again. In the situation where you are the director, editor and composer, then you need to have the notes so you can remember what thoughts and feelings you had about each scored scene.

During the spotting session, the composer will usually take notes about each scene and spot that needs music. The notes will include information about what genre of music to use, what the emotional intent of the scene is and what the start and end time is for each cue. A cue is an individual piece of music. If you are spotting using a software application that has markers, you could place a marker at each cue point.

Once you have an idea about what the music should accomplish in the film, you can start the process by spotting the places in the film where you feel music should exist.

- Watch the movie all the way through to get a feel for the story.
- Watch it a second time and stop when it feels like music should be present.
- Note the start timecode or minutes and seconds where the music should start.
- Note the time where it feels like the music should end.
- Try to get a feel for what genre of music would work.
- Note what type of instruments you would want to hear.
- Note what key might be best for the cue.
- Note what tempo or tempos might work.
- Note the time where there may be a key turning point or emotional change.
- Note where there may be a critical line of dialogue.
- Note if the music should come in hard and fast or ease in slowly.
- Note where a scene reaches its climax or ending.

The more notes you have, the better prepared you'll be for the composing process.

Some directors will give general comments about what they want and then leave the rest to the composer, while other directors have very specific ideas about the instrumentation, style and placement of the music cues. The more communication between the director and the composer, the less the chance of error and the greater the chance the score will achieve the director's vision for the film.

If a director is schooled in music, then they can communicate with the composer in musical terms. If the director is not familiar with musical terms, then talking about the emotions of a scene is a functional approach. The director can also play musical examples to get ideas across.

Some musical ideas may be affected by considerations such as needing to use music because of an actor's poor performance in a scene or a scene needs to feel more important or perhaps funnier or a scene is moving too slowly and needs the music to increase the pace. These are not the best reasons for using music, but sometimes the music can help.

There needs to be a reason to use music in a given scene. Some directors want music whenever there is no dialogue, but that may not always be the best choice. If a scene is intense, it may be good to take a breath before using music. It may be more effective to let the sound effects take over and ease the audience down from the intensity of a dynamic

scene. Silence can be an effective tool in storytelling. It can also make large sounds or music stand out when it precedes them.

In the shower scene from both *Psycho* (1960 and 1998) movies the scene begins without any music. There are only sound effects up to the point the murderer pulls back the shower curtain. It is then that the shrieking music begins. Having only the natural sound of taking a shower precede the music makes the music even more jarring when it starts.

There are no hard and fast rules as to when to use a music cue. You may want to use music as a transition from one place to another or to show the passage of time. You may use it in a montage sequence. You may use it to highlight an emotional moment. When the purpose of a cue is to underline an emotion, great care needs to be taken to make sure that the music doesn't overdo it. If the actors are doing their job, then the music needs to be subtle or not used at all.

If you are using music under a dialogue scene, then make sure it's subtle and not too melodic. A strong melody can actually compete with the dialogue and distract the audience. If that happens the music has failed the film. Dialogue is the most important part of the sound design for a film. If you add music to a dialogue scene it normally needs to fit in naturally and play in the background.

Music can also fail the film by drawing attention to itself. This might be all right in a montage sequence or action scene, but not during a dramatic scene. In order to avoid drawing attention to the music, it needs to be introduced at a key point in the scene. It could be introduced when there is an emotional change, a camera move, an important action or something else that keeps the audience's attention in the story and yet allows for the music to come in. How to end the music is another consideration. It could end at a change in the action or tempo of the scene or it could play through to the end of the scene. It might even bridge between two scenes by carrying over a bar or two into the next scene.

CUES

Once the spotting session is over, the composer needs to begin the process of composing the cues. The notes and cue list are indispensable in this creative process that will tie the entire film together musically.

Here are some basic guidelines for using cues.

- *Hiding the Cue*: In covering the entrance of a music cue, so that it is unobtrusive, it can be slipped in during a distraction or emotion shift. Usually the music starts in response to a line of dialogue or some specific action. Since it's a response, the music shouldn't come in early or it will be foreshadowing an event. It shouldn't come in exactly at that special hit point either. Try letting it start just after the shift. That allows the music to heighten the drama.

- *Play the Cue Through*: If music starts within a scene, it normally should play through the scene. However, sometimes stopping the music during a scene can heighten a dramatic moment. The cue can then be over, continue through the scene or change somehow.
- *Bridge the Cut*: It's better to have the music bridge into a new scene from the previous one. Often the cue is started under the last line of dialogue from the previous scene. The cue could also come into the scene not long after the cut and under a line of dialogue or during some initial action. Take care when starting the cue right after the scene change as it might seem late to the audience and might draw attention to the music and away from the story. That's why bridging is a better option.
- *Ending the Cue*: Be careful not to end a cue too soon. If your cue ends on a held note or chord, you can run it long and let the music mixer end it properly during the dubbing session. There needs to be a reason to end a cue. It may be a scene change, emotional change, action change or even a time change. Let the story or given scene determine when to exit a cue.
- *Shifts*: A subtle way to start music is to bring it in when something changes on screen. The change could be a pertinent line of dialogue, an emotional outburst, a camera movement, an action on-screen or even a cut.
- *Crossfades*: Starting a cue right at the very beginning of a long dissolve will clue the audience that a major change is about to happen. Usually a dissolve represents a passage of time.
- *Wall-to-wall Music*: Normally you need to avoid wall-to-wall music. If there are no breaks or quiet time, the music becomes carpeting or wallpaper and loses its ability to support the story. It may work for some films, but great care must be used to keep the score fresh and not repetitive.
- *Music with Dialogue*: A music cue can be brought in during a dialogue scene, but it must not draw attention to itself. The cue needs to be composed so that it plays with the dialogue and weaves throughout it without competing with it. To keep the competition down, try not to have any loud solo instruments playing during the dialogue section.
- *Music without Dialogue*: A scene without dialogue is one of the easiest to cover as there is no talking to compete with. The old saying is: Music up when they kiss and down when they talk.
- *Music or SFX (Sound Effects) Cue*: In action scenes with music and extensive sound effects, either the sound effects should be dominant or the music, but together they can be confusing and distracting.
- *No Cues*: Sometimes a scene doesn't need any music. If you watch it and you don't sense that there would be music in the scene, leave it out.

In order to keep track of all the cues you may have for your film, the cues are named in accordance with the reel and the chronological order in the reel. For example: the first cue in reel one would be 1m1. The "m" stands for music. The second cue in reel one would be 1m2. The first cue in reel three would be 3m1 and so on. If your film is a short and has only one reel,

then the first cue would be 1m1 and the second 1m2, and so on. If you revise a cue then it will be 1m1 rev1 or whichever revision number it is. You could even drop the reel number in a short film and just use chronological cue numbers, m1, m2, m3, and so on.

HITS OR HIT POINTS

A hit is a specific moment in a cue that is accented by the music. The moment might be a particular line of dialogue, a visual edit or even a camera movement. There is a tendency for composers who are beginning their career to use too many hits. This tends to make the hits less important because they become common. They also start sounding like a cartoon, when nearly everything has a hit.

Hits are usually high points or turning points in a scene. There can be chord hits, orchestral hits, percussive hits or whatever type of hit that will work for a specific point. Hits are usually a specific instance in a scene where the music needs to match the action. Making the score match the action is an involved process that takes planning and timing, especially if there is score leading up to the hit, as the music has to work with the picture.

1. A hit can start a cue and then the music can move into its purpose.
2. There can be one or more hits during a cue. These can highlight an emotional or an action-oriented change that needs emphasis. If a hit needs to be subtle, then just making a chord change might suffice. If the hit is a big one, then you might want to use a change in tempo or instrumentation too.
3. A hit can bring a cue to an end. Depending on the scene, you may fade out the hit or you may end it quickly.

A hit doesn't have to be the start or end of a cue, but can also be a key change, a change in tempo, introducing a new instrument, starting a new melody, changing a chord progression or any other manner that says change, yet works well with the scene. Whatever changes in the music you use, it should be for a purpose. It should also convey information about events and emotions.

In order to make sure your hit points match the visuals, it's good to have worked out where the hit points will be before you start scoring the scene. That way, you will have created the music based upon the tempos you need and not have to edit the music to get the tempos right.

Watching a few films that are similar to the one you're working on is a good way to get a sense of when to use a cue and add a hit.

TEMPO MAP

Tempo mapping is the layout of beats per minute for a cue or different parts of a cue. You may envision a cue that starts out slowly and then ramps up to a faster tempo when the action starts. In the following example the tempo starts at 75bpm (beats per minute) and then increases to 122bpm.

Figure 11.2

Derek Jones, Chief Engineer and Production Manager at Megatrax, discusses a great example of tempo mapping:

You may want to have a big hit at the beginning of a big car chase scene. The scene starts with a drum hit and then light violins holding a chord until 17 seconds into the scene when the car door slams. Right into that car door slam you want to do a string riser so it stops right before the door sounds. Then you want to pause for the door slam. Now start a soft yet driving filtered-type drum loop with French horns and some distorted guitar playing a bed as the chase scene begins.

Measure 1 would be where the big drum hit is going to be . . . measure 2 could be where you want the strings to start rising, measure 3 will be where the strings stop (this will probably be a short odd meter bar to last through the door slam but also setup the tempo for the loop and musicians that come in right after).

Find something visual to use as a reference point in the picture, like a picture edit or an action . . . So the scene start is the cue's start. So find the frame where the scene starts. Select from there to the next "action point" on the film. Let's say we see a guy's feet from the calf down walking toward a '68 Shelby Cobra blocked in the center of the shot several feet away. As soon as we see the legs/feet, we want the string riser to start . . . so you select from the first frame in the scene to the first frame of the legs shot. In Pro Tools, Hit Cmd+I and say start 1|1|000, end 2|1|000 and set it to 4/4 meter. Boom . . . Pro Tools automatically calculates the exact tempo it will take for a 4/4 measure to be that EXACT length.

Next you select from the first frame of the leg shot up until, let's say, 4 frames before the door slam (not sure if that would work, you would have to decide if 4 frames is enough of a pause to make the door slam stand out). Hit Cmd+I again and this time say 2|1|000 to 3|1|000 4/4. Now you have a new tempo for bar 2.

Now look ahead and try to get a vibe for the picture editing style in the moments leading up to the chase and the chase itself. Are there a lot of fast picture edits? Lots of action or are there lots of aerial/panoramic shots? How quickly do the picture edits go by? Whether knowingly or unknowingly, most picture editors will basically cut a sequence to a very steady tempo. Selecting and using Identify Beat you can look for similarities in tempo and find a rough rhythm that the scene is cut to. Once you find that, you have your tempo for Bar 3. Let's say it's 131 beats per minute for this example.

Go back to bar 3, which happens 4 frames before the door slam. Set bar three to be 131 bpm. How many quarter notes go by starting at bar 3 before you start to feel the dead air after the door slam? Maybe 3 quarter notes? So make bar three a measure of 3/4 and then make bar four 4/4 and it will continue at 131 bpm at 4/4. The reason for the 3/4 bar at 131 is to hopefully give any live players (guitarists, orchestra, bass player, keys, etc) a couple "clicks" at the new tempo before they have to play so they can get into the groove.

You probably could have made bar 3 a measure of 4/4 with a different tempo . . . but then that wouldn't help the musicians who might have to start playing right at bar 4. So that is why you would do that . . .

OK . . . so now that you have the tempo roughly mapped out, start writing the music you were envisioning . . . put your percussion and tense violin hit on bar 1 . . . let the violins hold a really high chord lightly in the background through bar 1. At bar 2 trigger the string riser MIDI note . . . and stop the note right at bar 3. At bar 4 start your drum loop at 131bpm and start playing around with brass lines, bass parts etc. as the chase sequence plays out . . .

So, it's hard to just "say" this is how you create a tempo map because it is going to be different for every scene.

CLICK TRACKS AND GUIDE TRACKS

A click track is essentially a metronome that keeps all of the music tracks at the same tempo and thereby in synchronization with each other, especially if parts are recorded at different times. Click tracks are useful in film scoring to guide the tempo changes in the score by speeding up and slowing down where needed and by timing the hits so that they are in synchronization with the visuals. Recording with a click track makes the music tighter and easier for the music editor to edit.

Once you have a click track, you can record a guide track, if it's useful to your musicians. A guide track is usually an instrument such as a keyboard or guitar that has been recorded just as a guide for the other musicians. It's not intended for the final score. The musician creating the guide track will perform in synchronization with the click track. This recording will help

the actual score musicians with timing and consistency, especially if you are tracking different instruments in different recording sessions.

TEMP SCORES

Temp or temporary scores are very useful for getting a feeling of what type of score will work with the story. They can also act as a guide for the composer. Temp scores are often used for test audience screenings.

The temp music is edited into the film at the appropriate places. Since it wasn't written for the film, it takes some careful editing to get the music to fit properly with the picture edit.

Temp music is often protected by copyrights, so make sure you are following copyright laws when you use it. If you decide to use copyright protected music in the final mix of your film, you'll have to acquire the proper rights.

Occasionally, a director will become so used to hearing the temp music that they want to use it in the final mix instead of a scored cue. If the temp music is a popular song, this may cost the production a lot of money. To keep costs down, I suggest that you do not become fixated on the temp music and be open to the score.

MUSIC SOFTWARE

In order to compose music you can use a pen or pencil and paper, but you might want to use notation software such as Finale, MuseScore or Sibelius. MuseScore is free and available for both PC and Mac usage. To create, edit and mix a musical score for your film, you'll need to have a way to make music and a way to edit it in synchronization with the picture. Some of the industry standard software applications for creating music are Logic, Reason, Cubase, Digital Performer and Pro Tools. Whichever one you choose to use, make sure you get to know it very well, so it can be an effective tool for you.

If all the above software applications are outside of your budget, you can acquire software such as Sonar, Sound Forge, FL Studio, GarageBand or Acid, which are all useful for music creation. The software available to you will depend on whether you have a PC or a Mac.

Some music production software applications, such as LMMS, DarkWave or Temper, are available for free; however, some of them don't allow for synchronization with video.

SCORING

Scoring is the custom creation of music that is designed to work with a film. This film music doesn't come from a specific source inside the story world, like a song on the radio within the story would, but is added as a layer of pertinent sound that helps tell the story. If the music is helping the audience to understand and feel the film, then it has done its job.

There are some short cuts to scoring that come with standard movie conventions. You can use a simple melody in a major key for the protagonist and a dark piece in a minor key for the antagonist. A simple melody is one that has no counter melodies and no strong rhythm such

as you get from a bass or drums. Below is the beginning motif of Beethoven's 5th Symphony in C minor. It's simple and effective for a symphony, but might be too intense for some film scores, plus it's instantly recognizable as the 5th.

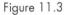
Figure 11.3

You may find that an effective theme can be created using only a few notes. The film, *Jaws*, 1975, is a good example of simple and effective scoring. The shark's motif is a repetition of two notes, E and F, which are a semitone apart. The rising tempo at which the notes are played increases the suspense.

Sometimes a vocal chorus is useful in supporting a sense of mystery and awe. Hearing voices without any specific lyrics can suggest something religious, eerie or even fantastic.

Some science fiction movies employ the use of strange sounding electronic instruments, such as the Theremin, to tell the audience that what they're seeing is not normal. Such music could also be used to show a character is confused, drunk or on drugs. A standard synthesizer is useful in creating these types of sounds too.

Romance stories often utilize string instruments to create a soft and gentle feeling. Westerns commonly rely on folk music performed on pianos, guitars and accordions, while war films tend to have some form of a march and often use brass instruments in the score.

Instead of an orchestra, some composers may use different types of bands; for example, using a jazz ensemble to support the story. Often, this means that the lead instrument is a saxophone. If you wanted an older jazz sound, then you could use a clarinet instead of the saxophone. The other common instruments in a jazz band might be a double bass, a piano and usually a drum kit.

In scoring, less is more. There are times where a big orchestra is the right choice, but more often it's the score that utilizes just a few instruments and has a simple rhythm or melody that works best.

As you prepare to create the score for a film, brainstorm: sit down and play. Come up with a bunch of two or four bar phrases. Spend at least 30 minutes to an hour doing this. As you finish one quick phrase, move on to another. There will be time later to play with each one. Choose the phrases that you feel best fit the story and now develop them into an eight-measure theme. Play with the harmony or melody. Invert some notes. Reverse the order of the notes. Play with the music until it feels right.

If the brainstorming isn't working, try adapting some public domain classical music to the film. You might take a theme and alter it in some way to make it sound different, natural and effective.

Once you have your main theme, you can build on the score from it. This is where variations on a theme come in handy for various scenes. By altering an instrument, a tempo or a key, you can change the purpose of the main theme. For example, the same theme can be hopeful in one cue and sad in another.

Changing the tempo is one of the greatest tools you have as a composer or editor. Most software will allow for the tempo to change during a cue. You'll need to map out whatever changes you do. It's better if you ramp up or down from one tempo to another. It would be quite abrupt to change from 80bmp to 120bpm. If you are recording live musicians, such a quick change might be difficult for them to perform. A simple way to make a transition in tempo is to hold a note and then begin the new tempo during or at the end of the note.

The important thing to remember is that the score needs to have continuity throughout the film and that it needs to support the story, while remaining invisible most of the time.

THEME AND MOTIF

Themes are generally considered to be longer pieces of work than motifs. Motifs are parts of the theme. Leitmotifs are lead motifs that identify a character, place, object, idea or feeling in a film. Generally speaking, themes are several measures long and motifs are only a few measures long. A motif may even be a short phrase of only a few notes. A great example is the reoccurring leitmotif when Darth Vader is nearby or on screen in the *Star Wars* movies. His theme is usually written as a march, but when he is dying that theme has a slower tempo and no longer sounds like a march, because it conveys a sense of life fading away.

Throughout your film, you may choose to speed up, slow down, change instruments and keys, whatever makes that cue work for a given scene. By altering the leitmotif, you can demonstrate a change in a character, like a character becoming brave. You can also use them to foreshadow events. You can use them to show a change in relationship between two of the characters. These changes might be nuanced or direct hits.

Unless you have specific input from the director, as the composer, you'll need to decide how many themes are in the film. You may have only one theme and several variations that will work for the entire film or you may choose to have several themes that you adjust throughout the film. You'll need to find a way to hold all of these themes together and that might be through the use of some commonality, such as the same group of instruments, the same lead instrument or the same music genre.

TITLES, MONTAGE AND CREDITS

The music used with the title sequence can be either a song or score, so long as it sets up the story. The title music can give the audience an idea of what type or genre of film they are about to watch. It can set the emotional tone of the film. It can weave in the various motifs. It can also let the audience know the locale and time period of the film.

Montage sequences can have sound effects supporting them or they may have music. Sometimes they have both. If it's music, it could be a score or it could be a song playing along

with the sequence. If the music has any lyrics, they usually give meaning and create continuity for the various images that make up the montage.

The end credit music is often a song that maintains the feeling of the film and also offers a sense of closure. The right song can have the audience leaving the theater with a smile on their face, which is good for word-of-mouth promotions for your film.

COMPOSING, ARRANGING, ORCHESTRATING AND INSTRUMENTATION

Composing

When you're creating music, you may be inspired by an existent score or song, which may influence your composition. That can be useful so long as you do not copy the melody or the lyrics, as these are probably copyright protected. You can usually use the same chord progression, instrumentation and tone without violating a copyright.

In part, you need to choose your instruments according to timbre. You don't want the frequency range of the instrument to compete with the dialogue or the sound effects.

You may choose to use a major key, minor key or even atonality to create your score or at least portions of it. Atonality is music that has no tonal center. It also has no major or minor keys. The most well-known is the 12-tone technique. It works particularly well for horror films.

If your score doesn't contain any atonality, then you'll want to decide on whatever melodic, harmonic, rhythmic, and so on styles will work for the film. The cues do not have to all sound the same, but they should fit together musically.

As you compose for the different cues, be careful to avoid "mickeymousing," which is when the music matches the action on screen. For example, when Mickey Mouse climbs a ladder, the music ascends with each of his steps. This merely parallels the action and doesn't add any information to the scene. It might be cute in a Mickey Mouse cartoon, but not so great for a scene in which the killer is climbing down the stairs into the basement where the last person alive is hiding.

It's also good to avoid musical sting sound effects. Let the actual sound effects do their job. If you need a stinger, place it just before or just after the sound effect, but make sure they work together.

A drone or a sustained low note can be very effective, but when higher notes are held for a long time they become annoying. Think of a low note as below normal speaking range and a high note as one above the normal speaking range.

Arranging

Once the music is written, it may then be augmented by arrangement, which can include adding new thematic pieces, structure development, key changes, transitions and even endings to a musical cue. Basically, arranging adds variety and interest to the overall score.

Arranging can be seen as the process of creating moods. There is no defined way to do this. It's best to experiment until it sounds and feels right to you and the director.

Orchestration

Orchestrating is the process of transforming the composer's and possibly arranger's score into sheet music for the individual instruments.

There are many considerations when tailoring the score for each instrument. For example:

- What is the range of notes for the cello or some other instrument?
- How do string musicians decide which way their bows will move?
- Does the instrument bow over the bridge or perhaps near the bridge?
- What key is a particular instrument in and how do you make a transposition into other keys?
- When do you dovetail two different instruments?

If you are using samples, be aware that you need to create music that sounds realistic. Don't have instruments doing more than could be humanly possible in a recording session.

Instrumentation

Instrumentation is the process of selecting and combining instruments for a musical composition. There are some conventions in regard to such aspects of the film as era, genre, ethnicity and location.

For example, if the location is in Australia, then there is often a didgeridoo in the score. If the location is in Scotland, then a bagpipe is common. If the location is in Africa, then drums are associated with many cultures located there. In terms of era association, rag time music represents the 1920s, swing music the 1930s and big band music in the 1940s.

When composing or even when using loops or pre-existent music, it's best to be aware of the frequency range of the various instruments, especially if those instruments are within the speaking range of the actors. Most instruments have some, if not all, notes within the human speech range. You'll need to be aware of that so you don't compose in a way that competes with the voice. A post-production technique for using EQ (Equalization) to make the dialogue stand out from the music is as follows:

Most normal human speech occurs between 80Hz and 1100Hz, which is E2 to C6 in musical terms. If you have recorded music that is within the frequency range of the human voice and it is competing with the voice, you'll need to add EQ to the music or to the specific instruments that are competing so that the voice stands out. The approach I suggest taking is that when having to EQ music for voice, add an equalizer to the

dialogue track. I then decrease or cut the "gain" by at least −12dB and sweep through the frequencies of the dialogue until the level of the voice is at its lowest or thinnest. To avoid using a notch filter for this process, I adjust the "Q" until it's shaped like a bell. Once I've found the right frequency range, I either note, copy or save this setting and then apply it to the music track. I then return the dialogue back to its original EQ and set to work adjusting the level of the music EQ until the voice stands out. If you have a frequency analyzer, then you can use it to find the frequency range of the voice and apply that to the music.

Sometimes the letter "Q" is referred to as meaning quality or even quantity, but neither is accurate. In 1920, K.S. Johnson, an engineer at Western Electric Company, chose the letter Q because it was the only letter in the alphabet not being used as an engineering physics symbol. Put simply, Q is a symbol for frequency and bandwidth ratio. It has nothing to do with quality or quantity.

When composing a cue, it may not be necessary to have an entire orchestra. You may be able to accomplish the same goal with a string quartet or even a solo instrument. Often a single violin can support a romantic scene.

Try to create texture, color and timbre by using different instruments, otherwise the music can sound repetitive and get boring, but don't go overboard.

Because of budget and time constraints, it's becoming more common to combine both instrument samples and live musicians. In order to make the sample seem more natural, it's common to add randomization to the notes. Different parameters can be automated to make the samples fit in better with the live acoustic instruments. This may take some experimentation, but it's often possible to blend them together effectively.

MOCK-UPS

Whether you like to sit down with paper and pencil or you prefer to write using software or you like to use MIDI to create rough versions of what are called mock-ups, you need to compose music that will work with each given scene.

MIDI mock-ups are great for films that will ultimately use live musicians as it gives the director an idea of what the orchestra will sound like. Mock-ups are commonly done with samples or virtual instruments. The composer writes the music and then creates it using a keyboard and samples of instruments. The better the samples the better the mock-up will sound. Most composers try to have really good sounding mock-ups as they are trying to get approval for their score, which may be performed by an orchestra.

Mock-ups are usually provided to the director as they are created and are stereo-interleaved tracks that are either .mp3, .wav or .aiff files. These files can easily be cut into the picture editing

software. The director can then hear them in place against the picture and decide if the cues are working.

RECORDING PERFORMANCE (TRACKING)

Whether you are recording a solo instrument in your bedroom or you are recording in a large studio, ideally, you'll be able to play the film so that the music is performed in synchronization with events on screen. Whether or not you can see the film, you can still record the music cues by using a click track. The click track will play in the musician's and the conductor's headphones, which will allow them to play according to the tempo and meter changes needed for the film. Tempo being the speed of the performance, such as 66 beats per minute and the meter is the regular pattern of beats, such as 2/4 time.

It is critical that the musicians playing rhythm instruments, often drums, hear an accurate count-in. I suggest a two-bar count of one . . . two . . . one, two, three, four.

If you are doing the recoding of the music, then you'll need to know what microphone to place where in order to get the best sound. There are many books and articles available on microphone placement for instruments. If you are recording at a studio with an engineer, they'll make sure the microphones are set up properly. There are many different ways to microphone different instruments. A grand piano could be microphoned with just one microphone or with many more.

If you are recording a large orchestra it's best to record the entire orchestra first, then record sections and finally the solos. This keeps costs down by allowing the unnecessary musicians to leave once they have finished playing.

It's common to record an orchestra or even a solo instrument at 24 bits and 96K. This will include the recording of harmonics that are out of normal human hearing range. Some scientists say that even though we cannot hear them, we sense them and the music sounds better to us, if those ultrasonic frequencies are there.

The most common file formats are BWF (.bwf), WAV (.wav) and AIFF (.aiff). More often than not, these are the formats that are accepted at a dubbing stage. MP3 files are not considered to be of high enough quality to be used for film scoring.

DIGITAL MUSIC

Synthesizer

A synthesizer or Synth is an electronic musical instrument that generates electrical signals that are converted to sounds. They can either imitate musical instruments or they can generate other types of sound.

A synthesizer is usually operated by playing a keyboard, which produces sounds using voltage-controlled oscillators, amplifiers and various filters.

Some notable synthesizers are TAL-Bassline, Crystal, FreeAlpha and Synth 1. All of them are for PC and Mac.

Synthesizers are commonly used for sci-fi and horror films. They can be used to create some unique sounds. The limit is your imagination.

MIDI and Virtual Instruments

MIDI (Musical Instrument Digital Interface) is a controller or sequencer that fires off electronic signals that create the sound of virtual instruments. When a MIDI key is depressed, it sends a signal that turns on the note and also determines how loud to make the note, which is based upon how hard or fast the key is hit. Once the key is released a "turn the note off" message is sent.

MIDI is a useful tool for creating a score. It can be used to manipulate sampled instruments or synthesized ones as well as augment real instruments. It is often used to mock-up what a final real orchestral score might sound like. The key to using MIDI is to get the music to seem as real as possible by manipulating the sounds. However, your film may not call for the sound of a real orchestra or real instruments, so a MIDI score might be all you need.

Most software used for MIDI allows for some velocity and pitch randomization. This will help make the MIDI music sound more human made. Adding some volume and pan automation can help reduce the mechanical sound of MIDI instruments. Reverberation is always useful to get the music to sound like it was recorded in a studio space and not sound like a series of ones and zeros.

Samples and Loops

The continual improvement of the quality of audio samples has led to many no and low budget films being able to utilize the sound of real instruments. Often the scores for these films are created and performed entirely by the composer on a keyboard.

The samples are recordings of actual instruments and sounds that can be played back at different pitches. A sampler uses sounds that are loaded or recorded into it to generate music. They function similarly to synthesizers, but they don't create sounds, they manipulate them. The most common manipulation is to pitch shift the sounds into a musical scale. This allows for playing individual notes, multiple notes and chords.

Loops are samples that have been created or edited so that they can be repeated in a looping fashion that sounds continuous. The key and tempo of the loops can be changed so that the music or beat doesn't sound too repetitive.

Most samplers allow for the ADSR envelope to be altered for the notes being played. Normally the envelope modulates the loudness of a sound overtime. The envelope looks generally like the graph below, although the durations will vary.

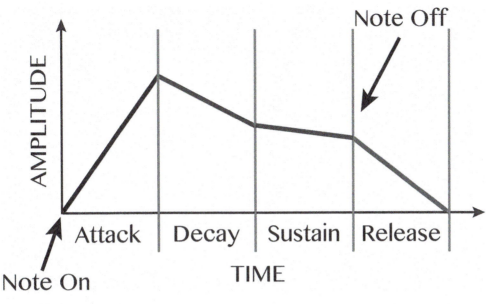

Figure 11.4

ADSR is an acronym that stands for Attack, Decay, Sustain and Release.

- *Attack* time begins when a key is pressed and continues until the sound hits its peak.
- *Decay* is the time it takes for the sound to drop from the peak to a sustained level.
- *Sustain* is the level that is maintained until a key is released.
- *Release* is the decay time from the moment a key is released until the level drops to zero.

In television, because of tight production schedules, it's common to use sampled instruments in soundtracks. In film, it's less common, at least when it comes to Hollywood big budget films. Low and no budget independent cinema composers are much more likely to use sampled instruments.

If you don't have the budget for a composer and you decide to take on the task for yourself, then using software that allows you to manipulate samples is a viable direction to go. Most music creation software or digital audio workstations come with samples. Some come with thousands of them. Most of them allow you to create music in synchronization with the picture.

Unless you want the sound of a large orchestra, it can be fairly straightforward to make an effective score for your film. If you want that orchestral sound, you'll have the challenge of manipulating the various instrument samples into sounding like an actual orchestra. It could be just as effective to use only a few instruments and a simple score.

If the samples that come with the software you're using for your score are not of adequate quality or there are instruments that you want to use in your score, but they are not included in the samples you have, then you can download or order some really good samples online. There are some free samples, but check out the quality before you download. There are some really high-quality sample libraries available and to keep down costs, you can often purchase just the instruments you'll need for your score.

The goal of your score is to augment the film. It should help tell the story using the music that fits a given scene and the film as a whole. Since music supports the story, it need not draw attention to itself and using poor-quality instrument samples might do just that. If you have an electronic sounding saxophone, then it will pay to find a realistic-sounding one and manipulate it to fit the score. You want your score to sound real, not phony.

One issue with using samples instead of live musicians is that the live musicians can express the right emotions at the right time. That's hard to do with pre-recorded instruments that are edited into position and manipulated to sound decent.

Since samples are not as nuanced as live musicians, it's best to compose your music knowing the limitations of the sample approach. In other words, take what you have and blend the elements together so they work. There are bowing, blowing and striking techniques that would be extremely difficult to accomplish with samples, so don't attempt them in your composition.

If you are the composer and the editor, then you'll have an easier time of the process. You'll know all about the music you are editing and what you, the composer, were trying to accomplish with each cue.

GARAGEBAND

GarageBand is a sequencing software that allows you to mix audio files, MIDI and samples to create your own film score. GarageBand uses Logic Pro's audio engine. GarageBand is very user friendly. When you first open GarageBand, you'll have several project options. Under the option titled, "New Project," you'll have several icons to choose from; for scoring, you need to select the one entitled "Empty Project."

Figure 11.5

Next drag your film into the track area or go to File>Movie>Open Movie. Once the movie and its audio track are imported, they'll be displayed in the timeline. If you want to make the film larger, you can now size it as needed by dragging out from any one of the corners.

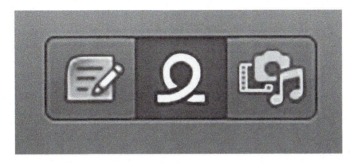

Figure 11.6

Look in the upper right corner of the window. Now click on the "loop" icon, which is the one in the middle position. This will bring up your loop options, which include many instruments and styles of music. There is a good selection of loops that come with GarageBand, but you may choose to buy more to do your score.

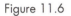

	Scale:	Any	
Reset	Favorites	Rock/Blues	Electronic
All Drums	Jingles	Urban	World
Beats	Percussion	Jazz	Orchestral
Bass	Tambourine	Experimental	Cinematic
Synths	Shaker	Country	Other Genre
Piano	Conga	Single	Ensemble
Elec Piano	Bongo	Clean	Distorted
Organ	Mallets	Acoustic	Electric
Clavinet	Vibes	Relaxed	Intense
Guitars	Strings	Cheerful	Dark
Slide Guitar	Woodwind	Dry	Processed
Banjo	Horn	Grooving	Arrhythmic
Vocals	Saxophone	Melodic	Dissonant
Sound Effects	Textures	Part	Fill

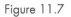

Figure 11.7

You can now start selecting loops and MIDI music to add to the time line. Once you find a loop or music you think will work, click on it and drag it over to the area labeled, "Drag Apple Loops Here."

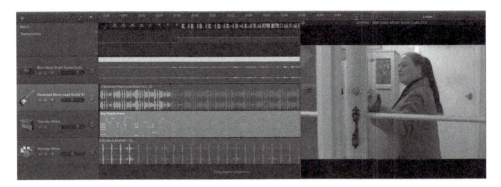

Figure 11.8

This image is a music cue in the short film, *Skin Deep*, which has a simple score. The darker files on the timeline are for the drums and guitar, which are audio files. The lighter track is a keyboard MIDI track.

GarageBand will allow you to do some editing, tempo changing, key changing and some other alterations to the music in order to get it to play well with the picture.

Next go to the "Track" pull-down menu and select "Show Master Track." The image below shows the master track with the volume displayed. This will allow you to change the master level up or down along the timeline.

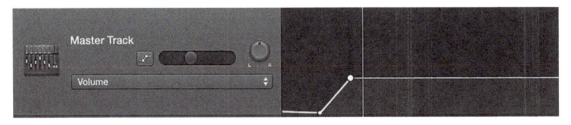

Figure 11.9

Besides the volume level displayed, there are also ways to alter the music by using EQ, compression, reverberation, echo and other plugins.

Figure 11.10

The lines in the below tempo window show how tempo can change during a score.

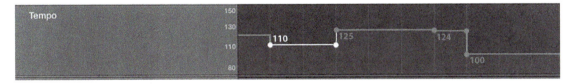

Figure 11.11

There are many easy to follow tutorials on the internet that will help you learn how to use GarageBand to achieve your score.

Unless there has been an upgrade, GarageBand's highest resolution is 24 bit and 44.1k. You would need to up-sample it to 48k for video. Most sound design mixes are done at 24 bit and 48k at the very least, so the music file would normally be converted up to 48k sample rate upon ingesting into a DAW or NLE. If your DAW or NLE system doesn't do an up-conversion to 48k, then you'll need to use a third-party software application to accomplish this. Without

the up-conversion, the music will run at 44.1k in a 48k session and thereby run slower, which may well cause it to be pitched down.

SONG SCORE, POP MUSIC AND SOURCE MUSIC

Songs are generally not considered to be part of a film's score, but they can be used to enhance and comment on some aspect of the drama of the story. Scores do not usually have lyrics, although they may contain choirs singing. If a composer uses a choir, they may have them singing actual lyrics, made-up words or just syllables, like *ahs* and *ohs*. There are virtual instrument choirs that can be very effective in a score. EastWest has a choir sample package that allows you to enter text from nearly any language and the "choir" will sing it.

A composer may write a pop song for a film, which is usually based upon the overall theme for the film. The composer of the film, *Titanic*, 1997, James Horner, wrote the song, *My Heart Will Go On*, for singer, Celine Dion. The song fits in well with the story.

The difficulty of using songs as a score is that they usually have only one mood, while a scene may have several mood or emotional shifts within it. A song would then not be able to support the scene well. Songs do work well with action scenes and montages as they usually only have one mood and there is little if any dialogue for lyrics to compete with. If the style of your film calls for it, you could use an existing song or hire a band to create and perform a song. The important aspects are that the song fits in with the film and that there is a valid reason for using the song; it should either add something to the drama or emotions in a scene or comments on the entire film.

Sometimes songs are used as source music. Source music is when a song is occurring within the story and not as an underscore. Academics refer to this usage as being diegetic, which means within the story world where the characters can hear it. Source music might come from a radio, television or even a band in a scene in the movie. Source music is different from the score in that the score is not heard by the characters.

Some composers have played with the audience by having music that seems to be part of the score, but is then revealed to be music that the characters are listening to on a radio or juke box. The opposite happens too. This is when characters may be listening to a song on the radio or juke box and it carries over to the next scene where the music is now acting like score. The EQ, volume and reverberation may need to change so that the score music no longer sounds like it's diegetic.

Most songs are selected for their lyrical content. The words and message are what's important. Sometimes composers will use particular songs because of the popularity that the song has. When an audience hears a song they are familiar with, the meaning of the lyrics can be applied to the story. Great care must be used when selecting a song as it may well date the film.

Director, Quentin Tarantino, is known to use pop songs in his films. *Pulp Fiction*, 1994 and *Reservoir Dogs*, 1992 are filled with them.

Music can also be used contrapuntally or as counterpoint to the action in a given scene. Using happy music during a sad scene is a classic example of this type of musical juxtaposition.

Sometimes composers choose to use soothing classical music over a very violent scene just to soften the intensity of the actions on screen.

If you use songs in your film, you'll need to get all of the rights to use them. If your film is going to be broadcast, then you'll need to fill out a music cue sheet. The cue sheet contains information such as what song you used, the composer, the publisher, how much of the song was used and how it was used. How it was used includes having it play with the main title sequence, the end credits, as a background or other purpose in the film. The cue sheets are used by ASCAP (American Society of Composers, Authors and Publishers) or BMI (Broadcast Music, Inc.) to determine the costs of the song's usage and how much royalty to pay the composer or composers and other rights holders.

CUE PACKAGES

Packages are common in productions such as documentaries, industrial films, instructional films and some television programs. They are sometimes used in creating a score for a film. A composer is hired to create music that will work for the subject matter or genre of the program. The score is not produced in synchronization to the picture. It's up to the picture or music editor to make the cues work. The composer must create music that is flexible, has various hit points and can be easily started and ended.

If the music is created for a television series, the producers can build up a library of cues to use in subsequent programs. This saves money by only needing the composer until there are enough cues for all of the shows.

BANDS

It may work for your film to have a band, maybe a local band, creating the score. Before you chose this direction, make sure that the style of music the band plays will match the style needed for your film. You also need to determine if the instruments they use will effectively work for creating the emotional support needed for your story. If it's a good match, then you need to meet with them to view and discuss your film. You'll need to tell them that the score needs to be secondary to the dialogue and that the music is there to support the story, not stand out on its own. This can be a hard concept to grasp for musicians who are used to being on stage and being the center of attention.

If the band's music doesn't work for underscore, it may work well for the opening titles, montages, closing credits or all three. You can then create the underscore separately. If you choose to do them separately, then whoever does the score might try to work with some of the elements used in the songs created by the band in order to maintain a level of continuity to the music. This may mean using some of the same instruments, tempos, keys and styles.

MUSICALS

If your film is a musical, then the songs will act as a form of dialogue, helping to tell the story. The lyrics are directly tied into the spoken lines of the script. It's common for a line of dialogue

to lead into a song. When a character breaks into song, these are usually moments of intense emotions for that character and they use a song to express them.

Technically, the songs for a musical are written and often recorded before the film is shot. This allows the actors to lip-synch to the music during their performance. The songs are played during the shooting of the scene so the actors can follow along. Sometimes the song is played into a wireless earpiece and the actor sings along in synchronization with the music. This allows for the actor to add the natural emotions to their singing, which comes from being on the set with other actors and not alone in a vocal booth.

LIBRARY MUSIC: HARD DRIVES, CDS AND DOWNLOADS

There are some great pre-recorded music libraries available for scoring your film. Some things to consider when using a library are that the tracks are available to anyone, so they are not exclusive to your film. They are preset in duration, so you have to edit them to make them work. There are usually only a few variations of a track, if any, which means that you have little choice in instrumentation, tempo or hits for any given track.

There are some music libraries, like Associated Production Music, Extreme Music, SonicFire, FRESH Music and VideoHelper, which create their music so that it's easy to edit. They might include numerous hit points within each cut, which helps with timing a hit or with beginning or ending a cue within time limits. They might also include sections of the music that can be looped or can be edited to adjust timing. The music usually includes quiet parts as well as intense parts so you can mix and match to your needs. It's easy to edit because they usually don't change key or tempo, which can be helpful or limiting depending on the needs of the cue.

Sonicfire Pro creates music loops that are designed so that they can be easily edited to whatever length you need for your cue.

Some of the music library companies will compose music for your production. Others, like De Wolfe Music or FRESH Music, simply license the music they have. Some of them charge a flat rate to use their song. Some charge per music cue used or by length, purpose of use or type of distribution of your film.

You can often download music cues from a website and pay the licensing fee at the same time. This will allow you to use the music in your films, but not own it. There are many ways to license the use of music. Here are a few examples. You can pay for a royalty-free usage of a musical piece, which means you make only one payment no matter how broad the distribution. You can pay for each time a musical piece is used in a production whether you use 5 seconds or 5 minutes; the cost is per times used. You can pay one amount for festival rights, but an additional amount if the film is distributed to theaters or shown on television or the internet.

There are a number of composers who have their music on websites, like SoundCloud, where you can download and use them for free or very little money. Normally, these composers require that you list them in your credit for their music compositions.

Nearly all composers want to be credited for their music. The film industry's common guideline is "credit where credit is due." One example is composer, Steven O'Brien:

soundcloud.com/stevenobrien/. His SoundCloud music is licensed under the Creative Common Attribution License, which means you can use the music for free, so long as you have a credit that reads: Music by Steven O'Brien, and the internet address of the SoundCloud page that contains the track you used. He provides more details on giving him credit at: steven-obrien. net/#faq. If you want a lossless version of a music piece, which is .wav and not .mp3, then contact him at: steven@steven-obrien.net.

EDITING

Editing cues means matching the emotional and synchronization points so that the music complements the action, flows naturally and maintains the integrity of the composer's concepts.

Music editors are more common to big budget films. Because of tight budgets, lower budget films often have the composer or picture editor performing the duties of the music editor.

In order to edit properly, it helps to be working in software that's designed to do audio editing. It can be done in video editing software, but there are fewer controls. It's best to have a copy of the film in the QuickTime format, as it's the most universal for sound work purposes. If you haven't already done so, you'll need to import the film, along with its audio, into your software for music editing.

The sound on the QuickTime movie may come in different configurations. The more common configurations receive the dialogue and sound effects on one track and the temp music on another or receive a version that has no music in it at all, just dialogue and sound effects. Whatever configuration you receive, your job is to make sure that all the cues that have been created work well with the picture, sound effects and dialogue.

If you have imported the film and corresponding sound into the session that also contains your music tracks, then you're ready to edit. If you are working in a new session, then you'll need to import the film and its sound tracks and the tracks of scored music into the session. If there are any songs used in the film, they'll need to be imported too.

The list of cues and your notes are very useful for guiding you through the editing process. You can use the cue names and in and out times as a guide for placement of each cue on the editing software's timeline. Some software will put a time stamp with the start timecode into the metadata for each music cue. This will allow you to import the cue directly to its place in the timeline. I suggest that you start with the first cue. Once it's working well with the picture, then work your way to the end of the film one cue at a time.

Orchestral music can be more challenging than music with a strong beat. The downbeats give you edit points, but orchestration is not always as defined. You'll have to work to find the right place and possibly have to use a long crossfade to make orchestration work well. However, if there is a strong melody and you use a long crossfade, it might make the differences noticeable, especially if there is a key or tempo change in the middle of the fade.

There are usually several types of crossfades available in each of the software applications used for sound editing. I suggest that you start with an equal power crossfade and use the standard curve shape setting for the in and out fades. This setting will avoid any dip in volume in the middle of the crossfade.

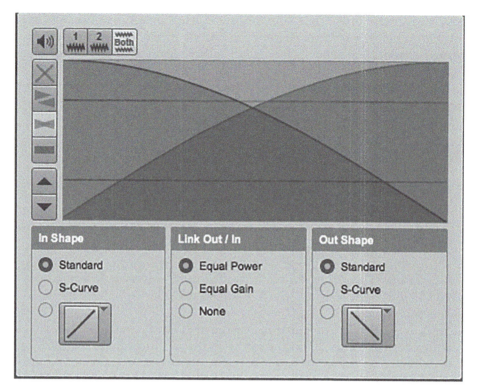

Figure 11.12

If the software you are using has some form of Elastic Audio or Elastic Time, you'll be able to lock your cues to the specific spots the cues were created for and adjust the tempo as needed.

Some editors say that in order to come across to an audience as being in synchronization, music hits should happen within one-third of a second after the picture hit occurs. This allows the audience time to digest whatever has happened on screen so they are ready for the music. Other editors say it should be right on the action. It's best to experiment with the timing to get it to work properly.

You may need to change time signature or tempo, so that your start and time points for hits line up better on the timeline. Ideally, you won't have to resort to this method, but it is an option for keeping your music in synchronization with the picture.

If you are editing with music that is not custom-made for your film, you'll need to make the music fit. One simple trick is to back-time the music so it has a natural ending. For example, if you are using 40 seconds of a 60-second music cut, then you'll need to edit out 20 seconds. You can start by placing the end of the song at the place spotted for it to end. Play it to see if it ends well. If not adjust it along the timeline until the ending works. Now go back

40 seconds from the end of the cue and edit out the first 20 seconds. If you are lucky, the new beginning will sound like a natural start for your cue. A quick or slow fade-up might help the start. If you are not lucky, then you'll need to edit the music so it has a natural start. This may mean taking out a section in the middle of the cue and then joining the beginning and the ending so they are as near as possible to 40 seconds and the music works well with the picture. If you need to remove a large section of a song, try cutting out a verse or chorus. This may get you closer to the desired length. You'll probably still need to do some fine editing to get the song to work well.

Editing music often requires a good sense of rhythm. It is common to want to cut on the downbeat so that there is no interruption in the rhythm. However, cutting on backbeat 2 or on beat 3 may sound much more transparent in some music. The downbeat is the first beat of a measure. A backbeat is the accent that's put on the second and fourth beats of a measure in 4/4 time. Most music used for scoring is in 4/4 time.

If you are shortening or lengthening a musical cue or if you are trying to get two different pieces of music to segue, then you will want to mark the rhythm of both of them using markers. Most editing systems have some form of a marker that can be placed in the timeline or onto an audio clip. The goal is to put a marker on every beat of one of the bars of both pieces of music and then line up the markers of both pieces. The first beat of one piece will be aligned with the first beat of the other. This will then allow you to do a clean edit that maintains the rhythm. The next issue is making sure the melody, chord changes and key changes still sound right. You may have to find another section of one of the music pieces and see if it sounds better. If your editing system can do a roller edit, then you can roll along until you find an effective edit point.

If finding an edit point in the melody, chord progression or key is proving difficult, you could try to find a place where a note is held for a couple of beats or more and doing a crossfade into the other piece. Find a section of the music that doesn't have any short notes included with the held note. The long or held note acts as a transition to the second piece and can makes a crossfade workable.

If you've joined the two edited song segments together, but it doesn't work, try another place. If you can't find a natural edit point, then try a short crossfade. It's always a bit of trial and error and luck to get these types of edits to work. If you have run out of options, then you might try a different cut of music.

If there are any songs used as source music in the film, each will have to be edited for perspective. Just like with sound effects and Foley, if there is a cut from a close-up to a wide shot the volume level, EQ and reverberation may need adjusting to match the camera angle. For example, if the first shot is a wide-angle perspective of some high school students dancing around a car from which music is blasting and then we cut to a close-up of the driver sitting in the car, the sound of the music will change. The wide-shot music will be at a lower volume level than the close-up. The frequency range will be different in the close-up. The reverberation in the car may sound considerably different than that in the wide shot. The music might need to be edited so that the close-up music is on one track, the wide-shot music on another and if there are other camera perspectives, those will have to have to be on their own tracks. This will allow

for the each track to have its unique settings for EQ, reverberation and volume level. It can also make it easier for the rerecording mixer to handle the different perspectives of sounds, if you are mixing at a studio. Another approach would be to add automation to the clips and do the perspective changes all on the same track or perhaps you use the music unchanged.

If the picture has been re-edited since you created the music, the picture editor will be able to give you a "change list" of the picture changes that will contain the timecode and how many frames were added or removed or if the shot or scene has been omitted or moved. There is software like Conformalizer that will do the editing for you, but you'll still have to make sure the music is working, which may mean a considerable amount of editing to get everything to line up properly and flow. This can be a cumbersome process depending on how many tracks of music you have, where the changes are and whether or not a cue has to be shortened or lengthened. This may mean re-synchronizing cues, editing cues and probably smoothing out the cues.

STEMS

In film post-production there are three separate types of sound. These are referred to as DME (Dialogue, Music and Sound Effects). During the final mix of the film all the sound is mixed down to these three elements, which are called stems. The three stems can be played together and you'll hear the final mix. It's much easier to make a change in the stems than it is in the final mixed tracks. It would be difficult to change a music cue, if there were sound effects and dialogue playing at the same time, but if you make the change in the music stem, the dialogue and sound effects are not affected.

Another attribute of having stems is that the music and sound effects can be played together, without the dialogue, and a foreign dialogue track can be added to them, which will make the foreign version sound a lot like the original language version when mixed together.

In music there are also stems, which are the various types of instruments being grouped together. Strings might be one stem, percussion another and brass another. There might also be stems such as a violin pair, viola pair, cello pair, and so on. The music stems, which are sub-mixes, make it much easier for the rerecording mixer who is mixing the music for the DME and final mix, because the music is already somewhat premixed.

MIXING

It is common practice for the music to be premixed prior to the rerecording or dubbing session. This premix will allow you to reduce the number of tracks you provide for the final mix session. It's important that you group similar types of instruments together. You might premix the percussion instruments, in which case you might have the snare drum tracks mixed down to a stereo pair. The overheads might be another stereo pair. If there were two microphones on

the guitar, then you might mix those down to just one track or you could leave them as two discrete tracks, if there aren't too many other tracks.

Normally, the music mixer does not want to mix your music for you. They want you to bring it in at mixed levels. However, they will probably change some of your levels to make the music work better with the film. They'll do some EQ adjusting so that some of the instruments don't compete in the same frequency range as any of the actor's voices. They may add some reverberation or other filtering to make the music fit into the mix, but they don't have the time to do your mix.

Your premix should have very little compression on it, if any. Film sound is about having a wide dynamic range. Too much compression reduces that and makes your music sound harsh. When the rerecording mixer hears highly compressed music, they'll drop the volume level considerably to compensate for the compressed music banging at the top of the range. Nuance, subtlety and suggestion are what film music is about, especially under dialogue. There are times when it needs punch and other times when the details of the music need to be heard by the audience and not drowned out by blaring instruments.

If the film mix is only in stereo, then you can deliver a stereo mix pair along with the other tracks. Make sure that all of them are at your mix level. If the music is for a surround film, then discuss with the director and the rerecording mixer how to assign your music tracks to the various cinema tracks available. Most studios have a template that can be used for music sessions. They will set up in a way that will allow them to input your session into their system and be familiar to the mixers.

If the mix is for television, then it's more common to use some compression on your tracks, so that the music cuts through household noise and can be heard on a small screen's speakers. You'll want to cut the lower frequencies though, so they don't rattle the small speakers on a standard television set.

If you are the rerecording mixer doing the final mix of dialogue, music and effects, then you can add the panning that you want to the music mix. If you are mixing in a studio with a rerecording mixer, then ask them if they want you to do the panning or to leave it for them. This is especially true if the mix is being done in surround. If you are the one doing the panning, then you might try placing the music in the left and right speakers and the music's reverberation in the surrounds. It could add some depth to the music. Do not place the music in the center channel as that's for dialogue.

DELIVERABLES

If you are taking your music to a studio to be dubbed into a film's audio track, then you need to talk to the rerecording mixer to see what specifications they require for the delivered music tracks. The most commonly acceptable formats are .wav and .aiff. They may want a stereo mix, a 5.1 or 5.0 mix or they may want all the tracks or just the stems. It's becoming more common for the music editor to do some or all of the premixing, especially on low and no budget films.

The software used for a studio mix is almost always Pro Tools. Most studios can also work with other software like Nuendo, Cubase or Logic Pro, but Pro Tools is dominant in the film and music industry.

You may be required to provide a Pro Tools or other editing software version for the studio to import into their system. They may want you to have a one-frame long 1kHz tone "beep" or "pop" placed exactly 2 seconds before the first frame of action, which is known as the FFOA. If you are using timecode, that could be at 00:59:58:00 for the first reel of a film. The first frame of picture would then be at 01:00:00:00. Some studios want to have a count-down leader, such as the SMPTE (Society of Motion Picture and Television Engineers) leader, which starts at 01:00:00:00 and then the 8-second leader would follow. In this instance the 2-pop would occur exactly at 01:00:06:00 and the FFOA would be at 01:00:08:00.

Make sure that you have the correct timecode for your music session. Find out from the picture editor what the time code is for the video they are giving you. Also, find out what the audio sample rate is. Usually the audio coming with the video is at the 48k sample rate. You want your music session to be set up to match the video, otherwise you may be editing tracks that are out of synchronization. Some software, such as Pro Tools, will convert the audio import to match the session sample rate, but it will not change the video rate.

Most films are shot at 24 frames per second (fps), but there are other possible rates. The film might be at 25 fps, 30 fps, 29.97 fps or even 23.976 fps. You need to know the video rate in order to avoid having to convert your session to match it. The good news is that you can convert the audio sample rate.

It can be very helpful to have the picture editor give you a version of the film with a time-code burn-in. This is a window that displays the timecode for each frame visually. Make sure that the timecode for the first frame of your session matches the timecode for the first frame of the picture in the timeline. Now you can randomly check along the timeline to see if the time-line timecode matches what has been burnt into the picture. If they are not in synchronization, you have a problem with either the picture or session timecode.

EXERCISE

Most computers come with some form of music-making software. Some of them allow you to play video along with the music timeline. GarageBand is an excellent example of this type of software, although it does cost several dollars to download. GarageBand can be used to create a viable score for a film.

Open a new session in GarageBand and then import a short film or film segment and its audio. Now using the supplied samples and MIDI instruments create a simple score to support a music-free scene from a film. The key is to have the music work with the action and emotions and for it not to distract from the story.

CHAPTER 12

Mixing Myself Preparation

You've finished editing your film. Perhaps you or someone else has done all the necessary sound editing and designing. You are ready to mix the dialogue, sound effects, sound design, backgrounds, Foley and music.

The type of film you have created will determine which aspects of sound will be dominant. For example, a horror or science fiction film will usually have more sound design and possibly more music than a drama or comedy.

The type of distribution that you have in mind for your film will impact the levels for the mix. Film is mixed at a lower level than television, DVD and VOD.

This chapter covers the normal steps you need to take in order to prepare to do your film's mix yourself. The various approaches for processing the dialogue, sound effects and music as well as the mixing are in subsequent chapters.

INTRODUCTION

As more and more post-production budgets decrease in size, there is a trend toward sound editors doing premixing and, to a lesser degree, rerecording mixers doing sound editing. People in each position are integrating the other's skillsets. Sound editors have been doing some mixing in the box and many rerecording mixers have been making changes to a sound editor's work on the rerecording stage.

Some rerecording mixers have become sound editors and will do both jobs on a film, the idea being that they already know the material from doing the editing, so the mix will go smoother and faster.

PREPARING YOUR MIXING ROOM

If you are mixing at home in one of your rooms, you'll need to make the space as sound friendly as possible. You'll want to take into consideration some form of acoustical treatment. This could be as extensive and expensive as bringing in an acoustics expert to test your room and design the correct acoustic treatment for your room or you could try attaching inexpensive foam mattress tops to your walls to help deaden your room and put your money into buying a decent pair of studio reference monitors.

I have seen mixing rooms that used egg crate-type foam and carpeting to act as acoustic treatment, but the results are limited and could actually create problems. This type of foam is better at absorbing the higher frequencies and doesn't do much to reduce the troublesome lower frequencies. Another inexpensive way of deadening a room is to buy fiberglass insulation rolls and affix them to the walls, fiber side out, and then cover them with a cheap porous material, like hopsack or burlap. The material helps keep the fiberglass fibers from floating around the room and into your lungs.

If your intended distribution is for cinema theaters, then you'll want to have a room that comes close to acoustically representing that type of space. If your film is destined for television, DVD or streaming, it will help to mix in an acoustically treated room, but near-field monitoring will suffice. I do suggest that if you are planning on a theatrical release, you do your final soundtrack tweaking or final mix on a professional mixing stage that is designed for theatrical mixing. It could also be helpful to mix the first few minutes of your film in your smaller room and then take those few minutes to a theatrical mixing stage and play it back to be able to hear the differences between a small room and large-room mix. If you pay attention to how the levels, panning and reverberation sound in the big room, you might be able to make some appropriate adjustments to the mix when you're in your smaller room. If you are mixing for broadcast, your small room may be adequate.

A good starting point is to have a room to work in that does not have much reflectiveness; in other words, it doesn't have anywhere near as much reverberation as your bathroom. There are three elements to acoustic treatments: bass traps, acoustic panels and diffusers. The bass traps are to absorb the lower frequencies, which are the biggest problem in a small home studio. The acoustic panels are used to absorb the middle and high frequencies. The diffusers are for scattering the sound that was not attenuated by the other acoustic treatments. There are many books and websites that go into great depth on this subject. I'm covering a couple of possible approaches, but they may not be the best approach for the room you've chosen to mix in.

If you can afford to buy only one of the acoustic treatments, get some high-quality porous broadband bass traps as they also absorb some of the middle and high frequencies. If you can afford to buy some acoustic panels, all the better, as they reduce frequencies that the bass traps don't and when properly placed they will reduce or remove standing waves that may occur between facing walls in the room. Standing waves may cause a phasing effect where some frequencies are increased, while others are cancelled out. It also affects the rate of decay of the offending frequencies. These affected frequencies are usually below 300Hz in a home mixing room.

If you can afford more acoustic treatment, buy bass traps to put on the wall directly behind you. This will keep the low-frequency sounds that bounce off the back wall from causing phase interference with the direct low frequencies that you are hearing in your sweet spot. There are other places for bass traps, such as the corners, but that will add to the expense. You may want to add diffusers to the back wall too.

Some engineers would say that acoustic panels are more important than bass traps. I find both to be important in treating a room. I suggest placing acoustic panels on the ceiling above the sweet spot and on both of the side walls at a position nearest the monitors along with having bass traps behind the monitors and on the rear wall.

If you're doing a surround mix in your mixing room, then you'll need additional acoustic treatment for the additional monitor array. This will add more expense to your trap, panel and diffuser budget; however, it may still be cheaper than doing the mix at a professional facility, especially if you are mixing a low budget feature.

There are room correction systems that will measure the frequency response of your room from different locations and then create a correction filter to apply to your playback. In a small room, the locations for getting measurements should focus around the sweet spot. These systems are reasonably priced, but they do not fix all of the problems typically found in a home mixing studio. They are good at balancing out the amount of bass, but they have little effect on early reflections and reverberation. You'll need some acoustic treatment for these time domain problems.

There are many ways of acoustically treating a mixing studio. These are only a few suggestions on what to do, but your room may well require specific treatment.

Once the room's reverberance has been reduced, then you need to set up your workstation for optimum monitoring. If you're not in an acoustically treated room, then you'll be better off with near-field monitoring, which will reduce the level of the reflections you hear and thereby have a more direct sound when you're sitting in the sweet spot.

If your room is a rectangle, then put your mixing workstation in the middle of one of the shorter walls. If you have a square room, just pick a wall. This positioning is designed to put your sweet spot in the place where it's minimally affected by the sounds bouncing back and forth between the walls and causing various frequencies to be increased or decreased in volume. The larger your room the less of a problem this is.

In a near-field monitoring situation your monitors may be as close to the wall as possible, but leave enough room to place a 4-inch (10 centimeters) thick bass trap between the wall and each monitor. This will be helpful in reducing low-frequency reflections. Some monitors require a couple of inches of air space behind the monitor to help with cooling, so 6 inches (15 centimeters) from the wall would be better monitor placement for them. Instead of being next to a wall, a second approach is to place the monitors at least 7 feet (2.2 meters) from the front wall and about 2 feet (.6 meters) in front of the sweet spot. You should put up bass traps directly behind the monitors to reduce any problems from there. This second approach is only practical in a larger room, not your typical bedroom.

Ideally, the monitors will be at least 3 feet (1 meter) from the sidewalls. Low frequencies are more of a concern than high frequency when it comes to monitor placement, as there may be a bass build-up, which will give the person mixing an inaccurate assessment of the low

frequencies and may result in improper equalization. The higher frequencies are less of an issue as they're more directional in nature.

In a mixing room, larger than your typical bedroom, the sweet spot is around 33.3 percent, or near that number, from the wall in front of you, if you are facing the longer part of the room unless the room is big enough to meet Dolby room requirements given below. Once you've determined where that spot is, put a mark or an X on the floor or ceiling so you know where to sit. Ideally, you should have at least 10 feet behind your listening position, but that may be difficult in a smaller mixing room.

Now, if you are doing a surround mix, then you need to position your head in a sweet spot that's at the 66.6 percent mark. In other words, the sweet spot is approximately 33.3 percent from the back wall, not the front wall. This positioning assumes that you have set up and placed your surround monitors properly.

A minimum Dolby-approved room must be at least 20 feet (6 meters) long, 13 feet (4 meters) wide and have 9 feet (2.7 meters) high ceilings. They state that the listening position needs to be two-thirds of the way back from the front wall or screen, which would put it at 13 feet and 4 inches (4.06 meters). This size room would call for mid-field if not far-field monitors. Mid-field monitors are ideal for a sweet spot of 6 to 10 feet or 1.8 to 3 meters. A much larger mixing room, that simulates a cinema theater, would commonly use larger far-field monitors either mounted flush in the front wall or behind the screen.

If your mixing room doesn't meet Dolby standards minimum size or even come close, then mix with near-field monitoring and put some form of sound deadening material on the wall behind each monitor, as this will reduce reflections. Be careful not to have the monitors too close to the side walls as well.

Ideally, the near-field monitors should be pointing directly at the ear corresponding to the side the monitor is on. The monitors should be at about ear level. If they are higher than ear level, then point them down toward the ear. If they are lower than ear level, then point them up. It is better to have the monitors on stands, but if you have them on your mixing desk, you should have foam monitor isolation pads for them. There are some models of pads and stands that are height adjustable like some of those made by Ultimate Support Systems. Tilting the monitor can help in reducing standing waves between the front and back walls.

The person mixing and the two near-field monitors should form an equilateral triangle. Some engineers believe that when mixing stereo, it's better to point the monitors so they are aimed 16 inches (.4 meters) behind the sweet spot. I prefer to have the monitors pointed directly at my head with the tweeters at ear level.

It's always best to mix in an environment that closely resembles the one for which the film is intended. If the film is meant to be exhibited in a cinema theater, then it would be best to mix it on a properly calibrated mixing stage.

If you are planning a theatrical release that is not surround, then you'll want a version that is LCR (Left, Center, Right) so that the dialogue is in the center speaker and the music and sound effects are primarily in the left and right speakers.

If you are doing a surround mix, you'll need to have your surround monitors and your LFE (Low Frequency Effects) calibrated and in the best alignment in order to monitor properly.

There are plugins, such as Waves M360 Manager and Mixdown that will assist in making the sounds in your mix well balanced, properly placed and effectively spread in the theater environment. There is another Waves plugin called UM225-UM226, which can be used to do a stereo to 5.0 or 5.1 surround up-mix. You can put some of the atmosphere sounds in the surrounds and some of the music, but leave the dialogue in the center and the sound effects in the left and right speakers. If you're not experienced at surround mixing, then I suggest that you keep it simple and stay with stereo and LCR.

If your film is intended for streaming onto a laptop, then there is no great need to mix on a cinema mixing stage. The speakers on the laptop will be very small and unable to effectively reproduce frequencies below about 200Hz. You should be able to do that mix with a pair of near-field monitors.

You need to decide which form of exhibition is the one that your film will most likely be played in and mix toward that end. Most big budget feature films are mixed for a variety of exhibition formats, some of which include cinema, television, VOD and DVD release.

REFERENCE LEVELS

Sound Pressure Level, dB SPL, is the scale we use when we talk about the real world. The SPL scale runs from 0dB up to 140dB for humans, but a level of 120dB can cause hearing loss. The standard studio film mix is done with the monitors calibrated to 85dB SPL. If it's a surround mix, then the surrounds are calibrated at 85dB SPL. This is loud enough for humans to hear the entire range of sounds in a film. Most conversations occur between 50dB and 70dB, with whispers hitting around 20db to 30dB.

In your NLE (Non-Linear Editing) or DAW (Digital Audio Workstation) you'll have a decibel scale that is common to digital audio. It's called full-scale dBFS. The measurements are in negative numbers starting with 0dB and going down. If a sound exceeds 0dB, it will clip or overmodulate and sound terrible.

In order to get the real world in synchronization with the digital world, you have to calibrate your monitors with pink noise and set your editing system to –20dBFS. This will give you 20dB of headroom for the mix.

If you're mixing for a NTSC television broadcast, then you would have reference tone of 1kHz at –20dBFS (full-scale), which is the proper reading on a decibels full-scale digital meter. Your top end peaks would be –10dB.

If you're mixing for a PAL television broadcast, then you would have a reference tone of 1kHz at –18dBfs and a top peak level of –9dB or –10dB for the BBC in the UK.

If you're mixing for a theatrical release, then you would have reference tone of 1kHz at –20dBFS. Your top peak level should be around –12dBFS for loud action sounds like gunshots and explosions, but they could technically go as high as 0.1dBFS. Normally the dialogue mix level should be around –18 to –24dB. The sound effects and music should be adjusted in accordance with the dialogue. Dialogue for a television program, DVD or VOD, should sit around –12dB.

Technically speaking, your film mix will have a huge dynamic range and you can take advantage of that. Your levels could be like this, but there's not much headroom with the scream:

- –0.1 Screaming
- –12.0 Loud dialogue
- –20.0 Normal dialogue
- –24.0 Quiet dialogue

Once your room is calibrated for mixing, you could use meters to mix by, but it's usually done by taste; that is, the rerecording mixer adjusts levels by what seems right for any given moment. A meter could be useful to glance at occasionally to make sure nothing unusual is happening, but the real test is how the mix sounds.

If you are not in a calibrated room, then a meter becomes a very important tool for getting the right levels for your mix. Many professional film dubbing stages have a PPM (Peak Program Meter), which combines peaks and average loudness together. With this type of meter the dialogue sits around –20dB PPM for SMPTE and –18db PPM for EBU (European Broadcasting Union) standards.

The Dorrough loudness meter is used by a lot of studios as a master output meter. It can display the relationship between the average level and the peak levels. It's something like a VU meter and a PPM meter combined, but better. The RMS level should be driven close to the –1 bar right of the center and the peaks should be driven to the edge of the +1 bar farther to the right. If the sound level moves into the red, then the level should be decreased. Bars numbered 12, 13 and 14 are the red area.

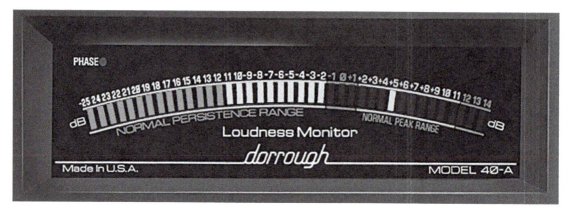

Figure 12.1

It can be purchased as a mono/stereo or surround plugin for $200–250. You should still have your room calibrated to ensure a good mix, but this meter is very useful. The 0dB on the meter will match a –20dBFS in Pro Tools or other editing systems.

All of the professionals will tell you that the best way to handle a film mix is to get your room set up properly and then mix it by ear. If it sounds good in a properly set-up room, then it should sound good in a theater. To be sure, you'll need to test it in a properly set-up theater.

The dynamic range of cinema is far greater than that for other exhibition formats as it is the loudest point minus the quietest point as measured in decibels and without distorting. In terms of digitally recorded sound, 16-bit audio has a range of 94dB, while 24-bit audio has a range of 144dB. The dynamic range of humans is roughly 140dB, but be aware that 140dB is the threshold of pain.

Meter Plugins

There are plugins that are used to keep your mix within selected standards. These standards might include US television, UK television, Australia television, Japanese television, cinema trailers and cinema films. A number of companies make these loudness meters, which are great for monitoring true-peak levels. The use of one of these plugins will keep your mix from clipping during a mix or down-mix.

Waves, Isotope, TC Electronics, NuGen and Dolby are a few of the makers. They range in price from $150 to $600.

ROOM MONITOR CALIBRATION

It's best to do your mix in a room that's been calibrated to meet exhibition format specifications. Once your monitoring is set up as good as you can get it, then mix with your ears. Your ears are the true test of how well the film is mixed.

Detailed information about calibrating your room, should you choose to do that, is discussed later in this chapter. If you just want to get into it and are not planning on a television or theatrical release for your film, then you don't need to be as specific in your set-up. If you are planning on showing your film in the festival circuit, then it's a good idea to follow the cinema set-up, as most short films are all over the place in levels. If you have a feature film, you'll need to set up as close to the calibration levels as you can, especially if your film gets picked-up for distribution.

If you are mixing in either stereo, LCR or surround sound for your film, then it's best to calibrate your room. Although it is a very useful tool, you don't need to worry about the X-curve as it's not very useful for small-room monitoring with near-field monitors. X-curve addresses reverberation in a larger room by using EQ (Equalization) to attenuate frequencies that might cause inaccurate sound reproduction. The idea of using near-field monitors and acoustic treatments is to effectively reduce or eliminate the room's reverberations from your listening position because you are too close to the monitors to hear the reverberations.

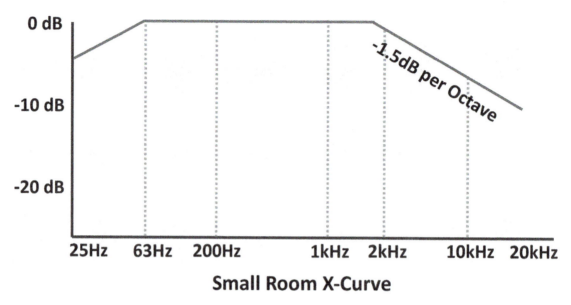

0 dB

-10 dB

-20 dB

-1.5dB per Octave

25Hz 63Hz 200Hz 1kHz 2kHz 10kHz 20kHz

Small Room X-Curve

Figure 12.2

According to most technical manuals, the Small-room X-curve applies to rooms with less than 5,297 cubic feet or 150 cubic meters. That would be a 20 × 33 foot room with 8 foot ceilings or in metric, a 6 × 8.33 meter room with a 3 meter high ceiling. It states that the frequencies should be flat up to 2kHz and then drop by –1.5dB for every octave above 2kHz. This means that there would be a drop of –3dB at 4kHz and a drop of –6dB at 8kHz.

As the mixing room gets smaller, there is less need for any EQ because there is less reverberation. If the room is the size of a bedroom, no X-curve treatment is needed. However, you may need to try to deaden the room with absorption materials on the walls, floor, windows, doors and even the ceiling. The more you can reduce the reverberations, the better your monitoring will be.

If you choose to mix your film in surround sound, you'll need to make sure all the monitors are calibrated to establish balance between them so that you are listening to proper levels at your listening position.

The most effective way to do this is to adjust the amplifier or monitor gain controls to proper playback levels. You will need to have either a RTA (Real-Time Analyzer) or a SPL (Sound Pressure Level) meter. We'll focus on using the SPL meter for room calibration. The SPL can be purchased for $30.00 or less on the internet. The goal is to get each monitor set to the same SPL level relative to each other while –20dBFS (full-scale) pink noise is playing through them one at a time. Use RMS (Root Mean Squared) as Peak will be too loud.

If you choose to calibrate your room, there are step-by-step instructions available on the internet; in particular, you can search on abluesky.com for the instructions and the downloadable sound files needed to do the calibration. A basic guide is given below.

For film, the SPL level on a large mixing stage will be 85dB-C (C weighting) Slow for the front or main monitors (LCR) and –85dB-C slow for the surrounds. If you have more than

two surrounds, then calibrate them at 82dB-C slow. The LFE is a channel, not a speaker, and should be mixed or recorded at –10dB, while the sub-woofer, which is a speaker, should be calibrated +10dB above the 85dB of the main monitors so that it plays back properly in the cinema. You would use the C weighting scale because it is quite flat and includes more of the low-frequency range of sounds than either the A or B weightings. It also relates closer to the frequency sensitivity of the human ear at high noise levels of 100dB and above.

The 85dB-C set-up is only for large mixing or dubbing rooms where the front monitors are at least 13 feet 4 inches from the listening position and the rooms are thousands of cubic feet or hundreds of cubic meters. For television, the target SPL level is dependent upon the broadcaster and the country, but the norms are either 78dB or 79dB-C slow for all monitors including the surrounds. For a small-home mixing stage, or your 10 × 13 feet (3 × 4 meter) bedroom, the level may be closer to 76dB-C slow for each monitor.

If your film is going to be viewed via streaming, then follow the specifications required by the exhibitor's website.

The most important aspects are that you maintain a consistency in your mixing level and that it is at an adequate level overall. If you don't have the tools or money to create an ideal mixing space, you can strive for consistency by making sure you set your levels and then stick with them. For example, if you have your near-field powered monitors volume level knob set at 50 percent, keep it that way. You may want to draw a line or put a piece of tape with a line on it, so you can always have the same monitor volume throughout the mix. This is especially important if you change the volume level for another project or just to listen to some music. You want to be able to get the volume level back to the same place when you return to the mix.

If you are able to calibrate your room, here are the basic steps for setting speaker or monitor levels:

HOW TO CALIBRATE YOUR MONITOR LEVEL

Step 1: Open your DAW or NLE software to a new session.

Step 2: Play –20dBFS RMS uncorrelated pink noise, Pro Tools pink noise is correlated, at unity or digital 0dBFS through each monitor, one monitor at a time, turning off or muting the others.

Step 3: Use a SPL meter at the listener's mix position. Have the meter set to the C weighting and with a slow response time.

Step 4: For theatrical release, turn up or down the volume control to 85dB SPL on the three front monitors and if you have two monitors per surround channel, set them at 82dBSPL on the SPL meter, otherwise set them to 85dB SPL. The sub-woofer speaker should be calibrated +10dB from all of the other monitors as the recorded LFE channel needs to be –10dB when played in the theater. If you're in a smaller

room, then adjust at the typical television 78 or 79dB SPL level. If that's still too loud, then set the level at 76dB SPL.

Step 5: For broadcast, turn up or down the volume control on the first monitor until it measures 78 or 79dB SPL. Do this to each individual monitor until they all measure either 78 or 79dB SPL. EBU R128 standard is 77dB SPL.

Step 6: Mark the output level on your mixer, surface controller, monitor controller and whatever else is in the volume chain. If you want to have really precise calibrations, you can go through additional steps to get the frequencies response calibrated to a flat response for each monitor, but for non-professional rooms, it is more effective to do some acoustic treatment.

Two sources of pink noise reference files:
ATSC.org/refs/a85/ and abluesky.com/support/blue-sky-calibration-test-files/

Once you have your room calibrated and you know the type of exhibition you want for your film, you can set up your mix to meet the required standards. The Room Calibration Cheat Sheet shows how to calibrate for different exhibition formats. The middle column is about having the room calibrated to 85dB and then adjusting the monitor levels so that you can listen and mix at the appropriate level for each of the different exhibition formats in the right column.

Room Calibration Cheat Sheet

Dolby Cinema Processor	dBc SPL Dolby Pink Calibration	monitoring pot when calibrated to '85'	LUFS / LKFS / Leq(A) / Dialnorm	
7	85	0 dB	-31	THEATRICAL standard
6.5	83.33	-1.66 dB		
6	81.66	-3.33 dB		
	81	-4 dB	-27	DVD/BluRay standard
5.5	80	-5 dB		
	79	-6 dB	-25	common old TV cal.
5	78.33	-6.66 dB		
	78	-7 dB	-24	US TV standard*, ATSC speech sample
	77	-8 dB	-23	EBU R128 TV standard
4	75	-10 dB		
	72	-13.33 dB	-18	my WWW mixes

Figure 12.3

Buying Monitors

There are a variety of monitor sizes, shapes and designs. What you need to find is a fairly flat frequency range and a size to match your room. If you are mixing in your bedroom, a pair of 4.5–5 inch monitors will do the job. If you have a fairly large room or a basement studio, you might consider acquiring 7–8 inch speakers. The 5 inch and 8 inch would be the largest speakers in the monitor cabinet.

In order to get a fuller range of frequencies, you may want to use three-way monitors as opposed to two-way or single speaker monitors. Three-ways have three speakers that handle the high, middle and low frequencies independently, thus giving the listener a better reproduction of the sounds. Don't get monitors that are too big for your room and have too much bass response to them as they won't give you a true playback of your sounds.

Do not buy cheap monitors as they will not reproduce the frequency range very well. Many emphasize the lower frequencies, others emphasize the higher frequencies and others emphasize parts of both. The idea is to get monitors that have a fairly level frequency range across the spectrum of sound.

Some monitor manufacturers to consider for your studio are PreSonus, Equator Audio, Yamaha, Adam, Genelec, Neumann, Event, KRK, Focal, JBL, Alesis, M-Audio and Mackie.

NLE OR DAW

A NLE (Non-Linear Editor) and a DAW (Digital Audio Workstation) are the two most common tools for editing audio. The soundtrack for a film can be mixed on most of the NLE systems that are designed primarily for picture editing. However, a digital audio workstation would be a better option as they are designed for working with audio. A DAW is a NLE in that you can edit in a non-linear manner just like you can with the picture editing software.

There are a number of effective audio editing programs, such as Pro Tools, Nuendo, Cubase, Reason, Studio One, Sonar, Reaper, Logic, Sound Forge, Digital Performer and Audition, which are all PC or Mac compatible. Logic is for the Mac platform only and Sonar is for the PC platform only. Some of the above software is oriented more toward music than post-production sound, but they do work well for both.

I have used several DAWs and NLEs for sound over the years, but I always return to Pro Tools as it works best for what I do and how I do it. It's also the most common software used in professional audio. If you intend on working professionally in audio, then you should learn how to use Pro Tools at some point. In terms of your current film project, you'll have to decide which software works for you. You may not even need a DAW as your film might only require some basic sound editing that can be done easily on your NLE.

Software is merely a means to an end. The important thing is the result of your audio work. The real test is whether or not it sounds good to an audience.

Whether you are working on a DAW or a NLE, you will have many of the tools you need in order to do a decent job on the sound. Nearly all DAWs and NLEs will have equalization,

reverberation and compression, while some may also have pitch shifting and other useful plugins. If you want to take the processing up a notch, you might consider purchasing some higher end plugins from such providers as iZotope, Waves and Soundtoys.

MIXING IN-THE-BOX BY MYSELF

Mixing-in-the-box could be done on many of the professional rerecording stages or it could be done in your own bedroom. If you are doing your mix at home, you'll need a computer, software, plugins, monitors and a quiet and sound treated space.

The rerecording stage (or dubbing stage or mixing stage) system will have dozens of plugins that will help clean up and alter the sounds and most DAW and NLE systems will have similar or perhaps some of these same types of plugins. Your system will have whatever comes with the software unless you've purchased additional plugins.

Mixing-in-the-box allows the mixer to make changes right up to the final output. Not only can mixing-in-the-box be a faster process, but it inherently allows for more latitude to make creative decisions all the way to the end.

If you have a lot of tracks, you could still do premixes or predubs prior to a final mix. Another option is to roughly set levels as you edit and just do a final mix. The main issue with trying to mix as you edit is that the levels will vary over time and even the overall tone may be different, so it's best not to try to mix as you go, but just do some rough balancing of levels and leave the rest to the mix. The standard way of mixing feature length films is made easier by breaking the film down into 15 to 20-minute reels. In order to mix an entire feature film on your computer, it requires the computer to be fast enough to play all the tracks, do the necessary processing and have adequate storage to hold all the files. These super sessions are common on rerecording stages. The classic 20-minute reels can still be used, but they are located along the timeline at the hour mark. Reel one is at 1:00:00:00, reel two is at 2:00:00:00, and so on. If the session is not set up with these reel breaks at the hour, then they are one big session without breaks, running from beginning to end.

A mixing stage will often have two or more computers holding tracks to be mixed and even a separate computer to record the stems and print master on to. Having more than one computer allows you to separate the different sounds onto different systems. The dialogue could be on one computer, the music on a second computer and the sound effects could be on another or whatever arrangements works for the mix. This system would be difficult to undertake with just yourself as the mixer.

An option that could make your film mix easier and better is to do a premix on your own DAW or NLE system and then take that session along with any stems, if you have them, into a mixing stage for a professional rerecording mixer to do the final mix or at least provide you with the various deliverables you might need. Make sure that the software you use will be recognized by the software that is used at the mixing studio. Any NLE or DAW that is EuCon compatible should work.

EuCon is an Ethernet protocol that allows control surfaces to directly communicate with software such as Pro Tools, Logic, Nuendo, Sonar, Digital Performer, Cubase, Pyramix, Avid Media Composer, Final Cut and Premiere.

This will save you a lot of money and give you a great soundtrack. Make sure you listen to some of the film mixes the rerecording mixer has done before you commit your money.

SESSION SET-UP

If you are going to do your sound mix in a NLE, such as Avid, Final Cut or Premiere, then you will most likely be working with the session settings that you used for the picture edit. This will be either 16 bit or 24 bit with a 48k sample rate.

The sampling rate relates to the frequency response and the accuracy of the reproduction of the recording. The bit depth relates to the dynamic range and the accuracy of reproduction of the sound.

Nyquist-Shannon Sampling Theorem—The sampling frequency should be at least twice the highest frequency contained in the signal in order to avoid aliasing. If human hearing goes to 22k, then the recording should be sampled to at least 44k.

You could mix your film at 96k, if your computer had the necessary power, but the added value is arguably negligible, as humans really don't have the ability to discern much difference between 96k and 48k. However, there are people who claim there is a difference between 48k and 96k and people who claim that there is no discernible difference. Technically, there is more information in the higher frequencies and even though they may be above the human 20k hearing limit, some say we can "feel" them.

There is an advantage to creating sound design at 96k or even 192k, especially if you are going to do any extensive processing, such as pitch shifting, as the sound will be cleaner and have few if any unwanted artifacts.

Most DAWs can process at 16 bit and 24 bit. Some can do 32 floating point processing and even a few, such as Pro Tools, can have 32 bit floating point sessions and mixes at 64 bit floating point. The higher bit depth allows for less noise and more accuracy when down-converting to 48k for distribution.

Working at 32-bit floating point gives you about 150dB of signal to noise ratio with a dynamic range of about 1,540dB. That's enough to do some extensive sound design processing without noise issues. Many DAWs do 32-bit floating point processing internally, even if your session is set to 24 bits.

STEREO, LCR OR SURROUND?

Figures 12.4–12.6

Stereo is the simpler and easier of the three above options for a sound mix. You may also elect to have an even easier one, a mono soundtrack. I have mixed mono sessions before and find it a serviceable format, but it doesn't fill the space like a stereo or surround presentation would. A stereo mix allows you to position a sound from total left to total right or somewhere in between by using the panning function to create a phantom center. You can create a phantom center by mixing the sounds to both the left and the right monitors equally. This will work well for anyone sitting in the sweet spot, but may sound odd to anyone seated to one side or the other of the auditorium as they won't hear the phantom center.

If you are planning on a theatrical release, then you'll need a LCR (Left, Center, Right) mix. It assumes that you are mixing the stereo left and right channels and also the center channel. The center channel is where the dialogue and Foley are placed. The left and right channels are primarily for sound effects and music. If you do a surround mix, which would mean adding at least two monitors to the sides and possibly more monitors to the back, you could place sound effects, ambiences and music in those channels as well. It is a very rare situation in which you would add any dialogue to these side or back channels.

You can do 5.1 or 7.1 surround mixes in NLE software as well as digital audio workstations; it's just easier, more efficient and more controllable in the DAW. NLE systems like Avid Media Composer, Final Cut and Premiere are all are able to do a surround mix thereby allowing you to place the sound within the panning matrix of a room just like DAWs do.

Surround allows a better placement of sounds than mono, stereo or LCR outputs as there are more speakers surrounding the listener. However, getting that placement to work for every seat in the theater can be a challenge. There are many versions of surround sound. The most common are 5.1 and 7.1 systems. The 5.1 system consists of five speakers surrounding the listener and a sixth speaker for low frequencies. The speakers or the outputs are designated as L, R, C, LFE, LS, RS (Left, Right, Center, Low-Frequency Effects, Left Surround and Right Surround) using SMPTE standards. There are other standards such as L, C, R, LS, RS, LFE. Pro Tools has the film standard as the default. The 7.1 system consists of seven speakers surrounding the listener and an

eighth speaker for low frequencies. Two more channels are added to the 5.1 system to make it 7.1, left rear surround and right rear surround (L, R, C, LFE, LS, RS, LRS, RRS). Some DAWs have different output configurations, so you'll have to make sure the output you have setup is the one you need. The original and primary purpose of the sub-woofer speaker is to deliver sound effects such as explosions, volcanoes or spaceship engines. The LFE channel and the sub-woofer speaker usually handles frequencies below 120Hz or for DTS, below 80Hz. You could do a surround mix without the LFE, in which case you would do a 5.0 or 7.0 mix. You could also choose to mix without a LFE channel and let a base management system feed the sub-woofer with low frequencies extracted from the 5 or 7 main and surround channels.

If you choose to mix your film in 5.1, then you need to set up your room using specifications that come close to those for theaters. There needs to be 60 degrees of separation between the left and right monitors. The center monitor needs to be directly in front of the listener. The surround monitors are placed from 100 degrees and 120 degrees from the center monitor. The subwoofer's location is not critical, but should be in a position that its sounds blend in with the other speakers and isn't too far to one side or the other where it will sound localized or directional. Most people place the subwoofer between the left and right monitors.

You could do a surround mix in your editing system while listening to a stereo mix, but you would have to output the surround sound mix and then play it back in a surround system in order to be sure your mix works.

The surrounds are great for delivering sounds in a spatial and temporal manner. By using your surround speakers well, you can place a sound within the theater. The Dolby Atmos system is ideal for placing sounds as it uses multiple speakers. Many Atmos theaters have 64 speakers that are placed above, beside and behind the audience, thus giving the audience a 3D sound experience. Auro 3D and DTS:X are other forms of surround sound that can include speakers in the back, on the sides and on the ceiling.

Some NLE and DAW software have an option or plugin that can be used to change stereo mixes into a surround mix or a surround into a stereo mix. Alternately, a plugin can be purchased for this function.

If you have done a 5.1 mix and your system doesn't have a way of outputting a stereo version, then a simple way of turning it into a stereo mix is to put all six channels onto six mono tracks. Then route all the mono tracks to a stereo bus. Next pan the front and surround left tracks to the left and then pan the front and surround right channels to the right. Keep the center track and the LFE (sub-woofer) track panned in the middle. In order to avoid summing issues, reduce the volume of the LFE and the center tracks by –6dB and drop the surrounds by –3dB. Now, create an aux track and route the stereo bus into the aux track. Put a limiter on the aux track to catch any peaks; so do not apply too much limiting. Finally, route the aux track to a stereo audio track and record onto the audio track. You now have a stereo version of your 5.1 mix.

It's a great help if you have a control surface that can handle all your tracks at once. If you have a surface controller that has eight or fewer faders, then you can mix sections.

The norm is to start with the dialogue and mix it down first. After the dialogue levels are set, then you can mix down the Foley and sound effects next, followed by the music. Dialogue

is first since all the other sounds are set according to the dialogue levels. The Foley might be next as these are the sounds the actors make and they need to be blended with the dialogue to come across to an audience as real. The sound effects are next as they are usually in synchronization with actions in the visuals. The environment of the scene and the type of sound effect needed will determine the volume level of the sound effect. Music is next as it will need to thread through the dialogue and sound effects without bringing attention to itself, unless that's desirable. Some mixers will mix the levels of the music before the sound effects or do both together. I know of other rerecording engineers who mix the dialogue and music together and then add the sound effects, the concept being that the music supplies a layer of emotion to the dialogue. You can do whatever you decide will work best for your film.

CHAPTER 13

Premixing or Predubbing and DSP

INTRODUCTION

Preliminary mixing is a worthwhile step in the mixing process, especially if you are having your film mixed at a rerecording studio. If you are mixing the film yourself, then it is helpful in that it breaks down the process into bite-size chunks and allows for the focus in the final mix to be on creativity and storytelling. There is no one way to get the bite-sized chunks.

The premix can be done using all of the sound groups of dialogue, ADR (Automated Dialogue Replacement), walla, sound effects, ambiences, Foley and music, at onetime in one session, or you can divide it up into a separate mix each for dialogue, music and sound effects. However you decide to approach your mix, the first thing you need to do is make sure your session is set up in a way that will give you the outcome you desire, such as a stereo mix, a surround mix or both.

A standard approach to a premix is to do the dialogue first as it's key to mixing the other sounds. You'll be working on adding and adjusting the levels, pans, fades, EQ (Equalization), compression, reverberation, noise reduction and whatever DSP (Digital Signal Processing) effects that are needed to have a viable mix. You'll do whatever is needed to make the final mix as streamlined as possible, so that you and the director are able to maintain a creative flow with little time needed to make technical adjustments.

MIX PREPARATION

Once the picture is locked for good and the sound effects, dialogue and music are edited into their proper place, then it's time to prepare for the mix. Some people like to set levels as they edit. This is somewhat effective, but it usually requires you to go through and do a final mix anyway. Some people will adjust levels, do panning and even add DSP processing to the individual sound files and to the tracks. Some of the more commonly used types of DSP are EQ, compression, reverberation, noise reduction and effects.

If you have dozens of tracks, you may want to do a premix or mix-down. The idea of the premix is to reduce the track count to a manageable level and still maintain some separation of critical sounds from those that are mixed together. Once you've done the premix, you might have around four dialogue tracks, two ADR tracks, six Foley tracks, six sound effects tracks, two background tracks and four music tracks. You'll now have 24 tracks to do a final mix-down on. The actual number will vary for each project, but this example is not unusual. The number of tracks you can mix at a time is dependent on software limitations, the power of your computer, the number and types of plugins you are using and the sample rate you are using.

If I were mixing 24 tracks, I would do a premix for each of the sound types, dialogue, sound effects, music, ADR, backgrounds and Foley and then I would do a mix using VCAs

(Voltage-Controlled Amplifiers) faders. I would assign each of the sound types to one of the faders and then I would only have to operate six faders to do my final mix.

If you are doing your mix on a NLE (Non-Linear Editing) system, there are usually limits to the number of tracks you can have. Some NLEs only have 8 tracks or channels, while others may have 16, 24 or more. If your NLE system has limited tracks and you need more, then you should seriously consider transferring your audio over to a DAW (Digital Audio Workstation) for a final edit and mix.

It's common to do a temp mix on a NLE and then do your final on a DAW and some low budget filmmakers are doing a final mix right in the NLE. I have done final mixes in a NLE, but only when the track count is low, around 8–12 tracks.

Many of the NLE picture editing software applications have a broad range of plugins that allow for a decent amount of processing. However, if you have a feature film or a short film that requires a lot of sound tracks and processing, you will be better off with one of the DAW software. If you have hundreds of tracks and lots of processing, then you need to consider buying some hardware DSP processing, such as Avid HD/HDX or Waves DiGiGrid, which is getting into a serious financial investment. In terms of affiliated audio software for mixing, Media Composer has Pro Tools, Final Cut Pro has Logic and Premiere has Audition. They are there to allow for an in-depth sound edit, sound design and mix.

Your film may have a couple of dozen tracks or even less and you may elect not to do a premix, but to just go ahead and do a final mix with all your tracks at once. In order to have some control over your tracks and all the sound clips, it's best to have them all named or labeled and to have them in an organized layout. If you have a sound design that requires some processing and effects, then you may choose to create it as a single sound file. Put that file on its own track. It's best to leave all of the original tracks you used for the sound design in the session in case you need to make a change. You might mute them and even hide them, but still have them available, just in case they need some adjusting.

There is no specific way to lay out tracks and every film will have unique track needs just for it, but below is an example of what a track layout might look like from top to bottom or left to right.

TRACK LAYOUT

DX1 (Dialogue)
DX2
DX3
DX4

ADR1 (Automated Dialogue Replacement)
ADR2
Group1
Group2

DXF1 (Phones, etc.)

Psfx1 Mono (Production SFX)
Psfx2 Mono

Foley1 (Feet)
Foley2 (Feet)
Foley3 (Moves)
Foley4 (Specifics)

SFX1 Mono (Sound Effects)
SFX2 Mono
SFX3 Mono
SFX4 Stereo
SFX5 Stereo

BG1 Mono (Backgrounds)
BG2 Mono
BG3 Stereo
BG4 Stereo

SrcM1 (Source Music)
SrcM2

MX1 (Score)
MX2 (Songs)

DXSub (Stem)
FOSub (Stem)
FXSub (Stem)
BGSub (Stem)
MXSub (Stem)

Verb1
Verb2
Verb3
Futz

Master

(SFX and FX are both abbreviations for sound effects.)

VIRTUAL MIXING

Virtual mixing is what is commonly done on films today. Virtual mixing happens in DAWs or in-the-box. The sounds are mixed and played back, but they are not recorded into a separate file until the end of the process. In classic analog mixing, the sounds are recorded during the mixing process. The main advantage of virtual mixing is that changes can be made at anytime

up to the final output. If you needed to go back into the session and change something after the final output, it's easy because all of your mixing work is saved. All of the settings and automation are saved, even the fader moves and they can all be changed easily.

I tend to automate everything needed for each scene as I go through the film. Basic automation can be done with what are called break points. Using your cursor, you click and make a break point in the audio timeline and then raise or lower the volume level, pan or whatever controls and plugin options are available with your software.

Figure 13.1

If you find mixing with a mouse is harder than using faders, then there are some options for making your mix an easier process. If you can afford to buy a control surface that integrates with a NLE, such as Media Composer or a DAW, such as Pro Tools, then you'll have a simple and effective mixing system. Avid makes the Artist Mix, which allows for hands-on mixing of tracks. You can add to that the Avid Artist Control, which gives you additional controls over many of the transport, programming, mixing and processing functions that are within the NLE and DAW software. There are other control surface makers, such as Behringer and their X-TOUCH Compact Universal Control Surface or Mackie Control Universal Pro.

There are single channel controllers that are relatively inexpensive and allow you to use a fader instead of a mouse. For example the PreSonus FaderPort has a single fader and transport controls. If you only need some basic controls and yet want eight faders, you might acquire the Korg nanoKontrol. Any of them or a similar controller will save you a lot of clicking and dragging.

Some people do not like control surfaces and prefer to use the mouse to perform functions such as setting volume levels, pans and adjusting plugins. Other people prefer to mix on a console because they believe that using a mouse only allows you to focus on one track at a time, but using a console allows you to blend sounds from a number of tracks at one go. Either way you are doing virtual mixing, as the sounds are not actually mixed together until the end when they are output as mono, stereo or surround files.

MIX TOOLS

There are many types of tools that can be used in getting your mix to sound good. I will go over most of those tools, but some are easier to use than others. I've included the ones that film-makers are most likely to use in their mix. For example, I have not gone into using a vocoder or voice encoder along with omitting some techniques such as how to use a side chain. The main focus in this chapter is to provide you with enough information to prepare you for a fairly straightforward mix.

LEVELS

A level is an objective amount of sound at which an audio signal has been recorded, while loudness is a subjective measurement of a sound. The loudness of sounds is a relative experience, although we can measure it in decibels. However, there is another principle at work, which is called the equal loudness contour. It is a measurement of sound pressure level (dB SPL) over the entire hearing frequency spectrum. We might think that we hear sounds at the same volume level across the entire frequency range, but we do not. In order for us to perceive a 100Hz tone as being the same volume as a 1000Hz tone, the 100Hz tone must be 50 percent louder than the 1000Hz tone. This means that lower frequencies require more volume to be perceived as equal to those in higher frequencies.

Most people have the greatest sensitivity to sound between the 1k to 4k range, so the volume doesn't need to be as high to be perceived as loud. As the frequency gets above 4k, it takes more volume to be perceived as being equal in level, but not as much volume as is required for frequencies below 100Hz. This is something to be aware of when setting your levels and working with EQ.

Note:
Watch your meters to make sure you have proper levels. The most important level you need to pay attention to is the dialogue. All of the other sounds will be adjusted to fit in with the dialogue. If the dialogue level is generally moving between –24dB and –18dB on this type of meter, then you will have a decent level for your mix. A scream might hit –1dB and a whisper might drop to –30dB or lower. It all depends on the scene.

Figure 13.2

As previously discussed, there are some very specific ways of setting up a room and a session so that the levels meet strict standards, but these are a good guide, if you don't have the budget or tools to do it by the book.

GAIN STAGING

An important facet of setting levels is gain staging. Gain staging begins with the recording. There needs to be an adequate signal to noise ratio for whatever you're recording. From the recording on through the final mix, you want to maintain a good balance between the signal or sound and the noise. The staging is the different steps that the signal or sound takes from beginning to end. The signal will begin at a microphone and travel through the preamplifier and into a recording device. If you have inserted a reverberation or other effect between the preamplifier and the recorder or between the DAW and the output, then make sure that the input signal and the output signal are nearly the same. This is called adding make-up gain. If there are faders for subgroups or inserts, they need to maintain the levels. You don't want to be dropping the level along the way and then have to bring up the level at the end. This will bring up the noise floor as well and that will not sound very good.

Overall it is the process of setting your levels so that there is a good balance between the noise floor and the recorded sound and enough headroom to be able to add processing and still be able to adjust levels on the aux tracks and the master fader. The ideal is to have levels on your tracks peak between −12dB and −18dB and not have levels that exceed 0dB as that will cause clipping. Those settings will give you ample headroom to do whatever you need to do without having to be concerned with peaks that cause clipping. Plugins can add or reduce gain to a signal, so be aware of what the input and output levels are when you use a plugin.

The foundation for successful gain staging is to have the sounds on your tracks to be just popping into the yellow and mostly staying in the green. If your NLE or DAW has a clip gain feature, then use it to adjust the gain. Ideally, you want to have your fader for a given track to be at unity or zero.

If you are working in software that uses 32-bit floating processing, you'll have plenty of headroom, but when you convert it to 24-bit, it will not have nearly as much headroom. Again, have your peak track levels at between −12dB and −18dB and you should have no trouble with gain staging.

FADES

Fade In or Out

An audio fade is used to smoothly increase the volume entering into a sound or to smoothly decrease the volume exiting a sound. A −3dB fade is often too abrupt, while a −6dB fade is smoother and consistent throughout the fade. The −9dB will drop the volume level quickly, but as it reaches the lower volume level, it will smooth out the ending. A −12dB fade is similar to the −9dB, only it is quicker to drop, but slower in ending. Either the −9dB or the −12dB fade will work well for music fades.

Fades

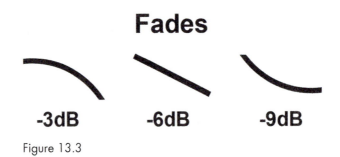

-3dB **-6dB** **-9dB**

Figure 13.3

Crossfade

When we use a crossfade combining two different sound clips that are of similar volume level, the result is that the level in the crossfade will be 3dB louder than either of the two clips. This means that you need to use a –3dB crossfade in order to not have the volume level increase. The basic rule is that anytime you double the power level of a sound or two sounds in this case, then you get an increase of 3dB.

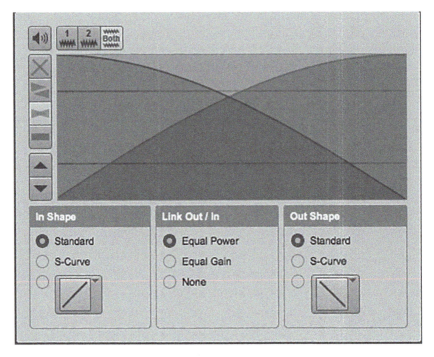

Figure 13.4

If you choose to use a –6dB or –9dB crossfade, there will be a dip in the audio level in the middle of the crossfade. There will be times when this might be useful, but the norm is to use a –3dB crossfade to keep the volume level consistent.

PANNING

Panning is the placement or a monaural, stereo or surround sound into a sound environment by using controls that shift the level of the sound between speakers. The physics of how the sound is distributed is based upon a chosen law. Pan laws can be based upon a square root or a sine/cosine law.

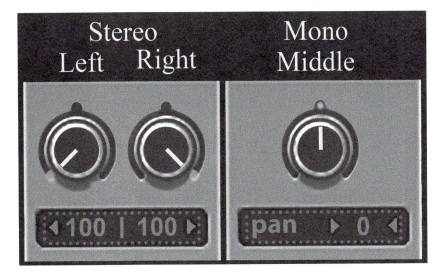

Figure 13.5

Pans are used to place sounds within the sound environment of the listener. Hard sound effects, like a left to right car-by, are often panned across the screen in relative position with the car. To be effective and sound appropriate, the sound needs to move from the left side of the screen through the center and off to the right. If the pan is between a left and right speaker, without a center speaker, there will be a phantom center sound that will sound natural in the sweet spot, but not for a listener who is seated on either side of the theater.

Whatever DAW mix-in-the-box or analogue console you are mixing on, there will be a pan power applied to the pans you use. Pro Tools allows you to choose between –2.5dB, –3dB, –4.5dB and –6dB, with –3dB as the default. Other software may have a different default value. If you edit your sound on one system and then move it to another, you may have issues with your pan levels unless you set the pan law level the same on both systems. In Pro Tools, you'll find this setting in the session window.

Anytime you pan a mono track in a multi-track session, you'll have to deal with the pan law. If your final mix is in three channel (left, centre, right) or stereo mix, then you would commonly use the –3dB pan law setting. Some mixes sound better with a –4.5dB pan law level. You'll have to decide for yourself. If you are panning between several speakers as in a surround system, you'll have to choose the pan law level that delivers a constant level as the sound is panned around the various speakers.

When you play the same sound through left and right speakers, there will be a summing of the levels that will increase the overall level by 3dB. So, in order to keep the level sounding consistent, you need to drop the pan level at its center by –3dB.

The pan law creates smooth transitions by reducing the volume level of the sound as it approaches the center and then increases it after it passes the center. If pan law is not applied the sound would become noticeably louder as the pan reaches the center.

Some systems may use a boost of 3dB on the left and right side speakers in order to give a smooth transition across the pan. The only issue with this approach is that it may cause the sound to distort with the added 3dB on each side speaker.

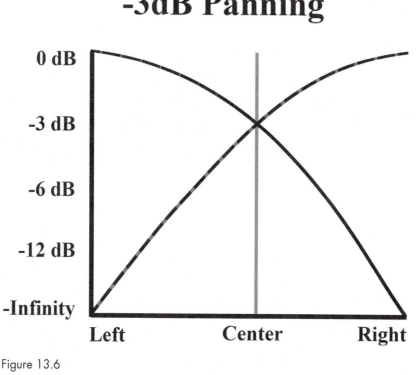

Figure 13.6

CONSTANT GAIN OR CONSTANT POWER

If your system has the option of constant gain or power, then you'll need to choose one or the other. Constant gain is panned at a constant rate between the left and right or front and back. Since it is a constant, there will be a somewhat noticeable change in the center because of the pan law. Constant power is a smoother transition because it gives the listener a sense of constant loudness all the way through the pan by dropping the center by –3dB, which Constant

gain does not do. This linear law would give a –6dB center level. A constant power with a –3dB will work well for stereo and surround panning in a theatrical mix.

Panning in Surround Field

A constant power pan law is used to maintain the level of loudness throughout the various pans of a surround environment. A commonly used plugin that allows you to pan the sounds in a surround environment is Spanner. It will also do an up or down mix from stereo to surround or the other way. It can be very effective in moving a sound around an environment. Even a subtle and slowly evolving shift in the surround speakers can give a sound some vitality, but don't overdo it.

When you pan sounds in a surround environment, you need to be aware that you may be listening on 5.1 speakers, but the audience may be listening on many more speakers. If you pan a chirping bird to the surround speakers, it will play on the side and back speakers in the theater, which might be an odd surrounding placement for one lone bird. A 7.1 mix or higher will allow for better placement of the bird's chirps.

The surrounds are good for placing ambiences, some sound effects and music. Great care has to be used to envelope the audience in the environment without distracting them. Unless there's a purpose for it, you don't want the audience looking behind them because of a noticeable sound they heard from the surrounds.

The LFE (Low-Frequency Effects) channel is where you can put some of the bigger sound effects. The dynamic range of an explosion is much more intense if there are low frequencies coming from the subwoofer speaker. Depending on the speaker model used, it could be producing frequencies between 3Hz and 120Hz.

A subwoofer reproduces low frequencies that the main speakers are not able to do. The subwoofer complements the other speakers in a system. A subwoofer speaker reproduces sounds that are sent to it from a LFE channel in the soundtrack that specifically sends very low frequencies to it.

Panning in 3D Space: Dolby Atmos, Auro-3D and DTS:X

Dolby Atmos is an object-based system that sends the sounds to the proper speaker placement in the 3D environment of a theater based upon the speaker system of that particular theater.

DTS:X is also an object-based system that is scalable to the size of any given theater and its speaker array.

Auro 3D is a channel-based system that can expand from a 9.1 to a 13.1 surround system depending on the size of the theater.

Dialogue and Foley are mixed in the standard multichannel format where they are placed in the center. However, the more dynamic sounds may be coming from anywhere and moving to another point in the three-dimensional space of the theater. Atmospheres or backgrounds may be moved, but are primarily set in place to work with the location for a given scene.

The dynamic sounds could be moved from speaker to speaker in a 360 pan around the theater. For example, a helicopter could do a full circle around the top of the audience. This would require the –3dB pan law to create a smooth transition from speaker to speaker.

EQUALIZATION

EQ is used to boost (increase) or cut (decrease or attenuate) the volume level of selected frequencies. It is very useful for making dialogue, sound effects and music work together to give a broad frequency range and not compete in the frequencies that are typically for dialogue. The human ear is more sensitive to boosted frequencies in the speech range than it is to cut frequencies. That's why it's better to cut than to boost if possible. The narrower the cut, the less noticeable it will be. The wider the boost, the less noticeable it will be.

The general rules are:

- Cut first and then boost, if needed
- Cut the Q narrow and boost the Q wide
- Don't cut or boost too much.

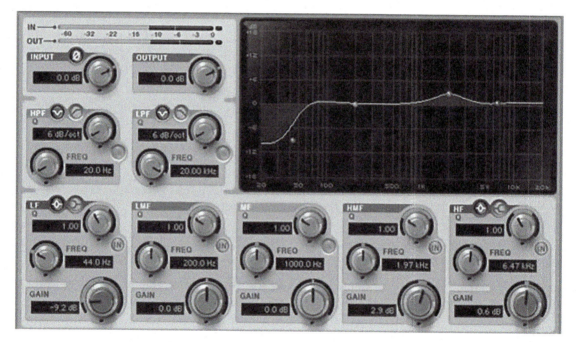

Figure 13.7

COMPRESSION

Once the EQ has reduced or removed the unwanted frequencies and/or boosted the desirable ones, you can focus on compression. A compressor is used to control the dynamic range of the sound, which is the difference between the loudest sound and the softest sound. It will limit the loudness of the peak sounds going through it. Once the loud peaks are tamed, you may need to increase the gain or volume level to get the sound back to the desired level. By adding

gain to the sound, you'll be increasing the level of the entire dynamic range including the noise floor, so be careful how much you raise the output gain level.

In the example that follows there are six controls for setting the compressor.

1. *Ratio*: The amount of compression applied to the sound. 3.0:1 means that for every 3.0dB above the threshold an input sound is, the output will be only 1dB higher.
2. *Knee*: The knee adds a soft turn-on of the compression. Without the knee, the compression would turn on at full force at the point the volume crosses the threshold.
3. *Threshold*: The level at which the compressor takes full effect. Any sound below the threshold will pass through, while those that exceed the threshold will be compressed based upon the ratio.
4. *Attack*: The length of time it takes the compressor to start working once a signal has reached the threshold level.
5. *Release:* The length of time it takes the compressor to stop working once the signal has fallen below the threshold level.
6. *Gain*: This gain knob controls the output level of all audio passing through the compressor. Since compression reduces the volume level, it can drop the level too low. Gain will add make-up gain to bring the output level back up to where the input level is. This is important for proper gain staging.

There are many different configurations of compressors available. The one available to you in your NLE or DAW may only have controls for the input gain and the threshold. The other controls are set automatically based upon these two controls.

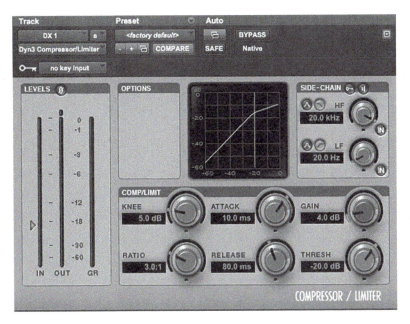

Figure 13.8

A compressor is used to control the dynamic range of a recording. Here are some steps you can take to try to find the right setting for compressing the sounds you have in your film.

- Start with a quick attack around 2.0 milliseconds and then adjust until you reach the desired sound.
- Set the release time at around 80.0 milliseconds and then adjust until it sounds right.
- Set the ratio to 2.0:1 and adjust up until it's doing a good job of squashing the peaks in the sound, but not flattening out the dynamic range. A ratio of 3.0:1 or 4.0:1 is usually sufficient to adequately compress most sounds.
- Set the threshold to a less sensitive level, so that only the loudest parts are being compressed. Try a gain reduction of between −3dB to −6dB until it sounds right.
- Set the knee at a low level and then increase until it softens the action of the compressor being engaged.
- Set the gain to the level you need the output to be.
- Now go back and tweak the attack and release times to get it sounding good.
- Switch back and forth between the uncompressed and compressed sound to determine if additional adjustments need to be made.

If the attack and release are set too fast or even too slow, there may be an unwanted and unnatural sounding pumping effect.

Do not use more than one compressor on a track as they will be multiplied in the compressing effect. For example, if you put a compressor on a track with a ratio of 3.0:1 and then add a second compressor to that track that is set at 7.0:1, the result will be an effective compression of 21.0:1. Both compressors together will greatly remove the dynamic range of the sound.

There are also multiband compressors that split the signal into several band-pass filters. You can select the frequency range for each band-pass filter, much like you do with a multiband equalizer. Then each band has its own compressor, which has its own adjustable settings for the threshold, ratio, attack and release. Once the signal has passed through all of the separate bands they are recombined into the output signal. This can be very effective in creating a richer and more open sound, especially when used on a dialogue track.

NORMALIZING

Normalizing audio can be done in two different ways, Peak and RMS (Root Mean Square) or averaging. The purpose of normalizing is to increase the gain of a sound file. This is often done to meet broadcast standards or to achieve proper levels for a theatrical presentation.

You would use peak normalizing to bring the *highest peak* levels in a sound signal to a user specified level. You could set the level at 0dB, but that doesn't allow for any headroom. If you are mixing several tracks and they have all been normalized to 0dB, then when you mix them together and the signals sum, you may well have some peaks that exceed the 0dB level and this will cause clipping. It's better to select a level between −3dB and −6dB in general to avoid summing issues.

While peak normalizing looks at the highest peaks, RMS looks at the entire sound level for a *signal average* including the peaks. When you normalize using the RMS option, you are

changing the average amplitude of the sound signal to a user-specified level. RMS is closer to how humans hear except that humans hear different frequency at different volume levels. RMS doesn't take that factor into consideration in its calculations.

A broadcast standard normalizing that is becoming common for television is the EBU (European Broadcasting Union) R128 option. It actually takes into consideration how humans really hear. It is not commonly found as an option on most NLEs and DAWs, but it is available. Normalizing is not commonly used for film mixes as the desired dynamic range of a film is too wide for it to be truly effective. For example, there are often quiet sound effects and music cues that are subtle in a film, but these could be reproduced much louder than intended if the EBU R128 or any RMS normalizer is used.

Normalizing is not compressing. Compressing changes the overall volume level of a sound file in varying amounts, while affecting the dynamic range of the sound file. Normalizing typically changes overall volume levels by a fixed amount without affecting the dynamic range.

I only use normalization when I have to, because it will bring up the volume of the noise floor, which I'm usually trying to keep very low. However, it is useful for getting a sound file to the maximum volume or for getting a sound file to match the level of some other sound files. A common mistake for a low and no budget filmmaker is to think of normalizing their film sound in the same way as pop music is normalized. A lot of music is normalized and compressed to get as close to 0dB as possible without clipping, but that's not the desired level for film and television sound. There needs to be a wide dynamic range, which includes adequate headroom to facilitate the dynamic range.

NOISE GATE

A noise gate is the inverse of a compressor. Once the input signal drops below the threshold, the gate closes and mutes the output. This can be useful in reducing or removing a noisy background; however, when the gate is off, the noise will return. If you are using a gate to clean up a dialogue track, it may sound odd if too much gating is applied. For example, I saw a film in a theater in Hollywood that had a scene at a beach. While two actors were talking, you could hear the waves breaking on the beach. When they stopped talking for a moment the sound of the waves dropped out. This on and off ocean waves sound demonstrated a poor use of a gate.

A noise gate is less noticeable when there is a lower noise floor. If you try to remove too much of the ambience, it will be noticeable. If you set the threshold of the gate just above the noise floor, it will be closed during pauses in the dialogue and then open when the talking starts again.

The controls are usually the same as you find on a compressor, with the exception of a possible "hold" function. The hold function keeps the gate open for a selected time after the audio falls below the threshold setting level. This can be useful in smoothing out the gate when there are a lot of rapid level changes.

As you adjust the setting on the gate, watch both the input and output levels. In order to keep the gate less noticeable, you'll want to keep the drop in volume level to −12dB or less. Like all plugins, you need to make adjustments according to your ears.

EXPANSION

An expander is basically the opposite of a compressor. It expands the dynamic range of an audio signal. They are generally used to reduce the level of noise floor, room tone or background sound in a scene. They can make a relatively quiet sound even quieter.

An expander kicks in when a sound goes below the threshold. Any sound that sits below the threshold gets expanded down by an amount determined by the ratio setting you've selected. For example, if the ratio is set at 2.0:1 and the sound drops 2dB below the threshold amount, the sound will be reduced by 4dB below the threshold setting. If you set the ratio at 10.0:1 or higher, you are effectively using the expander as a noise gate. In actuality, an expander acts much like a subtle gate.

EXCITER

An exciter, which can be called a number of names such as a harmonic exciter or aural exciter, is used in post-production to create harmonics. If a dialogue track has some high-frequency noise, you may choose to reduce or remove it using EQ, but the voice will then sound a bit odd without the higher frequencies. That's when an exciter can be used to create those high frequencies by adding the missing harmonics. The missing higher harmonics are created from the cleaner fundamental frequencies of the sound or dialogue. This will make the dialogue sound more natural, while also sounding cleaner.

A good starting place is to cut frequencies above 6kHz or 7kHz by at least −12dB, if not more. Now use an exciter to add back the missing harmonics. This approach can also be used to generate harmonics in lower frequencies too.

DE-ESSER

A de-esser does what its name implies; it removes the high-frequency sounds that are part of the sibilant letters that are spoken by an actors. When an actor says a word with a "s," "z," "ch" or "sh" in it, there may be a sibilance sound. More often than not, the offending sound is caused by the letter "s." Sibilance is often characterized as the sound of a snake or the whistle of escaping steam.

A de-esser is basically a compressor that reduces high frequencies. The two settings common to de-essers are frequency and range.

- *Frequency*: This is the frequency at which the compressor kicks in. It will then compress all frequencies above the setting.
- *Range*: This is the amount of gain reduction that will be applied to all frequencies above the selected frequency.

In this example, the de-esser compressor will be activated for any frequency above 6.0kHz and those frequencies will be reduced in volume by 5dB. This will reduce some of the offending

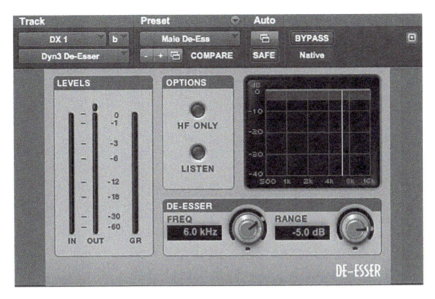

Figure 13.9

frequencies and make the actor's speech sound more natural. Generally, the range of sibilances for a male voice is around the 4–5kHz range and for women around the 5–8kHz range. Each voice will have to be dealt with individually. I suggest that you start by using an equalizer and set a narrow "Q" and use a boost of 12dB and then sweep through the frequencies between 3kHz and 8kHz; the offending sounds will become clear and you'll know what settings to use for the de-esser. Be careful not to cause other issues, like lisping, by adding too much de-essing.

NOISE REDUCTION

If you have a noisy track that can't be helped much with EQ, compression, noise gate, expander or any other standard approach, then you will need to try some form of noise reduction. Many of the NLE and DAW software applications have plugins that deal with noise reduction. Some are better than others. One of the best is iZotope RX, which is commonly used for film sound clean-up. Other worthwhile options include Sonnox, WaveArts, Waves, Acon and Sonic Solutions products.

Some people will go straight to the noise reduction plugins, but I think it's worth trying to fix the problem with basic tools first, especially if the noise isn't too bad. If the noise is significant, then you'll be able to improve it with noise reductions, but there are always compromises. It will be nearly impossible to remove all of the noise without leaving some form of signal degradation. The trick is to do enough noise reduction to make the noise unnoticeable or acceptable without having an adverse effect on the sound.

Noise reduction is commonly used on dialogue tracks to improve the intelligibility of the lines spoken by the actors. It can also be used on others sounds such as sound effects, ADR, Foley and music to clean up unwanted noises or ambiences.

Noise reducers are either plugins or stand-alone software or hardware, that integrate with NLEs and DAWs. They commonly use some form of noise sampling in order to apply various types of noise reduction. You select an area in a sound file that has the noise in it and capture that undesirable sound in a "noise profile." The noise reduction software will then analyze the selected area and determine what needs to be removed from the entire file. Many of the noise reduction software applications have presets that may work or at least get you close to where some manual adjustments will finish the job. There are other software noise reduction plugins that don't need to have a sample, as they do that automatically.

There are essentially two types of noise reducers: the fader-based ones and the graphical ones. CEDAR Audio and Waves Audio make two of the fader-style noise reduction plugins. The Waves WNS plugin has a graphic display to help with adjustments. These plugins are less visual, so you have to rely upon your ear for finding the best settings. The settings are primarily through the use of faders that control adjustable bands of frequencies. These are both very good at what they do, but they are limited in how much they can do to reduce or remove unwanted noise. However, the Cedar noise reduction plugin is very common in broadcast because it is real time and doesn't need any rendering like most of the graphic type plugins.

Graphic noise reduction is commonly used in NLE and DAW software. They can be used as real-time plugins, but they require a lot of processing power. For a film mix, it's better to render the cleaned file, rather than insert the plugin in a track.

Noise reduction needs to be used judiciously otherwise it can introduce artifacts that are worse than the offending noise. If you have some really bad noise, you could try removing some of it with one pass and then remove the remainder with another. If you find the process confusing, there are some fairly straightforward plugins, like Waves Noise Suppressor, which have a single fader to adjust. It is designed to tell the difference between dialogue and noise. You just move up the fader until you find the spot where the noise is reduced, but there are no noticeable artifacts.

REVERBERATION AND DELAYS

Reverberation is used to add reflections to sounds to make them seem to fit in a scene's environment even though they may not have been recorded in that environment. Many of the reverberation presets have a name like large hall, small hall or church. There are also ones called plate and spring, which are based on reverberation created using metal plates and springs. Some of the reverberations include presets that are more designed for sound post-production like kitchen, bathroom and bedroom.

Delay is an echo where the initial distinct reflective sound comes across as more spacious and open feeling than a reverberation would. A delay repeats from one to many times. If the repeated sounds are fast enough, you'll have created a reverberation-like effect; the issue being that it will not be able to reproduce the tailing effect of a reverberation. Also, be aware that a reverberation cannot create a delay.

Reverberation and delay are close in nature, but think of reverberation as multiple reflected sounds that blend together, while delay can be just one reflected sound, like an echo.

When working with dialogue, ADR, Foley and sound effects, you'll have to decide if reverberation fits the scene or if a little delay might be better. Whichever one you decide to use, make sure it's subtle unless the scene takes place in a cathedral.

If you want a bigger and closer sound, then set your reverberation decay at under 1 second in duration or your pre-delay at less than 100 millliseconds. If you want a more distant and distinct sound, then set your reverberation decay at more than 1 second and your pre-delay at more than 100 milliseconds. You may find that 200 milliseconds is what you need to make the dialogue and other sounds work. There are no rules, just suggestions followed by trial and error. The main settings to work with are the delay, rate and feedback (FBK). If you're working with music, you may want to have the reverberation in time with the beat of the music or, for effect, maybe not.

Figure 13.10

DE-VERBERATION

If you cannot afford to do ADR in a studio, but the production dialogue sound has a noticeable echo in it, then there are several brands of plugins that will help reduce or remove unwanted reverberation from your dialogue track. They will de-verberate the dialogue and give you a cleaner and more distinct sound. It won't remove the hollowness of a microphone that's too far away from the actors, but it will knock down the reverberations.

SPL (Sound Performance Lab), Acon Digital and iZotope RX all do some level of de-verberation to sound. You can pay under $100 or over $1,000. The more expensive de-verberations do a better job, but you may get acceptable results with the less expensive ones.

Most of the de-verberations have a selection of presets such as "Reduce Room Reverb." You then adjust the reverberation time. If the room is large, then it will be a higher or longer setting, as it takes longer for the sound to reflect back from the surrounding walls and surfaces. Now compare the original with the de-verberation-treated sound. If it works you're done, otherwise adjust until the reverberations are reduced and there are no noticeable artifacts heard.

EFFECTS AND FILTERS

The software you are using to mix your film will have some effects and filters included. In a general sense filters are effects too. Some common filters are telephone futzing, cell phones, walkie-talkies, radio transmissions, PA systems and other similar reduced frequency sounds. There are other types of filters that are not frequency based, but these are the ones you would most likely need for your film.

Some of the effects that are commonly used for music and sound design are Phaser, Chorus, Flanger, Vocoder, Doppler, Doubler, Distortion, Fuzz, reverberation, pitch shifting and time shifting or elastic audio and more. There are tutorials online for most of these plugins. You'll have to experiment to see which ones you need for your film. Most of them have presets that will work and often can be tweaked. The following EQ image is of a preset cell phone filter or futz. You can see that the highs and lows have been attenuated, which will replicate the frequency range of the tiny speakers on a cell phone.

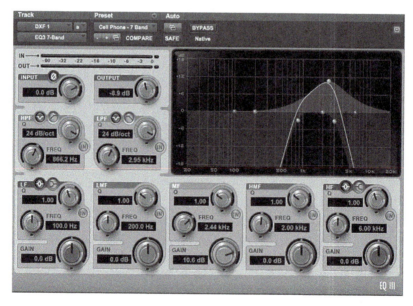

Figure 13.11

LIMITER

A limiter lives up to its name by limiting the volume level of a sound. They are used to reduce the peaks in the sound without having any effect on any other part of the sound envelope. They are similar to a compressor, but have different purposes. A compressor will reduce louder parts of a sound without squashing the peaks. They are useful for obtaining a consistent level for the sound.

Limiters and compressors are often used together. The compressor is used to smoothly roll-off the loudest levels to create a more consistent sound, while the limiter creates a wall to keep the strong peaks from clipping. Many engineers and rerecording mixers only use a limiter on the master. It depends on the type of mix that it is and how complicated the mix is. The limiter on the master is usually a brick wall that will not let anything exceed its limit.

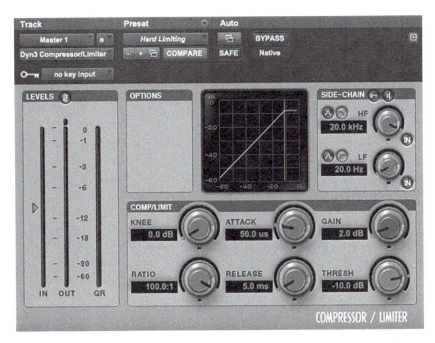

Figure 13.12

Limiters are useful in keeping the spikes or peaks from exceeding the limit you put on the signal. A limiter set at 0dB on your master fader is not the level you want for your film. There are two kinds of peaks; one that you see when you watch the meters on your editing software, and the other, which is not readily visible, but will cause a distortion that makes the mix sound edgy and harsh. These peaks are called inter-sample peaks. They occur between samples

when the signal is converted between the digital world and the analogue world. They usually occur in the higher frequencies. The way to avoid this issue is to mix at the appropriate level. If your loudest volume level is hitting around −10dB, then you have plenty of headroom for the inter-sampler peaks not to cause a significant problem. Some people say that a level of −3dBFS is adequate for negating the effects of inter-sampling. To be safe, set your master track limiter to −3dB at the most for a theatrical film. For a television set it at −10dB or whatever the deliverable requirements are for that network. If the gain staging of the sound has enough headroom throughout the signal path, then the chance of a limiter kicking in is minimal.

PREMIXING

Once you are sitting in the sweet spot, play the film through. If it's a feature, play the first reel or about 15 to 20 minutes or so. This will give you a sense of what you have to accomplish with the final mix. You'll pay attention to the levels, possible pans, potential EQ adjustments and how all the sound elements play together.

It helps immensely if you have a control surface that can handle all your tracks at once. If you have a controller that has eight or fewer faders, then you can mix sections.

The norm is to start with the dialogue and mix it down first. Dialogue is first since all the other sounds are set according to the dialogue levels. After the dialogue levels are set, then you can decide what to mix down next. I prefer to do the Foley and sound effects next, followed by the music. I do the Foley next as these are the sounds the actors make and need to be blended with the dialogue to come across to an audience as real. You could try to mix the dialogue and Foley at the same time to get that realistic feel, but that could be too much to do at one time. I do the sound effects next as they are usually in synchronization with actions in the visuals. I suggest starting with the ambiences or backgrounds first and then do the hard effects. The environment, emotions and actions of the scene and the type of sound effect needed will determine the volume level of the sound effect. Music is next as it will need to thread through the dialogue and sound effects without bringing attention to itself, unless that's desirable.

Some of the dubbing mixers like to mix the dialogue and music first and then adjust the sound effects to work with them, the concept being that the music supplies a layer of emotion to the dialogue. Other mixers like to mix the dialogue along with the Foley as they go together in the physical world of the film. They then mix the sound effects and music according to what is needed in any given scene. Whichever way you choose to mix, dialogue is the most important element, so everything else should be mixed to work with it.

If the system you're mixing on allows for automation, then you could start the mix using fader automation, unless you prefer to do the key frame or break point automation approach. Now you can progress scene by scene through the entire film creating automation as you go. Set your levels and then work on EQ and dynamic range and spatial layout. This means adjusting and equalizing the frequencies that need it, adding any compression needed to effect dynamic range and panning the sounds to their appropriate spatial placement in the speaker

array. If you are doing your final mix on a dubbing stage, then you could leave some of this to the rerecording mixer.

As you mix, watch the meters, but mix with your ears. It's also important to keep your ears fresh by taking breaks. It helps to get up and walk around for 5–10 minutes every hour just to clear your ears.

Your mix should eventually be a symphony of sounds that should blend together into one piece that supports the story and doesn't distract from it in any way. You don't have to have that goal for your premix, but your final mix should sound like a symphony.

BUSES, AUXES, SENDS AND RETURNS

A bus is a pathway down which a number of tracks can be routed. You may choose to put some processing on the aux track that the bus leads to; so that whatever tracks are sent to that aux track get the same processing. For example, if you wanted all of the Foley tracks to have the same reverberation, you would create a bus 1 output on each of the Foley tracks and send all the Foley tracks via the same bus to an aux track with an input of bus 1. The aux track would have a reverberation inserted on it. This allows you to control the output level of all of the Foley with just the one aux track fader. The output of the aux track with the reverberation added would then be sent to the master fader. You thereby had to insert only one reverberation in the aux track instead of one for each of the Foley tracks. This allows for a consistent reverberation effect and for less processing by the CPU on your computer.

The mixing signal path is really important in keeping your mix organized. A standard routing might look like this:

Audio Track > Audio Bus via Aux Send > into Aux Channel with Send going into it > Reverb or other processing > Aux channel output > into Master.

You might also have all of the Foley tracks going into a VCA fader and then into the master fader. This will allow you to adjust the wet reverberation of the Foley aux track with the dry Foley in the VCA fader as they go into the master fader.

The aux track is literally one that supports an audio track. In the mixing process, this means that the aux track supports the source track by processing a split signal from it. The source audio track will have a send applied to it. That send has a fader, which controls the level of the signal going down the pathway to the aux track. You can adjust the fader on the send for each Foley track to blend in the amount of reverberation you want. The send fader is a separate one from the Foley audio track fader. If you are working on a NLE system there may not be a send option available. In that case you'll probably have to put the same reverberation on each of the Foley tracks.

You can now put a send on the Foley footstep tracks and send them to an aux track that has a gate on it. You could now use the fader on the aux track to blend in the gated Foley with the ungated sound on the Foley footstep tracks. You might then send the output of the gated aux track to the reverberation aux track via bus 1. It can get confusing rapidly, so I suggest that

you keep it simple or use a basic template with which you have a good understanding of the signal flow.

The more tracks you have the easier it is to manage when you have submixes. If you route all of your Foley tracks through an aux track or several aux tracks and then down into only a few tracks to make a submix, then those few Foley tacks are a lot easier to handle in a final mix. For example, if you have a total of 12 Foley tracks, it would be easier to manage if you bussed them down to 3 Foley submix tracks. You could have one submix track for footsteps, one for cloth and one for specifics. When you do the final mix, you only have 3 faders to manage instead of 12.

The original 12 tracks are still in the session, but you only have to manage 3 of them in this case. You can still go in and make changes on each individual track, if the mix calls for it, but for the most part you are only dealing with a few Foley faders in the final mix session.

It's important to note that all buses you create do not have to go to an auxiliary track, but all auxiliary tracks need to have buses as their inputs. It's also important to note that whatever inserted effects you put on a Foley audio track will be passed on via the bus to the aux track. If you have an EQ on a specifics track, it will affect the sound that is being bussed so that the sound arriving at the aux track will be equalized.

In order to route multiple audio tracks into an aux track, first create an aux track. Next click on the audio input selector of the new aux track and choose bus 1 (mono, it could be a stereo aux also). Then click on the output of all of the dialogue tracks you want to send to the aux track and select bus 1. Now insert a reverberation into the aux track. You might choose to add an EQ too in order to make a different quality of sound.

You now have a simple routing set-up that gets the entire dialogue track sent to an aux track that is used to add the same reverberation to all of the dialogue at once.

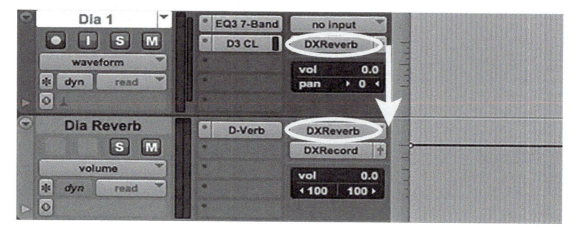

Figure 13.13

You can now route the output of the aux track that has the reverb or reverberation insert to another aux track, to add another processor, or an audio track for recording. It can get complicated so make sure the routing you use is simple and effective.

Notice below that the two dialogue tracks have outputs leading to the Dia Reverb track. The fader on the dialogue track adjusts how much of the dry or original signal will go to the Dia Reverb track and be mixed with the send signal that has a reverberation added to it and is also going to the Dia Reverb track. On the reverberation insert, select a 100 percent wet mix. By adjusting both the send fader and its dialogue track fader, you can affect the wet/dry mix of the reverberation.

When you use a send, you have two parallel signals running out of one track. The send is going to an aux track and the audio track, which has the send on it. The output of the aux track will be routed to the master track. The send fader will determine how much of the reverberation is mixed in with the original signal from the audio track. The send fader is usually a small fader or at least a separate fader from the one on the audio track. This small fader adjusts the signal level returning from the aux track. That returning signal is called a return.

In a film mix, it's not unusual to have two, three or more separate aux tracks, each with a different reverberation or other processor insert. There may be a light reverberation, medium reverberation and heavy reverberations or some other processors that are already set up and all you have to do is the routing and perhaps some adjusting.

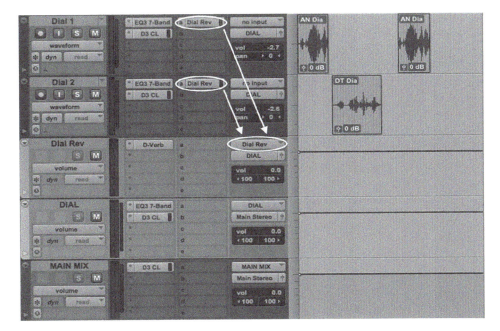

Figure 13.14

In order to stay organized, make sure that you only use specific buses and aux tracks for each of the outputs. In the final mix they will become stems of dialogue, sound effects and music. There could also be Foley and background stems. All of the stems will be at mixed levels.

When you use a send, you may have to select to operate in either pre-fader or post-fader mode. In Pro Tools, if the send is pre-fader, then it's not controlled by the audio track's fader. You could drop the fader to the bottom of the track, but the sends audio would not be affected and would still be playing into the aux track. If the audio track is in post-fader, the track's fader will affect the sends level and engaging the mute button would stop both audio tracks and its send's signal from going anywhere.

VCA FADERS

A VCA (Voltage Controlled Amplifier) fader can be very useful once you have all of the individual track levels closely set. For example, you could group all of the dialogue tracks and send them to a VCA fader. The VCA fader would then be sent to the master fader. The VCA fader is like a second layer in the mixing signal flow and is especially useful in large track count mixes. It's similar to an aux track but has fewer options and fewer limitations.

The main feature of a VCA for mixing is that you can control the overall gain of a group of tracks and still adjust the individual tracks that are in the group. If you have tracks grouped together without a VCA, you have to suspend the group in order to adjust any of the individual tracks and then you'll need to turn the group back on to continue the mix.

You want to avoid a situation where you have added reverberation or some other effect to one of the individual tracks in a group using a post-fader send and then you adjust the level of the group fader. Lowering the group fader will reduce the level of the individual tracks, but it will not affect the post-fader reverberation. You'll hear much more of the reverberation than the original sound because only the original sound was lowered. Instead, use a VCA group fader and you'll adjust all of the tracks and send levels at one time, so that the level sent to the post-fader reverberation will be adjusted along with all of the other tracks in the group.

A VCA does not allow inserts, as there is no signal passing through a VCA, so there's nothing to be processed. With a VCA fader all track levels are lowered or raised in relative position; therefore, its main function is to simply control the volume level of the group assigned to it.

Be aware that when you use a group fader, you are raising or lowering the summed volume level, so be on the lookout for any peaking caused by summing.

MASTER FADER

The main purpose of master faders is to control the master output levels for the mix. They can also be used to control the output level of bussed tracks, submixes, effects sends and other routing needs. It might be useful to have a master fader assigned to a bus to be able to adjust the input levels going into an aux or auxiliary track.

They are capable of accepting all types of tracks and they allow for the adding of post-fader processing. You could add a compressor or limiter to the master fader output to allow that last step of protection from clipping. They usually do not have the ability to pan, mute or solo.

If you choose not to go the grouping route, you can print the stems. If you do want to print your stems for the final mix within the DAW, then you may want to have all of your tracks routed into the various aux stems; you then route them to the print tracks. There could be a print track for the stereo or 5.1 mix: one for the dialogue; one for the music; one for the dry sound effects; and one for the wet sound effects. The wet sound effects stem will have the added reverberation and other processing. By having both wet and dry sound effects, you can choose between them during the final mix. You can now route all of the stems into the stereo or 5.1 mix aux track, plus route each into its own print track. Now go to the beginning of the time-line and hit record on the print tracks. You'll have a finished mix recording and three stems. It's a good idea to give unique names to these files so you can easily find them.

If you are doing the final mix with printed the stems, you will have more difficulty making changes at the sound file level as everything is baked into the stems. Because of this, I recommend that you don't create stems in your premix, but use groups. By grouping the tracks you are not baking in effects like reverberation into the session, but allowing them to be altered as you work through the final mix.

METERING

If you want your film to sound good in a theater or through television, the internet or on a DVD or Blu-Ray, then you need to be monitoring your sound with an audio meter. Meters will show how loud or quiet your film is. A common way to meter is to use VU meters and Peak meters or PPM (Peak Program Meter).

A VU meter shows the *average* volume level (RMS) of the sound passing through it. A PPM meter shows the *peak* volume level of the audio passing through it. Imagine that you are on a basketball team and the average height of the players is 6 feet or 1.8 meters, but the center is 7 feet or 2.1 meters tall. The center is the peak and the other players are the average.

All NLE or DAW software have some form of metering built into them. Some are better than others. Some meters combine both peak and average metering. There are also many software plugin meters available for free, while the high-end ones need to be purchased.

Premiere and Audition have the standard peak meters, but they also have the Loudness Radar plugin that measures the level of loudness over time. The target for this meter is to have your sound level hovering around −23 to −24 LKFS and occasionally popping into the yellow circle.

Final Cut Pro only has a built-in peak meter too, so you need to add a third-party averaging meter plugin to get a sense of the overall sound level.

If you can afford them or your system has them, I suggest that you try the Linear Extended meter for all of your non-master faders and K-20 for your master fader. These are both available in Pro Tools HD.

Pro Tools Standard meters include:

Sample Peak: (Default) Constantly shows all the dynamics of the signal
Pro Tools Classic: Metering scale goes from 0 to –60dB
VENUE Peak: Peak metering commonly used for events using Avid's VENUE.
VENUE RMS: Average metering commonly used for events using Avid's VENUE.

Pro Tools HD meters include the four in the Standard Pro Tools plus others:

Linear (scale goes to –40dB): Peak metering
Linear Extended (scale goes to –60dB): Peak and RMS average metering
RMS: Average metering
VU: Average metering
Digital VU: Average metering
PPM Meters: Broadcast Standards
K-scale Meters: (K-12, K-14 and K-20)

Figures 13.15 and 13.16

2-POPS AND TAIL POPS

Figure 13.17

It is a valuable and standard practice to have two pops on your timeline. Two-pops are useful in maintaining synchronization of all of the tracks and with aligning the sound with the picture once mix is printed and exported.

A 2-pop is a 1kHz tone that is one frame in duration. It is placed exactly 2 seconds before the FFOA (First Frame of Action) for the film or for each reel. A tail pop is 2 seconds after the LFOA (Last Frame of Action). Some people use the initials FFOP and LFOP for first frame of picture and last frame of picture. If you use a countdown the 2 is typically the last frame you see and it is accompanied by a pop. There are 2 seconds of black immediately after the single 2 frame.

The timeline example shows the 2-pop at the 59:58:00 timecode, which is 2 seconds before 1:00:00:00. The 1-hour mark is common for the beginning of a film in the USA, while the 10-hour mark is commonly used in the UK. If you are dealing with multiple reels, then you add an hour increment to the next reel. For example, if reel one starts at 1:00:00:00, reel two will start at 2:00:00:00.

It is good practice to put a 2-pop or synchronized pop and tail pop on every track that you have in your timeline. This will allow you to make sure all of your tracks are in synchronization when you've completed a pass and when you are done with your premix.

DIALOGUE AND ADR PREMIX

Dialogue

The standard starting place for a mix is with the dialogue. Your goal is to make sure that all the lines are intelligible and at the appropriate level. Once the dialogue is set, you can then mix the sound effects and music around the dialogue. Dialogue is the most important part of a mix. Everything else is secondary and serves the dialogue. A lot of student films put music first and the dialogue and story suffer for it. Music can greatly support a story, but it can also sink it if it overpowers the dialogue and thereby the story.

There may be creative reasons to obscure the dialogue or alter it with effects, but make sure that what needs to be heard is heard. Why write a script and have it performed if you aren't able to hear the words?

Dialogue usually contains the necessary exposition needed to tell the story and to give the audience information about the characters. Along with that, the delivery of the lines tells the audience about the emotional state of the characters. As the mixer, you can affect the dramatic elements of a character's lines by increasing or decreasing the volume level or equalizing frequencies. Just by bringing up the level of one word in a line, you can alter the meaning of a sentence or affect the emotions of the character.

Dialogue usually sits around the −24dB to −18dB range. If you're mixing for television, then a higher level of −12dB would be acceptable. If your monitors are calibrated to 78 or 79dBFS with a SPL meter, set for a C weighting, then normal dialogue should be between 50dBFS and 70dBFS.

Since dialogue is almost always positioned in the center speaker, you'll need to make sure you have it panned accordingly. There may be times to pan a character's voice off toward one side or the other as they exit the frame or as they move behind the audience, but these are rare instances that need justification.

As you mix each scene you'll have to decide if the boom microphone or the wireless lavaliere microphones work better. For example, in a scene where two people are about to do yard work, you may use the boom microphone for the wide shot of them walking up to the tool shed. This will make the dialogue sound like it's in the proper location and matches the camera angle or perspective. At the cut to a medium shot where the two actors walk into the tool shed, you may switch to the wireless microphones because there was no room for the boom in the tool shed. Since the wireless microphones are planted on the body of the actors, they will have stronger bass frequencies from the proximity to their chests. They will also not sound like they are in their environment because the wireless microphones are buried beneath the clothing of the actors. You'll need to do some subtractive EQ and addition of reverberation to make the wireless microphones come closer to sounding like the boom and the environment.

You may notice that there is a dropout or dip when you play both the boom and the lavaliere tracks together. This may be a phase issue between the two microphones not following the 3:1 Rule. Being out of phase will cause there to be a cancellation or a drop in levels, which most often occurs in lower frequencies. You might be able to nudge one of the tracks enough to stop the phasing. It may only take 1 or 2 milliseconds of nudging to accomplish this; otherwise you can avoid phasing issues by not playing both microphones at the same time.

If you do need to play both microphones at the same time for blending or crossfading purposes, then it will help to have a phase type scope plugin available. You can run both the boom and wireless lavaliere signals through it and determine if there is a phase issue.

Once you've found the best blend and you've taken care of the phasing issue, you could then add EQ if needed. You would need to use the same kind of equalizer on both tracks to maintain consistency. Different types of equalizers may function differently and cause a phase issue or other problem, so use the same one on both. They probably wouldn't have the same settings, but at least they would use the same processing.

It is common to insert EQ and compression on all of the dialogue tracks. If the dialogue calls for it, then adjust the EQ and compression to make it work well. The key is to not overdo

it. You need to listen to the dialogue or other sounds and decide if it needs equalizing or compressing. If it sounds good already, leave it alone. Less is more.

There are no specific rules for what order you follow to insert plugins. There are some commonly followed steps. First you may want to approach the sound by doing some correcting, so put in an EQ to clean up the sound. It's better to do some subtractive equalizing to remove unwanted frequencies before you put them through a compressor. You then might add the compressor to level the sounds and then you might, if it's called for, add a second EQ next to enhance the sound. After the sound has been equalized and compressed, you might add a de-esser, if needed.

Reverberation and delays are not commonly put on individual tracks, but are put on an aux track that have several tracks routed to it; however, there may be tracks that require their own special reverberation. In Pro Tools you can add processing to individual audio clips.

A good starting place for EQ is with the high and low frequencies that do not add anything of value to dialogue. A high-pass filter that reduces frequencies below 60Hz by –6dB or so is helpful for getting rid of low-end hum. You might even try cutting frequencies up to 100Hz if there's too much low end. Now use a low-pass filter to reduce frequencies above 12kHz by at least 6dB, if not more. You could even lower that to 10kHz if there's hiss in the sound above 10kHz. Now boost the frequencies around 3kHz to 4kHz by 2dB or 3dB to make the actor's speech stand out more.

If you use too much EQ, the actor's voice will not sound right. It's almost always better to add EQ to the sound effects and the music than the voice. Using subtractive EQ, you can reduce frequencies in the music and sound effects that are in the same range as the talent's voices. This will bring out the voice by making room for it in the entire frequency range of the sound effects and music. Don't overdo the frequency attenuation. A drop of –3dB to –6dB in the level may well be enough to make a difference.

If you choose to boost the dialogue with EQ, keep it minimal by starting with 2dB or 3dB around the 1kHz range with a "Q" of around 4 and experimenting from there. Remember that male voices and female voices usually occupy different frequency ranges, so you'll need to find the best frequency and Q for whatever voice you are working on. There is no recipe for using EQ as with each film the actors change, the sound effects change and the music changes. I've heard many low budget short films that have the dialogue played loudly in order to try to avoid competing with the music. It usually doesn't work. That's when EQ is at its best. It lowers the volume level of the frequencies that compete with the dialogue and that lets the dialogue come through without having raised its volume level.

A common problem with some short films is that the boom microphone is not held close enough to the actors. This causes the dialogue to sound distant and dull. Often the best solution is to do ADR. At least with the ADR you are starting with a good clean sound that you can process to sound like it's in the location where the scene takes place.

If ADR is not an option you can try to improve the dialogue by using some EQ. Some of the lower frequencies can be tamed by reducing frequencies around 250Hz–300Hz. Some of the higher frequencies can be helped by boosting frequencies in the area around 3kHz–4kHz by 3dB–6dB and using a fairly narrow "Q." Try doing the equalizing with the music and sound

effects playing along to hear how well the EQ is working with everything else. If you just played the dialogue track and adjusted the EQ, you might overdo it and have the result of making the dialogue sound odd.

If you have to EQ out a hum, HVAC sound or some frequency that affects an actor's voice quality, you could try boosting the harmonics. For example, if you have to cut the frequencies below 250Hz, which causes the actor's voice to lose some of the warmth in their voice, then you could try adding just a few dB to the harmonics. For example, if the lost fundamental frequency is 150Hz, then boost at 300Hz, 450Hz and 600Hz and listen to how that affects the actor's voice. Boosting harmonics can be useful for dialogue, sound effects and music, but only when it's beneficial.

Once you've got the levels and EQ where the dialogue sounds good, then move on to the compressor. If the location sound was recorded very well, there may be little need for the compressor; however, that's not often a consistent occurrence. If you use too much compression, the varied levels of speech from the actors will have a more narrow dynamic range. An actor's whisper could be nearly as loud as their normal voice, although that might work in some situations. Actors use intonation, pitch and volume to convey the emotions behind their lines; you don't want to take that away from them. Once you've set the levels and EQ on the dialogue in a given scene, then you can move on to adding a slight amount of compression with a ratio of 2:1 or 3:1.

Ideally, your dialogue or production track was recorded so well that you only need to use a plugin like Waves C4 or a similar multi-band compressor to clean it up. You have to experiment to find the offending frequencies and then add some compression to adjust them, hopefully leaving the heart of the dialogue frequencies intact. If this approach doesn't do the job, you may have to turn to one of the many noise reduction plugins available. Remember, you don't have to eliminate the noise; just reduce it to where it isn't noticeable.

A common way to smooth out the dialogue even more than what was done in dialogue editing is to add some backgrounds or ambiences. These will add a presence that is consistent across all of the cuts. It may be better to wait until the final mix to add the backgrounds, as then you'll know how much you need in comparison to the sound effects and music, if there is any for a given scene.

All dialogue that's on screen will be mixed mono and panned to the center speaker. There may be a time when an actor delivers a line off-screen and then the dialogue can be panned toward that side. Try panning about 20–30 percent to the side the actor is on. If you are mixing in surround, there may be situations where the dialogue and its partner Foley need to be panned with the actor as they move around the film world.

If the dialogue is noisy and it's hard to eliminate the noise, keep the dialogue in the center. If you pan a noisy dialogue track you'll also be panning the noise. This could be very distracting for an audience. If the dialogue is recorded well and there is call for it, it can be very effective to pan the dialogue into other speakers to give a more engaging and immersive experience to the audience.

Once the levels, EQ, compression, ambiences and noise reduction are dealt with, it's time to move on to reverberation. Since all the tracks of production dialogue will have all been

recorded in the same location, it is most likely that you only need to add a bit of reverberation to the dialogue aux track to make it work. You may not need any reverberation as long as the dialogue sounds properly placed in the location in terms of the reflections we would normally associate with that location. We expect a lot of reverberation in a cathedral, but not in a walk-in closet full of clothing. Let your ears and eyes tell you if you have the proper reverberation.

If you're doing a surround mix, then for most scenes you would not add surround reverberation to the dialogue tracks. However, if a scene takes place in a cathedral or similarly reverberant place, then you might want to add some surround reverberation or delay to encircle the audience and make them feel like they are in the reverberant or echo-filled place too. Since Foley usually goes along with dialogue, you would not normally add surround reverberation to it either. I say normally, because there are always instances where it will work and a cathedral might be one of them.

When you use reverberation, don't just think of it as being for interiors. Reverberation can be added to exteriors, as many exterior locations will have reflections too. It may not be appropriate in the middle of a hay field, but it might be effective in a street, alley, skate park or other location that has reflective surfaces. You may not need to add any reverberation or just a little bit, enough to sell the location to the audience, but not enough to draw attention to it. Normally, I try not to use reverberation on production dialogue unless it calls for it. Remember, we are trying to make the dialogue clear and intelligible and too much processing and cleaning might be counterproductive.

If the system you're mixing on has automation for the mix, then you'll have it easier than if you had to individually add processing to each clip. As you go down the timeline mixing scene by scene, it will be beneficial to be saving all of your decisions in alterable automation, rather than baking them into the sound files. Mixing-in-the-box means that you are able to make changes at any time up to the master output and that's an ideal situation.

ADR

ADR will sound very different from the production dialogue you recorded on set. The ADR will have been recorded in a quiet recording studio with very little reflection of sounds. If the ADR was recorded on location, then it will make the process a lot easier.

There are two approaches to ADR; the first is replacing the entire dialogue in a scene or even in an entire film and the second is a partial replacement where you insert a word or two or even an entire sentence, but not the entire dialogue for a scene. Whichever type you are working with in your film, there are some basic steps that need to be done in order to get the ADR to seem like it matches the production dialogue.

If you are working with a *complete replacement* of production dialogue, then it is a bit easier in that you don't have to match the sound of pre-existent production dialogue.

When you are working on a complete dialogue replacement, you'll need to get the level adjusted to the proper amount. Once the levels are set, then move on to the EQ. If you are doing a complete replacement, then you need to adjust the EQ to make the ADR sound like it was recorded on the location. Ideally, the ADR was recorded on the location shotgun

microphone or whatever microphone was used during production. This will make the qualities of the microphone consistent throughout the film. If the ADR was recorded with a different type of microphone, such as a large diaphragm condenser, then you'll probably need to reduce some of the low end and perhaps boost some of the higher speech frequencies, at the least. You should consider adjusting the EQ differently for a wide shot and close-up. The close-up could have more low end and the wide shot could have less low end and more high end. That would be equalizing the ADR to match the shot and the location. The amount of EQ should be minimal and not detectable by an audience.

When you are working on a complete ADR replacement, then you may not need any or perhaps very little compression as the recording was in a controlled environment with a stationary microphone and the mixer may have recorded with a light compression added.

If the ADR was recorded with both a boom microphone and a lavaliere, then you can choose the one that will better fit the scene or shot. I suggest that you try to use just one of the microphones and not try to blend them as there may be phasing issues or the sound from the two different microphones may not blend well.

Once the levels are set, the EQ adjusted and the compression is added, you need to work on the room tone or ambience. When the dialogue and ADR were edited, there should have been room tone added under the lines that are being replaced. If you are replacing the entire production dialogue with ADR, then you can choose the room tone that you like best. It needs to simply ride under the ADR and sound right for the location.

The next step is to add the necessary reverberation to the ADR. You need to use the right reverberation to place the ADR in the established environment. If you are doing a complete dialogue replacement, then you can choose the level of reverberation that works best for the location the scene takes place in. When you are completely replacing the dialogue, you could route the ADR tracks to an aux track and add reverberation or delay there.

If you are working on a *partial dialogue replacement* the process is similar, but there are some differences.

Once the production dialogue level is set, then you need to adjust the ADR level to match it. Be careful that when you add EQ or other processing you maintain the same gain staging throughout the signal flow.

The next step is to adjust the EQ to match the production dialogue. It's common to find that the production dialogue has more of the higher frequencies and that the ADR has more of the lower frequencies. If you have an audio spectrum analyzer, it can be very useful in finding the voice frequencies in the production dialogue and then adjusting the ADR to match.

You can start equalizing the ADR by adjusting the higher speech frequencies first and then move on to the mid-frequencies and then the lower frequencies. Work at this until they are as close as possible.

When you are doing a partial dialogue replacement, ideally, the ADR lines were recorded with the same make and model of microphone used for the production dialogue and the distance from the actor was about the same. You can check the sound reports or with the production recordist to find out what microphones were used and what the settings were for the original dialogue recordings. Many microphones allow you to use a low or high-frequency

roll-off and this will color the sound of the ADR. Each microphone has its own qualities and characteristics. There are a few microphones that have similar sounds, but most do not. The microphone used in recording the ADR can make a huge difference in how easy it is to match the production dialogue with the ADR in the mix.

After the EQ is set, you can start working with the room tone that was cut in for the ADR. The level of the room tone needs to match that of the production track. You may have to do a long crossfade into and out of the ADR room tone if it wasn't done in the ADR edit. It is crucial that you get the room tone to work seamlessly as otherwise it will draw attention to the change and that could make the ADR even more noticeable.

The next step is to add the necessary reverberation to the ADR. It needs to match the sound of the production dialogue as it reflects off the surrounding surfaces in the location of the scene. There is almost always some reverberation needed for the ADR. I suggest that you use a mono reverberation since both the production dialogue and the ADR would have been recorded in mono. You could insert a reverberation into the ADR track or you could do a send to an aux track with a reverberation on it. It just depends on how much and how complicated the ADR is. Even though it uses up some of the processing power of the computer, I prefer to insert the reverberation onto the ADR track. I do this because once I have it set to match the production dialogue, I can then send both the dialogue and the ADR to an aux track that has another reverberation on it. I only do this if the scene calls for them to have more reverberation.

IR (Impulse Response) convolution reverberations can be very useful in creating the necessary reverberation setting for a specific location. If the location sound mixer has recorded an impulse response sample at the location in which the ADR occurs, then the data from that recording can be applied to the ADR to make it sound like it was recorded at the location. If there is no IR sample from a location, then you can use a preset IR reverberation that may well match the size and type of location of the scene. Plugins like Altiverb, TL Space and Waves IR are very useful in getting the reverberation right as they have settings for some specific rooms or halls. Some plugins can create a reasonable IR by sampling the clap of the slate from a take done in the location which requires ADR. There are many controls for convolution reverberations such as room size, reverberation time, decay, resonance and more. These are fairly expensive plugins and are more complex than your standard default reverberation that comes with your software.

It is generally not a good idea to play with an actor's voice, especially if they are a well-known actor; however, there may be times where you choose or need to pitch shift their voice. Whatever pitch change you do should be minimal. You might pitch shift up or down an actor's voice by a semitone or even less to match the production dialogue.

FOLEY PREMIX

The dialogue premix and the Foley premix need to work well together. The Foley always stays with the dialogue. The simple reason is that the actor's mouth, feet, clothes and hands all occupy the same space at the same time. Usually, wherever the actor is in a given scene their other body parts are there too unless it's a horror film. This means that if an actor is far away

and walking toward camera, then we'll hear their footsteps and their clothes more loudly the closer they get to camera. If an actor exits the frame and then comes back into frame, their Foley needs to pan with their voice if you choose to do a pan. Because of this close relationship, it's helpful to premix the Foley with the dialogue playing.

If you're adding reverberation to the dialogue track, then you need to add it to the Foley tracks too. It may work to use the same reverberation settings for both, but usually it works better if you tweak the reverberation for the dialogue and Foley separately. You might try compressing the Foley tracks, especially the footsteps, and then add the reverberation. Adjust the Foley reverberation so that it matches the dialogue in feel. You may also try to EQ all of the Foley by putting a low-pass filter at 8kHz so that the hiss and noise that can occur in Foley recordings is removed.

Figure 13.18

Foley footsteps need to sound realistic. Most Foley artists will walk an actor and try to do the levels and variations in the sound of footsteps for you. However, you may need to tweak them. This means that you may need to ride the faders in order to get the right level as the actor moves around.

SOUND EFFECTS PREMIX

Once the dialogue and Foley are premixed, you can either move on to sound effects or music. I suggest that you take on sound effects first. Sound effects are the real story world sounds, while music, especially score, is most often outside of the story. Most sound effects are based upon the real world and are used to position the story in the time period and location in which

it occurs. The exception might be sound design elements, which are often not of the real world, but are still there to support the story and the world in which the story exists.

Part of your job as the mixer is to determine which of the sound effects are needed in any given scene. If there are too many sounds happening, it may be too much for an audience to take in and the sounds just become noise. If there are not enough sound effects, then the believability of the story world may not be supported.

If you are working with the director, they may have strong ideas as to what sounds they want in a given scene. If you are both the director and the mixer, then you'll be able to make those decisions without discussion. If you are the sound editor, mixer and director, then you have probably already thought through the sounds you want used in a given scene.

I suggest that you determine what sound effects are needed in a given scene by deciding which ones have the highest priority. For example, if a scene is taking place in a prison visiting room, there are the usual air ventilation sounds, distant jail doors opening and closing, an occasional PA system announcement, footsteps in the hallway and the faint hum of the fluorescent lights above. In the visiting room, a woman is visiting her husband who is an inmate. During this visit the husband starts to become agitated toward his wife. He eventually jumps up and starts yelling at her. Guards come and haul him away. In the beginning of the conversation between the couple, you may play the natural sounds of the prison a bit low, not wanting to distract from the dialogue. As the husband becomes agitated, you may choose to bring up some of the sound effects, such as the sound of jail doors closing and footsteps hurrying down a nearby hallway. The husband is standing now and yelling. The visiting room door is flung open and two guards rush into the room. You may choose to make the sound of the visiting room door opening and hitting the concrete wall particularly loud. As the husband is leaving the room, the door is now closed softly. We just hear the air ventilation and a click in the soundtrack or maybe just the click as it has the highest priority by giving the scene emotional impact.

In the premix, you are deciding which sounds work best for a scene, but you still won't know how well they will play with the music. You'll find that out in the final mix. That's why you don't get rid of any of the sound effects; you just do a preliminary mix with them. The final mix may work best with all the sound effects being played throughout the scene in the prison visiting room or not.

When you use panning to place a sound effect, remember that the sound needs to be heard by everyone in the audience, so don't pan it too far from the center. If you are mixing in surround, you may venture out into the theatrical space with your sound effects, but if they are hard sound effects that match an action on screen, you need to have them placed in their proper perspective. If you have a sound effect that moves across the screen, such as a car-by, you will want to pan it across the three front speakers. If the recording of the car-by is in stereo, you'll want to pan it just the same, across all three front speakers. It won't work well to pan the left channel of the recording to the left speaker and the right channel of the recording to the right channel because there will be a phantom center that will not sound correct, especially if you are sitting in the center of the theater. You need to pan for the center speaker too.

DESIGN EFFECTS PREMIX

When you mix sound design effects, there are few limits, as they are usually meant to be outside the real world or in some cases they are meant to be hyper-real. It's common to use EQ, reverberation, compression, panning and level adjustments to make these sound designs become real.

Most sound design is created in a way that defines a monster, alien, spaceship or other world thing. The sound designer has put great thought, work and time into developing the sounds that are needed. They often use various sound processing techniques, both hardware and software, to alter the sounds. As the mixer your job is to bring all of those sounds together in a way that works within the context of the story world. You need to mix these sounds with other sounds and with the music, so make sure they all blend together and thereby do not compete with each other. If you are the mixer and the sound designer, then you may already know how the sounds will play together.

Ideally, the sound designs and the files that were used to create them are in the session. The source files are often muted and hidden as the sound design is what is being mixed. The files are there only to be used if necessary.

BACKGROUNDS PREMIX

Backgrounds inform the audience on what type of story world is being presented. If a scene starts out in black and slowly fades in, the audience will get their first clues about the setting from the ambience sounds.

Backgrounds, whether they are recorded in mono, stereo or surround, can be very effective in putting an audience in the middle of the story world. In order to effectively create the story world ambience, great care must be given to selecting the right sounds and then placing them in the space of the sound field. It's helpful if the premix is focused on creating the environment, so that it only needs to be played and tweaked during the final mixing.

Start by playing the constant ambient sounds, like wind and rain, and then start adding the ambient effects, like birds, dogs and thunder. You'll adjust the levels of each as you add them and then again after they are all playing, adjust them until you find the right balance for the scene.

You can now work with the panning in order to place the ambient effects where they help envelop the audience. Perhaps you have three bird tracks. You can place the birds where you want in the stereo or surround world by panning them. You may need to use some reverberation to make the ambient effects sound right for the scene's location. Even though you are panning some of the ambient effects, you need to keep the main ambient sounds anchored at the front. They may bleed into other speakers, but they need to be grounded in the front.

MUSIC PREMIX

Once the dialogue, Foley and sound effects are done, then you have the real sounds in place and the music can be premixed accordingly or it can wait to be mixed during the final mix. Music is often premixed by the composer or music editor and brought to the final mix. It is

common for the music to come to the final mix with all of the stems premixed as a stereo session or a surround version. The music may be delivered as a surround session and then used to create a stereo version. The music could also come as a stereo version that is turned into a surround version during the mix. The composer's mixes may be redone during the final mix, but at least the composer has put forward their idea of how the music should sound.

During the premix all of the tracks will have the volume levels set, the EQ adjusted, the panning done, reverberation added, ADR matched to the dialogue and the music blended in. The premix should be able to be played back sounding fairly integrated with the picture. It might even function as a decent temp mix for a test screening.

It is common for whoever composed and created the music to have done more than is needed. You'll have to remove the music cues that don't help or are conflicting with the sound effects or dialogue or even the need for silence. You could remove some of the music cues now, if you have the music, but it's better to wait until the final mix.

TEMP MIX

A temp mix is one that's done for audience testing. The idea is to fill the holes and smooth out the sound so an audience isn't distracted by the incomplete soundtrack. This means putting in the necessary sound effects, even if they are not the best or final choices, smoothing out the production track and mixing in temporary music that works well enough.

Historically, temp mixes were done as separate mixes on the rerecording stage, but now it's more common to use the picture edit version as a temp mix. Often a sound editor or sound designer will work with the picture editor to provide necessary sounds to be cut into the picture edit timeline. The music composer may also have score mock-ups that can be added to the picture edit too. The levels are adjusted to blend together all of the sounds and then the picture and soundtrack are exported as a video file and played for the audience. This method saves a lot of time and money.

Once your premix is done, it's time to move on to doing a final mix. This might be done by yourself on your own system or you could take your premix session to a rerecording studio or mixing stage and have a professional do the final mix.

The purpose of the final mix is to get all the elements working together to help tell the story. This is where you tweak and make final decisions. It's where the work you did with the premix allows you to be more creative and not have to concentrate on the more technical aspects of a film mix. The final mix is a time to make the sound design shine.

CHAPTER 14

Mixing Myself

Figure 14.1

INTRODUCTION

Once you've completed the premix and if you created stems and they're ready, it's time to do a final mix. The technical aspects of the final mix involves tweaking the levels, getting a good balance between the food groups (dialogue, effects and music), adjusting DSP (Digital Signal Processing) to improve the overall sound, getting all of the sounds to blend together well and preparing the deliverables. The artistic aspects involve making the right creative decisions to fulfill the filmmaker's vision and to make the story work.

The person doing the final mix is usually referred to as a rerecording mixer or dubbing mixer. If you are doing your own mix, you can call yourself whatever you want to. The important thing is to go through the film scene by scene and make the creative decisions along with the technical ones that will tell your story. In the end you should have the mix you want and the deliverables you need. The biggest issue with doing the final mix yourself is that it's hard to keep perspective. As the sound editor you may have to put in a sound you really like and as the mixer you really want to use it. However, if you had perspective you might readily see that the sound competes with the music and should be removed or at least played at a low level.

During the mix, you need to keep asking if the sound is being used in a way that supports the story and affects the emotional involvement of the audience. For example, if you have a scene that erupts into chaos, then you could use sound to reflect that chaos by having competing levels and frequencies and by having sound effects in conflict with music.

You need to determine what formats you'll need for distribution. You might have a stereo mix, surround mix, DME (Dialogue, Music and Effects), M&E (Music and Effects), television, DVD, Blu-ray, VOD streaming or other required mix. The television, DVD and Blu-ray are all similar mixes and you could use one for all three. If you don't have a contract, then you can create the mixes you need in order to get your film distributed the way you want. If you have a contract for distribution, then there will be required deliverables. Whatever you need to do, you'll almost always need to do a stereo mix as it's the most universal format.

SET-UP

Once you have gone through your film and done a premix or predub of all the tracks, you'll be ready to take on the final mix. If you elected to do premixes of the dialogue, sound effects and perhaps music in separate sessions for each, then it's time to import them all into the final mix session. This may be easier to do in a DAW (Digital Audio Workshop) than it is in some NLE (Non-Linear Editing) systems. If you are doing the mix all at once in a NLE, then the same approach is taken, as with a premix and a final mix.

The final mix is focused more on fine-tuning, such as balancing levels, adjusting sounds and removing competing or unwanted sounds or music. You need to be working toward a soundtrack that flows well and artistically supports the story. Keep an open mind about the mix and be willing to change your ideas if something else serves the story better. You'll know

you are doing a good job of mixing if the emotional elements of the film are affecting you. If you can feel it, then the audience can feel it.

Ideally, your final mix will be set up to output the primary format or formats that you'll be using for exhibition. One costly approach is to mix in surround, either 5.1 or 7.1, and then take that mix into a 3D space, like Atmos, and do a mix for that environment. If you need a stereo or LCR (Left, Center, Right) mix, then either one or both can be created by doing a fold-down from the surround mix. Depending on your needs, just doing a stereo mix may work well for you. Otherwise, a LCR is a basic mix that will work for nearly all cinemas because there will be a signal for the LCR speakers. Another mix to consider is the LtRt (Left total Right total). This is very common in the festival circuit and in television and is a DVD format. It allows for a stereo system to play a stereo mix and for a surround system to play a surround mix. The trick is in how the mix is encoded and decoded. There are plugins that will allow you to do this fold-down from your surround mix.

In most DAWs there are templates that are designed for specific purposes like film mixes and music mixes. Some of these are very complex and can take some time to figure out what the signal path is for the different elements in your mix. I try to keep the mixing paths as simple as possible without taxing the computer's processors. If your film sound is fairly straightforward and simple, then you might try mixing all the tracks directly to a master fader. If your film sound is more complex, then you may need to send each group of sounds to an aux track and/or a VCA track where they come together under one controlling track. For example, if you wanted all of the Foley sounds for a scene to have the same reverberation added to them, then you may be better off adding that reverberation to the Foley aux track, then to add the same reverberation to each individual Foley track. The Foley aux track would then feed the master fader track.

If you are planning on doing your mix in a NLE, like Media Composer, Premiere or Final Cut Pro, you'll have some of the same tools as in a DAW, but it's more cumbersome to try to do a mix in a NLE. They are primarily picture editing software that allows you to do an audio mix, but they aren't designed to work as a full feature DAW. Final Cut Pro has Logic Pro as its designated audio editor and mixer, Premiere has Audition as its audio counterpart, while Media Composer has Pro Tools. They wouldn't need these DAWs if they we able to do a complete audio edit and mix.

GETTING STARTED

Once your template or signal flow is set, you can start the process of mixing the stems if you did a premix or the sound elements if you didn't. If you had more than 24 tracks, you might want to consider doing a premix before you tackle the final.

Your session should be set up to be streamlined and give you the outputs you need. You can do separate mixes to give you the various formats that you might want for distribution. You could do a stereo mix and then do a surround mix. There is no rule that you need to do both at the same time. It does save time, but it could be a distraction too. If you do choose to do a surround mix, then approach it as a way to subtly enhance the audience's experience. Don't overdo it.

If you are doing a surround mix, don't neglect the LFE (Low-Frequency Effects) channel. It can be used for those intense sound effects that shake the audience.

If you are doing a mono mix or a fold-down to stereo or mono, you'll need to remove the LFE signal from the mix. Most stereo or mono systems would have trouble trying to reproduce the LFE frequencies without subwoofers.

DIALOGUE FIRST

If you've done some dialogue cleaning during the editing process or if you've done a premix, then you'll only have some tweaking to do in the final mix and you'll want to get the dialogue to work well with the music and sound effects.

If you haven't done so already, you'll need to add whatever EQ (Equalization), compression, panning, reverberation and other processing that is needed to make the dialogue shine. There are no hard and fast rules. You just use your ears to get the best sound you can. The main thing to watch out for is not to overprocess. Only do what needs to be done. You'll find that if you play the dialogue along with the sound effects and music, for a given scene, you'll need to do less cleaning. A common mistake is to clean the dialogue while only playing it and that can result in overprocessing. However, it's better to play the dialogue by itself when you're doing other non-cleaning processing. I suggest doing both; checking the dialogue processing by turning on the music and sound effects and then turning them off to do some tweaking.

Only add reverberation or delay to dialogue if the microphone used is too dry for the perspective of the actors in the scene. If the shot is medium to wide and the actors are wearing lavaliere microphones, then there won't be much reverberation, but if they are being picked up by a boom microphone instead, then there will be some reflections from the location's surfaces in the recording. You'll probably have to add some reverberation or delay to the lavaliere microphones, if you choose them over the boom.

You might decide to add a small amount of compression to the dialogue. This may work better on the lavalieres than it does on the boom. The compression used on the boom microphone recording can cause the natural reverberation to be more pronounced.

ADR

If you are replacing all of the dialogue in your film with ADR (Automated Dialogue Replacement), or even one scene, then you are free to create whatever sound will work for the location in which the scene takes place. If you are replacing just a word or a sentence or two, then you'll need to adjust the ADR to match the dialogue.

- First adjust the ADR volume level until it matches the dialogue.
- Next adjust the room tone or ambience level to match that of the dialogue track.
- Next equalize the ADR until there is a similar frequency spectrum. You'll probably have to cut some low end and boost some mid-highs to match the dialogue.

- Next add some reverberation or delay to get the ADR to sound like it's in the same acoustic environment as the dialogue. Start with it set at the minimum level and slowly increase it until it sounds right.
- Finally, readjust the gain or volume of the ADR and room tone to match that of the dialogue.

SOUND EFFECTS

Most films have a lot of sound effects. If you have a lot of tracks, you may want to use a VCA fader to control some of the food groups. You may have guns, cars, robots, hard or synchronization effects and other groups to contend with during the mix. Once the levels in each of the individual clips or tracks are set, it will be easier to route each group through its own VCA fader to control the group's level. If you have a group that needs some processing, then you would send that group to a common aux track.

If you've done a premix, you may have already added EQ, reverberation or whatever else was needed to make each sound effect work. If you haven't done a premix, then you'll need to make sure the sound effects have the same reverberation treatment as the dialogue. Most sound effects are recorded as dry as possible to allow the mixer to add what's needed for a given scene.

AMBIENCES

Ambiences need to be carefully blended into the overall sound design. The elements in the ambiences can be used to add emotion to a scene. I've used fairly melodic sounding birds in the beginning of a scene, but as the scene progressed and the two actors started arguing, I brought a crow track up subtly with just an occasional crow caw in the background. The idea was to have the unpleasant sound of the crow's call add to the emotional state of the actors and thereby the audience.

In terms of adding EQ to the birds, I wanted the melodic birds to sit above the actors' vocal frequency range so they wouldn't compete, but I actually wanted the crow to compete to add confusion to the arguing.

For your standard forest ambience, I would not want it to sit in the vocal frequency range, so I would either build it that way or add EQ to cut a hole for the dialogue.

FOLEY

The levels need to be loud enough to be intelligible, but not so loud as to be noticeable, unless there's a reason to bring them up. Most professional Foley artists will walk the Foley footsteps so that they get louder as the actor approaches the camera and softer as the actor walks away, so they are almost premixed.

Foley needs to fit with dialogue and it needs to be panned to the front speakers or monitors following the same placement as the dialogue. If all of the dialogue is in the center speaker, then put the Foley there too. It could be in the left and right speakers if the situation warrants it.

Make sure that all of the Foley has a low-pass filter that removes all frequencies above 8kHz. This will keep the air and hiss at a minimum. You may also want to have a high-pass filter that removes all frequencies below 100Hz. This will keep any rumble from getting into the mix unless it's desired. You may need to reduce the mid-frequencies some in order to not compete with dialogue and to allow the highs and lows to be boosted. Boosting them will make the sounds louder without interfering with the dialogue.

If you haven't put on some form of compression for the footsteps they may have fairly sharp transients when the foot first hits the surface being walked on, especially if it's a hard surface like concrete or wood. That attack can be a distraction, so a compressor with a fast attack and a fast release might soften those foot hits to an acceptable level. There are transient designer plugins that can easily control the attack. They have only a few controls and take a bit of finessing to get it working effectively on the exact transients you are softening. There may well be one that came with the software you are using to mix.

Add whatever reverberation you are using for the dialogue, if any, and then tweak the reverberation for the Foley as it is usually a bit different than what you have set for the dialogue.

When I was the Foley editor on a feature film, one of the interns asked me if it was true that all of the Foley faders were just set to −20dB and left at that level for the entire mix. I told the intern that Foley was mixed just like the other elements in order to get the right balance and to stop reading blog posts from amateurs.

MUSIC

Music is not reality. Dialogue, sound effects, ambiences and Foley are all there to create a reality or a world for the story to occur in. Music doesn't directly add to that reality or world unless it happens to be diegetic. Music is a convention that works with story-telling, but it's not necessary to tell a story. Mixing a score into a film soundtrack is an art form in and of itself. Music is a non-verbal indicator of emotions. It helps drive the story. It gives the audience information and it helps identify characters, locations and themes.

The music needs to help tell the story and provide an emotional road map for the audience. It's really important to get the right balance of music in the soundtrack. It is less common to premix music than dialogue or sound effects. Most composers and music editors will already have a premix done before the score reaches the final mix. That's not to say that there aren't any last-minute changes that require the music editor to shorten or lengthen a music cue to match a re-edited scene or segment. It is also not to say that the premix is the final mix.

The music world uses the term "stem" when it describes the different elements or food groups of instruments. There may be the drum stem, the string stem, the horn stem, and so on. They are all at a mixed level and can be played at unity and you'll hear what the composer intended.

During the final mix, the music is played along with the dialogue and sound effects and the director makes decisions as when to favor music or when to favor sound effects. Sometimes

silence is called for and a musical cue is dropped. Other times the music may pull the story along and the sound effects are dropped. Once all the elements are brought together in the final mix, the director can make the creative decisions that they believe creates their vision for the story.

Levels, panning, compression and reverberation are all part of getting the music to sit right in the mix. Riding the levels of the music can be a challenge. You'll want to bring in the music without calling attention to the move, unless it's an action scene or montage, although they may need to be brought in unnoticed too. If you have a scene that starts off with just music and sound effects and then turns into a dialogue scene, you'll want to dip the music under the dialogue. This needs to be done in a way that masks or covers the change. You could use the downbeat to slide down the music level, because that would sound fairly natural or you could hide the dip in a prominent sound effect, a drastic cut, a camera movement or an emotional change in one of the characters. The point is to find something that will distract the audience while you perform your slight of hand magic.

If the music tracks are stereo, they'll work well in either a mono or a stereo mix. If you use that stereo music in a surround mix, then you can pan a small percentage of the music into the surrounds, but keep the power of the music in the front speakers. If the music is premixed in surround, then you'll be all set for your mix, but be careful of what you put in the surrounds and how loud they are.

Doing a stereo mix is easier than a 5.1 mix. Creating a 5.1 mix when you already have a stereo mix might be a little quicker than doing a 5.1 mix as there are plugins that will help you do it. However, the resulting surround mix may need some tweaking to make good use of the surrounds. If you have a surround mix, the stereo mix is very easy to do. Most systems have a plugin that will do that for you and the results are usually fairly good.

DME, STEMS AND M&E

Figure out what your deliverables are. If you have a distributor, they'll tell you what their needs are. If you are self-distributing, then you'll have to decide what you need for the avenues of distribution you want to do. Television has very particular specifications. Each broadcaster or cable company may have their own specifications. The internet has its specifications and film festivals have their own specifications. I've entered short films and documentaries in a number of festivals and have found that there is no consistency.

You may well need to have a mono mix, a stereo mix, a 5.1 surround mix, a M&E plus other deliverable formats. It will be helpful if you have a good set of stems. At the least, you'll need to have a stem for each of the three main food groups: dialogue, sound effects and music. These stems should be able to have the faders set at unity and when all of them are played together, they replicate your mix. You may choose to break your stems down further and have an ambience stem, a Foley stem or even a loop group stem. These stems can be used to create other formats for the deliverables.

You might choose to do a basic stereo mix and then when the film gets picked up by a distributor, you do whatever mix is required, hopefully with the distributor's money. If you need

to do a surround mix, make a copy of the stereo mix session and call it a surround version. Then change all the pans on each track or bus to surround and start your surround mix.

The DME (Dialogue, Music and Effects) stems allow you to make some changes without going back into the mix. You can change a music cue or add a sound effect easily and quickly. The M&E is the music and effects part of a DME. These need to have all of the sounds in the film except the dialogue and ADR. They have to be fully loaded so that a foreign language version can be done. The foreign language distributors do not want to have to do any editing or inserting of missing sounds. Many foreign distributors will send the film back if there are any holes in the soundtrack.

MASTER OUTPUT

If your dubbing stage is not properly calibrated, then you need to be monitoring the levels on your master output meter. You don't need to stare at it, but glance at it often so you know that your mix is consistent and within acceptable range. Most NLE and DAW systems have useful meters to watch. There are some plugins, like the Waves Dorrough meter, which are very good at showing you both the peak levels and the average levels. It is commonly used on film industry mixing stages.

When you are done with the mix, it's time to output the film's audio tracks. You can usually select what formats to render and export. In a DAW, like Pro Tools, you could route all of the stems to an empty track. You would set your start point and then record arm the track and hit record. When it's done, you'll have a printmaster. Another option is to export the audio by rendering or bouncing to disk. Make sure you have all the tracks you want to include turned on and that you have the entire timeline selected.

QUICK AND DIRTY MIX

If you don't have any money and the deadline for a festival or other competition is rapidly approaching, then you can go for a "quick and dirty" mix, hopefully more quick than dirty, and then work on a final mix after the deadline. Here are some basic steps to get your sound to a serviceable level.

1. Clean up and smooth out the dialogue as best you can.
2. Replace or sweeten any critical sound effects.
3. Add any essential Foley sounds, especially footsteps.
4. Add whatever music will support the story.
5. Add background ambiences unless the music covers it adequately.
6. Mix dialogue, effects and music all together.
7. Review your mix.
8. Transfer to your picture in synchronization.
9. Send it off or upload it.
10. Use the prize money to do a better mix.

CHAPTER 15

Studio Mix

INTRODUCTION

Mixing is an art form, just like story-telling. All the separate sound elements are blended together and condensed down into a creative whole that works in congress with the visuals to tell an engaging story.

The common cited adage, *good, fast, cheap, pick two*, relates to mixing. You can do your own mix and it will be relatively cheap and hopefully good, but it probably won't be fast, especially if it's good. If you want your film done by a professional post-sound crew and rerecording mixers, then it will be good and it will be faster than doing it yourself, but it won't be cheap. However, you can keep the costs down by doing your own work through the premix and then take in your files or session for a final mix on a proper mixing or dub stage.

Much of the information in this chapter is also found in Chapter 14. The premise of this chapter is that you have done the editing and premixing on your own and you are doing the final mix on a dubbing stage with one or more rerecording mixers. Low budget films often have only one person doing the mix. Some may have two people doing the mix. Most larger budget films can have anywhere from one to three mixers.

In New York City it's common to have a single rerecording mixer and sometimes two. In a two-person team, the lead mixer will take the dialogue and ADR (Automated Dialogue Replacement) and may take the music, while the second mixer will take the sound effects and

Foley. In Hollywood, the teams are either two or three-person. The three mixers usually divide the duties based on dialogue, effects and music, one for each. The Foley may be handled by the effects mixer or the music mixer; it depends on how many tracks the film has.

If you've already done a premix and created stems, then they will mix using them. If you haven't created stems, then they might do that, depending on how many tracks there are for the mix.

Most low and no budget filmmakers can't afford a top-end full service mixing stage. These are the stages that can give you a mix that will play well in almost any cinema around the world. I say almost because there are always those cinemas that do not have their sound systems set up to theatrical specifications. If you can't afford the top-end, then there are the smaller sound mixing studios and they can usually do a good job too, but they may not be as experienced or have all of the top-end tools. If you choose a low budget rerecording studio, you'll want to make sure they can deliver what you need. They may well do a fine job, but you don't need any surprises.

If you've been working toward the final mix since you started editing, you probably have done a lot of the mixing work already, especially if you have done a premix on your own. Consult with the mixing stage to make certain your track plug-ins work with their system. When you go into the dubbing stage to do your final mix, you'll ideally have the levels, panning, EQ (Equalization) and noise reduction set-up and somewhat adjusted. It will at least sound good, even if it's not quite right. There is always some work that needs to be done as the different elements come together.

Whoever is doing the final mix on your film will play your tracks down to the end listening to what's on the tracks and to what you've done to the sounds and tracks so far. Don't be offended if they choose not to use some of what you've done as they may have a different and probably better way of producing the mix. It's always a good idea to meet with the person that's going to do your final mix prior to you beginning the editing of the sound tracks, so that you are doing the preparatory work that will best work for them. It will also save you time and thereby money for the final mix.

MIXER INTERVIEW

When you're producing on a limited budget, it's always a good idea to interview the rerecording mixer to make sure they can do what you need and have experience to do it. You don't want someone who has little experience, but acts like they do. You can always subtly test them by asking some technical questions. For example, you can ask how they've calibrated the room for monitoring. A larger film mixing stage will be calibrated at the Dolby standard of 85dB SPL for the three front speakers. If you are in a smaller studio, then they may calibrate for a lower level such as 78 or 79dB SPL, which is standard for a television mix.

Once you are convinced that a studio can do your mix, you can talk to them about discounts. If you are willing to work during downtime between regular paying clients, then you might be able to get a good deal. Companies want to keep their staff and rooms busy, so even a break-even rate is better than nothing for them. Ideally, you'll get one of the top rerecording mixers, but you may have to settle for an up-and-coming rerecording mixer who is in need of more experience. Companies will see you as a way of providing that experience as a trade-off for a discounted price.

We all tend to think we can make a good estimate of how long something will take. In the film business everything always seems to take at least 25 percent longer than we plan. There are many times when I've sent a text to my wife saying that I should be finished editing or mixing in about an hour and then an hour later texting her saying that it may be another hour.

If you are able to get a good deal, then make sure you make a prompt payment so that you can continue the relationship. It will also help the next filmmaker who needs a good deal at that studio. They will be more willing to help others if they haven't had to chase down their money.

Part of the discount deal usually means that your session may be canceled on short notice. That is, if a regular paying client needs your time, they get it and your session is rescheduled. That means that you need to be flexible and gracious in your dealing with the studio. Once the final mix is done, you should consider giving some sort of gift to the people who made it possible. I've been given event tickets, chocolates and even books by different clients who appreciated my working with them on balancing time and money for their projects.

MIX PREPARATION

Organization is the key term behind preparation for your mix. The more organized you are, the easier and better your mix will go. This applies to both mixing the film yourself or having it mixed on a mixing stage. Always contact the mixing stage and find out how they want the edited sound files delivered. Most of them have a list of specifications for you to use.

It's good practice to test your workflow from editing workstation to mixing stage before you're scheduled for the mix. You can transfer a session to the mixing stage and have it loaded into the mixing system. Now you can go through the session checking to see if everything is in its proper place and is correctly labeled. Being as prepared as you can will save you time and therefore money.

Cue Sheets

Cue sheets were commonly used before people started using the monitor on DAWs (Digital Audio Workstations) to view what sounds were coming up in the mix. Cue sheets were printed maps of what sounds were located on which tracks. Some rerecording mixers, especially the music mixers, still use them, but they are not necessary anymore. These are not to be confused with cue sheets in the music industry, which is a list of the music cuts used, duration of each cut and other information for royalty and other billing purposes.

Track Layout

Make sure that all of your tracks are organized in the various food groups, such as dialogue, sound effects, Foley, ambiences and music. Always check with the rerecording mixer as to how they want the track layout. If you've done a premix, then you'll have already organized your tracks and they probably all have been funneled into stems.

If you haven't done a premix, then you'll want all of the dialogue, ADR and loop group tracks together in the same area. You may want to include the production sound effects in this group.

You'll want all of the sound effects in another group. The backgrounds or atmospheres may be included or they may be a separate group.

You might have your Foley in another group, although some people like to include Foley in the sound effects.

You'll have the music as a separate group. This would include both diegetic and non-diegetic music. It would include score, songs and stings.

If you've done a premix, then include all of those tracks. This would include any aux tracks, VCA tracks and master tracks.

If you have done some sound design or processing on a particular sound, make sure you have the original sound on an adjacent track so the mixer can use the original if the processed sound doesn't work well with the other sounds.

If you have a sound or group of sounds that will need a change in volume, pan, reverb or other processing, then you could split that sound or sounds on to separate tracks, so that the rerecording mixer can apply the change to just the track that requires it. For example, if a scene has two people walking in a forest and one of them suddenly falls into a cavern, at the picture cut to the cavern, that person's voice would have echo or reverb added to it to match the chamber they fell into, while the person left standing above in the forest would sound normal.

It can really help keep track count down if the director has approved the sounds going into the final mix. This means you don't need to have many, if any, alternates for the various sounds. For example, if the director is happy with the sounds of a car and the wind and the music in a driving scene, then you don't need to have three or four optional winds or alternate car sounds; they've been approved.

Consolidating Clips

If there is a sound effect or some Foley effect that's been cut up into lots of separate files and they all follow each other on the timeline, it's best to consolidate them or group them into one continuous file. This makes it easier for the rerecording mixer to see what's on the timeline and not be visually distracted by a bunch of separate files. For example, if you're using some footsteps from a library for one of the characters and they are walking along a sidewalk, you'll have to cut each step along the way for the entire shot or scene. This will make a lot of individual files. Consolidating them into one file is good housekeeping and very helpful. Remember to give the new file an appropriate name.

Two Pops (2-pops) and Tail Pops

It is good and standard practice to have two pops and tail pops on your timeline. These pops are useful in maintaining synchronization of all of the tracks and with aligning the sound with the picture once the mix is printed and exported. If you didn't include them in your premix, then include them before you get to the final mix.

A pop is a 1kHz tone that is one frame in duration. It is placed exactly two seconds before the FFOA (First Frame of Action) and two seconds after the LFOA (Last Frame of Action). If you

use a countdown leader, the 2 is typically the last frame you see and it is accompanied by a pop. There are two seconds of black immediately after the single 2 frame and then the film starts.

Figure 15.1

The example shows the 2-pop at the 59:58:00 timecode, which is two seconds before 1:00:00:00. The 1-hour mark is common for the beginning of a film in the US while the 10-hour mark is commonly used in the UK. If you are dealing with multiple reels, then you add a 1-hour increment to the next reel. For example, if reel one starts at 1:00:00:00, the reel two will start at 2:00:00:00.

In order to make sure all of your tracks are in synchronization, when you are done with the premix, it would be good practice to put a 2-pop and tail pop on every track that you've created. If they all line up and are on the proper frame, then you have no sync issues, but if one or more are not in sync or alignment with the others, then you need to find where the sync is off and put it back in synchronization.

Volume Levels

If you've done a premix, then the volume levels should be close for all of the tracks. If you haven't done a premix, then the rerecording mixer will have to take up a lot of time setting the levels. It's best to get the levels of all of the sounds close to their final mix levels.

Panning

Panning is something that can be done in your premix or even in the edit. It might be better to pan your sounds for a stereo mix and leave the surround panning for the final mix. However, you could do preliminary surround panning and then just tweak it in the final mix. If you are not comfortable with doing surround panning in the edit or premix, then leave it to the rerecording mixer.

Processing

If you've done some preliminary processing, make sure that whatever plugins you used are available on the mixing stage. If the stage doesn't have the same plugin as you used, all of your

processing work will be gone, unless you rendered the sound file with the processing baked into it. If you have baked in some processing, make sure you also have the original sound file on a neighboring track so that the rerecording mixer can either use your baked-in sound or, if it's not working, then they can use the original sound and add their own processing.

PREMIXES

Premixes are particularly important if you have a high track count. Some television shows have between 200 and 400 tracks or more. Many big budget movies easily have 1,000 tracks or even as many as 1,500 tracks. These are usually action films that may have weapons firing and vehicles in chase scenes or some other sound-intensive scenarios. When there are so many tracks, it's common for a sound supervisor and a rerecording mixer to try to reduce the number down by mixing the levels, panning the elements and adding effects and then creating stems or groups for the various elements. There may be a stem for gunshots. There may be another stem for rocket fire. There may be another stem with vehicle sounds. By creating these virtual stems, they can bring down the track count to a manageable number. The original sounds are still there, if a change needs to be made, but the actual mix requires fewer faders. If the final mix is a surround mix, then the stems are usually surround tracks, so they are ready to be used in a final mix.

If you can do a premix and get your track count down to around 8 tracks or at the most 24 tracks, then the final mix will go faster and you'll be able to concentrate on creative decisions that support the story. If the track count is high, there may be two or three Pro Tools systems working together.

It is fairly common for sound editors to do the premix themselves. If the mix is going to be in a surround format, the edit room needs to be set up for 5.1 sound monitoring.

In order to keep all of the mixing in a virtual mode, the mixing console needs to be a control surface, which communicates with Pro Tools or one of the other DAWs. Otherwise, all of the automation, effects and premixing will be lost. If you've done a premix on your own system and are doing a mix on a mixing stage, then you will want to make sure that the console on the stage can access the Pro Tools or other DAW files and make necessary changes.

A professional post-production mixing console needs to be able to communicate with Pro Tools or another DAW via the EuCon Ethernet protocol. The consoles will have their own DSP (Digital Signal Processor) and also control over EuCon control-enabled DAW and NLE (Non-Linear Editing) systems. Some control surfaces and consoles are capable of a MIDI control system, but these are usually limited in their functions.

Some rerecording mixers will use Pro Tools or some other DAWs as effects boxes by routing signals to them for effects processing and then returning them to the console for mixing.

STEMS

Groups are premixed or sub-mixed tracks that contain several other tracks mixed together. There may be several groups from a premix going into the mix. There are usually the three main groups for the final, dialogue, sound effects and music. The dialogue group might include

dialogue, ADR (Automated Dialogue Replacement), and walla. Sound effects might include hard sound effects, Foley, backgrounds and sound design. Music includes score and source music or songs. Some of these groups may be split out. You may have the Foley group or the backgrounds group or some other specific type of sound. These groups may be mono, stereo, LCR (Left, Center, Right), or surround, whatever you require.

These groups are then mixed down into stems. Stem is the abbreviation for "stereo master," although the term applies to surround sound too. You should be able to put all stems at unity and they will playback just like the final full mix.

It's important to keep in mind that when you are talking about the music world, stem means groups such as drum stems, string stems, synthesizer stems, and more, while in the film and television world stem means dialogue, sound effects and music or DME (Dialogue, Music and Effects). So, when the music is delivered to the film mixing session they become premixes, although some people still refer to them as stems, and once the music is mixed with the picture in a final mix session the output is a music stem, which combines all of the drum stems, string stems and others into a final mix.

At the end of the mix, all of your tracks will be funneled down into the DME and master (print master). If you are doing a 5.1 mix, then you'll have six final channels for your mix (LCR, LFE, Ls, Rs or perhaps LRC, Ls, Lr, LFE).

In television the stems that are part of the output of the final mix include Narration, Dialogue, Music and Effects or NDME.

MIXING

In order to get to a final mix session, the sound goes through several phases, which will include some form of the following steps:

1. The various sound elements are placed and edited onto a timeline in a DAW or NLE session. These sound elements include the individual sound effects, the dialogue tracks, the music tracks, the ambience tracks and the Foley tracks. Whatever tracks are needed for the overall film sound design.

2. The various sound elements are premixed in order to make the final mix an easier and more creative endeavor. This is where several different stems or groups are created that will be mixed into the final three stems (DME) in the final mix. The premix stems might include ambience, Foley footsteps, Foley sound effects, car sound effects, gun sound effects, percussion, strings, brass, and whatever else is appropriate for your film.

3. The final mix stems will include D (Dialogue), which includes dialogue, ADR and group, M (Music), which includes score and songs, and then E (Effects), which includes sound effects, sound design, Foley and backgrounds.

4. The output of the mix will include a M&E (Music and Effects) mix, which is needed for creating foreign language version of the film.

5. The last item created is the master output, which is the full mix for duplication and distribution of the film.

The rerecording mixer is responsible for mixing all of the tracks you provide. If there is more than one rerecording mixer, then the dialogue mixer is usually the lead mixer. The other mixers will mix the sound effects and music under the leadership of the lead mixer. It is common to have a two-person crew too. In this arrangement the lead mixer will mix the dialogue and possibly the music too. The second mixer will mix the sound effects and Foley. There is no set standard, but these are common approaches as to who does what.

The rerecording mixer or mixers are charged with blending all of the sounds together to make a seamless soundtrack that will help convey the director's vision to the audience. The mixers will analyze the movie as a whole and then each scene to determine the best approach for mixing the sounds. If a scene is intense, they will adjust the sounds to support that feeling. In a scene that is romantic, they will adjust the sound for that feeling. In order to make the romantic scene stronger, they may bring up the level of the strings and reduce the level of the horns track, if there is any. They are always looking at ways of achieving the needed feeling for a given scene. They may even suggest to the director to remove the music from a scene and let the low rumble sound effect create the suspense for a scene or vice versa.

Rerecording mixers can use panning and volume levels to help focus the audience's attention in a particular direction that highlights an action, character or object. For example, if a couple are having a romantic conversation at a basketball game, the level of the game and the fans can be brought down enough to allow the conversation to come through clearly, even though in real life it would be difficult to hear.

In a surround mix, there is the ability for the rerecording mixer to pan the sounds around the speaker array. A 5.1 mix will allow the sounds to be panned around the sides. A 7.1 mix will allow the sounds to be panned around the sides and the back. You should have an idea about how you want the sounds panned or have panned them in the premix.

The rerecording mixers use their tools such as EQ, reverberation and effects to make the sound fit properly into a given scene and to create a balance of the dialogue, music and sound effects.

The basic steps to working with the sounds are:

1. Getting the balance of the relative levels right
2. Adjusting the panning to create a spread of the sounds into the listener's space
3. Adding whatever EQ, compression, reverberation and other effects that are needed
4. Monitoring and setting the final volume to proper levels and avoiding clipping

RUN THROUGH

The rerecording mixer or mixers will commonly run through the film from beginning to end to get a sense of the big picture, what sounds are available and what needs to be done to blend them together.

If your budget allows for only one mixer, then that mixer will usually work with the dialogue first as that's the foundation for everything else. They then might move onto the music as it provides the audience with the emotional cues. They would then add the sound effects and

balance them with the music. If they have stems to work with or VCA groups, then they may use those to mix all of the sounds at once.

If you discover that there is a missing sound or that the sound cut into the track doesn't work well, then you should be able to jump onto a side DAW, usually Pro Tools, and make the fix. This means that you need to have a portable hard drive loaded with the session and all of your sounds, so that you can access them on the DAW computer.

If the studio doesn't have a side DAW, then, if you can, bring your laptop with a DAW on it. If the studio can't connect your DAW, then you'll have to give them the missing sound to load into their system and edit in. That's one possible area where you could lose some time in the mixing process.

DIALOGUE MIXING

The dialogue mix is the most important part of the mix. The rerecording mixer will work to get the dialogue to sound good, get the perspective right and get it to sound proper for the location or environment it takes place in. If the mix is for television, then there is generally less volume adjusting for perspective.

The ADR will be adjusted, if it hasn't been in the premix. The room tone or ambience will be adjusted and the ADR will be processed to make it match the dialogue. The ADR may need some EQ to get the voice to match the sound of the production dialogue. It may need some reverberation to get it placed in the environment. It may need some pitch shifting to get the same frequency range as the dialogue.

Mixed along with the dialogue and ADR will be the loop group or walla if it hasn't been mixed in the premix. It will need some processing to get it to fit into the mix too.

SOUND EFFECTS MIXING

If you've done a premix of the sound effects, then most of what the mix will be about is deciding if the sound effects or the music or silence supports a given scene best. There may be some sounds that are dropped and others that may be highlighted to help tell the story.

FOLEY MIXING

The Foley may need some EQ and reverberation to get it to sound natural in a given scene. You may have already done this in a premix. The point is to realistically provide the sounds that were not picked up well or at all during production, because the microphone was pointed at the actors' mouths, not their feet or hands.

BACKGROUNDS MIXING

If you are doing a surround mix, you need to consider whether or not you want the ambiences panned into the surrounds. The idea of the surround speakers is to pull your audience

into the story by surrounding them with the sounds of the story. Since the picture can't break the boundaries of the screen, it's up to sound to do that, but only if it has a purpose and it doesn't interfere with the suspension of disbelief the audience is experiencing. In other words, it shouldn't draw attention to itself.

The mixer may use some reverberation in order to place the ambience in the environment. If there are individual elements in the ambiences, like specific birds, a distant tractor or perhaps a spinning windmill, they too may need some reverberation.

MUSIC MIXING

The rerecording mixer will not compress the music or score to the same extent that many modern songs are so tightly compressed. Music in cinema will average around 20dB in headroom, while modern songs are so heavily compressed that they have barely 1dB of headroom. Film and to a lesser degree television have fairly wide dynamic ranges. Film sound can express the range from a soft whisper to a loud explosion.

If you want the mixer to spread the music out into the surrounds, make sure it's not overdone. If the audience is only hearing the bass drum in the rear speakers, it will be distracting for them. The key is to not pan the music too wide.

If you are using virtual instruments and possibly MIDI in your score, then you should consider turning them into audio files for the final mix. This will allow the mixer to adjust and process them just like the other sound files.

If the score was created in Logic, Cubase, Digital Performer or some other software and the mixing stage doesn't support that software, then having the music as audio files makes them easier to integrate into the mixing system. Some mixing stages can run both Pro Tools and one or more of the other pieces of music creation software.

It is common for the filmmaker to be in love with the music and they want it to run throughout the film, but this may not serve the film on the whole. The rerecording mixer will guide you in when and where music is being effective for your story. They are probably right, so listen to them. There is also a common mistake in the music being played too loud. There are times for loud music, but usually the score needs to sit in the background playing on our emotions. I have seen far too many low and no budget films that are almost music videos with loud wall-to-wall music. Occasionally this works, but not very often.

Deliverables

INTRODUCTION

Deliverables are dependent on the distribution deal you have. There will be various types of output from the final mix. The most important is the composite master, which is what you could transfer to your NLE (Non-Linear Editing) and synchronize it up with the picture and then output both composited together for distribution. If the deal calls for a Dolby-encoded soundtrack, then you need to have that done at a Dolby-approved studio. Dolby is a system for achieving a high standard of audio reproduction. It's not necessary, but it is useful in getting your soundtrack to be replicated almost the same in whatever theater it plays in as long as that theater is also Dolby approved.

FILM

The last step for the mix is to create the printmaster. The rerecording mixer will combine the stems into a final composited digital soundtrack. This can be married to the video-edited master, duplicated and then released for exhibition.

A foreign version M&E (Music and Effects) will be created too. This allows for foreign language versions to be dubbed as there is no dialogue. If there were any sound effects or Foley in the production track, they would have been split out and then mixed in with the post-production sound effects and Foley. They are all then mixed together to create a fully filled M&E that requires nothing but the foreign dialogue.

Georgia Hilton is a producer, director and post-production supervisor, who is very knowledgeable about deliverables. Below is her list of what sound an independent film might be required to provide for a distribution deal.

DELIVERABLE SOUND FOR AN INDIE FILM

You may have to deliver 4 × 30-minute reels or a single full-length version.

1. The films LtRt/ LoRo mix for each reel and the full-length version.
2. The music LtRt/LoRo mix for each reel and the full-length version.
3. The SFX/foley/production sound—fully loaded M&E LtRt/LoRo mix for each reel and full-length version.
4. The dialogue LtRt/LoRo mix for each reel and full-length version.
5. The 5.1 mix full-length version.
6. The 5.1 music mix full-length version.
7. The 5.1 SFX/foley/production sound—fully loaded M&E full length version.
8. The 5.1 dialogue mix full-length version.
9. For each of 4 reels—5.1 full mix.
10. For each of 4 reels—5.1 music mix.
11. For each of 4 reels—5.1 SFX/foley/production M&E fully loaded mix.
12. For each of 4 reels—5.1 dialogue mix.

Source: https://www.gearslutz.com/board/video-production-post-production/954125-deliv ery-specs-vod-itunes-netflix-other-requirements.html

DCP

For cinema exhibition you'll probably have to have a DCP (Digital Cinema Package) for the digital projection system. DCP is a group of files that work in conjunction with each other to provide the data for digital film exhibition. There are picture and sound MXF or Material eXchange Format files. There are also metadata files for management and organization of the media. You also may have the option for encrypting the files or for adding subtitles. The sound is either 48k or 96k sampling and the bit depth is 24 bits. It needs to be at least 3.0 (LCR), or 5.1 (LCR, LFE (Low-Frequency Effects), LS (Left Surround), RS (Right Surround)) or any other multichannel format, but a mono track would work too. You should be able to play a DCP in any digital cinema around the world.

If you are not required to have your soundtrack DTS or Dolby encoded, then you can do a DCP in 5.1 or 3.0 and you should be able to meet basic requirements. Many filmmakers that only exhibit through film festivals often do not do a surround mix. They do the 3.0 mix and

leave it at that. If the film gets a pick-up for distribution, then they can do whatever mix is required for the deal they have.

Some NLE systems have the ability to prepare DCPs; however, they usually require you to use third-party software to actually produce the DCP. For example, Adobe Premiere sends the film to Adobe Media Encoder where it turns it into a DCP.

Some DCP software that's free includes OpenDCP and DCP-o-matic. Most of the software that's for sale provide free trial versions. The quality and features are different for all of them, so do your research.

There is software that will allow you to play your DCP on your own computer's monitor. If you do not have the DCP player software, the XYZ color space will look odd when played on your monitor. The player software can cost hundreds of dollars, pounds or euros. There are some free trial versions like EasyDCP that will at least let you know if the conversion worked.

You could try to get your local theater to run your short film or a few minutes test of your feature film to see if the colors and sound are properly encoded and decoded in a digital theater system. I've taken short films to my locally owned theater, loaded them on their D-cinema server and they've played it for me so I could check the conversion and they did not charge me anything. I was able to get the short films onto a USB flash drive, but if you have a longer short film or a feature, you'll need a large USB, SAS or SATA drive. Many cinemas require that the drives should be in a CRU produced carrier, which allows the drive to be directly inserted into the server.

If you can afford to have your DCP made professionally, it's the better option as the quality will be optimized and it will be tested and made playable in all projection systems. You can buy software like Clipster, EasyDCP or QubeMaster that make a DCP, but it can easily cost more than a thousand dollars, pounds or euros. I've tried some low-cost and free software options, but they are often complicated, limited in features and not reliable, which is why I did testing at my local cinema. Everything worked fine, but I had to do a couple of test to get it right.

DVD/BLU-RAY

There are specific settings that need to be followed to get good audio onto a DVD or Blu-ray. You will need to have either a LtRt (Left total and Right total) or a LoRo (Left only Right only) for stereo playback. If you did a surround mix, then you'll want to have a 5.1 option on the disks. There are plugins, like the Waves 360, which will fold a 5.1 mix into a LoRo. LtRt requires a matrix encoding and decoding so that the left, right, center and mono surround can be heard.

If you are creating the disks using a theatrical mix, you'll have to do some equalizing to bring down the higher frequencies so it plays better in a home theater environment. A television mix should function well for a DVD mix.

If you are making your own DVD and Blu-ray disks then you'll need a decent burner or if you are producing a lot of them you'll want a multiple disk duplicator. I've burned my own DVDs and Blu-rays, but only if I need just a few. When I've needed more for distribution, I've

hired a duplicating company to do the job and the cost was not very high. You may need to provide them with a pristine high-quality DVD or Blu-ray master. Each duplicator will have its own specifications for the master. Blu-ray allows for both 5.1 and 7.1 surround sound.

If you are just making a few Blu-ray disks for a festival exhibition, then it can be very useful to include two options for playing the film. One would be a Lt/Rt version and the other would be a 5.1 version. That way the projectionist can choose the proper format for the theater your film is playing in. Hopefully, they will be able to handle one of these versions.

If you are authoring your own disks, then you need to be aware of the Dialnorm or normal dialogue setting. It determines the DVD playback level for your film. The Dialnorm is the level that you used to mix your film. In the Dialnorm settings the range is from −1 to −31dBFS Leq(A). A setting of −31 will not do anything to the level, while a setting like −27 will cause a −4dB shift in the level. Most films work at the −27 level.

STREAMING

Let's take YouTube as an example, realizing that these specifications change over time. You can upload AAC-LC audio in stereo or stereo +5.1 surround. You could also do a two-track mono. The recommended bit rates are 128Kbps for mono, 384Kbps for stereo and 512Kbps for 5.1 surrounds. The sample rate will be either 48kHz or 96kHz. Other formats might be acceptable, but these are the recommended ones and these may change in the future.

Vimeo wants 48kHz and a constant bit rate of 320Kbps. They also recommend the AAC-LA (Advanced Audio Codec).

In terms of loudness, there doesn't seem to be a standard. I suggest that you keep your peaks below −3dB and that you average around −18dB to −20dB.

BROADCAST TELEVISION

Each broadcaster and cable company will have their own specifications. In SMPTE (Society of Motion Pictures and Television Engineers) countries like the USA and Canada, the reference level will be −20dBFS and in EBU countries like France and Germany, it will be −18dBFS. There will also be a maximum peak level too. That is commonly either −9dBFS or −10dBfs, but could be different.

You'll probably need a 5.1 and a LtRt mix. Always check on the specifications before you mix so you can deliver the required formats.

MARKETING

There are some great exhibition opportunities for independent films. You can put them on iTunes, Netflix, Hulu or on cable with VOD (Video On Demand). You can use YouTube or Vimeo to market your film with a trailer. You can create your own website or one just for your

film. You can put a pay for download option on your website. There are many options for selling your film.

Marketing used to be what other people did, but now it's common for filmmakers to do their own marketing, especially low and no budget filmmakers. It's not difficult to electronically distribute your film. You don't need a sales agent or a marketing company. You can essentially eliminate the middle person. The key is that you need to take off your filmmaker's hat and put on a marketer's hat. That means seeing your film as a product that has pluses and minuses in terms of marketability.

You need to know who your market is. What is the demographic for the film? Who will be willing to spend money to see your film? I assume you want to make money so you can make your next film and maybe have a decent budget for it.

You need to figure out how you are going to market your film and how you are going to get it seen.

ARCHIVING

Once you have completed the final mix and all of the other deliverable outputs, you need to consider how you are going to archive these along with the mix session and your finished film. I've had a situation where a confusing sentence had to be replaced with ADR (Automated Dialogue Replacement) seven years later because the new distributor believed that the sentence could be misconstrued by the audience. I had saved and archived everything and was able to replace the offending sentence easily and in very little time.

There are places like Iron Mountain that will store your film along with thousands of others from the studios, but it costs a lot of money. Once you've made your digital film, you're going to have to find a place to store everything including the final mixes, media, session data and whatever else you may need to recreate your film. Many filmmakers are storing their video projects onto hard drives, DVDs or optical disk along with a player. They may even include a laptop with the editing and mixing software and proper codecs loaded on to it. Most formats don't last long before something replaces them. You need to be prepared for that call seven years from now asking for a change.

No one I know shoots on standard definition anymore and HD is fading fast. You may be able to keep your film elements for 10 or more years, but then you'll need to transfer them to another format to keep them current. If your film was shot on motion picture film, then it should last 100 years or more in such a climate-controlled environment as Iron Mountain.

The key to archiving video is to have lots of copies in different places and update them before the format becomes obsolete. You could store your film in the cloud and update it when a new format emerges.

Summary

CLEAN PRODUCTION SOUND

The best sound design needs to start with the best production tracks. A lot can be done to clean up dialogue tracks, but having clean tracks will make the process easier and cheaper in the long run.

It is a common mistake of low and no budget filmmakers to focus on the picture and only give cursory attention to the sound. Picture and sound need to be given the same attention to get good results.

CREATING SOUND DESIGN

Sound design is one of the least costly aspects of filmmaking, yet it can elevate the overall quality of a film. It only requires time and imagination.

The best sound design starts with well-recorded production sound. There are lots of tools to attempt to clean up poorly recorded production sound, but there are limits.

- It can be a waste of time to start sound editing until the picture is truly locked.
- Work on editing and cleaning up the dialogue first. It's the foundation for all of the other sound.
- Spot the film for all of the sound effects, Foley and music cues you'll need.
- Make sure all of the production sound is in synchronization.
- Record the ADR (Automated Dialogue Replacement) and walla and edit them onto the timeline.
- Record as many clean sound effects as you can, then get the rest from libraries. Edit the sound effects into the timeline.

- Keep all of your individual sound design tracks, but bounce the layers down into one file to make it easier to mix. Mute the layers and just mix with the bounced file.
- Record the needed Foley sounds as cleanly as possible and edit them in.
- Create musical cues or find music that will work with your story.

MIXING

Bring all of the dialogue, sound effects and music together in a premix that is focused on the more technical aspects of the mix, such as levels, pans and reverberation. Combine the various audio tracks, sound effects, Foley, dialogue, ambiences, and so on into aux tracks, which will make the final mix easier.

Do a final mix that creates continuity between the dialogue, sound effects and music in a creative way that supports the story.

Output your mix in whatever formats you need and composite the mix with your finished picture for distribution.

CONCLUSION

The more you learn about the process of post-production sound and the more experience you get creating it, the higher production value your films will have. The higher the production value, the more seriously people will take your filmmaking prowess.

Knowledge is power and it can be used to create, entertain and inform others. As an artist and a storyteller, your primary function is to provide a mirror on the human condition and to do so in an entertaining manner.

INTERNET RESOURCES

- Filmsound.org
- CreativeCow.net
- YouTube.com
- Soundonsound.com
- Gearslutz.com
- Vimeo.com
- Filmmakeriq.com
- Videomaker.com
- Mixonline.com

Glossary

Absorption: When sound strikes a surface or medium that reduces the sound energy.

Active Loudspeaker: A speaker that has an internal amplifier.

Acoustics: From the Greek *akouein* meaning to hear. It is the science of sound wave behavior. It includes the generation, transmission and reception of sound.

ADR (Automated Dialogue Replacement): ADR is the rerecording of the production track because of issues such as a noisy background, unwanted sounds or poor actor performance.

Ambience: Sounds such as backgrounds or atmospheres, which are the foundation sounds inherent in any environment.

Attack Time: The length of time it takes the compressor to start compressing once a signal has reached the threshold for it to start working.

Bandwidth: The range of frequencies on either side of the center frequency. In equalization these are the frequencies that are affected by cutting and boosting.

Bit-depth (word length): A 16-bit word contains more information and thereby more dynamic range than a 10-bit word and a 24-bit word contains even more information.

Bus: A bus is an assigned path to route one or more audio signals to a particular destination. Destinations can include groups, auxiliary, mixes, VCA master, recorder or the master.

Channel Strips: Controls the input and output along with the processing of a signal.

Comping: Takes the best part(s) of each recorded take and combines them into one final edited version.

Compression (audio): Technically, compression refers to adding (boosting) gain or volume to soft areas and reducing (cutting) loud areas. The proper use of compression can enhance and even out the audibility of a track.

Compression Ratio: This is the ratio of input to output after the compressor has activated. A ratio of 4:1 represents medium compression and means that when the incoming level (that is, the level above the set threshold) rises by 8dB, the outgoing level will only rise by 2dB.

Condenser Microphone (capacitance microphone): Most common microphone style for recording voice. Requires phantom power or battery due to its low-volume output. It uses variations in voltage to create a signal.

Console, Board, Mixer or Mixing Desk: It takes various input signals and amplifies, balances, processes, combines and routes them to a master or output.

Crossfade: The fading in of one sound while fading out another sound over a specific time frame. At some point the sounds are blended at an equal level of loudness.

DAW (Digital Audio Workstation): Any computer-based system designed to record, edit and playback digital audio. The more advanced systems can do multi-track recording and mixing using audio tracks, samples and MIDI sounds.

Decibel or dB (1/10 of a Bel): A logarithmic measurement of signal strength used to compare the ratio of two quantities in terms of how loud a sound is. If a signal level is increased by 6dB, it will technically be twice as loud, but our ears may not register that much of an increase.

De-esser: A fast-acting compressor that reduces high frequencies on such sibilant sounds as s, z, ch and sh.

Delay (digital delay): This is a time-based effect that is considered to be an echo sound. Signal adjustments include delay time and the number of repeats desired. Delay is different than reverberation, although they can be used together.

Deliverables: Materials turned into the producer upon completion of a project. This would include all media, edit and mix sessions, various mixes and documentation.

Diffraction: The bending of sound waves as they change directions while passing around objects or through openings.

Diffusion: The scattering of sound waves in an even manner within a given environment.

Direct Sound: Sound waves that directly reach the listener before reflecting off any surface.

Distortion: The addition to a signal in the reproduced sound that was not in the original sound. This could be the clipping of sound that is caused by input levels set too high.

DME (Dialogue, Music and Effects): The three types of sound tracks.

Doppler Effect: For a listener, the apparent change in pitch or frequency of a sound when there is relative motion between the source and the listener. The classic example is the train passing by where the pitch of the whistle sounds higher approaching the listener and lower going away.

Dry and Wet: Dry means a signal is free from processing and wet means that it has processing or effects added to it.

DSP (Digital Signal Processor): Digital devices or software plugins used to alter some characteristics of a sound.

Dynamic Microphone: It does not require phantom power or batteries. It uses magnetic variations to create a signal.

Dynamic Range: The loudest point minus the quietest point equals the dynamic range. It is the range of sound intensity a system can reproduce without compressing or distorting the signal. Dynamic range is measured in decibels (dB).

The dynamic range of 16-bit audio is around 96dB.
The dynamic range of 24-bit audio is around 144dB.
The dynamic range of human hearing is roughly 120dB.

Echo: After the original sound the echo is the sound reflections that are delayed by at least 35 milliseconds. Any less and we perceive it as part of the original sound.

EDL (Edit Decision List): A list of edits used to assemble a production. It can also be used to reassemble a production.

Equal Loudness Principle: The human ear is not equally sensitive to all audible frequencies. We hear middle frequencies better than high or low ones.

Equalization (EQ): The process of adding and subtracting gain levels to user-selected frequencies in order to correct or enhance the sound.

Expander: It increases the dynamic range of a signal. A compressor does the reverse.

Fader: A slider that regulates the loudness level of each channel on a console.

Far-field Monitoring: Listening to monitors from a distance. These monitors are designed to provide the highest-quality sound reproduction much like that of a cinema.

Filter: A device or software plugin that affects certain bands of frequencies. A telephone filter will reduce both the high and low frequencies, leaving the middle frequencies.

Foley: Creating and recording character-related sound effects in a studio or purpose-built stage. These sounds include footsteps, clothing movements and sound effects.

Frequency: The number of cycles per second in an audio wave. It is sometimes measured and notated in Hertz (Hz) or kHz. The human ear has a hearing range from 20Hz to 20kHz.

Frequency Response: It is a microphone's output level or sensitivity throughout its effective operating range from the lowest to the highest frequency.

Gate: The inverse of a compressor. Once the signal drops below the threshold, the gate closes and mutes the output. It can be used to reduce or remove a noise floor during the quiet times.

Haas Effect: The human psychoacoustic phenomena of correctly identifying the direction of a sound source. The direct sound from a source first enters the ear closest to the source, then the ear farthest away.

Headroom: The amount of buffer in your audio level, below the peaking point of 0dB. Headroom of 10dB or 12dB is a safe target, and it's a requirement for television.

High-pass Filter: The passing of high frequencies and the blocking of lower ones.

Indirect Sound: Sound waves that reflect from one or more surfaces before reaching the listener.

Insert: An access point that allows the inclusion of external devices or software plugins into the signal flow. Common inserts are gating, compressing, equalizing and reverberation effects.

Inverse Square Law: This is where sound decreases over distance; specifically, it drops 6dB for every doubling of distance from the sound source.

ISDN (Integrated Services Digital Network): Digital audio is transmitted over long-distance telephone lines between the talent and the recordist.

Knee: The moment that the compressor starts to reduce the gain. A soft knee gently engages the compressor and is less noticeable.

Layering: When many sounds occur at once in order to create an overall sound. For example, a rocket ship blastoff may consist of several sounds blended together to create the desired sound.

Limiting (limiter): The process of placing a limit or brick wall on the maximum volume of an audio track or signal. The very loudest points will not be allowed to increase beyond a user set level.

Loudness: The relative volume of a sound as it's a subjective measurement for each person.

Low-pass Filter: The passing of only the low frequencies and blocking of the higher frequencies.

Masking: The hiding of some sounds by other sounds when they are played together. Loud sounds tend to mask soft ones and lower-pitched sounds tend to mask the higher ones.

Master Fader: The final fader that combines together the other signals before output.

Mastering: The final step in preparing the audio material for duplication and distribution.

Metadata: Metadata is useful data or information that's included with the media.

Mixing: The process of blending sounds, music and voices together into a final or near final stage.

Mute: Cuts off the flow of the signal on the track on which the mute button has been activated.

Near-field Monitoring: Direct monitoring of sounds. The monitors are placed close to the listener to reduce any early reflections from the studio walls.

NLE (Non-Linear Editing): The ability to freely move media along a timeline in a software-based editing system.

Normalization: Process of applying a constant amount of gain to a sound to achieve a target level. It can be used to bring the average or the peak levels to the target level.

Nyquist Theorem: It states that the sampling frequency should be at least twice the highest frequency contained in the signal in order to avoid aliasing. If human hearing goes to 22k, then the recording should be sampled to 44k.

Overload Indicator: An indicator found on audio signal processing and mixing units that lights up once the signal level exceeds a preset level, often around −3dB. It's usually a red light.

Pad: Reduces the power of a signal into a system or recorder. It is used to reduce loud sounds to a recordable level.

Pan: A control that shifts the signal between the left and right speakers or to various speakers in a surround system.

Parametric Equalizer: It permits the user to set the cut/boost of a selectable band of frequencies. The center frequency of the band is tunable over a wide range of frequencies. A parametric is great at focusing on a problem frequency and attenuating it.

Passive Loudspeaker: Requires an external amplifier to power it.

Peak: The maximum level of a signal of an output. It is the peak value or highest voltage that the sound waveform will reach before distorting.

Perspective: The adjusting of the sound level and distance in relation to the viewpoint of the camera in a scene.

Phantom Power: DC power carried via an XLR microphone cable from a recorder, camera, mixer or interface to the microphone. It's usually 48 volts, but may be some other voltage. The benefit of phantom power in a studio environment is that it eliminates the need for batteries. In the field it may need to have a battery-powered source from some attached device.

Phase: The time relationship between two or more sound waves at a given point in their cycles.

Pick-up Pattern:

Omnidirectional—All directions.
Bidirectional—Two opposite directions.
Unidirectional (includes: Cardioid, Super-cardioid, Hyper-cardioid and Shotgun, which is a hyper or super cardioid with an interference tube)—One limited direction.

Pink Noise: Pink noise has equal energy per octave. Whenever we hear a frequency doubled we hear it as an octave. Pink noise relates to how humans actually hear.

Pitch: The highness or lowness of the frequency or what we call the tone of a sound.

Pitch Shifting: A process that uses digital signal algorithms to change the original pitch into other pitches.

Plosives: A plosive speech sound in the English language is caused by saying the t, k, p, d and g consonants.

Plugins: Software-based signal processing tools that are added onto the basic software.

Potentiometer (pot): A variable resistor that controls the volume level.

Preamplifier (Pre): It functions between a microphone or instrument and a recording device. The preamplifier boosts the audio signal to an appropriate amount of gain.

Proximity Effect: The increase of bass frequencies as a microphone comes closer to the sound source.

Psychoacoustics: The scientific study of the human perception of sound along with our response to sound.

Q: The measure of the bandwidth of frequencies the equalizer settings affects. This can be narrow as in a notch filter or broad.

Reflection: A sound that is reflected off of a hard surface.

Release Time: The length of time it takes the compressor to stop working once the signal has fallen below the threshold.

Rerecording: The final stage of audio post-production in which all the sounds are combined into a complete and final recording.

Reverberation: It is a time-based effect that involves multiple reflections of an original sound wave. Reverberation has a repetitive sound, unlike a delay.

RMS (Root Mean Squared): It is the effective value of the entire waveform. It is the continuous power of a signal. It is close to how our ears hear.

Sampler: An audio device or software that manipulates short sounds or music phrases and plays them using MIDI commands.

Sampling: It is the number of samples taken of an analogue signal in the process of converting the sound into the digital domain. The higher the numbers of samples, the higher the quality. Common sample rates include: 44.1kHz, 48kHz, 96kHz and 192kHz.

Sends: A send is a pathway on either a mixer, recording interface or recording software that allows a separate signal of an individual channel to be sent to a separate output. A signal may also be sent to an outboard processor and then returned to the mixer.

Sibilance: A consonant that creates a hissing sound like s, sh or z.

Signal to Noise Ratio: It is a measurement using a ratio to compare the level of a wanted signal or sound to the level of the background noise or noise floor. A ratio that is 1:1 means the noise and the wanted sound are at the same level. A ratio more than 1:1 means the signal is louder for the wanted sound.

Solo: Cuts off all signals flowing through a mixer except on the track on which the solo button has been engaged.

Sound Design: The process of creating the overall sonic character of a production. It also applies to the creation of sounds not commonly found in nature.

Sound Envelope: Refers to changes in loudness over time. There are four stages:

1. *Attack* time begins when the sound hits strongly.
2. *Decay* is the time it takes for the sound to drop from the peak to a sustained level.
3. *Sustain* is the level that the sound is maintained.
4. *Release* is the decay time from when the sustain stops until the level drops to zero.

Sound Pressure Level: A measure in dBs or decibels of the pressure or level of a sound wave.

Spotting: Watching a production and deciding on the specific placement of music, sound effects and ADR.

Surround Sound: A term for sound systems using more than the standard mono or stereo speaker array. The purpose is to position speakers in order to create a 3D experience.

Sweet Spot: The ideal location in a room for someone to be to hear the playback of sound from monitors properly.

Tempo: The speed, in beats per minute, at which music is played.

Three-to-One Rule: For every unit of distance away from the sound source, your microphones should be at least three units apart. For instance, if your microphones are 1 foot from the source they should be 3 feet apart. This will keep you from having phase problems when close microphoning. Phase problems will cause cancelling out of frequencies or an entire spectrum of frequencies.

Threshold: It sets the level where compression starts to take effect. Sounds below the threshold pass through unaltered and only sounds above the threshold are compressed.

Timbre: The tone or quality of a sound that differentiates it from other sounds or instruments that have the same pitch and volume.

Timecode: The electronic frame numbers are 30, 29.97, 29.97—drop frame, 25, 24, 23.97 in frames per second. An example might be 01:01:20:16, which is one hour, one minute, twenty seconds and sixteen frames.

Transducer: Any device that coverts energy from one form into another; for example, mechanical into electrical. Microphones and loudspeakers are both transducers.

Trim: Gain control for input into a system. It can boost low-level sound sources like some microphones and instruments.

Walla (loop group): Background voices that are recorded in a studio to create a crowd ambience and call outs of specific crowd lines.

White Noise: A wideband noise that contains equal energy at each frequency. It sounds like a hiss.

Windscreen and Pop Filter: Cover or screen for a microphone that reduces wind noise and plosives.

XLR: A connector for use in sound and electronics. The most common XLR in audio work is the standard 3-pin XLR.

Zero Crossing: The point where the waveform crosses the centerline, which is at zero amplitude or voltage. At the zero crossing there is no increase nor decrease in the voltage, so there will not be an audible "click" at that edit point.

Bibliography

BOOKS

Ament, V.T. (2009). *The Foley Grail: The Art of Performing Sound for Film, Games, and Animation*. Amsterdam: Focal Press/Elsevier.

Purcell, J. (2007). *Dialogue Editing for Motion Pictures: A Guide to the Invisible Art*. Amsterdam: Focal Press.

Rose, J. (2009). *Audio Postproduction for Film and Video*. Amsterdam: Focal Press/Elsevier.

Wyatt, H. and Amyes, T. (2005). *Audio Post Production for Television and Film: An Introduction to Technology and Techniques*. Oxford: Focal Press.

Yewdall, D. L. (2012). *Practical Art of Motion Picture Sound*. Waltham, MA: Focal Press.

Magazines

Rob Winter, (2004, September v.14 issue 9), "The Best Music in Film." *BFI: Sight and Sound*. Quote from Lewis Gilbert, Director.

Websites

DuArt: Sections of *Preparing a Picture Edit for Sound Editing & Mixing & Preparing Your Elements for a Sound Mixing* were used with permission from Ron Harris, DuArt.

Georgia Hilton, MPSE CAS MPE, (2014, September 11) https://www.gearslutz.com/board/video-production-post-production/954125-delivery-specs-vod-itunes-netflix-other-requirements.html

William Kallay, (2004, September 24) fromscripttodvd.com article, *Avram Gold, M.P.S.E. Behind ADR*, http://www.fromscripttodvd.com/adr_fixed.htm

Debra Kaufman and Ron Lindeboom, Creative Cow, John Roesch Article: *The Art of Foley: John Roesch Honored by MPSE*. https://library.creativecow.net/kaufman_debra/John-Roesch_Foley-MPSE/1

Derek Jones, Chief Engineer and Production Manager at Megatrax blogs a great example of tempo mapping. http://duc.avid.com/showthread.php?t=267717

Tim Prebble, Sound Designer, (2008, March 3) Hiss and a Roar, *Recording FX at 96k*, Music of Sound. http://www.musicofsound.co.nz/blog/recording-fx-at-96k

Interviews

Avila, Steve, (2014, June 5). Personal Video Interview.

Berger, Josh, (2015, November 14). Personal Video Interview.

Boyd, Terry, (2014, June 5). Personal Video Interview.

Czembor, Martin, (2014, November 15). Personal Video Interview.

Derfel, Isaac, (2015, November 14). Personal Video Interview.

Grzaslewcz, Marlena, (2015, November 14). Personal Video Interview.

Pullman, Jeff, (2015, November 14). Personal Video Interview.

Riddle, Ron, (2016, July 19). Personal Video Interview.

Salib, Matt, (2014, June 5). Personal Video Interview.

Shedd, Ian, (2014, June 5). Personal Video Interview.

Whitver, Ben, (2014, June 5). Personal Video Interview.

Index

Page numbers in *italics* refer to figures.